BAROQUE PAINTING

BAROQUE PAINTING

**Two centuries
of masterpieces
from the era
preceding the
dawn of
modern art**

BARRON'S

Editor: Stefano Zuffi
Iconographic research: Francesca Castria
Texts by Francesca Castria
(the chapters on France and Great Britain)
and Stefano Zuffi
(the chapters on Spain, Italy, Flanders, Holland,
Germany, and Austria)
English translation: Mark Eaton, Felicity
Lutz, Paul Metcalfe for Scriptum, Rome

Front cover:
Frans Hals
The Laughing Cavalier, detail
1624
oil on canvas,
32¾ × 26½ in.
(83 × 67.3 cm)
Wallace Collection, London

On the first pages:
Anthony van Dyck
Three Children of the De Franchi Family,
detail, 1627
oil on canvas,
86¼ × 59½ in.
(219 × 151 cm)
National Gallery, London

Diego Velázquez
Las Meninas,
detail, 1656
oil on canvas,
122 × 108¾ in.
(310 × 276 cm)
Prado, Madrid

Jean-Baptiste-Siméon Chardin
Girl with Racket and Shuttlecock,
detail,
oil on canvas, 32 × 25½ in.
(81 × 65 cm)
Uffizi, Florence

All inquiries should be addressed to:
Barron's Educational Series, Inc.
250 Wireless Boulevard
Hauppauge, NY 11788
http://www.barronseduc.com

International Standard Book Number: 0-7641-5214-9
Library of Congress Catalog Number: 99-73531

Printed in Italy

987654321

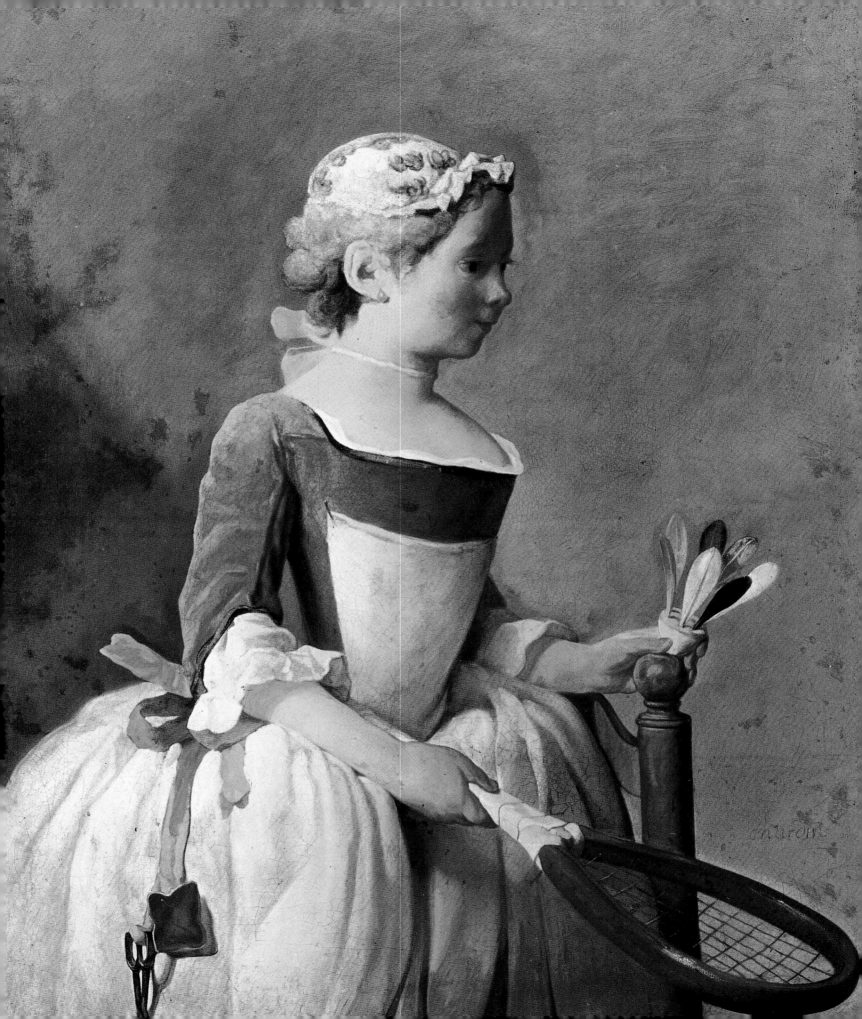

This volume presents the great adventure of Western painting in the seventeenth and eighteenth centuries through the phases of a rich and complex period that can be described from the cultural standpoint as "Baroque." This adjective is to be understood here in the general sense as defining an era rather than pinpointing the character of individual artists and movements. It is essential to dismiss the vaguely negative connotation still attached to the word "baroque" in ordinary language and opinion, when it is used to indicate something excessive, exaggerated, or overpowering.

On the contrary, the Baroque era was for many countries a period of splendor, "the golden century" for culture and the economy. The seventeenth and eighteenth centuries witnessed the formation and consolidation of the strong and clearly recognizable national identities underpinning the present geopolitical configuration of Europe and America.

Many fundamental breakthroughs in thought and science date back to these two centuries, especially the concept of using a systematic method to gain knowledge of the universe surrounding us. The almost simultaneous invention of the telescope and the microscope symbolizes the desire to go beyond what can be seen with the naked eye, to use new tools to tackle a world that eludes the senses, but that can be conquered by the mind.

As the "art of the visible," painting measures itself against the advances in science and in turn pushes itself beyond the limits of the consolidated rules and the harmonious canons of the Renaissance. While humanists and artists had long endeavored to establish the rules and canons of beauty and elegance by drawing upon classical antiquity, the Baroque marked a courageous step beyond these limitations. An art of extreme emotion, often inspired by the theater, the Baroque strives for the "wonder" of unexpected spectacle, but is also ready to plumb the depths of the human soul as never before. As in the tragedies of Shakespeare, in Baroque painting magnificent and turbid figures from the past become anguished and unfailingly "modern" images of human feelings, fear, and misery.

Maybe the greatest innovation of Baroque art lies not "inside" the painting itself, but outside it in the new role assigned to the viewer. From Caravaggio on, the person looking at the painting was no longer an extraneous "spectator" but an "eyewitness" present at the time and place of the events depicted.

The protagonists of this volume are among the greatest masters of art of all time, but alongside the great figures, the seventeenth and eighteenth centuries boast a whole series of impressive artists who contributed toward forming the figurative climate and artistic culture of their nations. For this reason, the volume is organized in terms of the national schools of the different countries, with a distinction made between the seventeenth and eighteenth centuries. (It is only in the case of eighteenth-century England that we have included the first artists of the United States, who received their training at the Royal Academy in London.) We thus seek to facilitate a knowledge and understanding of painting in which the most extraordinary masterpieces are never the lone, isolated result of a sudden outburst of creative genius, but emerge from a complex climate, from a historical and intellectual context, which they then come to epitomize and symbolize. The common points of reference, including the great myth of Rome, the cultural exchanges, and the travels of artists and works of art, mark the constant stimulating cross-fertilization in an era that continues to offer new emotions and discoveries.

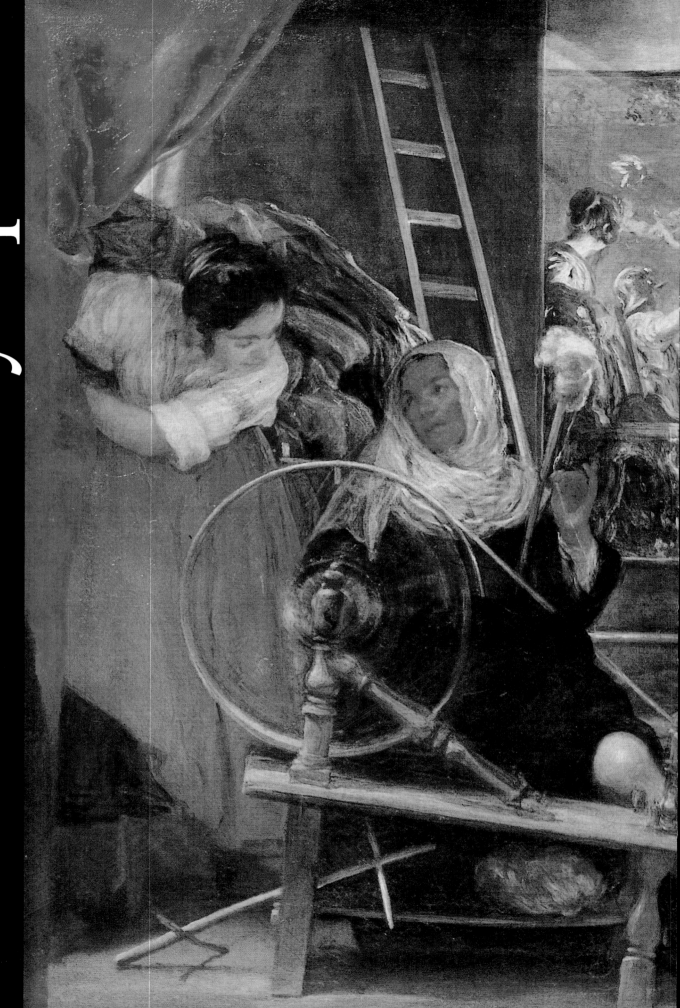

Seventeenth-Century Spain

Diego Velázquez
*Las Hilanderas
(The Myth of Arachne)*, detail
c. 1653
oil on canvas,
86½ × 116¾ in.
(220 × 289 cm)
Prado, Madrid

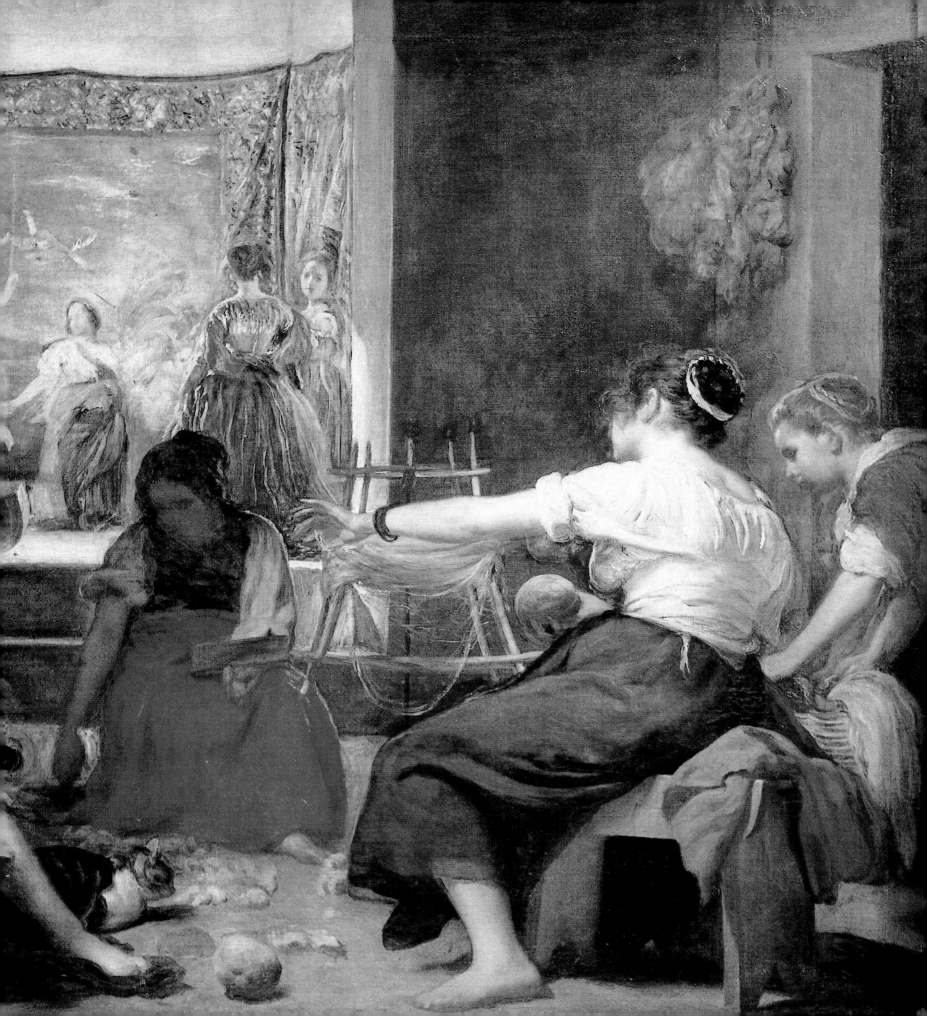

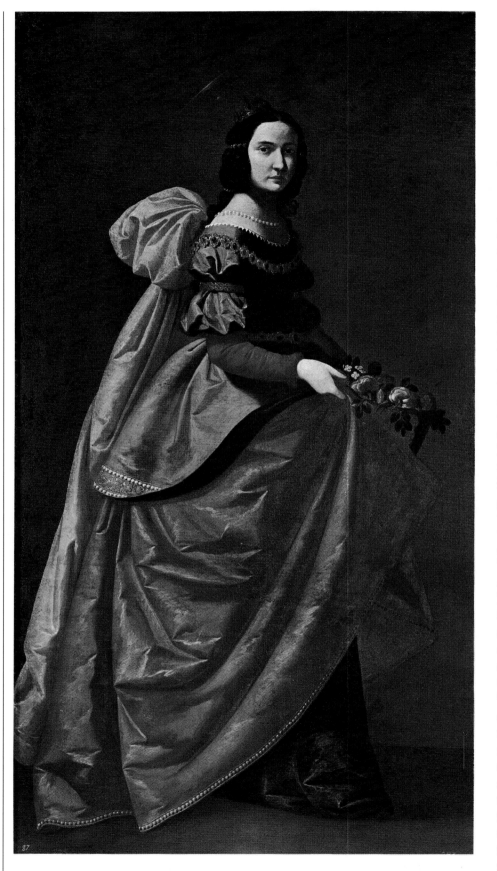

In the history of art and literature, the seventeenth century is for Spain *el siglo de oro*, the "Golden Century" of cultural glory that makes the Spanish nation an indispensable point of reference for any understanding of the anxieties, projects, unrest, and splendor of this controversial and fascinating era.

More so in Spain than anywhere else, the seventeenth century was one of glaring contradictions, where apparently irreconcilable manifestations and phenomena coexisted, and indeed provided extraordinary inspiration for poets and painters. If we observe the historical situation, the decline of the universal powers of the emperors of Madrid is, in fact, quite evident. In order to understand this turn of events, we must go back to the mid-sixteenth century, and precisely to the year 1548. It was then that the great Charles V won a decisive victory in the bloody and exhausting war of religion against the German Protestant princes. Unimaginable wealth began to flow in from the overseas colonies with the precious metals from Central and South America (like the proverbial gold of Peru). The proud crest chosen by Charles V—the Columns of Hercules and the motto *Plus Ultra*—had a very real significance. The image of the emperor and his artistic tastes were expressed to the highest degree by Titian, *el pintor primero*, in a series of masterpieces executed during a relationship lasting decades.

Exhausted by a life of incredible physical and psychological strain and by ruling for more than thirty years over an empire "on which the sun never set," Charles V decided to abdicate in 1556, and arranged his succession in such a way as to split the empire effectively into an "Austrian" part, entrusted to his nephew Ferdinand, and a "Spanish" part (including the Italian colonies of Naples and Milan as well as all the American possessions), entrusted to his son, Philip II. It was the reign of Philip II (who died in 1598) that began the historical phase characterized by the gradual loss of power, introverted bureaucratic retrenchment, and the increasingly elephantine and remote administrative management of a tottering empire. It was to take centuries, right up to the wars of independence in the American states, but the fall of the Spanish empire, paradoxically accompanied and almost underscored by impressive architectectural initiatives, began during the second half of the sixteenth century. This state of pomp and decline was to be portrayed

Opposite page:
Francisco de Zurbarán
St. Casilda
c. 1640
oil on canvas,
72½ × 35½ in.
(184 × 90 cm)
Prado, Madrid

in masterly fashion by the greatest painters in Spanish art, from El Greco to Velázquez, and by the seventeenth-century writers (Cervantes, Góngora, Tirso de Molina, and Quevedo). There is a striking parallel between the growth of the Escorial—the huge, gloomy sanctuary-palace-museum-cemetery built by Philip II, which became the model for architectural style, sculpture, and painting—and the total failure of the most important military campaign launched by the emperor, namely, the foolhardy attempt to invade England with the *Invincible Armada*, the slow, ostentatious fleet routed by the English ships in 1588. For the first time since the heroic days of the feats performed by the Catholic King Ferdinand against the Moors at Granada, proud Spain experienced drastic, unmitigated military defeat. The Spanish war machine, which had fought back with pride at the Battle of Lepanto, but could not quell the drive for independence in the northern Netherlands, received a mortal wound. While Spain gave Catholicism the impassioned voice, the soaring mysticism, and the organizational commitment of figures such as Ignatius of Loyola and St. Theresa of Avila, the psychological, military, and political scenario was changing, together with the course of art, as the sixteenth century drew to a close. The turning point in the field of painting came mainly through the extraordinary creative vein of a painter of bizarre genius, Domenikos Theotokopoulos, known as El Greco. Born on the island of Crete, then a Venetian possession, El Greco arrived in Toledo at the age of thirty-six with a rich artistic experience gained in Venice and Rome in contact with the great masters of the Italian High Renaissance (Titian, Michelangelo, and Tintoretto). The works painted in Italy, however, gave little warning of the violent passions, feelings, and emotions that were to erupt in his paintings after he settled in Spain. El Greco's high-strung, mystical temperament was able to identify perfectly with the historical and cultural context in which he found himself. The intense, "extreme" emotions expressed by the painter were portrayed against the background of Castile, and reverberated with still greater intensity and conflict. El Greco put himself forward as a painter-courtier, offered his services to Philip II, and sought to enter the artistic workshop of the Escorial, but the sovereign's response was cool and the painter was relegated to the sidelines. His art was mainly devoted to the churches of Toledo, for

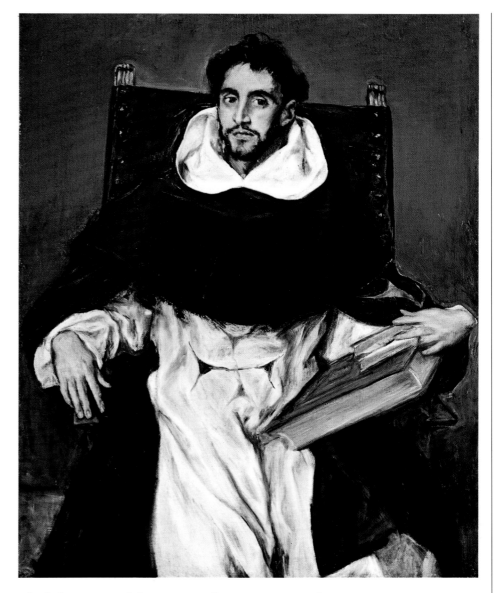

El Greco
Fray Hortensio Felix de Paravicino
1609
oil on canvas,
44½ × 33¾ in.
(113 × 86 cm)
Museum of Fine Arts, Boston

which he executed huge, magnificent paintings where the influence of the Italian masters gradually gives way to an astounding, remarkable, visionary creativity.
With El Greco, Spanish painting entered a new international dimension that more than makes up for the not so brilliant period of the sixteenth century. At the same time, it must be admitted that El Greco's style—so very particular and fragile in its intimate equilibrium, pushed to the limit of artistic verve, but without falling into the trap of absurdity or exaggeration—had practically no followers. The great painting of *el siglo de oro* has its primary point of reference in Velázquez, an absolutely outstanding figure and one of the seventeenth century's leading international artists. Unlike El Greco, the precocious and highly cultivated talent of the master from Seville soon won explicit official recognition. For decades Velázquez was the court painter, but his ties with Philip IV were not confined to a simple, cold relationship beginning and ending with the supply of works of art.

11

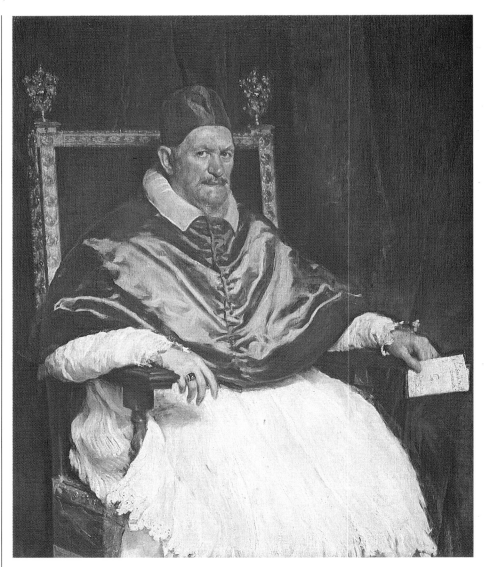

Diego Velázquez
Pope Innocent X
1650
oil on canvas,
55 × 47¼ in.
(140 × 120 cm)
Galleria Doria Pamphili,
Rome

Diego Velázquez
Mercury and Argus
1659
oil on canvas,
50 × 97¾ in.
(127× 248 cm)
Prado, Madrid

Almost one century later, this meeting of personalities was reminiscent of that between Charles V and Titian. In point of fact, the latter is a precise stylistic precursor of Velázquez. The rich flesh tones and colors and the broad brushstrokes of the Venetian live again in the Spaniard's art, especially in the vibrant portraits of the king and his family, the courtiers, and the figures gravitating around the royal palace. Velázquez was also influenced by the paintings of Caravaggio, which he studied carefully during his two long stays in Italy. In the seventeenth century, Caravaggio's diagonal light and use of shading influenced the whole of European painting, but Velázquez grasped the true import of the innovations put forward by the Lombard painter and did not merely stop at chiaroscuro effects. Perhaps no other artist has ever succeeded in capturing with such lucidity the lyrical and melancholic poetry, the daily hardship and fleeting joys of a dust-laden, threadbare world, poor but vital, imbued with humanity and truth. A superb portrayer of the most sumptuous court attire, Velázquez also depicted the ragged poor, offering a parallel vision of the century's two opposite extremes untouched by rhetoric or populism.

Directly or indirectly, Velázquez constituted the yardstick for all the Spanish painters of *el siglo de oro*, and above all

Jusepe de Ribera
*Martyrdom
of St. Bartholomew*
1630
oil on canvas,
92¼ × 92¼ in.
(234 × 234 cm)
Prado, Madrid

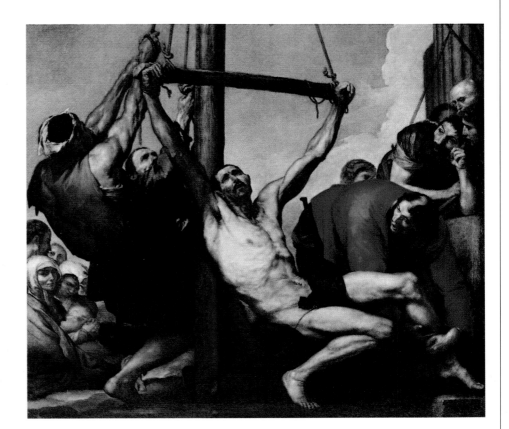

for those of his own city. The Seville school produced many of the leading masters, including Zurbarán, Murillo, and Valdés Leal. This great Andalusian city with its wealth of historical traditions in the architectural and intellectual fields must for this reason be regarded as the center of Spanish art in the seventeenth century. Its rich and varied cultural life included significant initiatives on the part of the religious orders, which constituted the principal patrons of local art. It is very interesting to note the great differences in the compositional and stylistic choices of Seville's painters, which is evidence of an enormous variety of proposals and solutions. Zurbarán is distinctively static, interested in almost sculptural figures, with a magnetic and almost metaphysical appeal; Murillo, by contrast, is an outpouring of affectionate, endearing devotion made up of smiles, human warmth, and the flashing eyes of urchins in need of redemption. With his frayed, dramatic brushstrokes, Valdés Leal exemplifies the most tormented aspect of a mortifying religious sentiment, verging at times on the macabre and terrifying. The Seville school also produced Alonso Cano, originally from Granada, who was involved in works commissioned by the conde-duque de Olivares and settled in Madrid, where he became the closest assistant and follower of Velázquez. An important position is occupied by Jusepe de Ribera, a painter of great international renown, though he was stubbornly linked to Spain despite the fact that he spent practically all his life in Naples (which was, it should be remembered, one of Spain's most important colonies and the city with the largest population in seventeenth-century Europe) and was firmly rooted in the local school. The explicit reference to Caravaggio, authoritatively emphasized and developed by Ribera in terms of a strong human element and straightforward realism, is the "common language" of seventeenth-century Spanish painting. This is especially true for paintings of religious subjects, large numbers of which were commissioned by the Catholic world, both clergy and private collectors. The rare but extraordinary still lifes merit a separate chapter. The canvases by Zurbarán and the specialist Sánchez Cotán give an essential, "silent" interpretation of great rigor. Far removed from the loud exultation of other works from the same period, the Spanish still

lifes are a moment of solitude and contemplation, a highly concentrated and fascinating synthesis. A few banal objects, some vegetables hanging against a black ground, become a window onto the absolute, opposite in thrust but no less significant than the more exuberant and complex canvases of the Spanish Baroque. These masterpieces give a terrible and fascinating insight into the theme of *desengaño*, or disillusionment, the sentiment that dominates seventeenth-century Spanish culture and constitutes its most direct and intense interpretive key. Hovering between dreams of glory and present-day hardship, torn between the pride of being a subject of an intercontinental empire and the everyday trials of a sun-drenched and dazzled country, the Spaniard of the Baroque century experienced the strongest contradictions. He could be overwhelmed by them in tragicomic fashion, like Cervantes's hero, or take refuge in mysticism or a dream world. "Life is a dream" is the message of a desperate epic poem. Seventeenth-century Spanish painting succeeded in giving a moving image of dreams and life, of chimeras and reality.

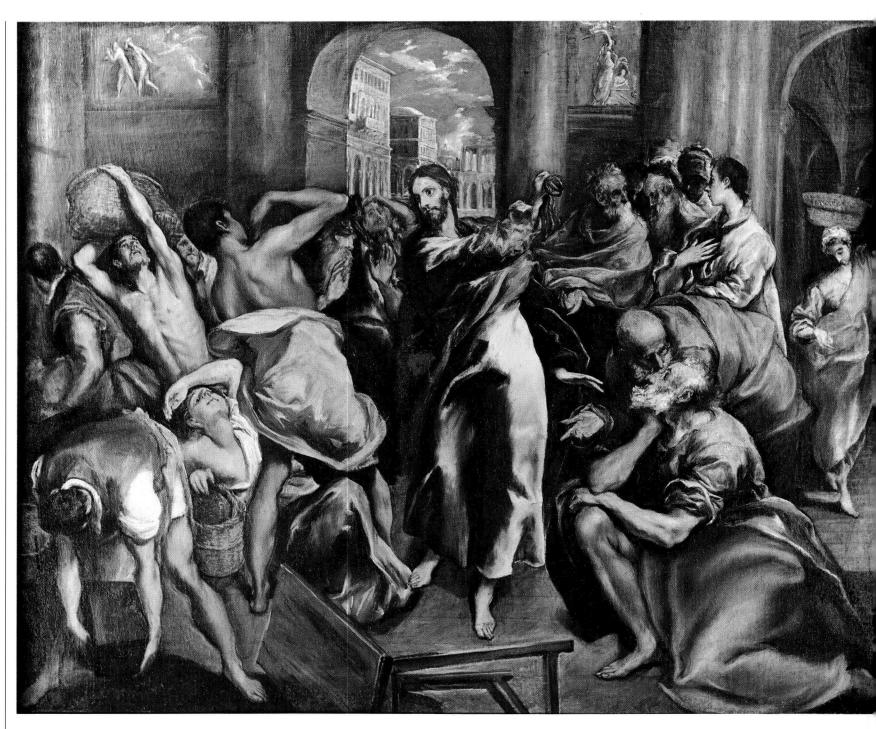

El Greco

Domenikos Theotokopoulos
(Crete, 1541–Toledo, 1614)

Probably trained by the Cretan painter
of icons Michele Damaskinos, Domenikos
Theotokopoulos was referred to as a
"master painter" in his homeland as early
as 1560. Shortly afterward he moved to
Venice (the isle of Crete was a Venetian
possession at the time) and came into
contact with the leading artists of the High
Renaissance. Titian, Tintoretto, and Jacopo
Bassano played a decisive role in forming
his style. He acquired a feeling for rich and
glowing color, and his early works indicate
careful study of Tintoretto's elaborate
perspectives. This Venetian experience was
to remain a key element in all his work,
together with a deep, intense, tormented
religious sentiment. Around 1572, while
still a young man, he arrived in Rome,
where he studied the works of
Michelangelo and enrolled at the
Accademia di San Luca. In 1577 he moved
to Toledo, the city that was to become his
adopted home. From this time on, his real
name was definitively replaced by the
nickname by which he became famous and
that recalled his distant but never forgotten
homeland. In alternating altarpieces,
medium-sized devotional works, and
highly intense portraits, El Greco marked
a radical turning point in Spanish art,
and acted as a bridge between Renaissance
and Baroque. His painting gradually took
on visionary, fantastic overtones, with
figures elongated beyond the limits of
verisimilitude, phosphorescent colors,
and dizzying compositional layouts.
In the closing years of the sixteenth
century and especially in the works painted
in the seventeenth century, El Greco
moved still further toward a visionary,
magical, and tautly evocative style. Among
his later works, attention should be drawn
to the extraordinary *Laocoön* in the
National Gallery of Art in Washington,
the only work in the artist's vast output
with a literary or mythological subject.
El Greco played a crucial role in Spanish
painting by breaking with the tired
repetition of worn-out models and opening
up an era of courageous innovation.
Despite the well-equipped workshop set
up in Toledo with numerous assistants
and copyists, El Greco's style had
practically no followers, and thus was truly
unique in the panorama of European art
on the threshold of the Baroque era.

El Greco
Christ Driving the Money Changers from the Temple

c. 1600
oil on canvas,
41¾ × 51 in.
(106.3 × 129.7 cm)
National Gallery, London

El Greco
The Trinity

1577
oil on canvas,
118 × 70½ in.
(300 × 179 cm)
Prado, Madrid

This solemn, monumental painting acts as a bridge between the master's Italian experience and the beginning of his life in Spain. The expressive force and imaginative thrust are balanced by a powerful depiction of anatomical detail. The abandoned body of Christ shows the influence of the late works of Michelangelo (the *Last Judgment* in the Sistine Chapel and the *Rondanini Pietà*), which El Greco had evidently studied during the years spent in Rome.

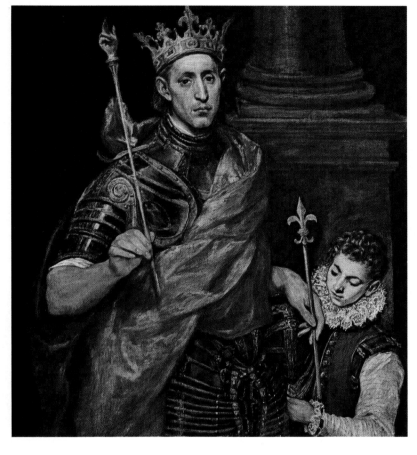

El Greco
St. Louis, King of France, and Page

c. 1586
oil on canvas,
46 × 37½ in.
(117 × 95 cm)
Louvre, Paris

The physicality, attention to descriptive detail (e.g., the breastplate painted with almost illusionistic precision), and three-dimensional energy derive from El Greco's Italian training and are features peculiar to his earliest works. At the same time, the overpowering melancholy that envelops the figures, the elongation of the forms, and the atmosphere of bitter foreboding are all characteristic of the painter's mature work, which aims at a complete autonomy of form.

El Greco
The Miracle of Christ Healing the Blind

1570–1577
oil on canvas, 47 × 57½ in.
(119.4 × 146.1 cm)
Metropolitan Museum of Art, New York

Repeated in a number of versions, this is one of the painter's most interesting youthful compositions. Influenced by the Venetian style, it dates from the Italian period, the years when El Greco was described as a "worthy follower" of Titian. In this case, however, he appears to follow not so much the teaching of Titian as the "manner" of Tintoretto.

El Greco
El Espolio
(The Disrobing of Christ)

1577–1579
oil on canvas,
112¼ × 68 in.
(285 × 173 cm)
*Sacristy of the Cathedral,
Toledo*

This magnificent canvas marks the beginning of El Greco's work in Toledo. It was not only a turning point in the painter's career, but also a very precise point of reference for Spanish art in subsequent centuries, from Goya to Picasso. The expressive distortion of physiognomy, the compressed and suffocating composition, and the violent colors constitute a type of figurative art where purely realistic characters alternate with visionary forms of expression.

El Greco
Adoration of the Shepherds

1603–1607
oil on canvas, 126 × 70¾ in.
(320 × 180 cm)
Prado, Madrid

The violent contrast between two works of El Greco's early maturity, the *Disrobing* and the *Burial of the Count of Orgaz*, and this painting from his last period, highlights the transition from a concrete, volumetric style of painting to a fragmented, almost immaterial image conveyed by the ardent glow of a light in which bizarre figures, elongated anatomies, and magical apparitions emerge.

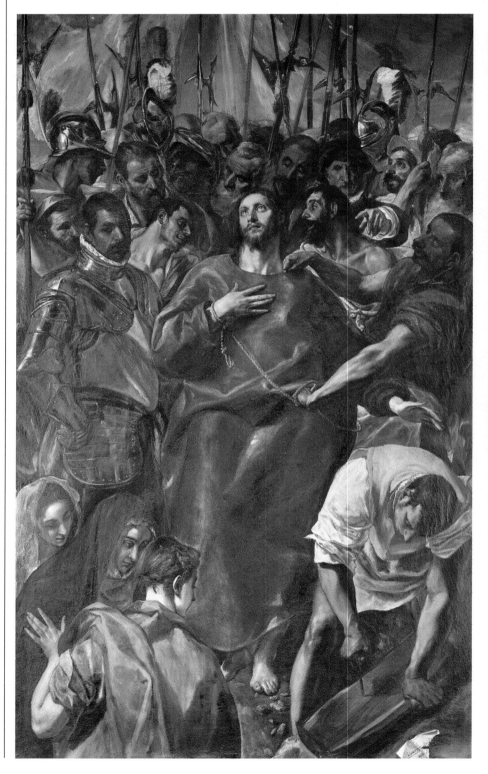

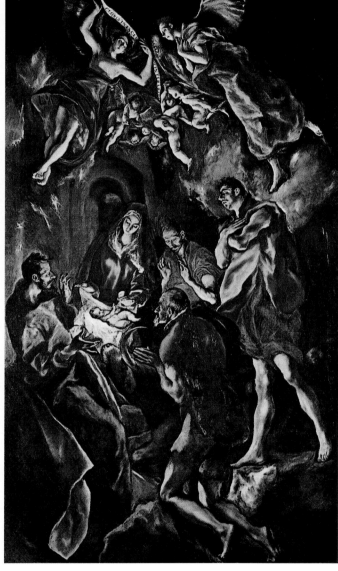

El Greco
Burial of the Count of Orgaz

1586–1588
oil on canvas,
181 × 141¾ in.
(460 × 360 cm)
Santo Tomé, Toledo

This is the painter's greatest masterpiece and one of the most striking works of the late sixteenth century. In the lower portion of the painting, the count, clad in shining armor, is laid to rest at a solemn funeral in which a number of saints participate. In the mystical upper portion, the nude count presents himself in heaven before the luminous figure of Christ his judge.

El Greco
Martyrdom
of St. Maurice
and the Theban Legion

1580–1582
oil on canvas,
176½ × 118½ in.
(448 × 301 cm)
Nuevos Museos,
El Escorial

Relations between
El Greco and Philip II
were not easy. The painter
sought access to official
commissions and in
particular to the bustling
workshop of the Escorial,
but the king did not
greatly appreciate the
emaciated, contorted,
unreality of the painter's

large-scale compositions.
In this complex work,
note the effort made
to combine codified
gestures of a classical
type (it is also possible
to recognize the
influence of Titian's
Address of Alfonso d'Avalos)
with glaucous light
and liquid colors.

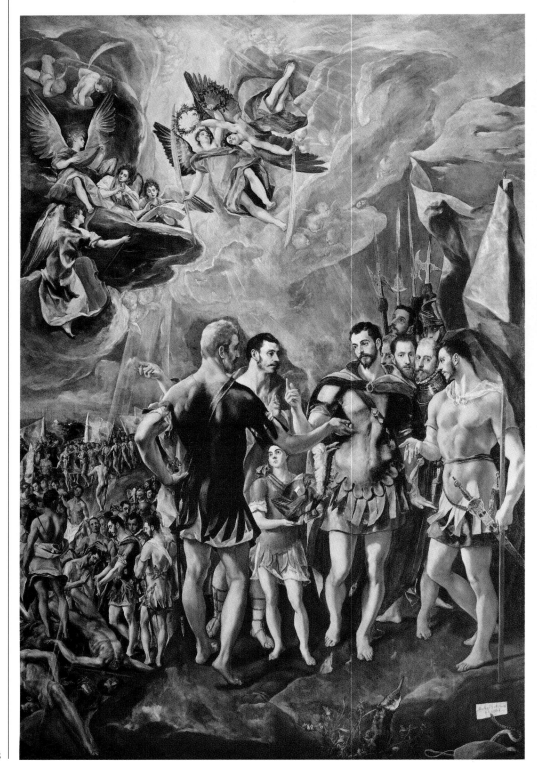

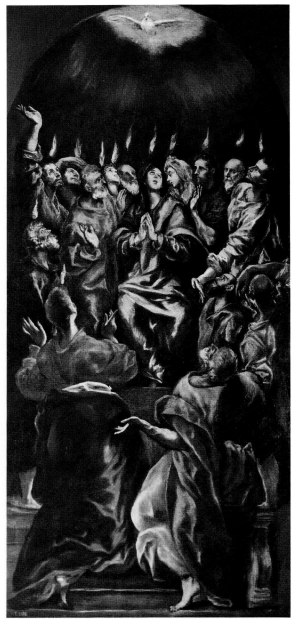

El Greco
Pentecost

1604–1614
oil on canvas,
108¼ × 50 in.
(275 × 127 cm)
Prado, Madrid

This characteristic work
of the painter's late period
is also one of his most
individual masterpieces.
Inspired by the flames
symbolizing the descent of
the Holy Ghost on the
Virgin and the Apostles,

El Greco subjects all
the figures to an upward,
soaring movement. The
dark background renders
the scene even more
evocative and mysterious.
The possible parallel with
Tintoretto's last works
underscores the
uninterrupted link with
Venetian painting but also,
on the part of El Greco, an
emotional, spiritual, and
mystical attitude totally
immersed in Spanish
culture and devotion.

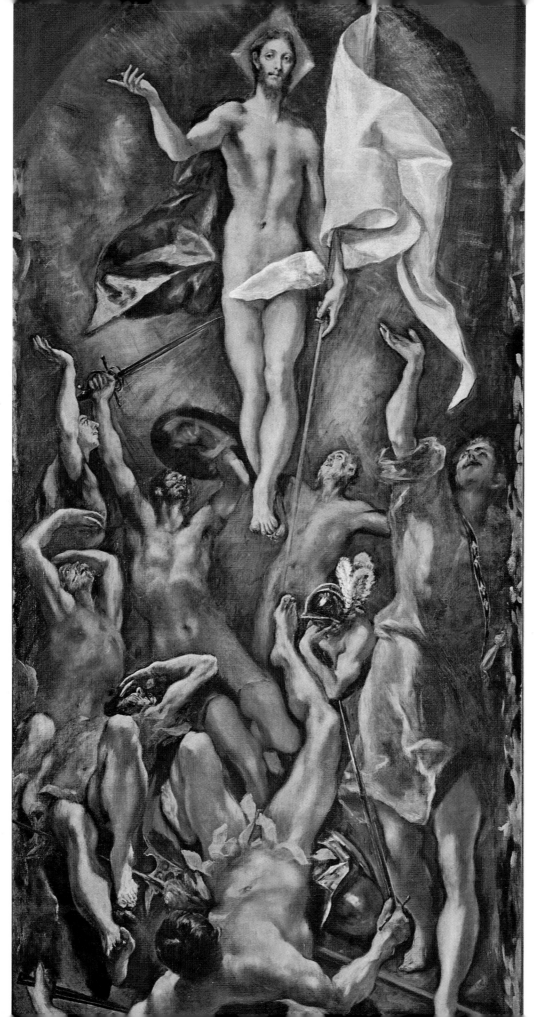

El Greco
Resurrection of Christ

c. 1590
oil on canvas,
108¼ × 50 in.
(275 × 127 cm)
Prado, Madrid

Through El Greco's altarpieces it is possible to reconstruct a highly intense creative renewal of religious art, and in particular a profound rethinking of iconographic elements that had appeared to be consolidated and unalterable. El Greco assimilates and interprets the dictates of the Catholic Counter-Reformation in an extremely original way. Once again it is necessary to recall the decisive turning point that occurred in Italian artistic culture in the 1570s at the height of an intense debate on the development of the depiction of religious subjects. The indispensable involvement of the faithful, repeatedly urged as the vital objective of devotional paintings, can be obtained in many different ways, as can be seen from the approaches adopted by Annibale Carracci and Caravaggio in the closing years of the sixteenth century. For his part, El Greco chose a visionary, evocative approach that was fascinating, unreal, and distorted.

El Greco
St. Jerome as a Cardinal

c. 1604–1605
oil on canvas,
34¼ × 42¾ in.
(86.9 × 107.9 cm)
*Metropolitan Museum of Art
(Lehman Collection), New York*

Halfway between a portrait and a collector's piece, this striking picture provides an excellent demonstration of the painter's capacity for concentration on a single figure. Even though the most important part of his career is characterized by large-scale religious compositions with many figures, El Greco repeatedly painted individual images or whole series of half-length figures against neutral grounds, accentuating the solitude and inner fervor of the champions of the faith, mortified in the flesh and extremely severe in their expressions.

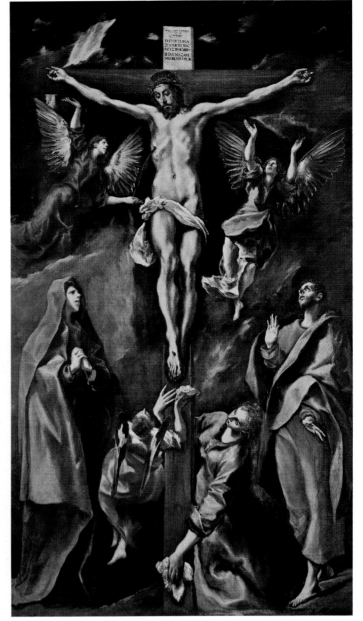

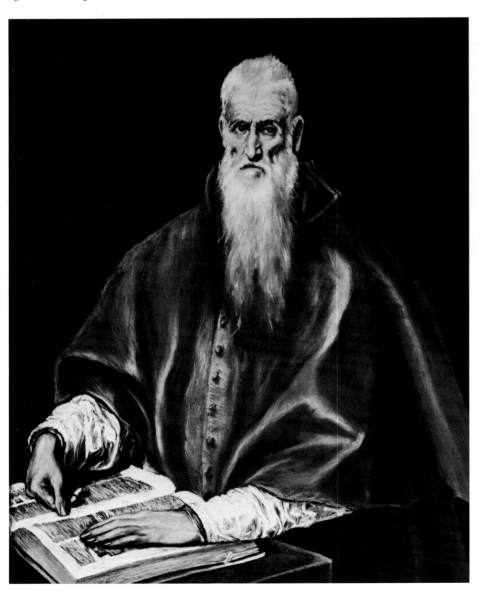

El Greco
Crucifixion

c. 1600
oil on canvas,
122¾ × 66½ in.
(312 × 169 cm)
Prado, Madrid

The intense pathos of some religious paintings by El Greco seems to vibrate within the canvases like an agonizing tuning fork and reverberate out toward us. These are works "with no background," with all the figures projected into an empty, unreal space, with phosphorescent colors and frozen gestures, which constitute a kind of grandiose reworking of the Byzantine icons the painter had admired and copied during his youth on Crete. In the last period of his career, now far removed from the influence of Italian classicism and made still freer by the fame achieved within an established framework, with all his financial problems and stylistic doubts resolved, El Greco felt free to express the mystical inspiration with which his soul was overflowing. This great altarpiece presents a wealth of fascinating detail, such as the two angels collecting Christ's blood at the foot of the Cross.

El Greco
Portrait of a Cardinal, probably Don Fernando Niño de Guevara

c. 1596
oil on canvas,
42¾ × 67¼ in.
(107.9 × 170.8 cm)
Metropolitan Museum of Art, New York

Though not very numerous, as a whole, El Greco's portraits constitute a very particular progression. Trained in the spectacular realism of Titian, the painter uses a free style of brushwork in his portraits to suggest fluid poses and expressions. In this case, for example, the figure displays such feverish haste that it conveys a considerable sense of anxiety. The pose is traditional but the nervous hands indicate expectation. There is also an extraordinary glint of disdain behind the lenses of the unusual spectacles, while the lips appear to be pursed in mute rebuke.

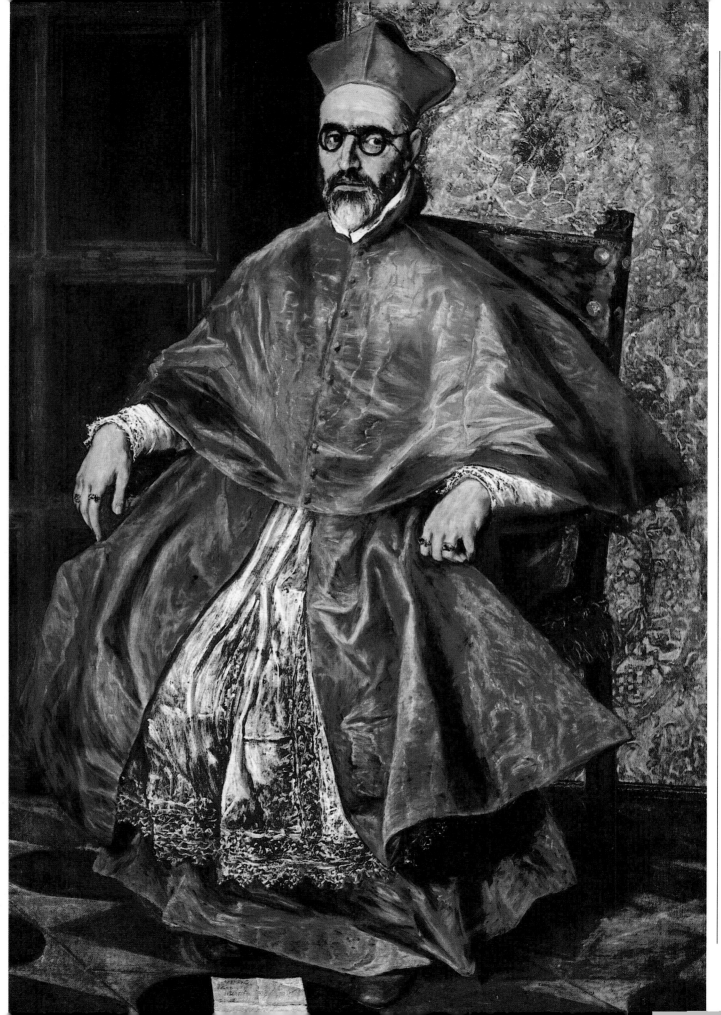

21

El Greco
St. Bartholomew
the Apostle
c. 1610–1614
oil on canvas,
38¼ × 30¼ in.
(97 × 77 cm)
*El Greco Museum,
Toledo*

The house of El Greco in Toledo is well preserved and gives the impression of the comfortable abode of a prosperous citizen. In addition to some significant items from the painter's art collections (which are important if we are to know his tastes and assess the influences at his disposal), the house contains a number of good paintings by El Greco himself, including one of the best series of half-length Apostles.

El Greco
Betrothal of the Virgin

1608–1614
oil on canvas,
43¼ × 32¾ in.
(110 × 83 cm)
*Romanian National Museum
of Art, Bucharest*

Executed in the last years of the painter's life, this small to medium-sized work has the translucent fragility of a butterfly's wings. The figures, slender to the point of evanescence, are by now as far removed as possible from the full-bodied characters painted at the beginning of El Greco's stay in Spain. It is illuminating to compare this wraith-like priest with the powerful God the Father of *The Trinity*. Interest also attaches to the depiction of the room, where the perspective floor laid out in a classical grid contrasts with the backdrop of fluttering drapes to accentuate the ambiguity of the vision.

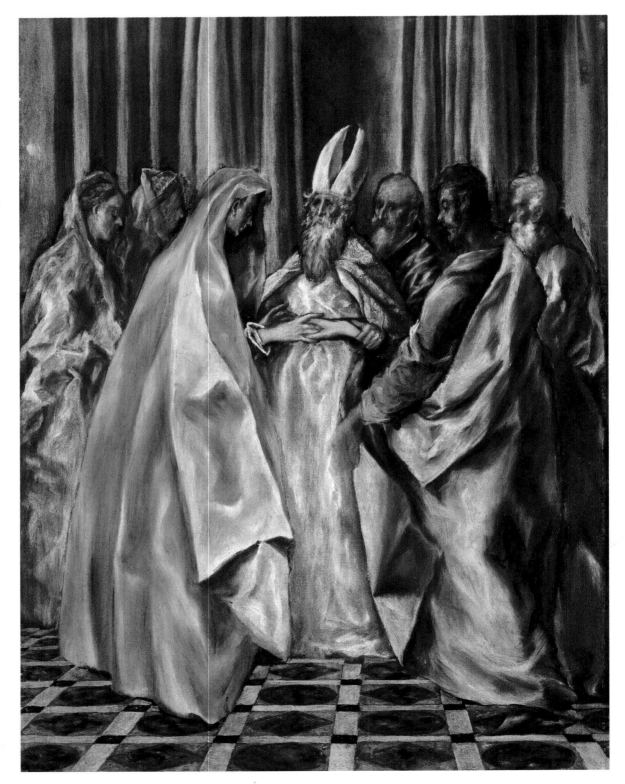

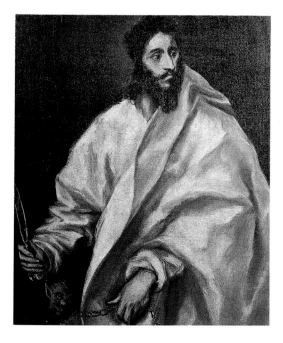

El Greco
Baptism of Christ

1596–1600
oil on canvas,
137¾ × 56¾ in.
(350 × 144 cm)
Prado, Madrid

El Greco's favorite format
for large-scale compositions
is a highly elongated
rectangle with the height
measuring over twice the
width. These unusual
proportions accentuate the
tapering vertical impetus
of the figures and make it
possible to depict scenes on
two levels, one above the
other. In the lower portion,
which is often painted in
darker shades, the figures
have greater earthly
corporeality. In the upper
portion, reserved for
heavenly apparitions, the
light explodes to the point
where it dissolves the image.

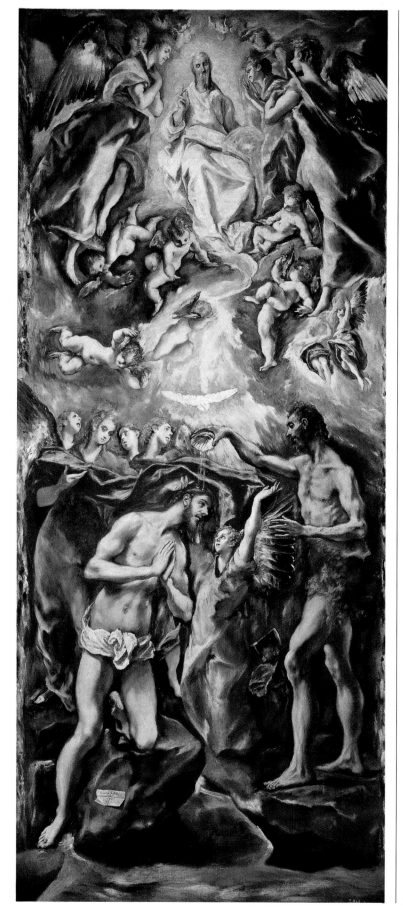

El Greco
Vision of St. John
1610–1614
oil on canvas,
78½ × 88½ in.
(199.4 × 224.8 cm)
*Metropolitan Museum of Art,
New York*

This unfinished apocalyptic
scene is one of the last
and most mysterious
of El Greco's masterpieces.
The evangelist, situated
on the left, seems almost
terrified of the thronging
nude figures and raises his
arms toward an
oppressive, harsh, dense
sky that seems to loom
threateningly.

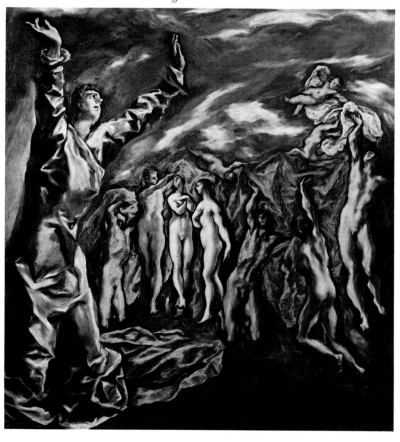

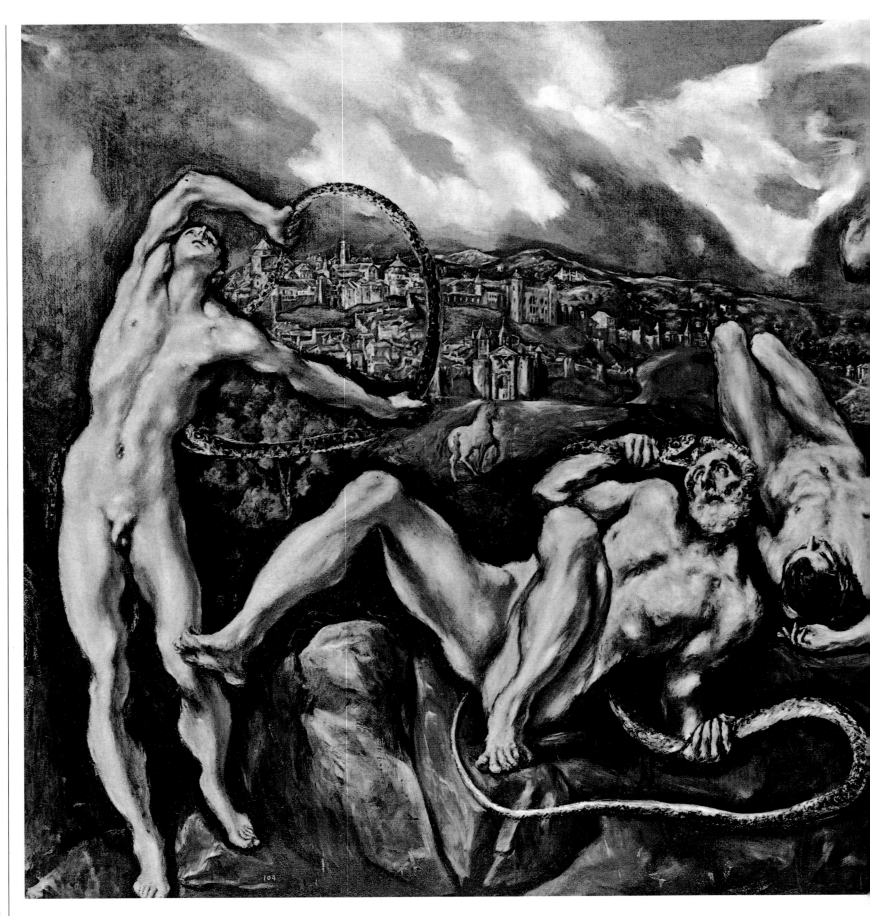

El Greco
Laocoön and His Sons

c. 1608
oil on canvas,
56 × 76 in.
(142 × 193 cm)
*National Gallery of Art,
Washington*

This is the only composition on a mythological theme painted by El Greco and it has very few possible terms of comparison. The Homeric episode of Laocoön and his sons devoured by serpents, made famous by the discovery of the celebrated Hellenistic group of statues, was a theme widely interpreted in the art of the late Renaissance. El Greco's interpretation is decidedly unusual, first because it makes absolutely no reference to the statues (except perhaps in the face of Laocoön), and second because the scene is set on the outskirts of Toledo under a stormy sky. The pale figures stand out in the foreground with a disquieting and yet fascinating sense of ambiguity. The terrible end of Laocoön and his two sons is narrated by means of photographic stills and frozen gestures, making them appear dramatic athletes of death. The figures are static but rendered fluid by the glimmering, visionary brushstrokes and the flowing shadows that herald the storm gathering in the sky.

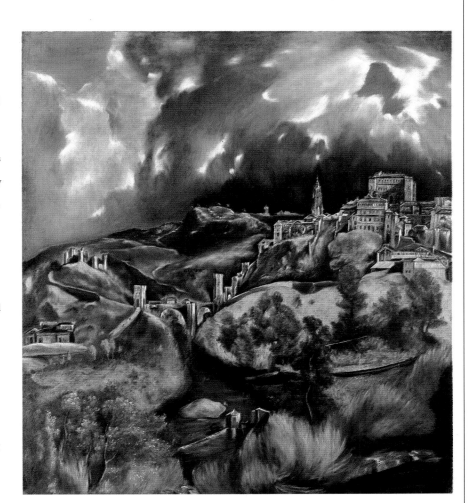

El Greco
View of Toledo

c. 1597
oil on canvas,
47¾ × 42¾ in.
(121.3 × 108.6 cm)
*Metropolitan Museum of Art,
New York*

The only landscape painted by El Greco shows the unmistakable panorama of Toledo with the town walls (*cigarralles*) and soaring Gothic spire of the Cathedral dominating the wild countryside. While the place is easily recognizable, the painter once again distorts the image in a dramatic, expressive way. The choice of just a few colors electrified by the stormy atmosphere strips the landscape of any charm. As is confirmed by the presence of a similar landscape in the background of the grim *Laocoön*, El Greco interprets the backdrop of his adopted city in a violent manner, transforming the ancient and beautiful historic center into the gloomy announcement of impending disaster, which is almost symbolic of Spain's imminent decline.

Diego Velázquez

(Seville, 1599–Madrid, 1660)

Encouraged to paint since his childhood, Velázquez entered the workshop of Herrera the Elder at the age of ten. One year later, as proof of his precocious talent, he was apprenticed to Francisco Pacheco, a very influential figure in the cultural circles of Seville, known as a painter, art theoretician, and man of letters. Velázquez owed Pacheco not only his artistic training but also his taste for classical culture, and even his wife. In 1618, already regarded as an independent painter, although he was only nineteen years of age, he married Juana Pacheco, the daughter of his mentor.

His first works are mainly *bodegónes*, that is, genre scenes of everyday life with still-life studies (for example, *Old Woman Frying Eggs* or *The Water Seller of Seville*), or religious subjects interpreted in a "naturalistic," contemporary manner. Caravaggio was a decisive influence, and his compositional layout of scenes and powerful interplay of light and shade were elements taken over directly by Velázquez. This immediate and intelligent reference to Caravaggio indicates the painter's precise orientation toward Italian art. The main turning point in his career came in 1623, when the conde-duque de Olivares, the powerful prime minister at the court of Philip IV, summoned his fellow Sevillian to Madrid to become the king's official

painter. Velázquez worked mainly as a portraitist and was thus obliged to take into consideration Titian's sixteenth-century portraits. His initial Caravaggesque naturalism was thus enriched by a new monumental dimension that enabled him to tackle vast scenes of a historical or literary nature with great confidence and perfect chromatic intuition. He made his inevitable first visit to Italy between 1629 and 1631, and his contact with the great examples of Renaissance art made his painting technique still more varied and flexible. On his return to Madrid, where he was now firmly established as official painter to the Spanish court, Velázquez began to produce a large number of works for the royal residences, and a whole series

of individual and group portraits of court figures, including not only the king and the princes, but also the dwarfs and jesters. A painting like *Las Meniñas* (*The Maids of Honor*) is sufficient in itself to epitomize an entire century and define the master's style. The work, carried out above all for Philip IV and his family, explains why so many of Velázquez's paintings have remained in Madrid and are now housed in the Prado. The painter's second visit to Italy was made between 1649 and 1651. The most famous result of this, the portrait of Pope Innocent X, has remained in its original location, the Galleria Doria Pamphili in Rome. During these years, Velázquez carried out a kind of wonderful and intense rereading of his own output

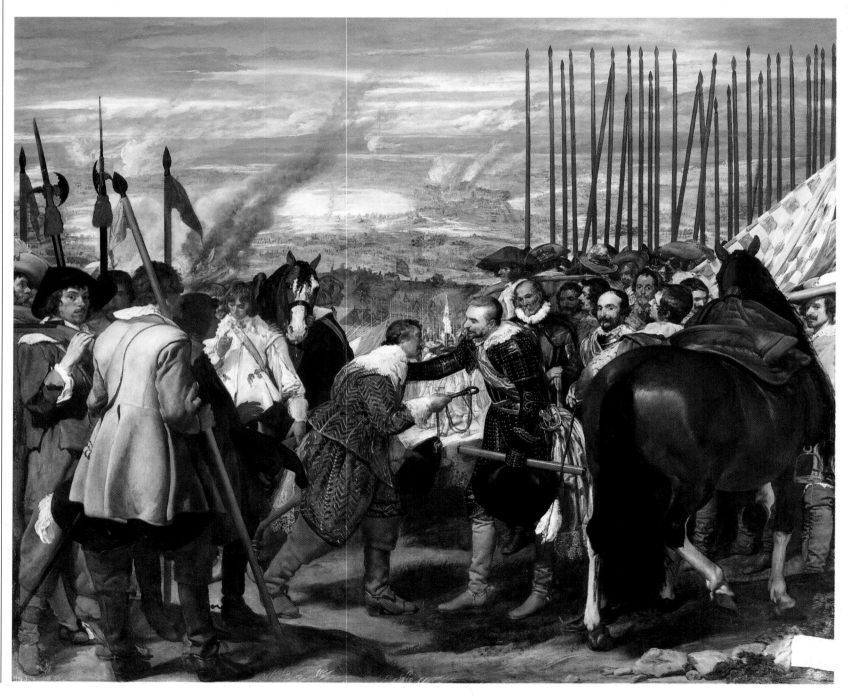

and, going further back, of the links between the painting of the sixteenth and seventeenth centuries. Following the example of Titian, and exactly as Rembrandt was doing in the same period (but in a totally different personal and social situation), Velázquez started to paint with large, separate brushstrokes, thickly laden with material and charged with expressive intensity. With his absolute freedom of style, Velázquez is rightly indicated as an artist of pivotal importance in the history of art. Rediscovered by the French painters of the nineteenth century, and in particular by Manet, Velázquez also constitutes a precise point of reference for Picasso and the movements of modern art.

Diego Velázquez
Surrender of Breda

1633–1635
oil on canvas,
120¾ × 144½ in.
(307 × 367 cm)
Prado, Madrid

This absolute masterpiece of historical painting commemorates an episode in the war between Spain and Holland in 1625. The defeated Justin of Nassau symbolically consigns the key of the fortress of Breda to the victor, Ambrogio Spinola. Against the background of a desolate landscape marked by the smoke of fires, the two generals meet in an atmosphere of calm and mutual respect. They have both dismounted and there is no sense of rhetoric. Velázquez accentuates the human element in this episode. Memorable gestures are thus absent in the ranks of soldiers and there is nothing to distinguish the victor from the vanquished. For soldiers, war is a dirty, fatiguing business with little room for heroics. The scene is given a very theatrical setting with the soldiers on the left and the large horse dominating the right-hand side. The two groups are symmetrically juxtaposed to leave the center of action free for the meeting of the two generals, who are moved slightly out of the foreground. At this point, with splendid pictorial inventiveness, Velázquez inserts the mobile "screen" of lances raised high in silhouette to separate the proscenium from the backdrop, where the landscape fades away into the distance bathed in a pale light.

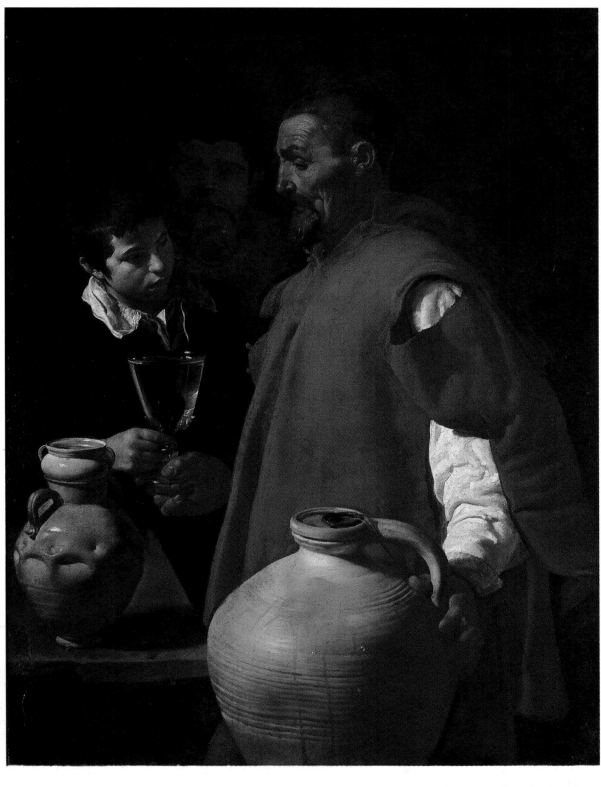

Diego Velázquez
The Water Seller of Seville

1618–1619
oil on canvas,
41¾ × 32¼ in.
(106 × 82 cm)
Wellington Museum, London

This is the best version of a subject repeated a number of times by Velázquez when still a youth. The influence of Caravaggio is very strong, not only in the powerful contrast of light and shade, but also in the choice of an everyday subject, taken directly from the street, and in the concrete evidence of realistic detail. While Velázquez never painted authentic "still lifes," in his youth he was particularly interested in depicting everyday utensils, and investigated their shapes, colors, and materials to amazing effect.

Diego Velázquez
Kitchen Interior with Christ
in the House of Martha
and Mary

1618
oil on canvas,
23½ × 40¾ in.
(60 × 103.5 cm)
National Gallery, London

Unusual and somewhat
mysterious, this painting is
part of a tradition of
interpreting Gospel

subjects within everyday
settings. In this specific
case, there is even a doubt
as to whether the
"window" in which the
Gospel scene appears
might actually be a
painting hanging in a
kitchen where a young
cook is listening, with an
expression of annoyance,
to the advice and chiding
of an elderly woman.

Diego Velázquez
St. Anthony the Abbot
and St. Paul the Hermit

c. 1634
oil on canvas,
101¼ × 74 in.
(257 × 188 cm)
Prado, Madrid

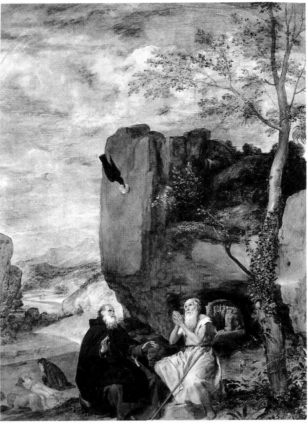

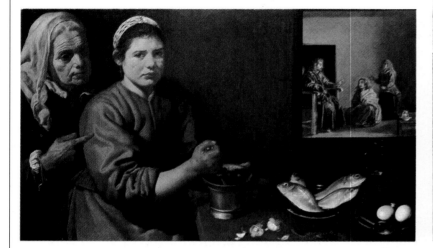

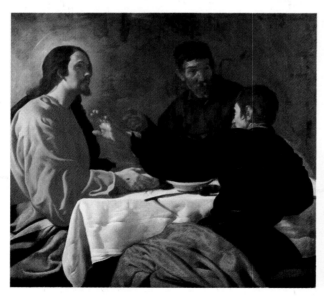

Diego Velázquez
The Scourging of Christ

1632
oil on canvas,
65 × 81 in.
(165 × 206 cm)
National Gallery, London

Velázquez succeeds in
producing a concrete and

credible image of
a subject from the
Counter-Reformation
catechism. The real subject
of the painting is the
contemplation of Christ's
wounds by a devout soul
guided by his guardian
angel, but the great
master's thrilling realism

strips the action of any
admonitory or didactic
overtones to present
it on the plane of pure,
impassioned, emotive
participation.

Diego Velázquez
Supper at Emmaus

1620
oil on canvas,
48½ × 52¼ in.
(123 × 132.5 cm)
*Metropolitan Museum of Art,
New York*

The reference to
Caravaggio, who painted

various versions of the
same subject, is clearly
recognizable. Velázquez,
too, concentrates on the
human reaction of the two
disciples, on their surprise
when Christ reveals his
identity. The white tablecloth
gathers and reflects the
light to suggest an easily
recognizable diagonal.

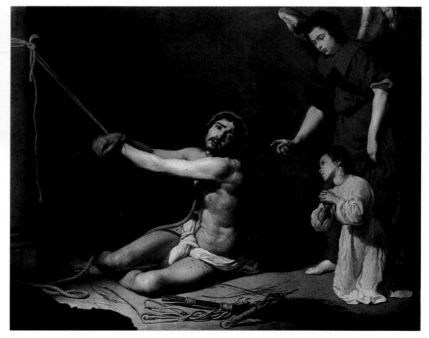

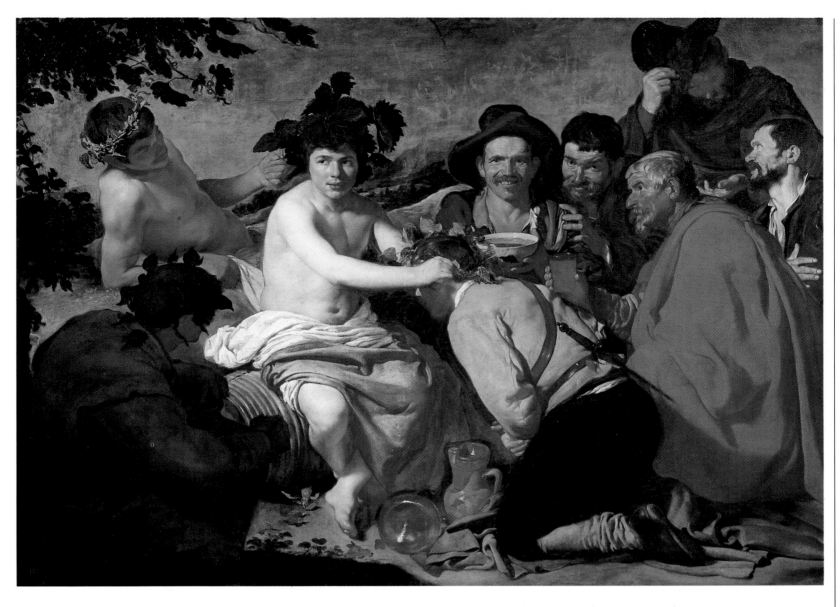

Diego Velázquez
Los Borrachos (The Topers
or the Triumph of Bacchus)

1628–1629
oil on canvas,
65 × 88½ in.
(165 × 225 cm)
Prado, Madrid

These two works mark
the beginning of the
painter's artistic maturity,
which coincided with his
departure for Italy (1629).
Despite the presence
of divinities and literary
figures, the realistic
approach, the relish for
direct participation in
events, and the
extraordinary credibility of
the peasants surrounding
Bacchus and the blacksmiths
interrupted in their labors
by Apollo belong to the rich

and concrete world
of Velázquez, and show
his skill in depicting
contemporary scenes.
The happy drinkers are
reminiscent of certain
international paintings of
the Caravaggesque school,
as well as Dutch-Flemish
genre painting, at least as
regards subject matter. In
Velázquez, however, there
is none of the detachment
and derision often glimpsed
in other painters of the
period. On the contrary,
his empathy for people can
be seen in the smiles on
the peasants' faces and in
the blacksmiths' rippling
muscles. Be they kings or
princes, peasants or jesters,
Velázquez treats people
with a sense of deep respect
and preserves their dignity.

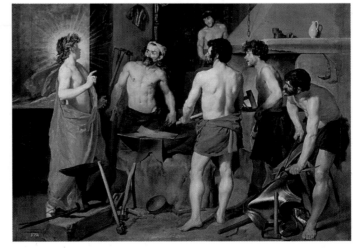

Diego Velázquez
The Forge of Vulcan

1630
oil on canvas,
87¾ × 114¼ in.
(223 × 290 cm)
Prado, Madrid

Painted in Rome during
his first visit to Italy, this
work continues the
curiously ambiguous
blend of mythology and
rustic reality seen in
Los Borrachos, from which
it can be seen to have
developed, despite the
differences in format.
Evidence of the painter's
knowledge of Roman
antiquities can be seen in
the choice of "classical"
poses for the figures,
which are clearly inspired
by ancient sculptures.

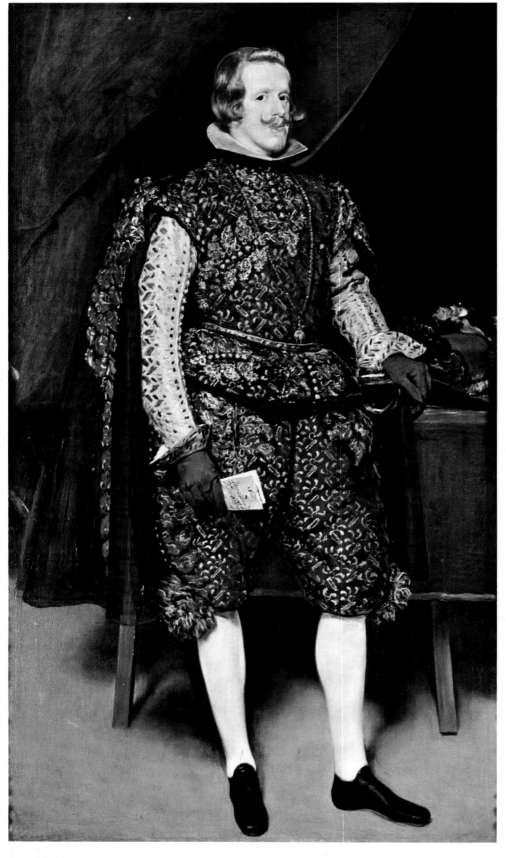

Diego Velázquez
Portrait of Philip IV

1631–1632
oil on canvas,
76¾ × 43¼ in.
(195 × 110 cm)
National Gallery, London

This spectacularly beautiful painting recalls the historical models of sixteenth-century full-length portraits, but it has a new sumptuous quality. After his stay in Italy and the broadening of his figurative horizons on a European level, Velázquez displays an exceptional skill in rendering the sparkling effects of threads of precious metals and of embroidered materials in his detailed reproduction of garments. This virtuosity is, however, never an end in itself. Observe the telling contrast between the magnificent apparel and the uncertain expression of the king, whose face, still framed by beautiful blond locks, is beginning to show the first signs of fatigue and worry.

Diego Velázquez
Philip IV in Armor

1625
oil on canvas,
22½ × 17¼ in.
(57 × 44 cm)
Prado, Madrid

This work marks the beginning of the long series of portraits Velázquez painted of the long-lived king, at whose side practically his entire career unfolded. The close relationship established between the painter and his sovereign recalls celebrated cases of the past. Year after year Velázquez portrayed the physical changes in the king, almost mirroring the passage of time. Velázquez painted dozens of portraits of Philip IV and members of the royal family in many different situations and formats. Here the king, little more than an adolescent, is captured in all his blond fragility, in all his slender, noble beauty.

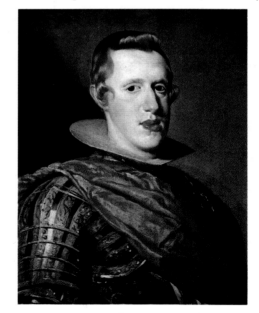

Diego Velázquez
Don Luis de Góngora
y Argote

1622
oil on canvas,
20 × 16¼ in. (51 × 41 cm)
Museum of Fine Arts, Boston

In this striking, highly
concentrated and eloquent
portrait, Velázquez captures
not only the features but
also, and above all, the
personality of the great
writer.

Diego Velázquez
Portrait of a Sculptor

1636
oil on canvas,
43 × 34¼ in.
(109 × 87 cm)
Prado, Madrid

The sitter may be Juan
Martinez Montañes, a good
Baroque sculptor also
employed at court.

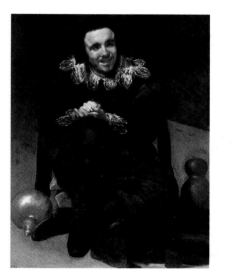

Diego Velázquez
El Bufón don Juan
de Austria

c. 1632
oil on canvas,
82¾ × 48½ in.
(210 × 123 cm)
Prado, Madrid

The paintings of court
jesters form a very
characteristic group within
the series of portraits
painted by Velázquez. The
royal inventories show that
the rich costume of gaudy
colors worn by the sitter
was given to him in 1632.

Diego Velázquez
El Bufón Pablo
de Valladolid

1632
oil on canvas,
82¼ × 48½ in.
(209 × 123 cm)
Prado, Madrid

This masterpiece of
synthesis and simplicity
was to be admired for
centuries and imitated
by Goya and Manet
because of the evocative
contrast between the black
garments and the neutral
ground.

Diego Velázquez
El Bufón Juan de Calabazas

c. 1639
oil on canvas,
41¾ × 32¾ in.
(106 × 83 cm)
Prado, Madrid

The nonchalant, conniving
sitter was a famous
member of the "motley
crew" of dwarfs, actors,
and *locos* (jesters and
buffoons) surrounding the
royal family. Such figures
had never been given
so much space before.
On some occasions,
Velázquez painted them
full length in the same
pose and format as the
king. On others, as in this
case, the painter succeeds
in communicating the
humor, verve, and
grimaces of the *locos*,
but always avoids pathos
or sentimentality.

Diego Velázquez
Philip IV on Horseback

c. 1635
oil on canvas,
118½ × 123½ in.
(301 × 314 cm)
Prado, Madrid

The history of the equestrian portrait begins with Titian's *Charles V at the Battle of Mühlberg* (1548), one of the most prestigious works held in the collections of the kings of Spain, and Velázquez clearly draws inspiration from this historical model. Like his ancestor, Philip IV appears in profile in armor, but while Titian's painting conveys the dramatic atmosphere of the battle in dense undergrowth at dusk, Velázquez's great work has the vast, clear serenity of a classic riding-school exercise, with the splendid steed controlled by the expert rider against the background of a vast, wide-open landscape. Charles V fought in battle in person. Philip IV entrusted the command of the army to the all-powerful conde-duque de Olivares.

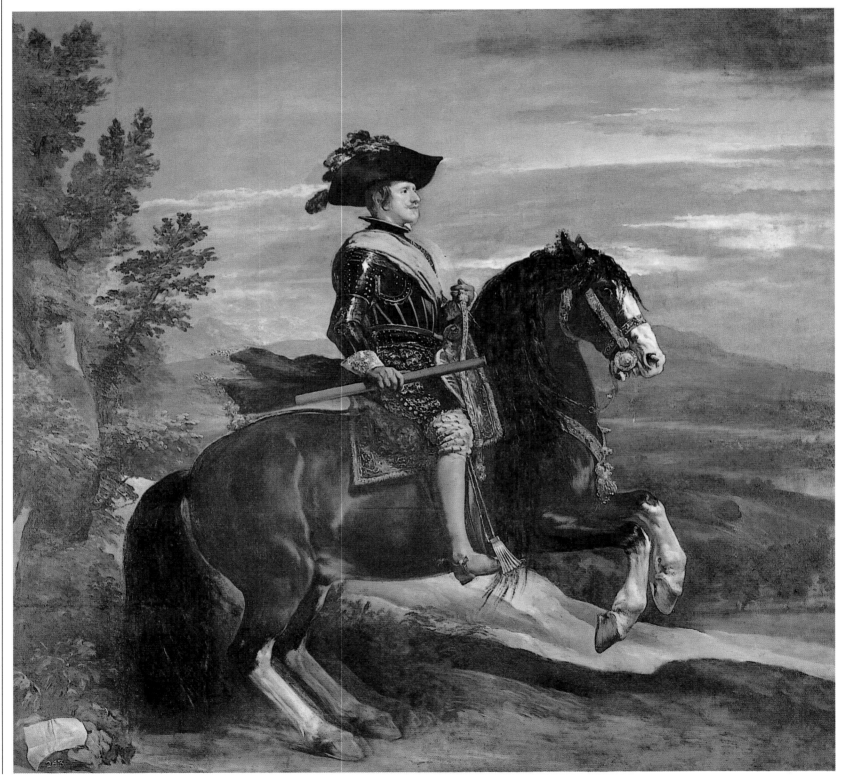

VELÁZQUEZ
(rotated, right margin)

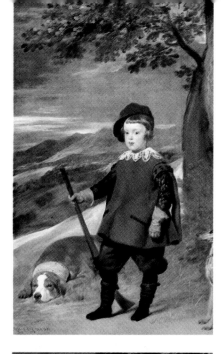

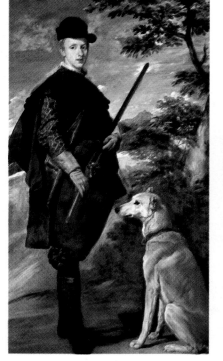

Diego Velázquez
Prince Baltasar Carlos
as a Huntsman
Cardinal Infante Fernando
of Austria as a Huntsman

1635
oil on canvas, 75¼ × 45½ in.
(191 × 103 cm) and
75¼ × 42 in. (191 × 107 cm),
respectively
Prado, Madrid

Velázquez took advantage of
this "sporting" theme to paint
portraits of a less static and
official nature, more directly
inspired by the natural poses
of the figures portrayed.

Diego Velázquez
Coronation of the Virgin

1641–1642
oil on canvas,
69¼ × 52¾ in.
(176 × 134 cm)
Prado, Madrid

Later in his career,
Veláquez received a rather
small number of requests
for religious paintings, and
portraiture became his
main area of activity. Those
he did paint, however, are
balanced works of great
beauty. Velázquez keeps his
distance from the brutal
realism of Ribera, the
frozen immobility of
Zurbarán, and the gently
flowing style of Murillo.
His religious works are at
the same time sophisticated
and credible, and his
sincere religious feeling
does not conceal but rather
accentuates the psychology
of the divine figures.

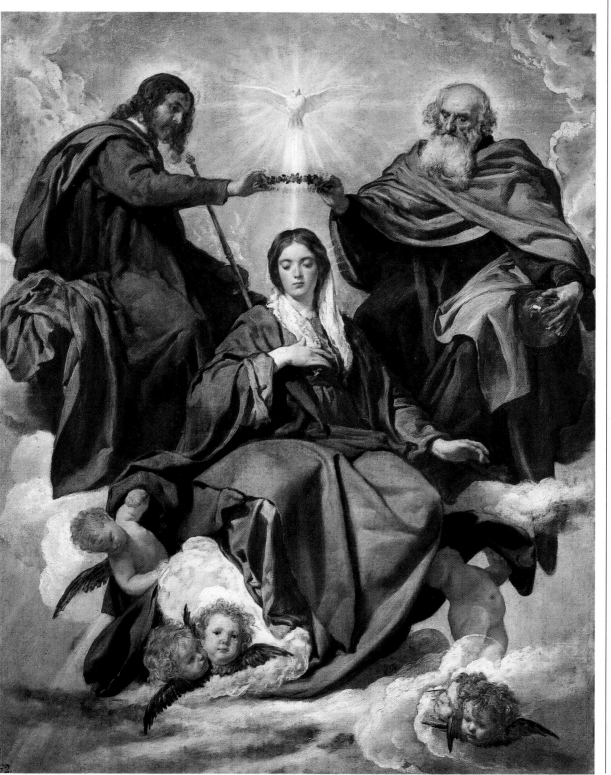

Diego Velázquez
Young Woman Sewing

c. 1641
oil on canvas,
29¼ × 23½ in.
(74 × 60 cm)
*National Gallery of Art,
Washington*

This work marks a brief
but splendid return to
the youthful period
of the *bodegónes* or genre
paintings, when the young
Velázquez painted domestic
scenes and episodes of
everyday life. In the years
of his maturity, and with
a technique very different
from that used in the early
years of his career,
Velázquez took a
momentary break from
official portraits and again
tackled a genre subject:
an ordinary girl performing
an ordinary, everyday task.
The great immediacy of the
work suggests a "snapshot."
It may be interesting to see
this charming work as part
of a sequence stretching
from the *Mary Magdalenes* of
Caravaggio and La Tour to
Vermeer's *Lacemaker*.

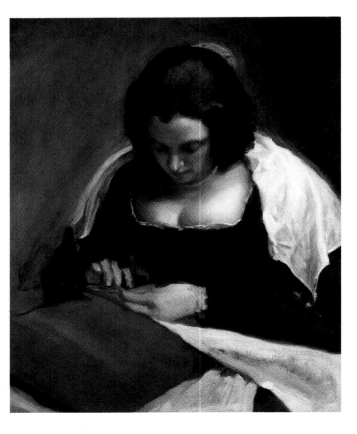

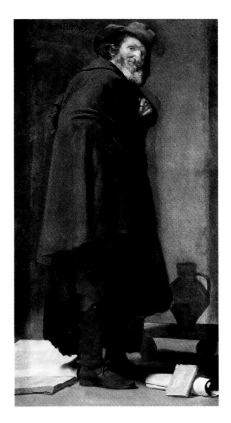

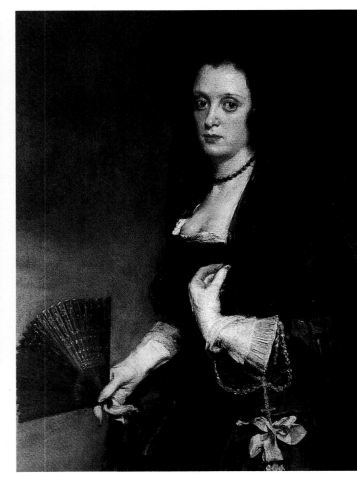

Diego Velázquez
El Bufón don Sebastián
de Morra (?) with a Pitcher
1644, oil on canvas,
41¾ × 33¼ in.
(106 × 84.5 cm)
Private collection, New York

Velázquez refuses to
indulge in any ironic
underscoring of the
deformity of the *bufones*
but, instead, accentuates
their dignity and their acute
and tortured intelligence.

Diego Velázquez
Lady with a Fan

1638
oil on canvas,
36½ × 27 in.
(93 × 68.5 cm)
Wallace Collection, London

This enchanting work,
a splendid example
of balance between the
perfect reproduction of
external appearance and an
impassioned representation
of the "movements of the
soul," effectively
summarizes Velázquez's
principal gift as a portrait
painter, namely, the ability
to identify with the
subject, to capture his or
her personality, thoughts,
and stirrings of the heart.
In this respect, Velázquez
can be classed with Titian
and Rembrandt as one
of the greatest portrait
painters. In this
unforgettable portrait
of a lady, the anxiety
of a moment is transmuted
into an extraordinarily
realistic, psychological
interpretation.

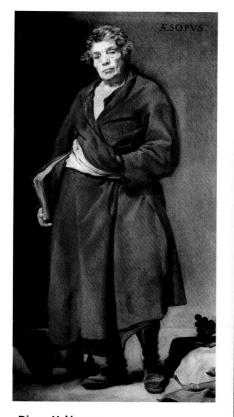

Diego Velázquez

opposite page:
Menippus

above:
Aesop
c. 1639–1640
oil on canvas,
70½ × 37 in.
(179 × 94 cm) each
Prado, Madrid

Ideal portraits of ancient philosophers and thinkers portrayed as bizarre vagrants constitute a specific genre in seventeenth-century art, and especially in Spanish painting. Ribera and Luca Giordano (to mention only painters featured in this volume) repeatedly tried their hands at this type of subject. While the other painters emphasize the crudest and most superficial aspect of realism with ill-concealed relish, Velázquez always strikes the higher note of the human element and dignified poverty.

Diego Velázquez
Philip IV
in Pink and Silver

1644
oil on canvas,
52½ × 38¾ in.
(133.5 × 98.5 cm)
*Frick Collection,
New York*

Following the development of the figure of the king (made unmistakable by his upturned moustaches), Velázquez arrived at this supreme masterpiece, a work of absolute beauty. The human aspect of the sovereign seems to be almost overshadowed by the splendor of his costume. The pale, feverish face with its heavy eyelids emerges from a wealth of transparent lace and incredibly elaborate embroidery. The master of a matchless technique, Velázquez engages in a kind of spectacular competition with the fabrics, seeming at times to weave and embroider with his brush.

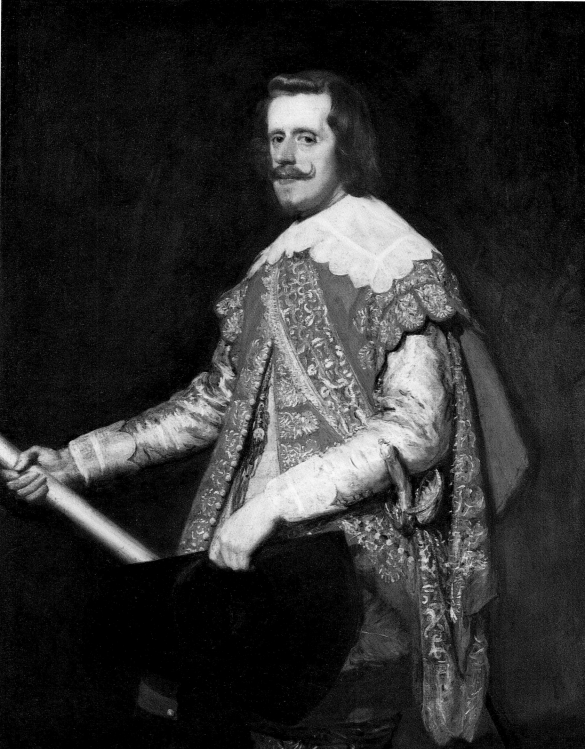

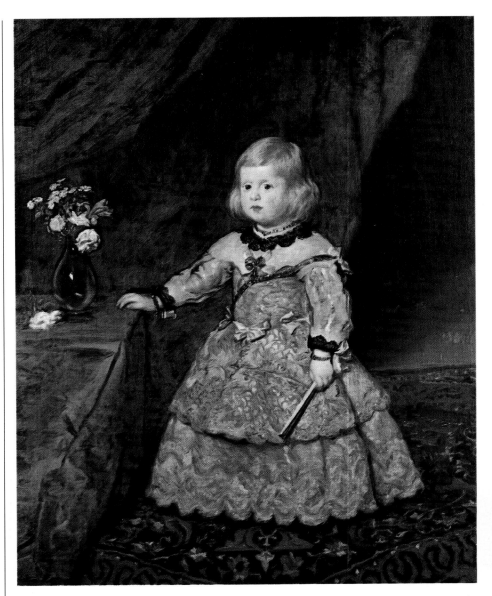

Diego Velázquez
The Infanta Margherita
Aged Three

1654
oil on canvas,
50½ × 39¼ in.
(128 × 99.5 cm)
*Kunsthistorisches Museum,
Vienna*

In the last decade of his career, Velázquez repeatedly painted the first-born daughter of Philip IV, tracing the little girl's development through her childhood into a kind of perfect court automaton, surrounded by the mincing affectations of the courtiers. Margherita's rosy features were to turn gradually into the elongated, slightly equine face of the Hapsburgs, soon accompanied by the unpleasantly protruding lower jaw that was evidently in the genes of Spain's rulers from Charles V on. This can be seen in the portrait of the Infanta at the age of eight. Here, however, Velázquez shows us an adorable little girl who has inherited her father's beautiful fine blond hair. The flowers on the table to the left constitute one of the best examples of seventeenth-century still life, while the sumptuous garments are reminiscent of the portrait of *Philip IV in Pink and Silver* reproduced on the previous page.

Diego Velázquez
Prince Felice Prospero

1659
oil on canvas,
50½ × 39¼ in.
(128.5 × 99.5 cm)
*Kunsthistorisches Museum,
Vienna*

This is one of the last and perhaps most moving of the painter's works. The prince, the son of Philip IV, is portrayed at the age of two, a weak, sickly child who was to die shortly afterward, in 1661. With truly touching delicacy and sensitivity, Velázquez captures the frailty of this small boy, lingering over his precious toys and, above all, his sad little face.

Diego Velázquez
Las Meniñas
(The Maids of Honor)

1656
oil on canvas,
125¼ × 108¾ in.
(318 × 276 cm)
Prado, Madrid

This masterpiece epitomizing the whole of Spanish art was painted late in Velázquez's career, after his second visit to Italy. It depicts a recurrent scene at court, the maids of honor attending upon the Infanta Margherita in a room of the royal palace, whose decoration is minutely reproduced. The child, now five, stands in the center of the painting, a dressed-up doll fussed over by two very young ladies-in-waiting, and is evidently the focal point and driving force of the whole scene. A female dwarf to the right recalls the portraits of the court *bufones* and a little boy disturbs the poise of royal etiquette by kicking an indifferent dog lying in the foreground. The apparently simple composition is seen to be more complex as the faces of the king and queen are reflected in a mirror at the back of the room. It then becomes clear that Velázquez has drawn us into a sophisticated game, an unpredictable reversal of space and situation. The king and queen are simultaneously spectators and protagonists of the scene. Their reflection in the mirror presupposes (as in the precedent of van Eyck's *Arnolfini Marriage Group*) their presence "outside" the painting, at our side. Another audacious leap is taken with the painter's self-portrait on the left, depicted in the act of painting the work itself. At this point the mental labyrinth of inner and outer, before and behind, is complete.

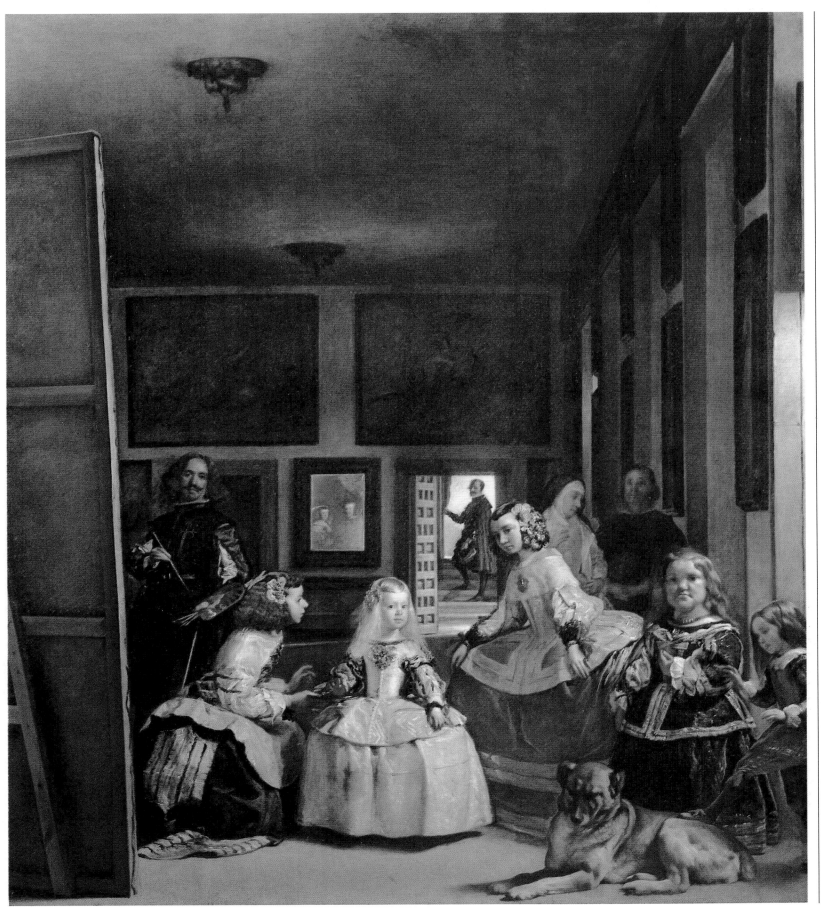

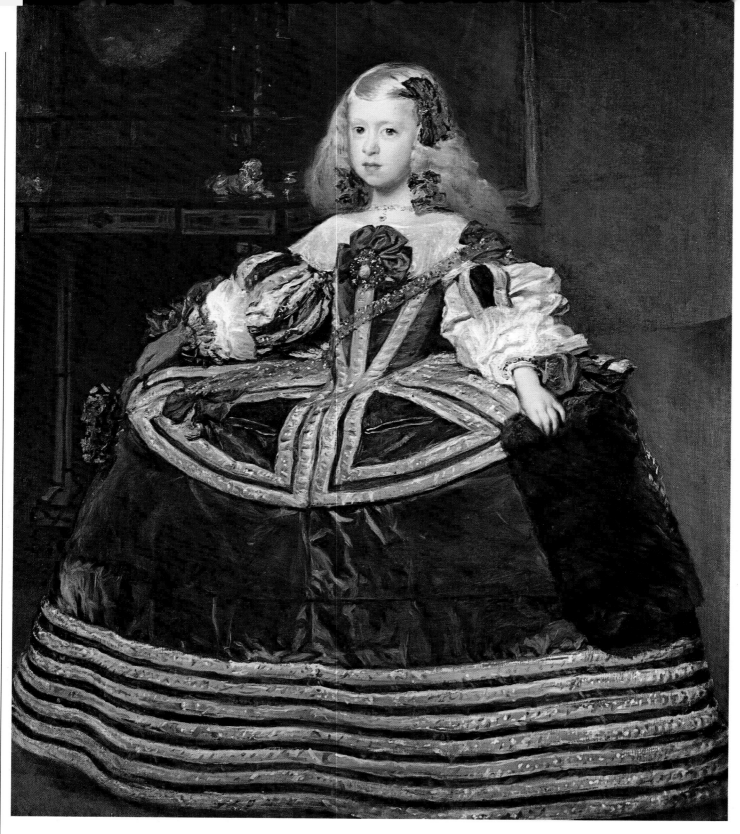

Diego Velázquez
The Infanta Margherita
Aged Eight

1659
oil on canvas,
50 × 42 in. (127 × 107 cm)
Kunsthistorisches Museum,
Vienna

The painting is completely dominated by the magnificent gown and the splendid shades of blue and gold. This was a very official work, sent to Leopold I of Austria, the uncle and future husband of the little girl, who became empress of Austria in 1666 at the age of fifteen. The dazzling splendor of the dress and the stately severity of the pose cannot conceal the incipient ugliness of the Infanta, portrayed by Velázquez first as a charming child of three, then as a doll surrounded by courtly affectation, and now as predestined to become an empress. The sitter's role dominates everything, and indeed, in this late work, one of the last painted by the master, the details of the setting somehow fade away, absorbed into the shadowy background.

Diego Velázquez
The Rokeby Venus

1650
oil on canvas,
48¼ × 69¾ in.
(122.5 × 177 cm)
National Gallery, London

Throughout his life, Velázquez cultivated his own great independent talent, though he constantly admired the Italian art of the sixteenth and seventeenth centuries. Like the other great masters of his time (Rubens and Rembrandt above all), he studied the great paintings of the High Renaissance and the innovations of Caravaggio with passionate dedication. In this splendid female nude, the only one in his entire oeuvre, Velázquez pays extraordinary homage to Titian, to his rich flesh tones and freedom in the use of color, and the tactile fullness of his brushstrokes.

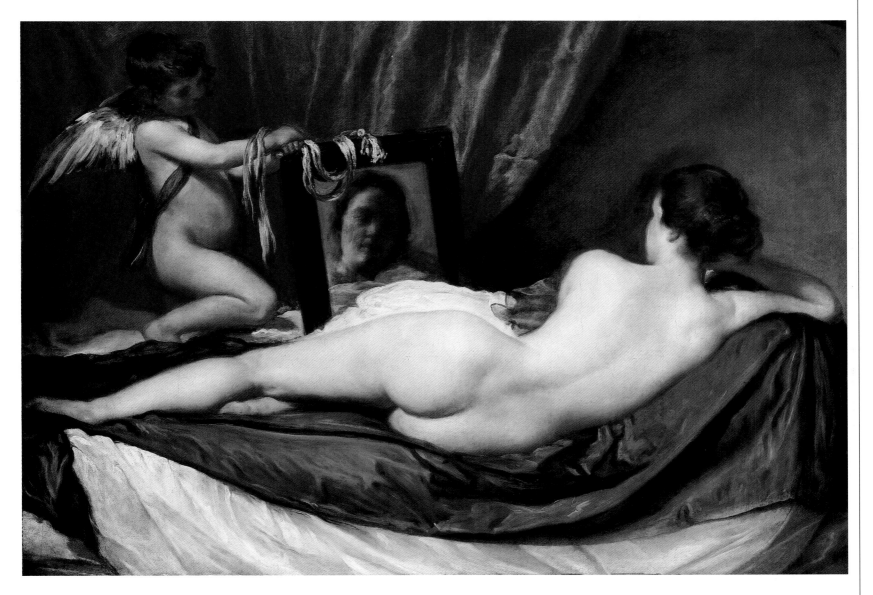

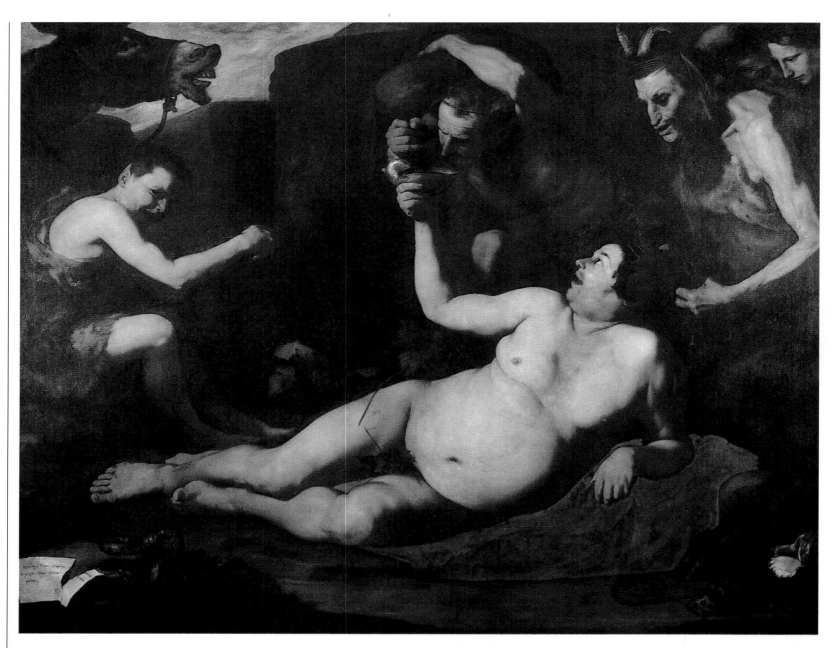

Jusepe de Ribera

Lo Spagnoletto
(Játiva, 1591–Naples, 1652)

Ribera acts as a link between Spanish painting and the Neapolitan school, and is one of the most interesting and original interpreters of the Caravaggesque style. The painter's once frequently used nickname "Lo Spagnoletto" (the Little Spaniard) has now fallen almost completely into disuse. Ribera was active mostly in Italy, but many paintings were for Spanish patrons. A particularly important role was played in terms of Ribera's career by the Duke of Osuna, the Spanish viceroy of Naples, who summoned the painter and introduced him to Neapolitan painting, but commissioned important canvases for his hometown in Andalusia. Taking Caravaggio's realism as his starting point, Ribera developed a figurative model that

was taken still further to become a violent expressionism marked by intense religious pathos, and a great interest in unusual physical traits and the psychological characterization of his figures. After initial training in Valencia, Ribera moved to Italy together with his brother Jeronimo, and by 1615 they were key members of the brilliant colony of Spanish painters in Rome's Via Margutta. His earliest works, immediately characterized by the influence of Caravaggio together with classical and Hellenistic art, date from this period. Ribera moved shortly afterward to Naples, where he found the perfect cultural environment to develop his study of pictorial expression. With the unfailing support of the viceroy and the Spanish nobles, Ribera devoted himself totally to his art. He also produced works for the many Neapolitan churches (especially the Carthusian monastery of San Martino), and became the model

for the development of local religious painting throughout the first half of the seventeenth century. The arrival of Velázquez in Naples, in 1630, encouraged Ribera to adopt a less harsh form of chiaroscuro and pay greater attention to color. This marked the beginning of a period in which he gradually used a range of lighter tones that created sweeping spatial effects, and a combination of bright colors. Despite being forced by a serious illness in 1644 to paint far more slowly than in previous years, Ribera managed to overcome his physical difficulties to produce a last group of masterpieces.

Jusepe de Ribera
Drunken Silenus

1626
oil on canvas,
72¾ × 90¼ in.
(185 × 229 cm)
Galleria Nazionale di Capodimonte, Naples

This painting plays a key role in Ribera's career, clearly showing the development of elements drawn from Caravaggio in the direction of an accentuated expressionism pushed to the limits of caricature. Practically all the light is concentrated on the obese divinity, who emanates a luminous aura.

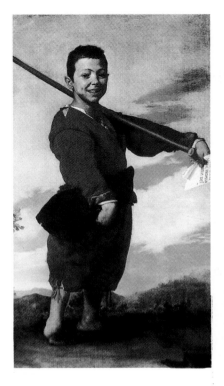

Jusepe de Ribera
Clubfooted Boy

1642
oil on canvas,
64½ × 37 in.
(164 × 94 cm)
Louvre, Paris

This painting, one of the
master's most celebrated
works, constitutes an
unquestionable milestone
in the particular genre
that took beggars and
the destitute as its subjects.
It depicts a young boy
asking for alms. In addition
to displaying the deformity
of his clubfoot, he also
holds a piece of paper
stating that he is deaf and
dumb. And yet he faces his
grim plight with a beaming
smile. It is difficult to
understand whether this
is the result of a further
handicap, this time of a
mental nature, or a
consciously adopted
expression. The portrait is
executed in a deliberately
rhetorical style, with the
beggar seen from below
and etched against the
background of the sky like
a little hero, carrying his
crutch as though it were a
banner, the heraldic
emblem of a tattered,
dusty, paradoxical nobility.

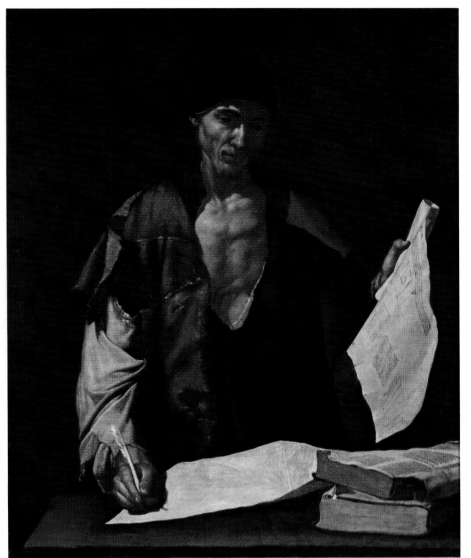

Jusepe de Ribera
Aesop

c. 1635
oil on canvas,
46½ × 37 in.
(118 × 94 cm)
Prado, Madrid

Typical of Ribera's
oeuvre are the half-length
portraits of philosophers,
poets, and prophets
depicted as wise men
dressed in tattered rags.
There is a sharp contrast
between the tools of
higher learning, such as
books and pages of notes,
and the poverty-stricken
appearance of the figures.
The sheer volume and
widespread distribution
of such works is evidence
of their popularity with
seventeenth-century
collectors.

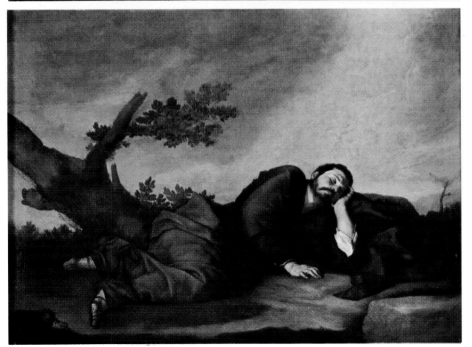

Jusepe de Ribera
Jacob's Dream

1639
oil on canvas,
70½ × 87¾ in.
(179 × 233 cm)
Prado, Madrid

During the 1630s, Ribera's
painting became less
agitated and expansive,
returning to a more
inward-looking, intimate
approach. Here the painter
offers a pleasantly bucolic
interpretation of the vision
of paradise revealed in
a dream to Jacob, who
certainly looks more like
a worn-out traveler than
a figure from the Old
Testament. The painter
barely sketches the
gleaming vision and
focuses on the slumbering
figure of Jacob.

Jusepe de Ribera
Pietà

1637
oil on canvas,
104 × 67 in.
(264 × 170 cm)

*Church of the Carthusian
Monastery of San Martino,
Naples*

One of the painter's most intense religious compositions, this work was repeated in different formats to become almost an obligatory model for the pathos-laden subject of grief over the body of Christ. Ribera succeeds in keeping the spectator's attention focused by limiting the number of figures and their gestures to the bare minimum, and abandoning his youthful exuberance to create a taut, emotional scene. The luminous body of the dead Christ, splendidly executed in terms of anatomical accuracy, is the focal point of the group as a whole. St. John supports Christ's head and shoulders, while Mary Magdalene devotedly kisses the pierced feet. This brightly-lit foreground contrasts with the darkness surrounding the Virgin Mary and St. Joseph of Arimathea.

Jusepe de Ribera
The Holy Family with
Saints Anne and Catherine
of Alexandria

1642
oil on canvas,
82½ × 60¾ in.
(209.6 × 154.3 cm)
*Metropolitan Museum of Art,
New York*

Toward the end of his career, Ribera's compositions became increasingly light and serene. After 1640, he painted a group of altarpieces and other religious scenes in which, while never losing contact with reality, he uses bright colors differing greatly from the earthy hues of his early works. This charming scene centers on the loving gesture of St. Catherine, while Mary gazes intensely toward the spectator in a flowing wave of primary colors (yellow, red, and blue). It may be possible to discern an echo of Raphael in the interplay of looks and gestures and the rotating relationship among the figures. Instead, St. Anne and St. Joseph derive more directly from the Caravaggesque model. The painting also contains a number of very precise still-life details, such as the workbasket in the bottom right-hand corner (a reference to the popular iconography of Mary sewing) and especially the fruit basket carried by St. Anne.

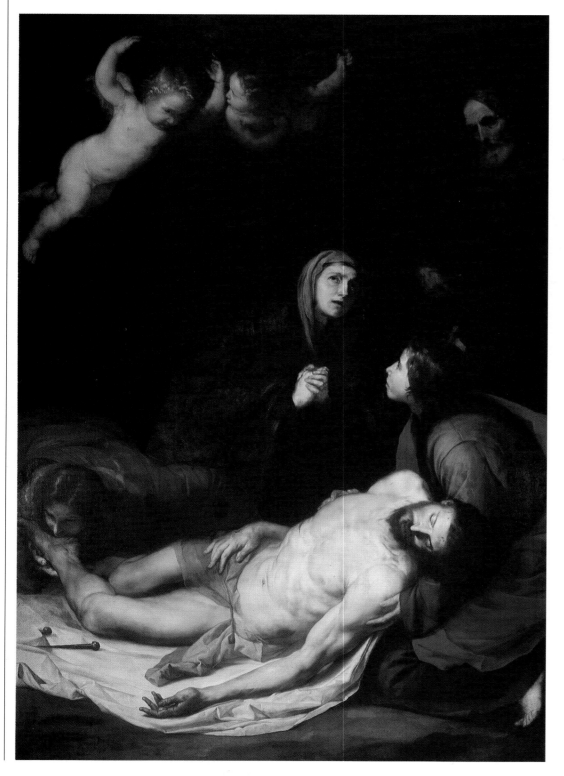

Jusepe Ribera
Gypsy Girl

1637
oil on canvas,
23¼ × 21½ in.
(59 × 54.5 cm)
National Gallery, London

Neapolitan genre painting is greatly indebted to Ribera, who laid the foundations by providing expressive models for an abundant output of common folk, urchins, and animated women from the city's alleys and the countryside. At times these figures were also instilled with a recondite symbolic meaning. Ribera painted allegorical images of the five senses on various occasions. However, the intellectual reference remains in the background and what shines through is the attractive immediacy of the figures, who are nonchalantly realistic and very present. The popularity of such works with the collectors of the period also led, however, to the production of copies, which were not always of a very high standard and spread an image of southern Italy that it is difficult to alter.

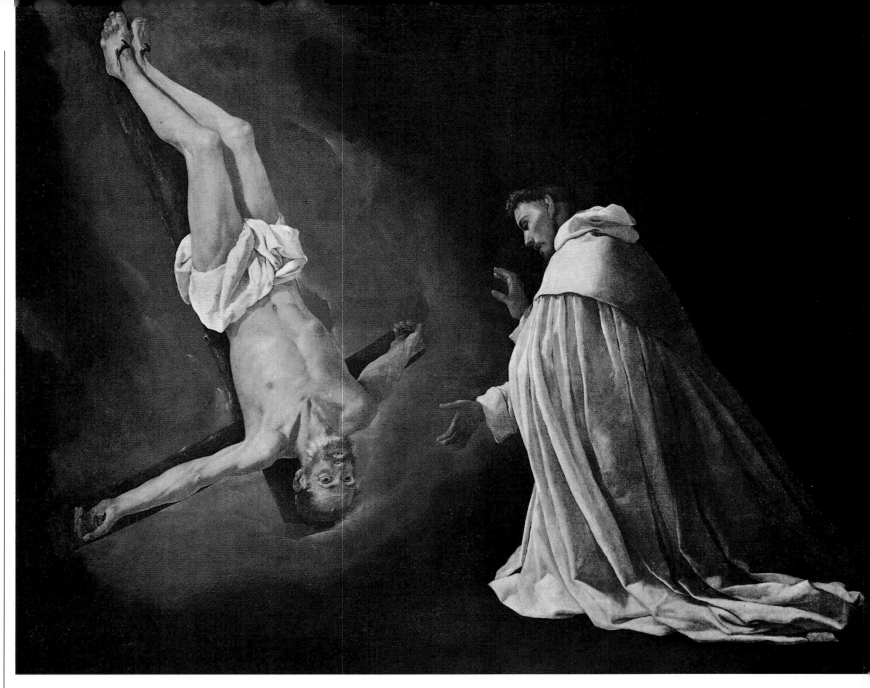

Francisco de Zurbarán

(Fuente de Cantos, 1598–Madrid, 1664)

An artist of great appeal, the painter of images that have a penetrating spiritual impact, Zurbarán can even be compared with Rembrandt as regards the highly significant course of his life. An early beginning in the provinces and a successful career with a great many commissions, some of considerable official importance, were followed, from the middle of the century on, by a swift decline due to changes in taste, and then death in poverty and obscurity. From his youth on, Zurbarán belonged to the flourishing Seville school, first as a pupil of Pedro Diaz de Villaneuva and then, from 1617, as an independent painter. An immensely prolific

artist, Zurbarán had a workshop in Llerena but sent most of his works to Seville, where he built up a well-deserved reputation. His own specific style became evident as early as 1620: austere spiritual images with sequences of friars, saints, and Holy Virgins captured in significant gestures and concentrated expressions. The young painter's fame grew with the delivery of the twenty-one canvases for the monastery of San Pablo in Seville. This group of works, now partially dispersed, constitutes an anthology of sculptural figures, of dramatic and determined champions of the faith. In his narrative pictures with various characters, Zurbarán always shunned dynamic compositions in favor of static scenes, in which spiritual intensity and deep emotion outweigh action and interlinking events. In 1629, the city corporation invited Zurbarán to move to Seville, where he received an

uninterrupted flow of commissions from various monastic orders, interested in a style of painting that was simultaneously evocative and dramatic, where the inner conflict of the figures and the strength of their faith emerged with great impact. While religious paintings thus remained Zurbarán's favorite, some innovations appeared after 1633, when he painted the *Still Life* now in Pasadena, a rare and striking example of genre painting that is almost metaphysical. In 1634, he moved to Madrid at Velázquez's invitation. There he worked for the court on paintings with secular themes for the royal palace of Buen Retiro. This experience ended quite soon, however, and after a few months Zurbarán returned to Seville to resume his customary impassioned production of religious works. Typical paintings are the captivating (not to say disquieting) images of saintly girls or young women, dressed in

sumptuous garments, appearing surprised and almost dazed before the spectator. Around 1650, however, the robust and ascetic spirituality expressed by Zurbarán began to lose ground to the warmer and more familiar religious images produced by Murillo. The painter then looked for new markets elsewhere, including the colonies in Latin America. Exhausted, his creative vein practically dry, and irrevocably outmoded, Zurbarán moved to Madrid in 1658, at the age of sixty. He died, alone and forgotten, in 1664.

Francisco de Zurbarán
Apparition of St. Peter
the Apostle to St. Peter
Nolasco

1629
oil on canvas,
70½ × 87¾ in.
(179 × 223 cm)
Prado, Madrid

A striking combination
of tangible realism and

Francisco de Zurbarán
St. Margaret

c. 1640
oil on canvas,
72¼ × 35½ in.
(184 × 90 cm)
National Gallery, London

The series of paintings
of female saints constitute
perhaps the most
captivating part of

mystical vision, this is one
of the most dramatic
works in the whole of
seventeenth-century art.
Imbued with the intense
devotion of Spanish
Catholicism, and based
on the relationship
between two static,
sculptural figures modeled
by the light, this work is
one of the best examples

Zurbarán's oeuvre.
Unfortunately, these
groups of paintings have
been dispersed over the
years and we no longer
have the impression of a
mystical procession of
enchanting inhabitants of
paradise, lining the aisles of
churches or the corridors
of convents, all of identical
format and often similar in

of Zurbarán's powers of
concentration. Through
his use of light and plastic
intensity, the painter
succeeds in making us
almost forget the figure
of St. Peter Nolasco and
places the viewer in the
saint's position of ecstatic
and terrible contemplation
of St. Peter nailed upside-
down to the cross.

their features. St. Margaret
is depicted in traveling
clothes, with a large hat
and striking embroidered
bag. Zurbarán has
conferred a subtle
melancholy upon this
motionless pilgrim,
who possesses a natural
elegance, and he captures
her evocative gaze and
frozen gesture.

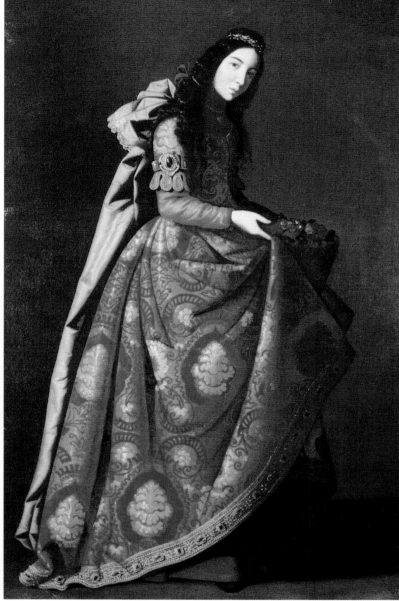

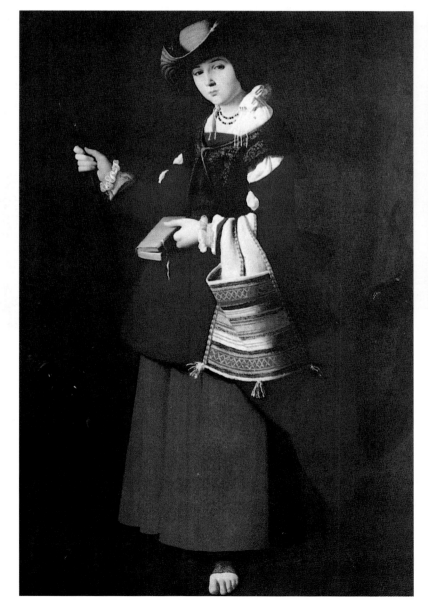

Francisco de Zurbarán
St. Casilda

c. 1640
oil on canvas,
72¼ × 35½ in.
(184 × 90 cm)
*Thyssen-Bornemisza
Collection, Madrid*

Zurbarán favored the
image of this Castilian
saint, rarely represented
outside Spain, and depicted
here in rich, fashionable
attire. The saint was a girl
of noble family, the

daughter of the governor
of Toledo during the
Moorish domination, who
disobeyed her Saracen
father and took food to the
Arabs' Christian prisoners.
Surprised by the guards,
she saw the loaves she was
carrying in her skirt turn
miraculously into flowers.
The figure is thus endowed
with both tenderness and
determination, and hence
is a perfect subject for this
painter's style.

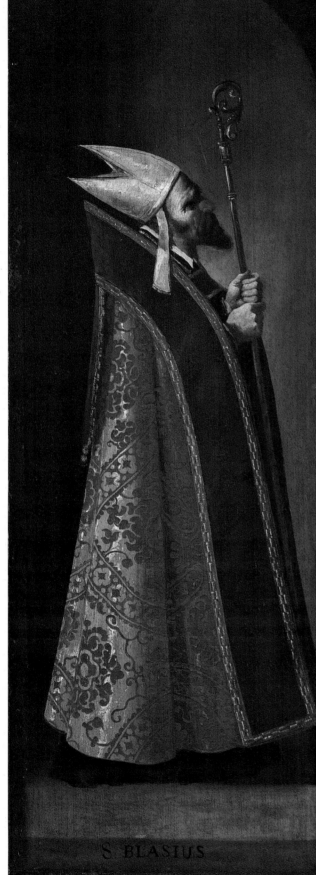

Francisco de Zurbarán
St. Blaise

c. 1630–1634
oil on canvas,
36½ × 12¾ in.
(92.5 × 32.4 cm)
*Romanian National Museum
of Art, Bucharest*

Despite the small size of
the painting, the saintly
bishop is portrayed with
monumental strength.
Enveloped in gilded
vestments, modeled by the
light like the precious work
of a goldsmith, St. Blaise
grips his crosier tightly. His
body is completely hidden
by his dalmatic; all that can
be seen are the hands and
the beautiful face in profile.
In this extremely balanced
work, with its interplay of
symmetry and reference,
the saint's pointed beard
offsets the points of the
miter on his head to create
an unusual silhouette.

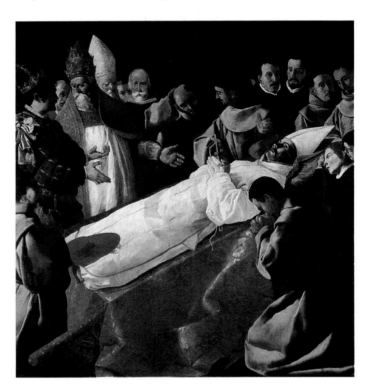

Francisco de Zurbarán
St. Bonaventura on His
Deathbed

1629
oil on canvas,
98½ × 88½ in.
(250 × 225 cm)
Louvre, Paris

This work forms part
of the cycle painted for the
College of St. Bonaventura
in Seville, which played a
crucial part in launching
the artist's career. As usual,
Zurbarán prefers static
figures in frozen poses,
which give his paintings
a clarity and resolution
of great emotional impact.
He thus did not hesitate
to infringe the canons
of perspective by raising
and modifying the saint's
bier to make it more
immediately evident.

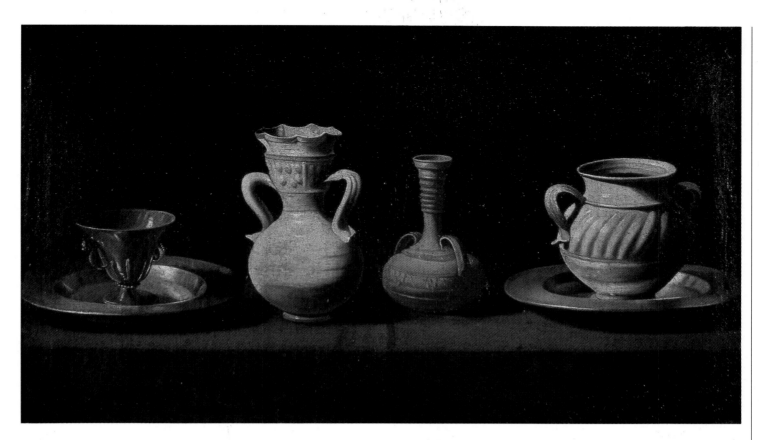

Francisco de Zurbarán
Still Life with Vases

1633
oil on canvas,
18 × 31 in. (46 × 79 cm)
*Museu d'Art de Catalunya,
Barcelona*

Zurbarán's rare but
splendid still lifes make
him one of the greatest
specialists in this genre.
Spanish still lifes can
essentially be divided into
two schools: the richer and
more "Baroque" style, of
Flemish origin, and the
"minimalist," metaphysical,
timeless style, which finds
its highest expression in
the work of Sánchez Cotán
and Zurbarán. A few items
are arranged in a perfect
sequence on a single plane.
Between them a silent
relationship of volume,
surface, and color is
established, as though
in a magical, motionless
game of chess, where the
human presence is
eliminated and everything
is frozen in a kind of
dreamlike timelessness.

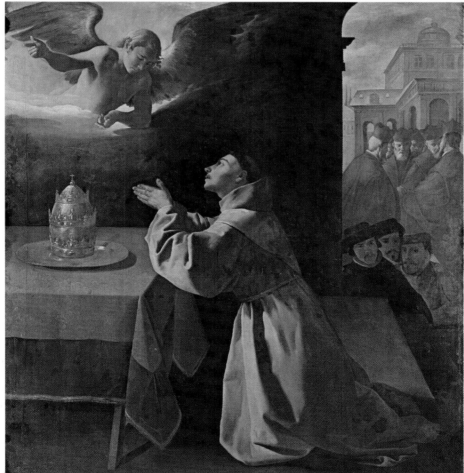

Francisco de Zurbarán
St. Bonaventura Praying

1629
oil on canvas,
93¾ × 87½ in.
(238 × 222 cm)
Gemäldegalerie, Dresden

Zurbarán worked for
various religious orders
and succeeded in giving
an extremely original
interpretation of the
mystical nature of the
figures and episodes
making up their history.
For the Franciscans of the
College of St. Bonaventura
he painted a very
demanding figurative
cycle tackling somewhat
rare themes in Christian
iconography. Here we see
the successful juxtaposition
of the ecstatic saint,
listening raptly to the
words of the angel, and
the conversation between
the cardinals and the other
figures on the right.

47

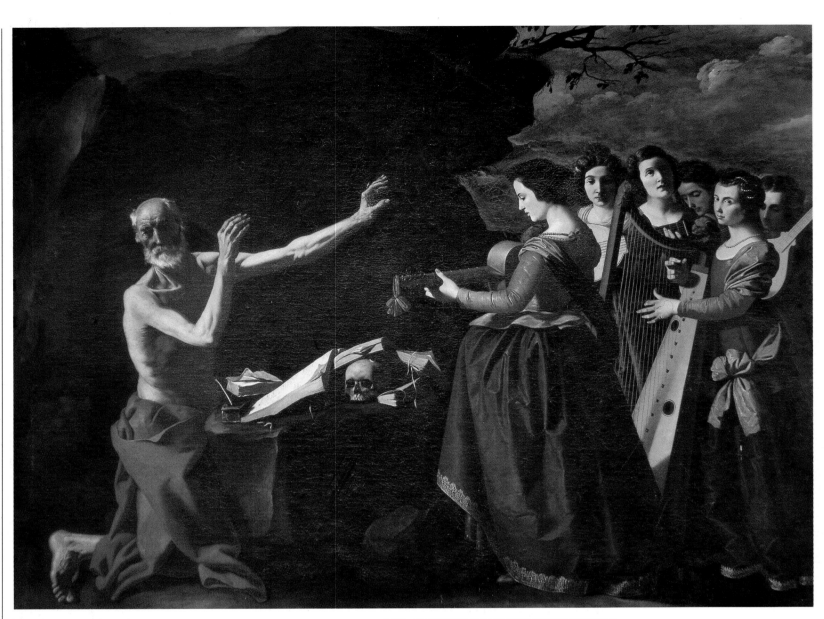

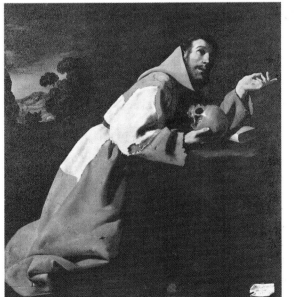

Francisco de Zurbarán
Temptation of St. Jerome

1638–1639
oil on canvas, section
of the altarpiece for
the chapel of St. Jerome
Jeromite Monastery,
Guadalupe

Zurbarán's beautiful female
saints appear to have
gathered together as angel
musicians for this heavenly
concert. The painting is
neatly divided into two
parts. On the left, the
stark image of the saint
fighting the temptation to
surrender to the music and
abandon his studies; on the
right, the exquisite group
of temptresses, whose
instruments are depicted
with great accuracy. The
background (a dark rock
behind St. Jerome, the
open sky behind the
musicians) also contributes
to this division. Thanks to
this device, Zurbarán
succeeds in avoiding the
confusion typical of
crowded compositions and
creates a work of great
charm and rhythmic
elegance.

Francisco de Zurbarán
Ecstasy of St. Francis

1639
oil on canvas,
63¾ × 54 in.
(162 × 137 cm)
National Gallery, London

The range of different
interpretations of the
ecstasy of St. Francis and
his meditation on death
would not be complete
without Zurbarán, ready
as always to freeze the
saint's gesture and endow
the figure with a powerful,
monumental, and almost
sculptural presence.

Juan Bautista Maino

(Pastrana, Guadalajara, 1580 – Madrid, 1649)

The son of a Lombard painter, from an early age Maino was involved in the work on the Escorial. Critical studies are now gradually rediscovering this artist, who was a celebrated painter in his day, but was later overshadowed by other great masters of the golden age of Spanish painting. An essential element in his formation was Caravaggesque realism, which he probably encountered in Italy, both in Lombardy and during a period of study in Rome. In 1611 Maino was living in Toledo, where he took the vows of the Dominican order. Very solid forms, clearly defined by the light and rich in color, predominate in his work.

Noted by intellectuals and courtiers for his rich, sumptuous style, Maino was summoned to the court in Madrid, where he became the painter who most reflected the tastes of Philip IV. In his official capacity, and with the support of the all-powerful conde-duque de Olivares, he played a key role in bringing Velázquez to Madrid in 1623 and introducing him at court. As the mentor of this talented young painter from Seville, it was probably Maino who encouraged Velázquez to study Italian art, and Caravaggio in particular.

Juan Bautista Maino
Reconquest of Bahia
in Brazil

1625
oil on canvas,
121¾ × 154 in.
(309 × 391 cm)
Prado, Madrid

This huge canvas celebrates the victory won on Brazilian soil by Don Fadrique de Toledo in 1625. Painted for the Buen Retiro palace, it provides a good example of a celebratory work before Velázquez's masterpieces, such as the *Surrender of Breda*, painted ten years later. The scene is neatly divided into two parts. On the right, Maino depicts the historical episode, almost buried beneath layers of symbolic reference. Below a precious canopy, the victorious general shows a small group of kneeling officers a tapestry in which Philip IV is being crowned with a laurel wreath by an incongruous couple, the corpulent conde-duque de Olivares and the allegorical figure of Victory, standing on the bodies of Heresy, Wrath, and War. In the foreground to the left, juxtaposed to this pompous scene, we have what is definitely the most interesting and lively section of the painting: a wounded soldier being tended with great concern and a group of women, children, and peasants commenting on the scene. The painter's greatest gifts come to the fore in this area of the canvas, and the influence of Caravaggio's early paintings is evident.

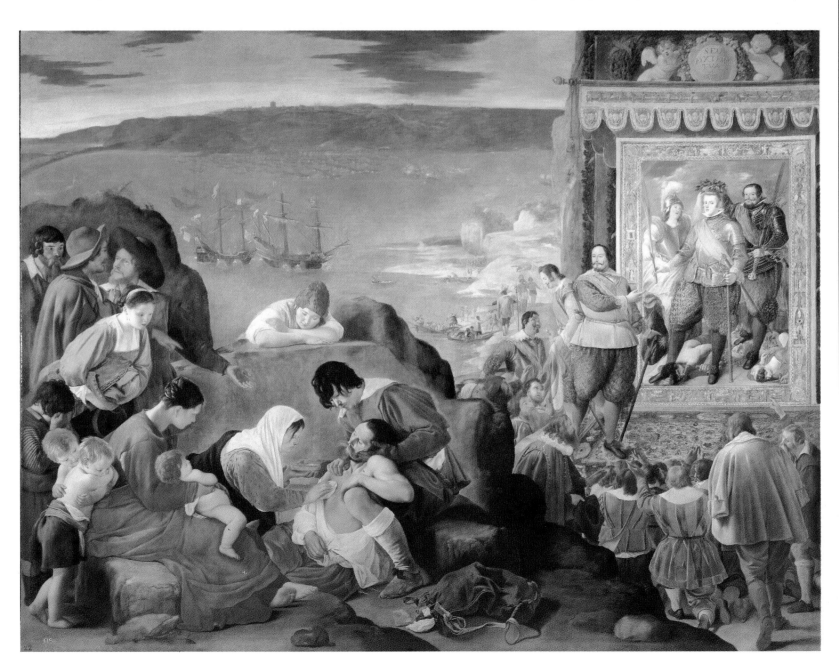

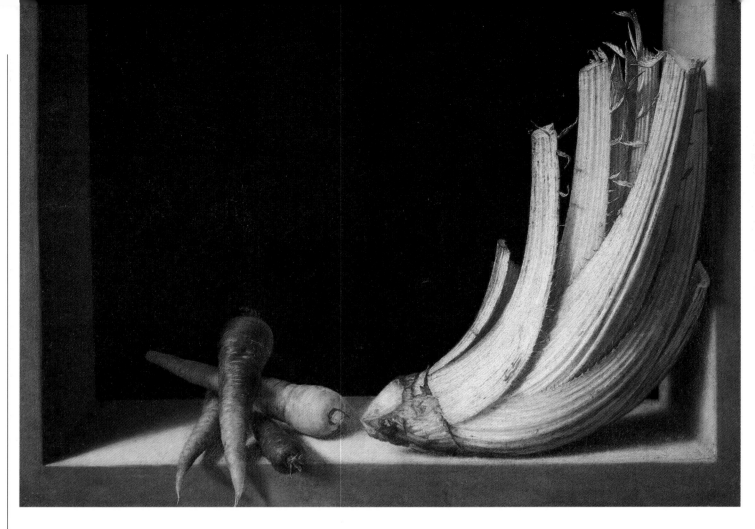

Juan Sánchez Cotán

(Orgaz, 1561–Granada, 1627)

Highly individual and extremely interesting both as an artist and as a human being, Sánchez Cotán is one of the first and greatest still-life painters. It is due to his work that the *bodegónes* genre (the term used for still life in Spanish art) rapidly reached a height perhaps only attained by Goya and, in the twentieth century, by Picasso. Trained in the artistic circles of Toledo, but steeped above all in the pure, intense, mystical spirituality of the late sixteenth century, Sánchez Cotán nearly always painted the same subject: a few pieces of fruit or vegetables inside a "box."

Juan Sánchez Cotán
Still Life with Cardoon

c. 1600
oil on canvas,
24¾ × 33½ in.
(63 × 85 cm)
*Museo de Bellas Artes,
Granada*

The cardoon frequently recurs in the works of Sánchez Cotán. It may have a hidden symbolic meaning (in order to enjoy it you must tackle its thorns), but the painter certainly exploits its compositional value as a large semicircular arch framed by a right angle.

Juan Sánchez Cotán
Still Life with Fruit
and Vegetables

c. 1602–1603
oil on canvas,
27¼ × 38 in.
(69.5 × 96.5 cm)
*José Luis Várez Fisa Collection,
Madrid*

This is one of the
"metaphysical" heights
reached by the painter,
who here sets "silent" fruit
and vegetables against his
habitual black ground.
A perfect composition, but
also one that is somewhat
disquieting. On closer
examination, the hanging
fruit and vegetables begin
to look like anatomical
specimens, amputated
pieces of nature.

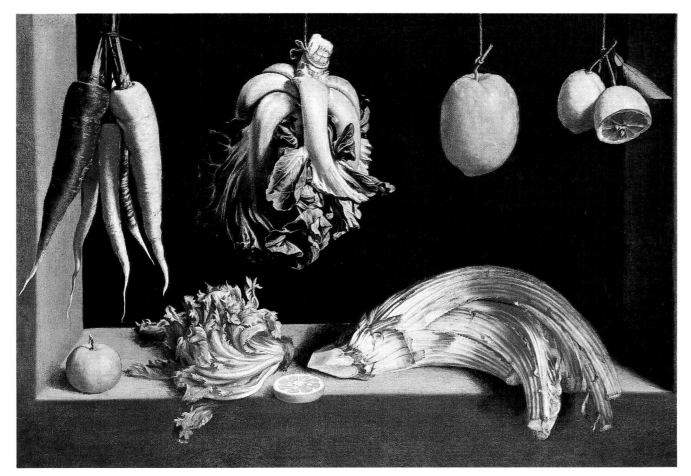

Juan Sánchez Cotán
Still Life

1602
oil on canvas,
26¾ × 35 in.
(68 × 89 cm)
Prado, Madrid

This is one of the painter's
richest and most complex
compositions, with an
unusual variety of objects,
and perhaps this is why he
signed it right in the
center. The cardoon
reappears, but it is lying
on its side in an unusual
position so as to describe
a sweeping upward curve
that embraces the other
items.

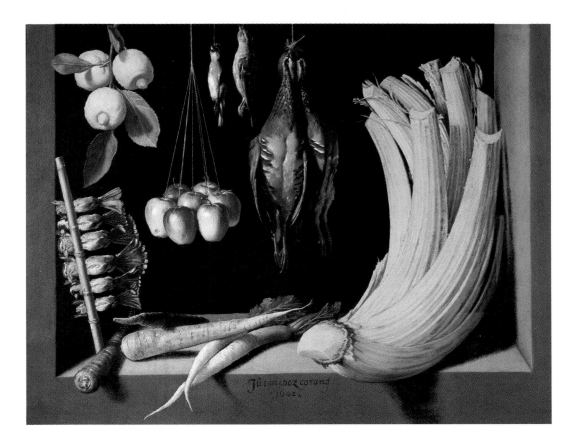

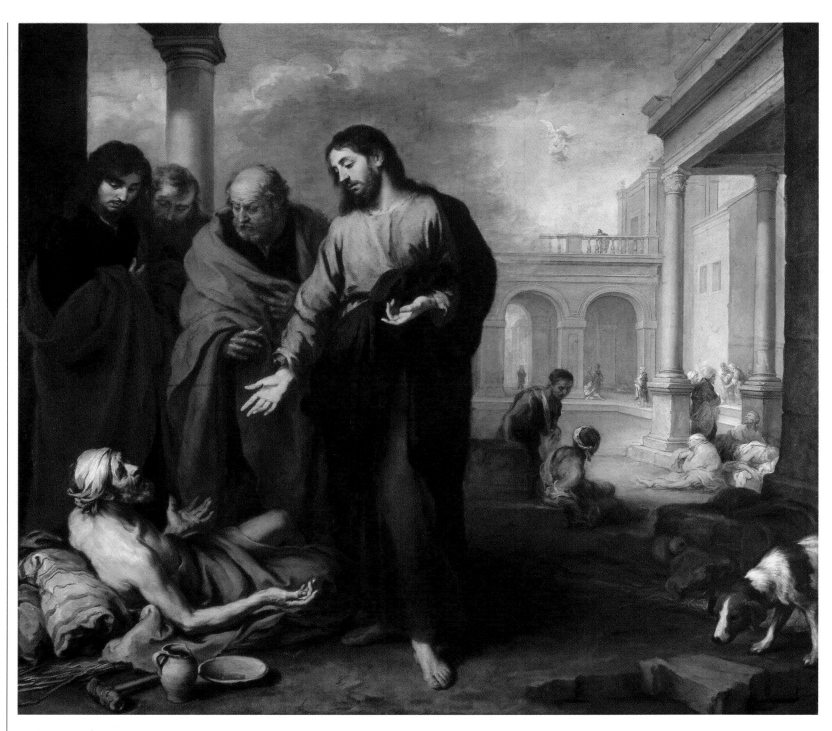

Bartolomé Esteban Murillo

(Seville, 1618–1682)

A leading figure in the "second generation" of Sevillian artists, Murillo is famous for his gentle, religious compositions that give an image of him that is endearing, but perhaps a little too sweet. In actual fact, the master's oeuvre and career are far richer and more complex. After training in his hometown, where he was noted for his precocious talent, Murillo established his own studio in 1639. A few years later he began to receive important commissions from the religious orders of the city. Unfortunately, many of his cycles of paintings have been dispersed and are now in museums throughout the world. His earliest works feature intense images of children playing, young beggars, and street urchins. While the influence of Ribera is evident, so is a taste for action, for genre scenes, and for descriptive detail. By 1650 the contrast between the essential, austere paintings of Zurbarán and those of the younger, dynamic Murillo was already evident. In 1655, after a period of assiduous study in Madrid, Murillo introduced still greater freedom and monumentality into his work. Beautiful female saints, impassioned Virgins, and enchanting angels began to appear with increasing frequency.

The success of this easily understood and pleasing work was overwhelming. In 1660, Murillo opened an academy of fine arts in Seville, and the activity of imitators and copyists, combined with what practically amounted to the mass production of devotional images, sometimes of inferior quality, led to a decline in his reputation for a certain period. His work has recently undergone considerable critical reappraisal, largely based on his captivating paintings of scenes and figures from everyday life.

Bartolomé Esteban Murillo

The Pool of Bethesda

1671–1673
oil on canvas,
93¼ × 102¾ in.
(237 × 261 cm)
National Gallery, London

This painting of great spatial breadth provides an excellent example of Murillo's familiarity with complex compositions, where an effective and sophisticated expressive link is forged between the main figures and the background. Two aspects are particularly important to the painter: the depiction of the miracle and its narrative handling. While emphasizing the monumental figure of Christ in contrast with the withered limbs of the paralyzed man, Murillo finds the right tone and rhythm for a flowing narration.

Bartolomé Esteban Murillo

The Descent of the Virgin Mary to Reward St. Ildephonsus with a Chasuble

c. 1650
oil on canvas,
121¾ × 98¾ in.
(309 × 251 cm)
Prado, Madrid

The spectacularly theatrical nature of this composition, worthy of a miracle play and capable of rivaling Rubens's religious works, makes this altarpiece one of the greatest achievements by Murillo, then still at the beginning of his brilliant career. The contrast with the essential, ascetic compositions by Zurbarán is evident. The shift in the fortunes of the two Sevillian artists corresponds to the change in taste halfway through the seventeenth century, when the solemn Caravaggesque rigor based on clean-cut light and shade gave way to the desire for richer, more colorful, and dynamic scenes.

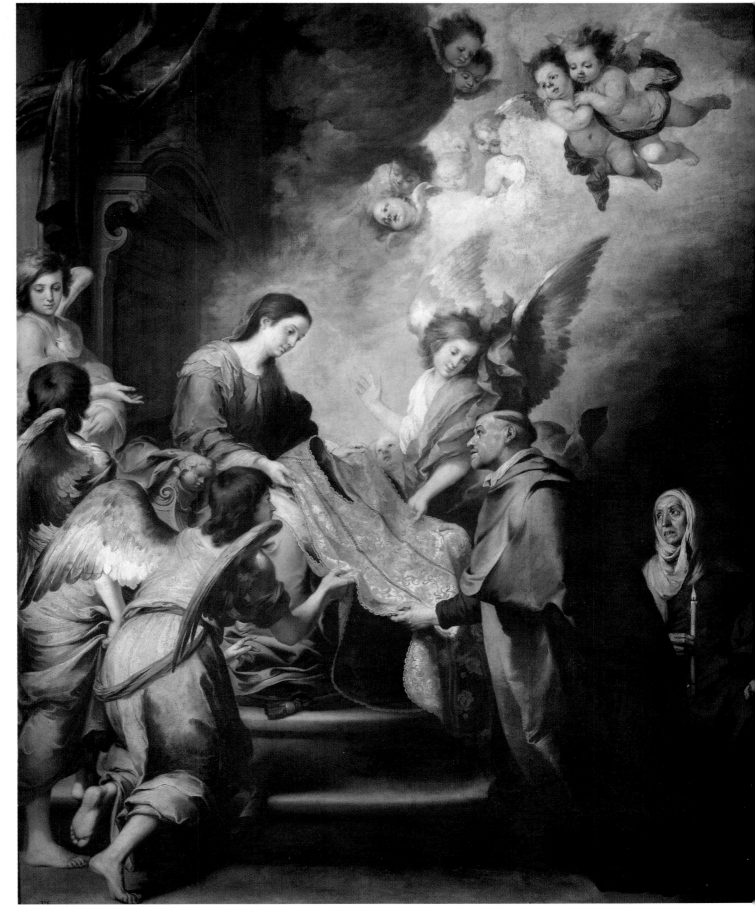

Bartolomé Esteban Murillo
Children Eating Fruit
The Little Fruit Sellers

c. 1670
oil on canvas,
56¼ × 41¼ in.
(143 × 105 cm)
and 56¼ × 42 in.
(143 × 106.5 cm),
respectively
*Alte Pinakothek,
Munich*

The critical reappraisal of Murillo is based above all on scenes such as those reproduced on these two pages, where the painter demonstrates his endearing capacity to depict the world around us, and the protagonists of a minor, everyday episode. Murillo's young beggars are of course very different from Velázquez's vagrants or Ribera's *Clubfooted Boy*.

Murillo prefers to present the situation with a delightful abundance of detail, including striking still-life elements. These canvases, intended as a pair, were evidently aimed at aristocratic collectors, who would certainly not be troubled by the marginal details of poverty, but rather would enjoy the excellent workmanship.

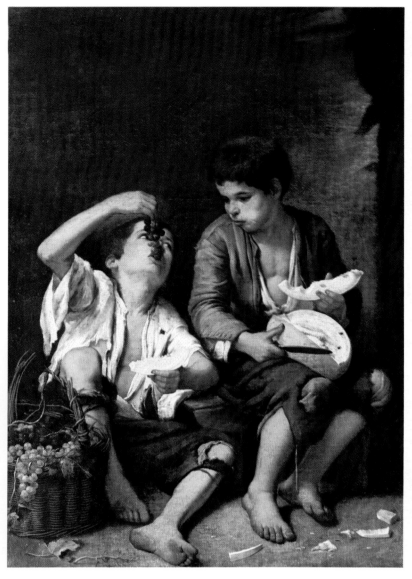

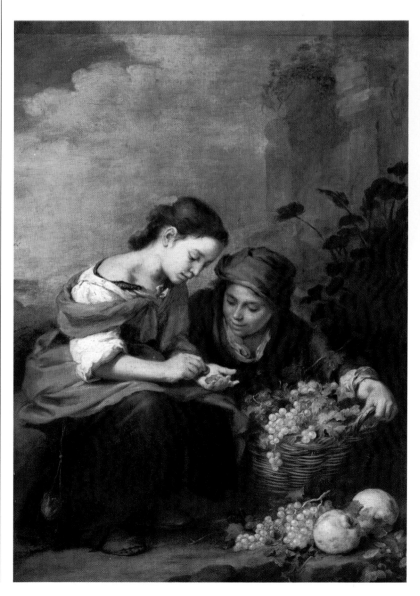

Bartolomé Esteban Murillo
Girl at the Window

c. 1670
oil on canvas, 50 × 41¾ in.
(127 × 106 cm)
*National Gallery of Art,
Washington*

This is perhaps the freshest and most endearing work in the painter's entire career, one that directly expresses all his *joie de vivre*. The subject, which also appears elsewhere in the course of Spanish painting, is an attractive one: a young girl gazes out of the window, while her nurse looks fondly on. One could almost say she is gazing out on life, emerging from the protective shadows of the house, and watching the world pass by. Murillo avoids the picturesque or merely illustrative. On the contrary, he depicts the feelings of the two women with affectionate sympathy, and invites us to contemplate the girl's healthy, youthful beauty.

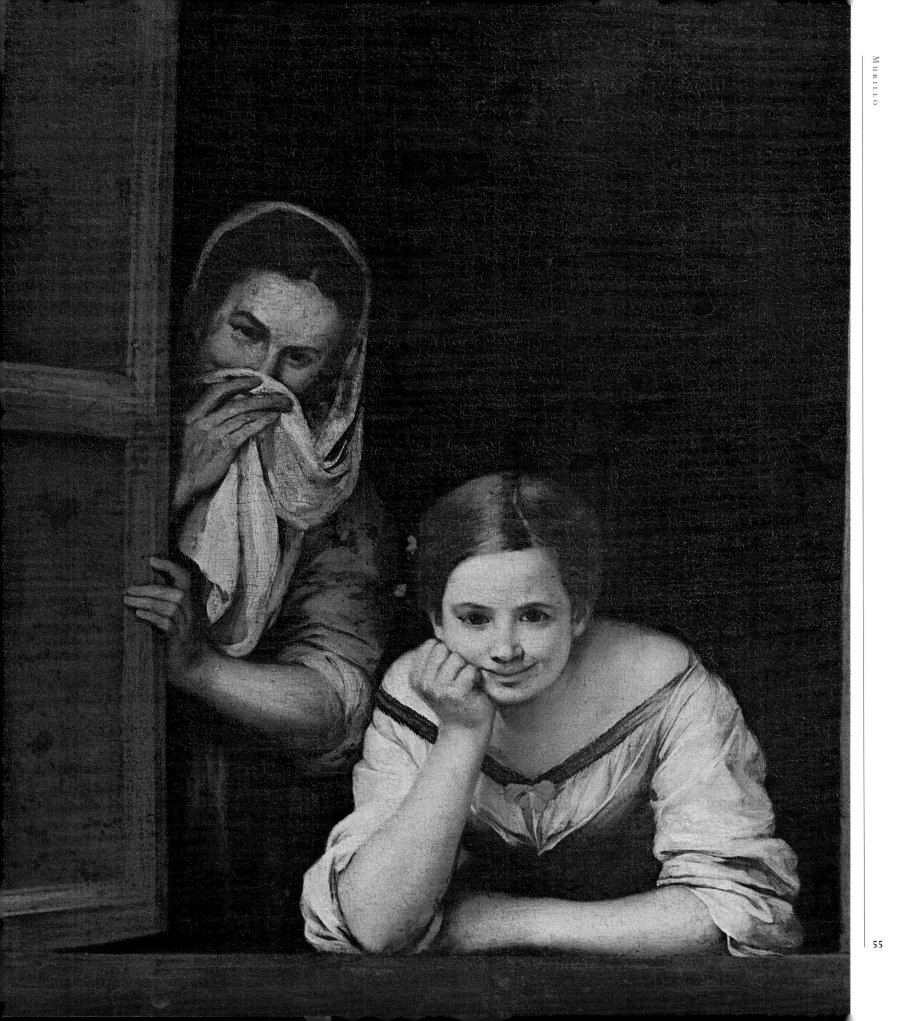

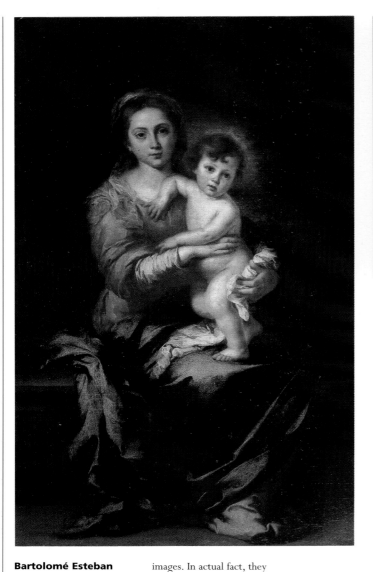

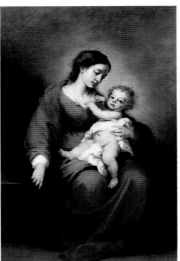

Bartolomé Esteban Murillo
Madonna and Child

c. 1672
oil on canvas,
66 × 43 in.
(165.7 × 109.2 cm)
Metropolitan Museum of Art, New York

Painted in the years of the master's maturity in a freer and brisker manner than usual, this work adds another chapter to the story of affection and caresses between Mother and Son as told by Murillo. The work originally hung in the private chapel of a noble family from Madrid, where it was seen by Palomino, the scholarly author of a fundamental work on seventeenth-century Spanish painting, who described it as "enchanting in its beauty and sweetness."

Bartolomé Esteban Murillo
Madonna and Child

1650–1660
oil on canvas,
61 × 42 in.
(155 × 107 cm)
Galleria Palatina, Palazzo Pitti, Florence

Murillo's art found its best known (though perhaps somewhat outmoded) form of expression in religious scenes full of sweetness and devotion, some of which were copied in small devotional images. In actual fact, they are very interesting works that also indicate a phase of transition regarding religious practices and points of reference. One century after the Council of Trent, and hence at a certain distance from the dispute over religious art between Catholics and Protestants, Murillo offers a series of divine figures that have immediate popular appeal, with none of the harshness of the early seventeenth century.

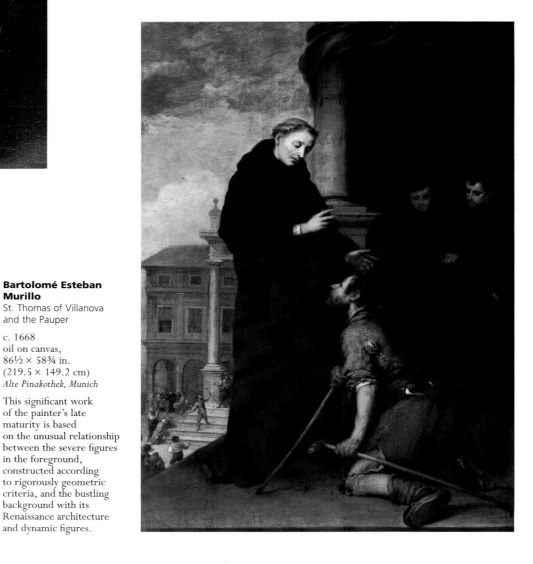

Bartolomé Esteban Murillo
St. Thomas of Villanova and the Pauper

c. 1668
oil on canvas,
86½ × 58¾ in.
(219.5 × 149.2 cm)
Alte Pinakothek, Munich

This significant work of the painter's late maturity is based on the unusual relationship between the severe figures in the foreground, constructed according to rigorously geometric criteria, and the bustling background with its Renaissance architecture and dynamic figures.

Bartolomé Esteban Murillo
The Flight into Egypt

c. 1645
oil on canvas,
82¾ × 64¼ in.
(210 × 163 cm)
Galleria di Palazzo Bianco,
Genoa

The flight into Egypt, this popular episode combining family life and divine destiny, is interpreted by Murillo with his customary sweetness. While the humble immediacy of the donkey and St. Joseph's traveling bag are reminiscent of Flemish realism, the luminous group of the Madonna and Child is a highly characteristic feature of Murillo's style. The scene unfolds before our eyes with no obstacles or awkwardness. Murillo seeks and successfully achieves simplicity, and this is an effective narrative that has few equals in the European art of the period.

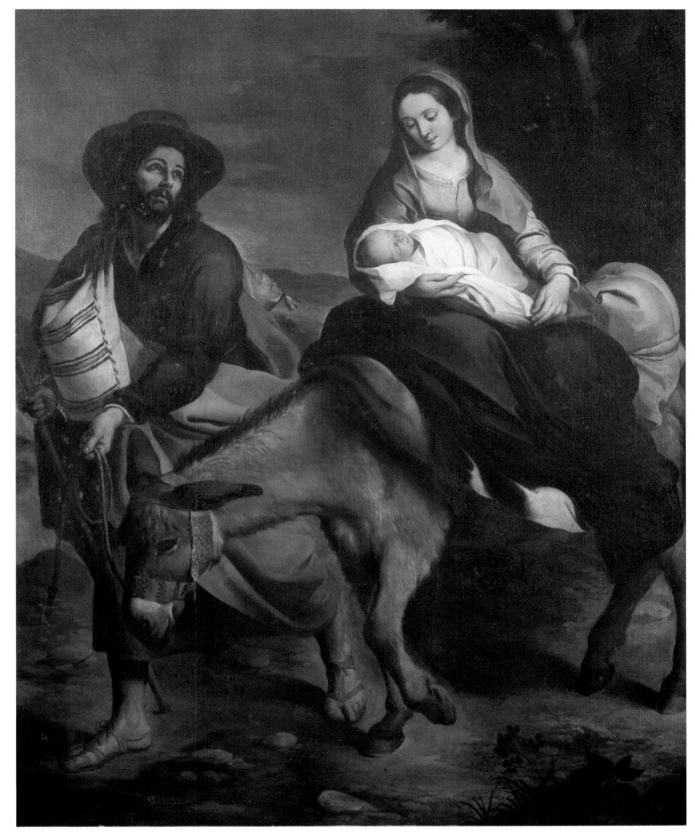

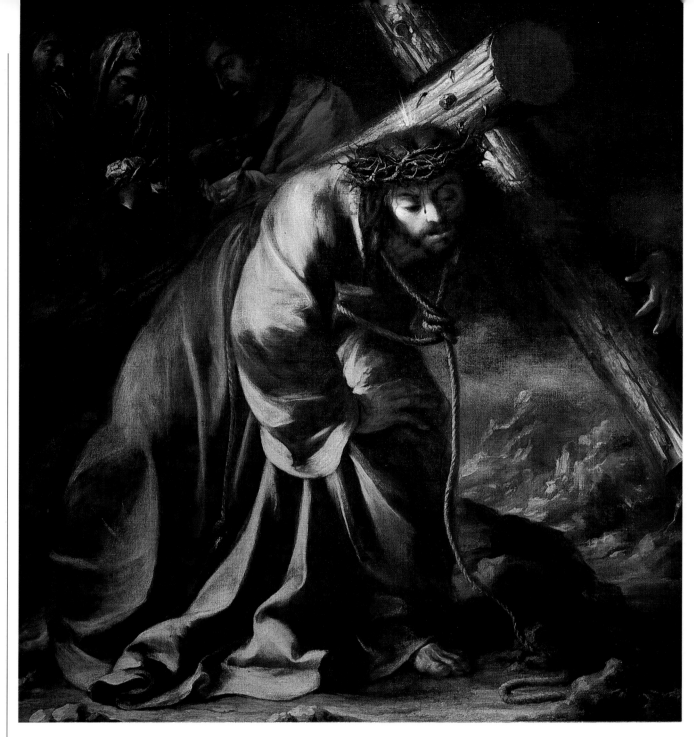

Juan de Valdés Leal
Christ Carrying the Cross

1657–1660
oil on canvas,
82¼ × 63 in.
(209 × 160 cm)
Prado, Madrid

With the dramatic involvement of a popular miracle play and in perfect harmony with Spanish religious feeling, Valdés Leal clearly draws inspiration from the large, sculptural groups carried in processions. Christ seems to loom over us, crushed by the weight of the terrible, heavy cross, whose rough wooden surface seems to emerge from the painting. The crown of thorns causes blood to run down Christ's face. Each detail moves the faithful to pity: the long rope around the condemned man's neck, the grief-stricken figures on the left, even the gloomy landscape. Valdés Leal stands out in Spanish seventeenth-century painting precisely by virtue of his bitter, desperate religious feeling. His best works, of which this is one, avoid the trap of facile pathos and remain among the most striking in Baroque art.

Juan de Valdés Leal

(Seville, 1622–1690)

Born in the same city as Murillo and a near contemporary of his, Valdés Leal represents the opposite side of religious painting in seventeenth-century Spain. While Murillo is sunny, endearing, soft, and familiar, Valdés Leal is gloomy, funereal, dramatic, and burdened with violent passion. These are, so to speak, the two contrasting sides of devotion and religious ceremony still to be found in Andalusia today. Trained in the workshop of Antonio del Castillo in Cordoba, Valdés Leal made his debut in the 1650s with paintings characterized by

sharp contrasts of light and shade, where we can already glimpse his desire to present the great moments of the faith, its mysteries, and its heroes in concrete realistic terms. He thus began to receive commissions from the monasteries and settled in Seville in 1657, despite the presence of Murillo. This was the *coup de grâce* for the aging Zurbarán, who left Seville for Madrid in 1658. While Murillo appears to be careful, sensitive, and precise in his execution of figures and narrative detail, Valdés Leal prefers a less sophisticated image, sometimes with the outlines barely sketched in by means of broken brushstrokes. This choice of sides is also to be seen in his use of violent, clashing colors and his leaning toward the

macabre and terrifying. It is hard to imagine paintings further from the graceful, sentimental manner of Murillo than the terrible *Hieroglyphics of the End of Life*, the frightening images produced in 1672 for the Charity Hospital in Seville, which are certainly his most celebrated works. In general terms, his career breaks with the long series of Spanish painters influenced by memories of Italian art. Even the almost obligatory reference to Caravaggio is developed emphatically with stress laid on the brushwork rather than on the light, and with deliberately fluid compositions.

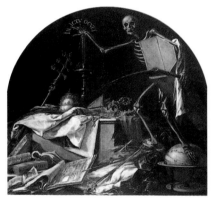

Juan de Valdés Leal
Hieroglyphic of Time
Hieroglyphic of Death

1672
oil on canvas,
90¼ × 78¾ in.
(229 × 200 cm) each
Charity Hospital, Seville

Constituting a macabre
high point in Baroque
painting, these two
canvases are
unquestionably among the
most frightening paintings
in the entire history of art.
The two works, known as
Postrimerías or images
of the after-life, were
inspired by the writings
of Juan Miguel de Mañara,
author of a dramatic
treatise on death.

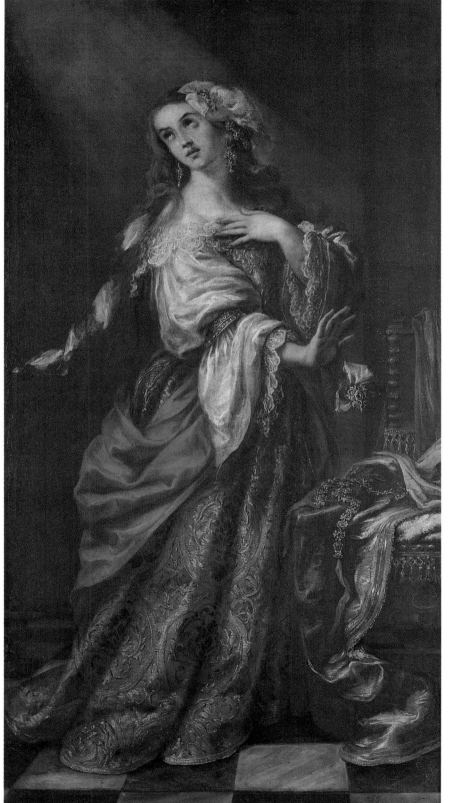

Juan de Valdés Leal
Mary Magdalene

c. 1670
oil on canvas,
85 × 46 in.
(216 × 117 cm)
*Esperanza de Borbón
Collection, Villamanrique
de la Condesa*

Alonso Cano

(Granada, 1601–1667)

A painter, sculptor, and architect of remarkable talent, Cano was trained by his father Miguel in his youth, and assisted him in producing painted carved altarpieces. He is one of the most interesting figures in seventeenth-century Spain, not only by virtue of his activities as a multifaceted artist, but also because of the events of his complex and sometimes dramatic life. His training was completed in Seville, in the workshop of Francisco Pacheco, together with Velázquez, his near contemporary. Cano shared his friend's admiration for the Italian art of the Renaissance, though he was not so concerned with the application of color and brushwork, but took a greater interest in the classical nude and anatomical drawings of great accuracy, which were also to prove useful for his highly esteemed work as a sculptor. On Velázquez's invitation, he moved to Madrid in 1637. At the court of Philip IV he distinguished himself as Velázquez's assistant, as a restorer of old paintings (including some masterpieces by Titian, damaged in the fire at the Buen Retiro palace in 1640), and as a painter of luminous religious compositions. The theme of the male nude continued to predominate and Cano preferred such scenes as the Scourging of Christ, the Deposition, the Pietà, and the Crucifixion, that is, every subject that allowed him to paint classical figures of Christ. His career as court painter was dramatically interrupted when he was forced to flee from Madrid after being accused—perhaps unjustly—of the murder of his second wife. After a period spent in Valencia, Cano returned to Madrid, but he had by now lost favor. In 1652, he returned to his hometown and began the great task of decorating the façade of the cathedral, his masterpiece as a sculptor. He also continued producing wooden sculptures— sometimes working together with Pedro de Meña—many of which were painted. Cano asked for permission to become a priest with the Chapter of Granada, but his acceptance was delayed until 1660 on the pretext that he had difficulty learning ecclesiastical Latin. During this period he painted an impressive series of canvases with *Stories of the Virgin* for the niches in the choir of Granada cathedral, a task that continued until 1664.

Alonso Cano
The Dead Christ Supported by an Angel

c. 1645
oil on canvas,
54 × 39¼ in.
(137 × 100 cm)
Prado, Madrid

Cano's serene compositions, devoid of the expressive excesses to be found in other painters and in the devotions of the period, always remain within the boundaries of an elegant formal rigor, and the emotions are restrained.

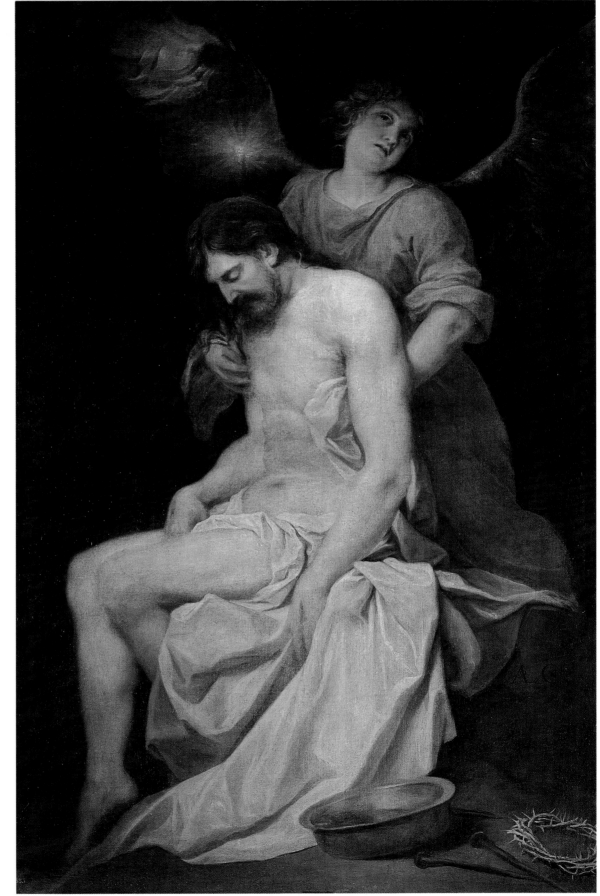

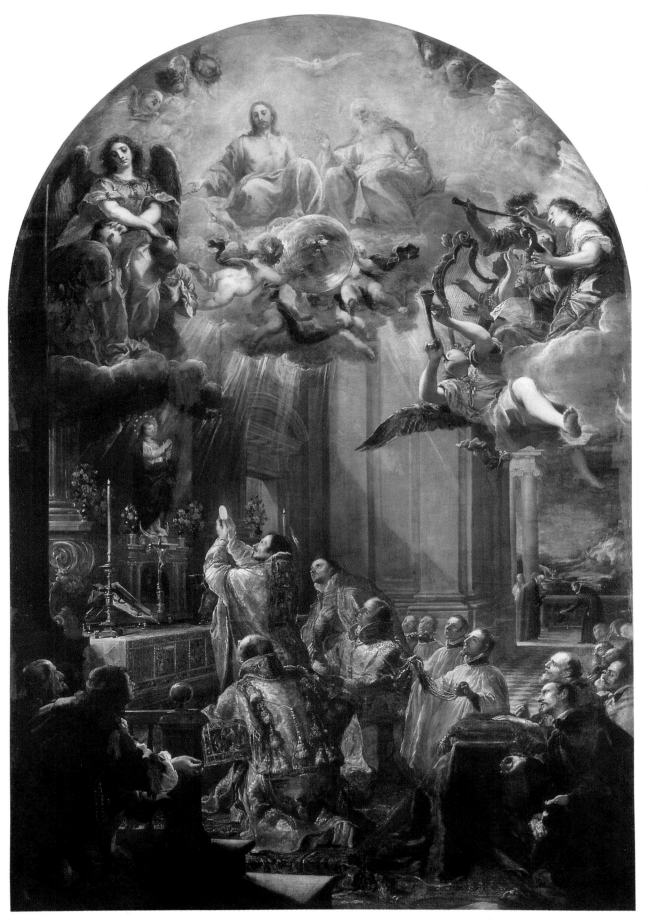

Juan Carreño de Miranda

(Aviles, 1614–Madrid, 1685)

The heir to a noble Asturian family, Carreño trained with masters such as Pedro de las Cuevas and Bartolomé Román. After an initial period as a painter of religious works (a field he never completely abandoned), Carreño joined the Madrid school, where he was noticed by Velázquez and invited to work on royal commissions. This contact with Velázquez marked a turning point in the career of the young Asturian artist, and the example of the great master remained of pivotal importance in his stylistic development, especially in regard to his work as a portrait painter. During the years Carreño spent at the court of Charles II, a relationship developed between him and the king that was reminiscent of the one between Velázquez and Philip IV. In the 1660s, Carreño was given positions that bore increasing responsibility. In 1669, on the death of Juan Baptista de Mazo, he was awarded the title of "painter to the king." Two years later he was appointed "painter of the chamber" or official portrait painter of the royal family. With his precise technique and unmitigated realism, Carreño painted the frail Charles II on numerous occasions and in different poses, giving an almost spectral image of the decline of the Spanish monarchy. Although he never attained the creative genius of his master Velázquez, Carreño is one of the most competent portrait painters of seventeenth-century Spain; though forced to paint his sitters in severe official poses, he is capable of conveying a sense of sickness and anxiety.

Juan Carreño de Miranda
The Founding of the Trinitarian Order

1666
oil on canvas,
124 × 86½ in.
(315 × 220 cm)
Louvre, Paris

Painted for the Trinitarian church of Pamplona, this is Carreño's masterpiece in the specific field of religious art. Drawing upon Flemish models, and in particular upon Rubens, Carreño creates a composition of flowing grandeur with an expertly handled group of figures moving diagonally toward the luminous celebration of the Host. The free brushstrokes and warm vibrant colors are very different from the studied, more detailed technique adopted in his portraits of the royal family.

Seventeenth-Century Italy

Orazio Gentileschi
The Martyrs Cecilia, Valerian, and Tiburtius, detail
c. 1620
oil on canvas,
137¼ × 85¾ in.
(350 × 218 cm)
Pinacoteca di Brera, Milan

Rome. The short name of the Eternal City encapsulates a vast number of projects, masterpieces, princely collections, and international artists forming strands that interweave to fashion and disseminate the Baroque art of Europe as a whole. Seventeenth-century Italian painting inevitably gravitated around what was happening in Rome, the true center of culture, art, and religion. Having aggressively recovered from the Protestant schism and its dire consequences (including the humiliating Sack of Rome in 1527), between the end of the sixteenth and the height of the seventeenth century, the home of the papacy enjoyed a period of splendor expressed through an unparalleled wave of urban reconstruction and architectural renewal. From Sixtus V on, the popes vied with one another to associate their names and heraldic crests with spectacular projects. At the same time, the great patrician families indulged in patronage of the arts (often benefiting from papal nepotism), and commissions came in from the new religious orders now spearheading a movement of evangelization that penetrated society and crossed the new continents.

Light and shade. Baroque Rome was both shop window and backroom, showcase and slum. Artists poured in from all over Europe to settle in the city. They all came to learn. Few came with specific, prestigious contracts or appointments in their pockets. Most of them relied for work on the support of the most firmly established national communities (the French, the Dutch, and the Flemish, and nuclei from the regions of Lombardy, Ticino, Emilia, and so on). Some were adventurers seeking to make a fortune. It was a disconcertingly rich human panorama that offered an unprecedented opportunity for meetings, exchanges of opinion, and parallel developments in style—especially when this ferment is seen against the monumental backdrop of the great classical ruins and the masterpieces of Michelangelo and Raphael.

Without wishing to minimize the importance of the very lively local schools (if we confine ourselves to artists presented in this volume, suffice it to mention the Genoa of Strozzi or the Naples of masters like Mattia Preti and Luca Giordano, places where Baroque flourished in an international dimension), what happened in Rome explains and encapsulates much of the history of seventeenth-century Italian painting. And this holds true for Europe as a whole. In addition, there is another factor that may appear insignificant, but should in fact be considered with a certain degree of attention. Rome was only marginally affected by the devastating outbreaks of the plague that struck other cities (Milan and Venice in 1630, Naples in 1656) and led to drastic interruptions in the development of their art and art collections.

From the closing years of the sixteenth through the first half of the seventeenth century (in strictly artistic terms, from the arrival of Caravaggio to Velázquez's second Italian journey), Rome was the scene of lively debate with a constantly varying interplay of influences, trends, fashions, specialized treatises and, of course, great masterpieces.

With some simplification, it is possible to identify three main trends succeeding one another in a sort of ideal relay race of artistic styles: the naturalism of Caravaggio, the classicism of Guido Reni and the Bolognese school, and the Baroque proper of Bernini and Pietro da Cortona. These three different figurative models were also the mainsprings of seventeenth-century European art as a whole.

In chronological order, the first movement was that launched by Caravaggio at the close of the sixteenth century. In the preceding decades, the fervor of religious and artistic renewal triggered by the Counter-Reformation had been partly hampered by the substantial mediocrity of its predominantly "rearguard" artists who had grown up in awe of the great models of the High Renaissance. Trained

Annibale Carracci
The Butcher's Shop
1585
oil on canvas,
49½ × 104¾ in.
(126 × 266 cm)
Christ Church Collection,
Oxford

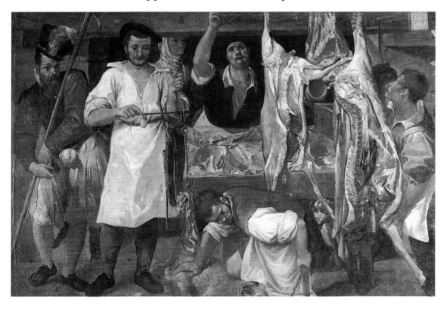

Guido Reni
The Dawn (Aurora)
1612–1614
fresco, 110¼ × 275½ in.
(280 × 700 cm)
Palazzo Rospigliosi
Pallavicini, Rome

Caravaggio
Beheading of St. John the Baptist
1608, oil on canvas,
142 × 204¾ in.
(361 × 520 cm)
St. John's Cathedral,
La Valletta (Malta)

Mattia Preti
*Sketch for fresco entitled
"The Plague in Naples"*
1656
oil on canvas,
50¾ × 30¼ in.
(129 × 77 cm)
Galleria Nazionale di
Capodimonte, Naples

in the Lombard school of realism, Caravaggio put forward a completely different model, which was to become the "common language" of seventeenth-century European painting after some initial embarrassment and rejection. Firmly anchored to reality, even its crudest and most down-to-earth aspects, Caravaggio's paintings are based on light, which was nearly always a shaft cutting diagonally through the scene to highlight some figures and plunge the other areas into the darkest shadow. Two effects are thus obtained: a disconcertingly direct and immediate realism, coupled with intense concentration on the main figures. The adventurous life of Caravaggio, sublime as an artist but violent and quarrelsome as a man, enhances his charisma as an artistic outcast, a wild and solitary revolutionary. What is certain is that by working in Rome and producing masterpieces both of genre painting for collectors and altarpieces for churches, Caravaggio made an immediate and widespread impact. When he died "as badly as he had lived" on the beach at Porto Ercole in 1610, the fruits of his activity were beginning to ripen not only in Rome and Naples (where he made two very productive stays), but also in other Italian and foreign schools. In many cases, for example, by Orazio Gentileschi or in the early works of Guido Reni, the dramatically rough edges of Caravaggio's work were toned down by elegant execution.

Around 1620, however, the influence of Caravaggio seemed to give way to a wholly different tendency, a controlled, intellectual style of painting based on a painstaking return to classical antiquities and celebrated Renaissance models. Promoted above all by painters of the Bolognese school, first and foremost Annibale Carracci, classicism established itself as a very characteristic trend in seventeenth-century painting. Taken up and developed also by foreign masters (such as Nicolas Poussin), classicism was also the result of the spread of academies of painting and drawing, whose pupils received a complete training that included not only the specific field of art, but also and perhaps primarily a vast, general, eclectic culture, which enabled them to interpret correctly even complex subjects drawn from Greco-Roman mythology and literature. The third important movement was the extraordinarily theatrical and exuberant style of painting that can be regarded as authentic Baroque. Promoted by the religious orders and widely developed throughout

the Catholic world, including the Latin American colonies, Baroque, however, originated in Rome with works commissioned by the Jesuits. The initial idea was that of a "total" work of art capable of sweeping the spectator away like a whirlwind. Architecture, painting, sculpture, and furnishings were thus supposed to work together to communicate ideas that were solemn and magnificent, rich and emphatic. Such an ambitious objective called for multifaceted personalities, for artists capable of "directing" projects crammed with special effects. The absolute genius of the Baroque movement—and not only in Rome—was Gian Lorenzo Bernini, a versatile sculptor and painter with many other talents. Next to him stands Pietro da Cortona, painter of the most spectacular fresco cycles executed in the mid-seventeenth century in Rome

and Florence. In the second half of the seventeenth century, however, the effects of the increasingly difficult political and economic situations began to tell on Italian art. Fewer great works were commissioned. The splendor of Rome began to wane and the cities and towns of the Renaissance grew visibly poorer. In some cases, and especially in regard to the small courts of northern Italy, the decline was quite dramatic. Famous works of art began to be sold abroad, together with entire princely collections. After being for centuries the principal center of production for European art, Italy slipped into a marginal role from the middle of the seventeenth century on. It became a place where painters went not in order to be updated on the latest advances in painting, but to study the remnants of a glorious and increasingly distant past.

Guercino
The Return of the Prodigal Son
1619
oil on canvas,
42 × 56½ in.
(106.5 × 143.5 cm)
Kunsthistorisches Museum, Vienna

Annibale Carracci

(Bologna, 1560–Rome, 1609)

An illustrious member of a family of painters, Annibale Carracci played a crucial role in the transition from the Mannerism of the late Renaissance to the early Baroque. Together with his brother Agostino and cousin Ludovico, he founded the *Accademia dei Desiderosi*, the first well-structured form of cultural training for young artists, providing a model for the programs of academies of fine arts that was to last almost to the present day. Annibale himself probably trained with his older

cousin Ludovico, with whom he also collaborated on a number of early works. Above all, Annibale and Ludovico shared the desire for a return to "natural" painting, a pure and simple style far removed from prestigious but complex and intellectual Mannerism. Annibale's first major public work, the *Crucifixion* for the church of Santa Maria della Carità in Bologna (1583), exemplifies this approach. In the following years, Annibale embarked on an impassioned study of Correggio and Titian, curbed the impetuous energy of his early years, enriched his palette, and softened his outlines. The result was a supple, delicate style, both classical and

up-to-date, which soon proved to be the right choice. Around 1590 Annibale Carracci moved to Rome, where his academic approach was enriched through contact with the enormous repertoire of classical art. In an exhilarating environment, surrounded by stimuli and points of reference at the highest levels of the art of the day, he broadened his range of subjects considerably, and also laid the foundations for the specific development of the "ideal" landscape. His presence in Rome was of crucial importance also for the establishment of an actual colony of painters from Emilia, including Guido Reni. The culmination

and quintessence of Annibale Carracci's work in Rome is the frescoed ceiling of the gallery in Palazzo Farnese, one of the greatest masterpieces of painting between the sixteenth and seventeenth centuries. Exhausted by the physical and intellectual energy expended on this work, Annibale Carracci never fully recovered and died in 1609, one year before Caravaggio.

Annibale Carracci
Pietà

c. 1599–1600
oil on canvas,
61½ × 58¾ in.
(156 × 149 cm)
*Galleria Nazionale
di Capodimonte, Naples*

The dramatic nature
of the subject is softened
by the supple, modulated
elegance of the execution.
Painted during the period
of his artistic maturity, at
the same time as the
frescoed ceiling in the
Galleria Farnese in Rome,
this splendid work
demonstrates Annibale
Carracci's ability to select
elements from various
artists of the past and
blend them together in an
original and highly
successful fashion. While
the soft, delicate treatment
of drapery and flesh are
reminiscent of Correggio,
the poses of Christ and
Mary are clearly modeled
on Michelangelo's *Pietà*
in the Vatican.

Annibale Carracci
The Dead Christ

c. 1590
oil on canvas, 27¾ × 35 in.
(70.8 × 88.8 cm)
Staatsgalerie, Stuttgart

Observation of Annibale
Carracci's more dramatic
works gives an idea of the
painter's commitment to a
more direct and human art,
capable of superseding the
sophisticated, elitist
intellectualism of
Mannerism and returning
to a simple, everyday
language. On many
occasions the painter
demonstrates his
extraordinarily refined
style, his perfect technical
control, and his ability to
create complex perspectives
and foreshortening. The
ultimate goal is never the
mere display of bravura,
however, but an immediately
evocative depiction.

Annibale Carracci
Crucifixion with the Virgin and Saints Bernardino, Francis, John, and Petronius

1583
oil on canvas,
120 × 82¾ in.
(305 × 210 cm)
*Church of Santa Maria
della Carità, Bologna*

Not altogether free of
polemical overtones, this
altarpiece marks the first
step in the career of
Annibale Carracci, who
left his cousin Ludovico's
workshop to establish his
own independent style.
At the height of the late
Renaissance in Bologna, a
period rich in cultural
stimuli, Carracci
vigorously proposed a
return to "natural"
painting, to an art based on
the direct observation of
reality. At the same time,
he looked at the world
with an "educated" eye,
one trained in the study of
the history of painting.
Thus, echoes of Raphael
and Titian can be discerned
in the emotions expressed
by the gestures and
features of the figures
portrayed.

Annibale Carracci
The Flight into Egypt

c. 1603
oil on canvas,
48 × 90½ in.
(122 × 230 cm)
*Galleria Doria Pamphili,
Rome*

All the elements are drawn
from observation of the
Roman *campagna* and the
area of the Alban Hills:
splendid views of nature,
rolling countryside, and
ancient ruins. At the same
time, the contemplative
atmosphere of the canvas
and the relations between
the figures and nature are
intellectual in tone, and
direct observation is filtered
through classical culture.

Annibale Carracci
Adonis Discovers Venus

c. 1595
oil on canvas,
85½ × 96¾ in.
(217 × 246 cm)
*Kunsthistorisches Museum,
Vienna*

After moving to Rome
around 1590, the painter
adopted an "elevated" style,
making his work both
serene and rigorous.
Increasingly frequent use
was made of mythological
or literary subjects, highly
appreciated by aristocratic
collectors, which Annibale
Carracci faultlessly
represented with a wealth
of precise references to the
poetic sources. As this
masterpiece effectively
demonstrates, they are
often exquisitely executed
works and indispensable
points of reference for the
development of classicism
in painting. Adopting a
form of academic
eclecticism, Annibale
Carracci once again draws
upon and develops the
stylistic elements of
Renaissance painting,
blending it with Greco-
Roman sculpture and
classical art in general.
However, the primary
point of reference remains
sixteenth-century Venetian
art and Titian in particular,
especially regarding the
radiant female nude set
against the background of a
dense, natural landscape.

Annibale Carracci
Homage to Diana

1597–1602
detail from the frescoes
in the Galleria Farnese
Palazzo Farnese, Rome

The arduous task of decorating the Galleria Farnese constituted the climax of Annibale Carracci's career, but it was so physically and creatively demanding that it exhausted him. The great scenographic hall, frescoed at the turn of the century, simultaneously marks the final stage of the Italian Renaissance and the triumphal birth of classicism, one of the major movements of European Baroque. It is also important not to underestimate the role played by this work as an authentic training ground for various artists, almost all from the region of Emilia, who were summoned by Annibale Carracci to assist in executing the frescoes. After various experiments and changes of plan, the painter decided to simulate a sumptuous princely gallery with paintings framed by carved decorations and stuccos. The largest painting, *The Triumph of Bacchus and Ariadne*, is set in the center of the ceiling, with other mythological scenes arranged along the walls. The result is a memorable masterpiece in which the numerous and explicit figurative allusions (to Raphael, Michelangelo, ancient art, and so on) blend in a flowing, luminous, idealized style. Painted at a time when Caravaggio's career in Rome was at its height, the frescoes strike us as the antithesis of chiaroscuro realism. It should be remembered, however, that after their respective work in Palazzo Farnese and the Contarelli Chapel in the church of San Luigi dei Francesi, Annibale Carracci and Caravaggio were both commissioned to work on the Cerasi Chapel in the church of Santa Maria del Popolo, where the former painted the *Assumption of the Virgin* over the altar and the latter the two flanking canvases with the *Martyrdom of St. Peter* and the *Conversion of St. Paul*.

Caravaggio

Michelangelo Merisi
(Milan, 1571–Porto Ercole, 1610)

A short, calamitous, and adventurous life forms the dramatic setting for the work of Caravaggio, the artist who did more than any other to influence the development of seventeenth-century painting by introducing a realism and use of light and shade that were to be followed for centuries to come. Most probably born in Milan (his nickname being derived from the Marchese di Caravaggio, for whom the painter's father worked as an administrator), Caravaggio received his training from Simone Peterzano, but above all he studied with keen intelligence the work of Leonardo da Vinci, Titian, and the sixteenth-century masters from Brescia. This gave him a very strong leaning toward

realism that was expressed through his handling of light and emotion. Around 1590, at an age when painters generally chose independence, Caravaggio moved to Rome. The early years were grim, fraught with poverty and illness. An assistant in the workshops of established painters, Caravaggio found it difficult to make a name for himself. This period saw the production of some memorable paintings heralding an authentic revolution in the history of art. Caravaggio brought the little world of the Roman alleys—cardsharps, gypsies, prostitutes, ambiguous young "hustlers," street lads, and strolling musicians—into painting. His early works, characterized by a light neutral background, are milestones in the birth of genre painting. The descriptive details—flowers, fruit, and various objects—are executed with the greatest care, and Caravaggio does not hesitate to

endow them with an independent dignity as artistic subjects. The *Basket of Fruit* in the Pinacoteca Ambrosiana in Milan is a celebrated model for still-life painting. The early religious paintings (such as the *Rest on the Flight into Egypt* in the Galleria Doria Pamphili in Rome) were still influenced by the naturalism of the Lombard school, but there was to be a further breakthrough. In the monumental paintings for the church of San Luigi dei Francesi in Rome (1600), Caravaggio offered a radically new and highly dramatic interpretation of altar painting. The figures emerge from the dark background to create an unprecedented, strong, expressive impact. The great religious works painted in Rome between 1600 and 1606 triggered widespread heated debate; some of them were refused by clients shocked by their excessively brutal realism. Found guilty of murder and sentenced to

death, Caravaggio was forced to flee from Rome in 1606, thus beginning a human odyssey during which he produced masterpieces that were to become points of reference for European painting as a whole. After an initial stay in Naples, Caravaggio went to Malta, where he was admitted into the Order of the Knights of St. John. This glory was, however, short-lived. He was imprisoned on Malta but succeeded in escaping, first to Sicily and then once more to Naples (1609–1610). Trusting that a papal pardon would be forthcoming, Caravaggio prepared to sail for Rome, but, after a series of adventures, he died of malaria on the sun-drenched beach of Porto Ercole.

Caravaggio
Basket of Fruit

1597–1598
oil on canvas,
18 × 25½ in.
(46 × 64.5 cm)
Pinacoteca Ambrosiana, Milan

Cardinal Del Monte gave this extraordinary canvas to Cardinal Federico Borromeo, Archbishop of Milan and renowned art collector. It marks the beginning of the still-life genre, and is poised between a meticulous imitation of reality and sweeping poetry. Federico Borromeo wished to accompany this work with another basket of fruit, but as he himself wrote, "since none could match the beauty of this one and its incomparable excellence, it has remained alone."

Caravaggio
The Cardsharps

c. 1594
oil on canvas,
37 x 51½ in.
(94.2 x 130.9 cm)
Kimbell Art Museum, Fort Worth

In this episode drawn from life on the streets, a youth attracted by the easy money to be made at gambling is cheated by a pair of cardsharps. The older of the two gives instructions to his accomplice, who slips the winning card from behind his back. Above and beyond any moralizing implications, the painting provides memorable evidence of Caravaggio's powers of observation, his ability to capture the immediacy of the scene, the mobility of the gestures and expressions, and the narrative force of the details of the clothes and the gaming table.

Caravaggio
The Young Bacchus

1595–1596
oil on canvas,
37½ × 33½ in. (95 × 85 cm)
Galleria degli Uffizi, Florence

Caravaggio
Boy with a Basket of Fruit

1593–1594
oil on canvas,
27½ × 26¼ in. (70 × 67 cm)
Galleria Borghese, Rome

Caravaggio
The Music Party

c. 1595
oil on canvas,
34½ × 45½ in.
(87.9 × 115.9 cm)
*Metropolitan Museum of Art,
New York*

Works such as this continue to pose a variety of questions, ranging from Caravaggio's alleged (but never proven) homosexuality to the recondite religious significance of his paintings. In this apparently realistic scene, we certainly note the presence of a winged figure (An angel? Cupid?) to the left, which contrasts with the corporeal reality of the other youths. The less than perfect state of preservation makes it impossible to read the score, which is perfectly visible in other works. Caravaggio evidently loved music. Musical instruments of excellent workmanship and very precise scores are to be found in many of his early paintings; it has even proved possible to organize concerts of the music in Caravaggio's paintings. Most of the pieces are late sixteenth-century motets and madrigals for various voices and lute accompaniment.

Caravaggio
The Fortune Teller

c. 1593
oil on canvas,
39 × 51½ in.
(99 × 131 cm)
Louvre, Paris

This is one of the first and most appealing of Caravaggio's Roman works. The painter again draws inspiration from everyday life, from the characters encountered in the streets. Here a smiling gypsy girl reads the palm of a young dandy and slips a ring from his finger. The circumstances in which the work was painted are described as follows by a writer of the period: "He summoned a gypsy girl who happened to be passing in the street and portrayed her in the act of telling someone's fortune … . He painted a young man resting his gloved hand on his sword and stretching his bare hand out to the gypsy, who is holding it and looking at it. And in these two figures, Michele unquestionably captured the truth." Caravaggio transforms the realism of the Lombard school into a dazzling whirl of characters, situations, and physiognomies. Another version of this subject is to be found in the Capitoline Museum in Rome.

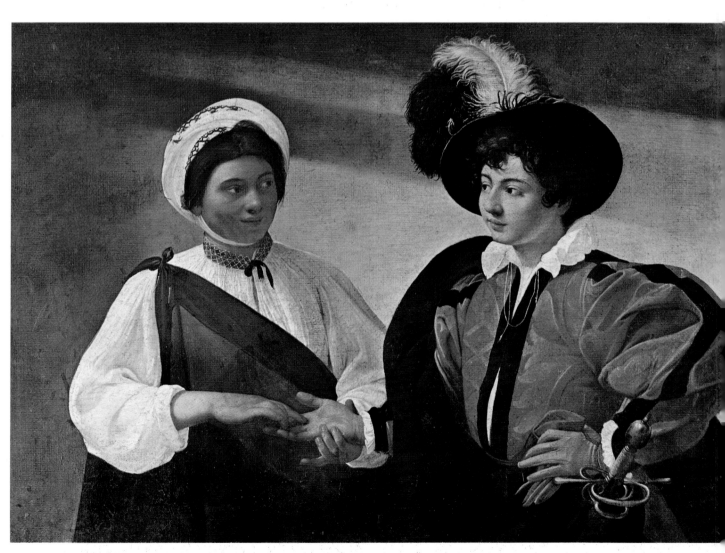

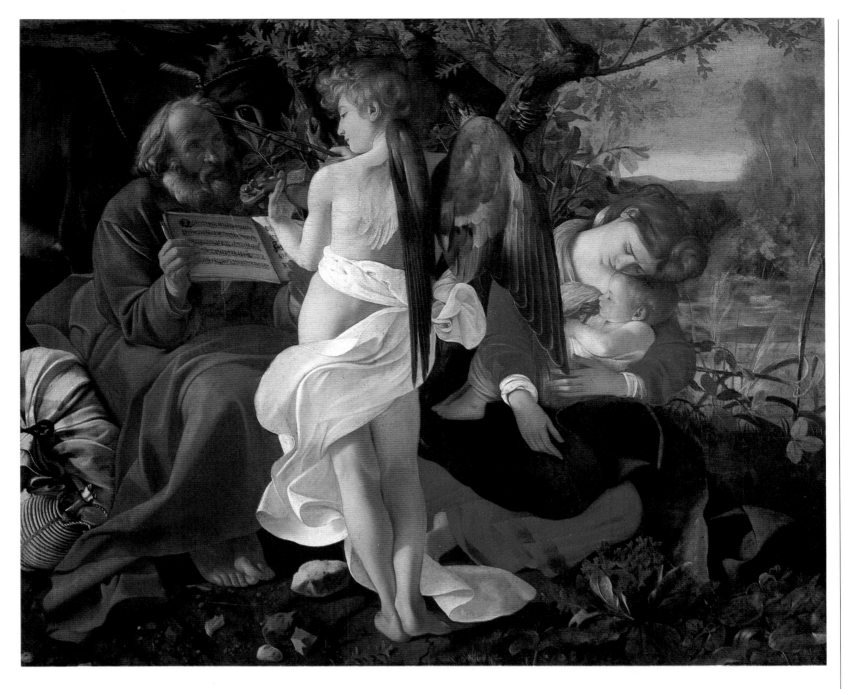

Caravaggio
The Conversion
of Mary Magdalene

c. 1597–1598
oil on canvas,
38½ × 52¼ in.
(97.8 × 132.7 cm)
*Detroit Institute of Arts,
Detroit*

Urged on by Martha, the
blooming Mary Magdalene
prepares to renounce
worldly vanities, while the
painter lingers over a
painstaking depiction of
the mirror, jewelry, and
other feminine items.

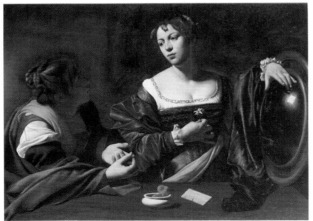

Caravaggio
Rest During the Flight
into Egypt

1595–1596
oil on canvas,
53½ × 65½ in.
(135.5 × 166.5 cm)
Galleria Doria Pamphili, Rome

Caravaggio instills the sunset
light with an unforgettable
quality, as though time itself
were standing still, as
though the whole of nature
were holding its breath to
listen to the music of the
angel violinist. Divine
enchantment and human
truth meet in a heavenly

lullaby for the beautiful
Christ Child firmly clasped
by the tired and loving
Virgin Mary. The virtuoso
soloist of the heavenly
orchestra is a slender youth,
loosely swathed in a white
tunic that seems about to
slip from his hips, presenting
a strong contrast with
the rustic St. Joseph
and the donkey peeping
through the foliage. Every
element is executed with
painstaking care and the eye
discovers one new detail
after another, while never
losing contact with the
figures.

75

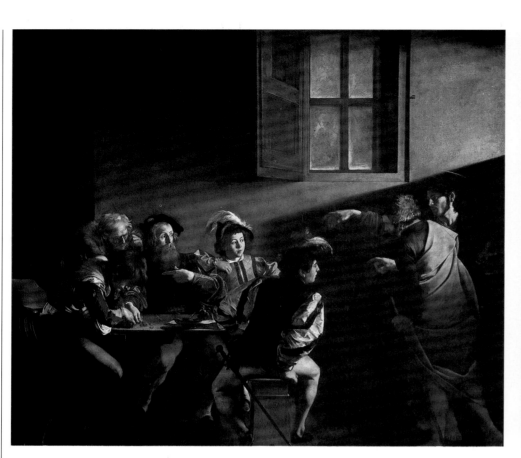

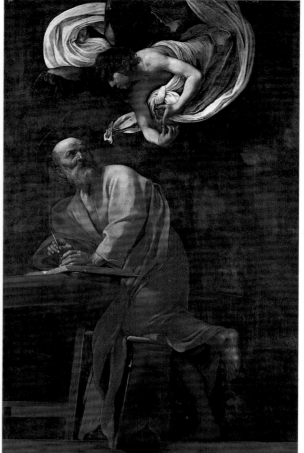

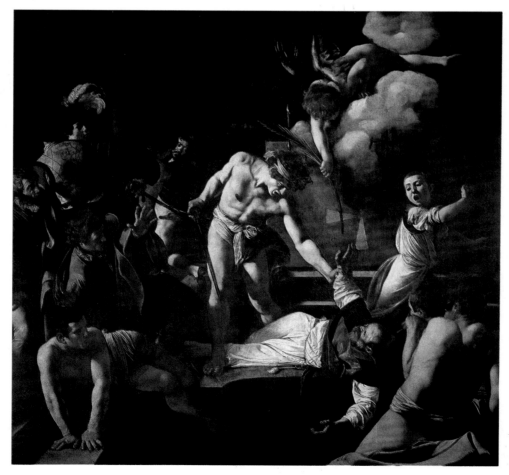

Caravaggio
St. Matthew and the Angel

1602
oil on canvas,
116¼ × 76¾ in.
(295 × 195 cm)

The Martyrdom
of St. Matthew

1599–1600
oil on canvas,
127¼ × 135 in.
(323 × 343 cm)

The Calling of St. Matthew

1599–1600
oil on canvas,
126¾ × 133¾ in.
(322 × 340 cm)
*Contarelli Chapel, Church of
San Luigi dei Francesi, Rome*

The long and complex
contractual negotiations
for the decoration of the
Contarelli Chapel in the
church of the French
community in Rome came
to an end with the decision
to engage Caravaggio to
execute three paintings:
the altarpiece depicting
St. Matthew writing the
Gospel, flanked by two
works showing the key
moments in the life
of the evangelist. Caravaggio
produced his first version
of *St. Matthew and the Angel*,

but the clerics found the
saint's expression too crude
and refused to accept it.
Before beginning a new
version of the altarpiece
(1602), Caravaggio
executed the two side
paintings, which constitute
an epoch-making turning
point in the history of art.
With tremendous force,
he draws the spectator into
the episode as it is actually
happening, when it has
reached its dramatic climax.
The *Martyrdom* is a brutal
execution, with the killer
bursting into the church to
strike down the saint during
the celebration of mass.
Caravaggio interprets the
scene as an episode of
violent crime, with the saint
attempting to defend
himself while the space is
rent by the figures of the
killer and of the choirboy
fleeing in terror. Much
calmer but by no means less
evocative is the scene of the
Calling. Christ enters a
guardhouse with soldiers
and tax collectors seated on
benches. Followed by a shaft
of light, He raises His arm
and points to the
dumbfounded Matthew,
who responds by placing
his hand on his breast.

Caravaggio
Christ Taken Prisoner

1602
oil on canvas,
52½ × 66¾ in.
(133.5 × 169.5 cm)
*National Gallery of Ireland,
Dublin*

This is one of the most
recent and interesting
additions to the catalog
of Caravaggio's works.
Discovered in the
possession of the Jesuit
order in Dublin, the work
had previously been
regarded as lost and was
known only through old
copies. The dramatic night
scene broken by the
metallic glint of armor
highlights the painter's
ability to convey gesture,
physiognomy, flashes
of anguish, terror,
excitement, and brutality.

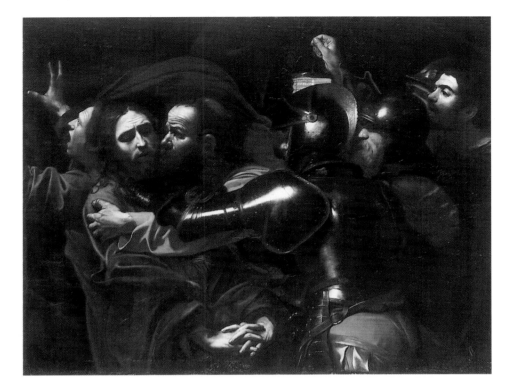

Caravaggio
Martyrdom of St. Peter
Conversion of St. Paul

1600–1601
oil on canvas,
90½ × 69 in.
(230 × 175 cm) each
*Cerasi Chapel, Church of
Santa Maria del Popolo, Rome*

In both cases, the scenes
unfold in silence and
solitude. Three soiled and
straining laborers lift St.
Peter nailed upside-down
on the cross. Contrary to
the whole of the previous
figurative tradition,
Caravaggio does not
condemn the executioners,
but rather underscores the
painful aspect of their task
with the rope that marks
two of them on the back
and arm, while the apostle
looks around, lost and
abandoned, with no
comfort from above. An
equally new interpretation
is given of the conversion
of St. Paul, whose fall takes
place not on the road to
Damascus but in the
darkness of a stable.

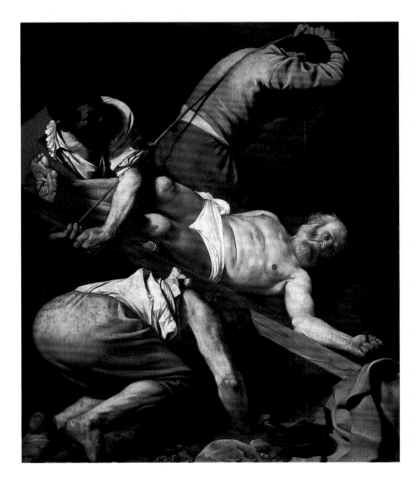

Caravaggio
Sacrifice of Isaac

c. 1603
oil on canvas,
41 × 53¼ in.
(104 × 135 cm)
Galleria degli Uffizi, Florence

One of the very few works by Caravaggio set in the countryside, this painting was produced for Cardinal Maffeo Barberini, when the artist was enjoying great popularity with the Roman aristocracy. Despite the identity of his client, Caravaggio refused to play down the "terrible" elements of the scene, especially the whimpering figure of Isaac, held down firmly by Abraham, who became a model for the portraits of bald-headed, bearded old men that were to appear frequently in Baroque painting. The angel seen in profile is, by contrast, a tribute to classical sculpture.

Caravaggio
Judith and Holofernes

c. 1599
oil on canvas,
57 × 76¾ in.
(145 × 195 cm)
Galleria Nazionale d'Arte Antica, Rome

This work forms part of a clearly identifiable group painted for Cardinal Del Monte, dramatic scenes depicted in a clear, steady light to obtain almost sculptural effects. The theme of decapitation reappears almost obsessively in Caravaggio's painting, and was to take on a strikingly autobiographical significance when the fugitive artist was sentenced to capital punishment in 1606.

Caravaggio
David and Goliath

c. 1597–1598
oil on canvas,
43¼ × 35¾ in.
(110 × 91 cm)
Prado, Madrid

Alone and silent in the
moonlight, David leans
over the fallen body of the
slain giant. Caravaggio
chooses neither the
moment of triumph nor
the instant in which David
hurls the stone from his
sling, but prefers to reflect
upon what comes after,
upon the moment when
the explosion of violence
has just ended and silence
falls around the scene
of death.

Caravaggio
St. Catherine
of Alexandria

c. 1598–1599
oil on canvas,
68 × 52¼ in.
(173 × 133 cm)
*Thyssen-Bornemisza
Collection, Madrid*

As a model for this
stupendous heroine,
Caravaggio used the same
girl who appears as the
frowning Judith on the
opposite page. This work
is typical of the period
when Caravaggio executed
the paintings in the
Contarelli Chapel, with
figures emerging strongly
from a dark background.
He creates an aura of light
around the face and bust
of the saint through the
successful device of
dressing her in a white
blouse, which contrasts
sharply with the dark
tones prevailing on
the rest of the canvas.
The details are depicted
with extraordinary
precision and immediacy:
the palm of martyrdom,
the cogged and broken
wheel, and the sword
become an almost tangible
physical presence.

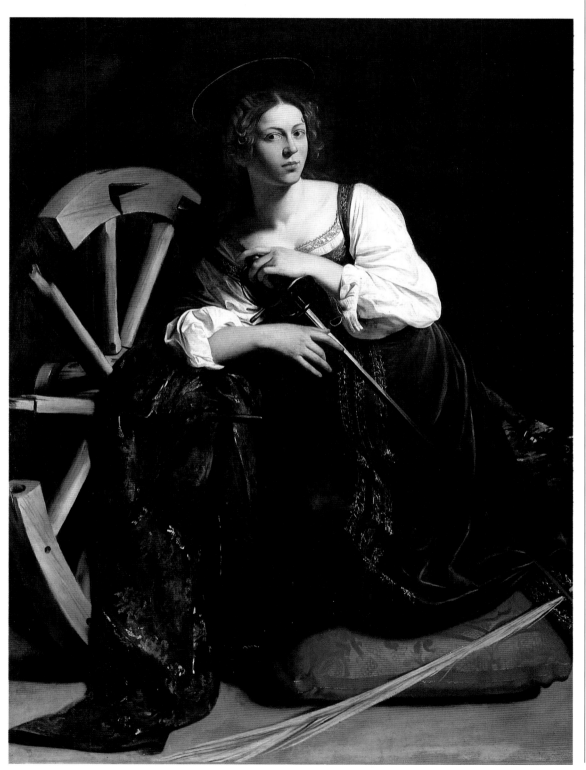

Caravaggio
The Madonna of Loreto

c. 1604–1606
oil on canvas,
102¼ × 59 in.
(260 × 150 cm)
Church of Sant'Agostino, Rome

An extraordinary masterpiece of religious painting, this work was originally produced for the altar dedicated to the Holy House of Loreto, thus explaining the prominent doorway of the house in Nazareth in which Mary stands. This Madonna comes from the ranks of the people. She wears her dark hair pinned up and an ordinary dress, and is holding the Christ Child with loving maternal confidence and presenting him to the two ragged, pathetic, elderly, kneeling pilgrims. These two wayfarers who have finally reached their destination are unforgettable figures. No longer possessing even the strength to rejoice, they kneel there, with dirty feet, speechless before the Christ Child. Very seldom has religious painting been so powerful and, at the same time, so evocatively sweet and serene.

Caravaggio
St. John the Baptist

1602
oil on canvas,
51½ × 38¾ in.
(131 × 98.6 cm)
Capitoline Museum, Rome

This work constitutes a joyful, almost Dionysian interlude in Caravaggio's painting. In his most successful period, the artist never ceased to study and try his hand at the great models of the past. The Hellenistic sculptures and the powerful nudes of Michelangelo on the ceiling of the Sistine Chapel are the historical forerunners of this striking youth, captured by the artist in a twisted, athletic pose.

Caravaggio
The Supper at Emmaus

1601
oil on canvas,
55½ × 77¼ in.
(141 × 196.2 cm)
National Gallery, London

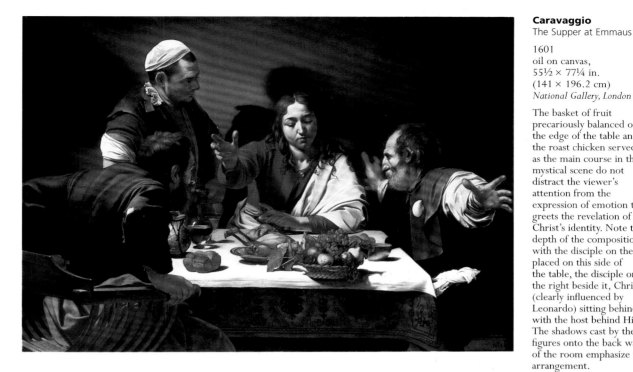

The basket of fruit precariously balanced on the edge of the table and the roast chicken served as the main course in this mystical scene do not distract the viewer's attention from the expression of emotion that greets the revelation of Christ's identity. Note the depth of the composition, with the disciple on the left placed on this side of the table, the disciple on the right beside it, Christ (clearly influenced by Leonardo) sitting behind it with the host behind Him. The shadows cast by the figures onto the back wall of the room emphasize the arrangement.

Caravaggio
Madonna of the Rosary

1606–1607
oil on canvas,
143 × 98 in. (364 × 249 cm)
Kunsthistorisches Museum, Vienna

A highly expressive work from the artist's first period in Naples, it was painted for a church belonging to the Dominican order. The theme is rather complex, representing the intercession of the friars, through the prayer of the Rosary, between the people and the Madonna. On the far left is the patron, his eyes flashing, turned toward the viewer. A large red drape frames the composition. Once again Caravaggio turns a complex doctrinal subject into a vision of powerful human emotion.

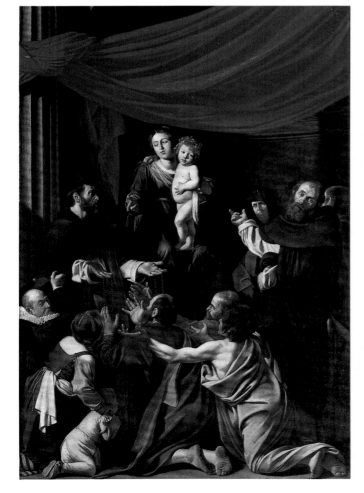

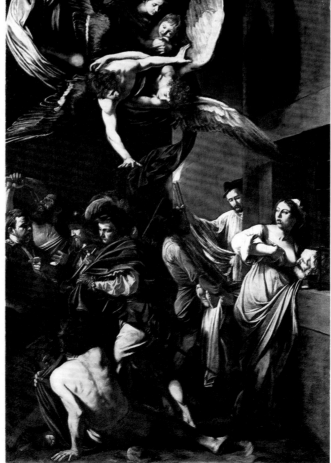

Caravaggio
The Seven Works of Mercy

1606–1607
oil on canvas,
153½ × 102¼ in.
(390 × 260 cm)
Pio Monte della Misericordia, Naples

Painted during Caravaggio's first stay in Naples, this work is a brilliant solution to a complex problem. With great intuitive insight, the painter uses an ordinary evening at a crossroads in the Spanish quarter of Naples as a setting for all the figures and episodes that symbolize the works of mercy: giving food to the hungry and drink to the thirsty, assisting pilgrims, visiting those in prison, clothing the naked, tending the sick, and burying the dead. As though leaning from a balcony, a smiling Virgin Mary, on the wings of two acrobatic angels, observes the scene.

Guido Reni
(Bologna, 1575–1642)

Pupil and follower of Annibale Carracci, model student of the Carracci Academy, expert in classical art and Raphael, Guido Reni is an outstanding master of seventeenth-century European art. For nearly three centuries, his pure, adamantine style, perfectly poised between formal precision and expressive density, was regarded as an absolute model. In the twentieth century, however, Reni's alleged "coldness" led to his being considered boring and monotonous. A more balanced critical view now prevails, and Guido Reni is again seen as one of the most intense figures in seventeenth-century European painting. After training in Bologna, he moved to Rome around the year 1600. This marked the beginning of a truly exciting decade. Reni went from Annibale Carracci's Farnese Gallery to the chapels with canvases by Caravaggio, seeking a stylistic point of contact between the two apparently very different approaches. The

resulting works of great interest demonstrated Guido Reni's critical acumen and artistic talent, and brought him to the attention of collectors and patrons. On the death of Annibale Carracci (1609), Guido Reni became the leading exponent of classicism and of the Bolognese school in Rome. The fresco of *The Dawn* (*Aurora*) in Palazzo Rospigliosi constitutes the ideal continuation of Annibale Carracci's work for the Farnese family and a solemn token of the painter's love for classical art. The great altarpieces painted for churches in Bologna, most of which are now exhibited in the city's Pinacoteca Nazionale, mark the apotheosis of a style of painting based on ideas, formal control of the emotions, and perfect balance between all the elements (light, color, expression, draftsmanship, and composition). Until the 1630s, Guido Reni remained faithful to a rich stylistic model full of color and energy. Then, in the last few years of his life, his painting became attenuated and evanescent, and he used a limited range of almost transparent colors, in which beauty and melancholy are mingled.

Guido Reni
Atalanta and Hippomenes

1622–1625
oil on canvas,
81 × 117 in.
(206 × 297 cm)
*Galleria Nazionale di
Capodimonte, Naples*

The subject lends itself to a dynamic interpretation, but Reni instead chooses to adopt a sophisticated stylistic device in which the gleaming bodies of the two adversaries are set in contrasting poses against the blue-brown background of earth and sky. The scene depicts the race between the quick-footed and invincible Atalanta and the wily Hippomenes, who, trusting in female vanity, drops a number of golden balls. Atalanta stops to pick them up and thus loses the race, overtaken by the young man. In this work of studied classicism, the idea of movement is conveyed only by the fluttering mantles.

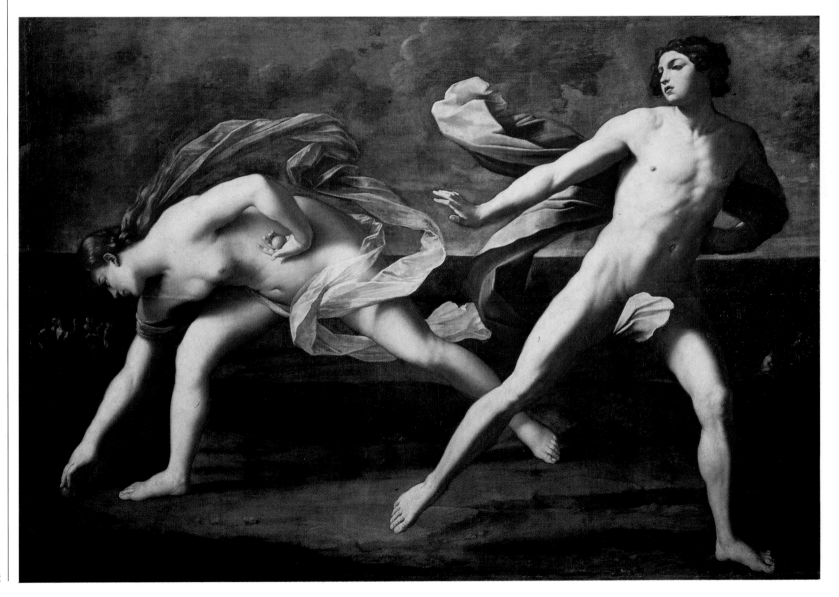

Guido Reni
Crucifixion of St. Peter

1604–1605
oil on canvas, 120 × 69 in.
(305 × 175 cm)
Pinacoteca Vaticana, Rome

Painted immediately after
Caravaggio's version, this
great altarpiece illustrates
the relationship between
Guido Reni and the
Lombard master in the
early seventeenth century.

Guido Reni
Slaughter of the Innocents

1611–1612
oil on canvas,
105½ × 67 in.
(268 × 170 cm)
*Pinacoteca Nazionale,
Bologna*

The harrowing scene of the
slaughter of the innocents
is translated into cadences
that possess a splendid
theatrical rhythm, and even
the background suggests a
stage set. Reni displays a
spectacular control of the
composition through the
close ties between all the
figures. On the left, the
soldier with his raised
knife and the screaming
mother fleeing with her
child form an eloquent
group. The extended links
between the figures stretch
over practically the entire
surface of the painting.

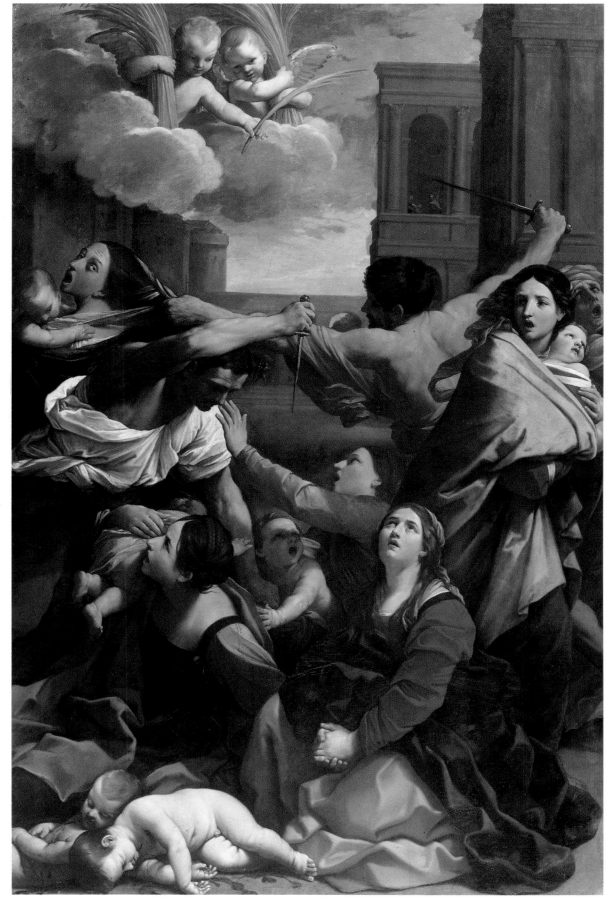

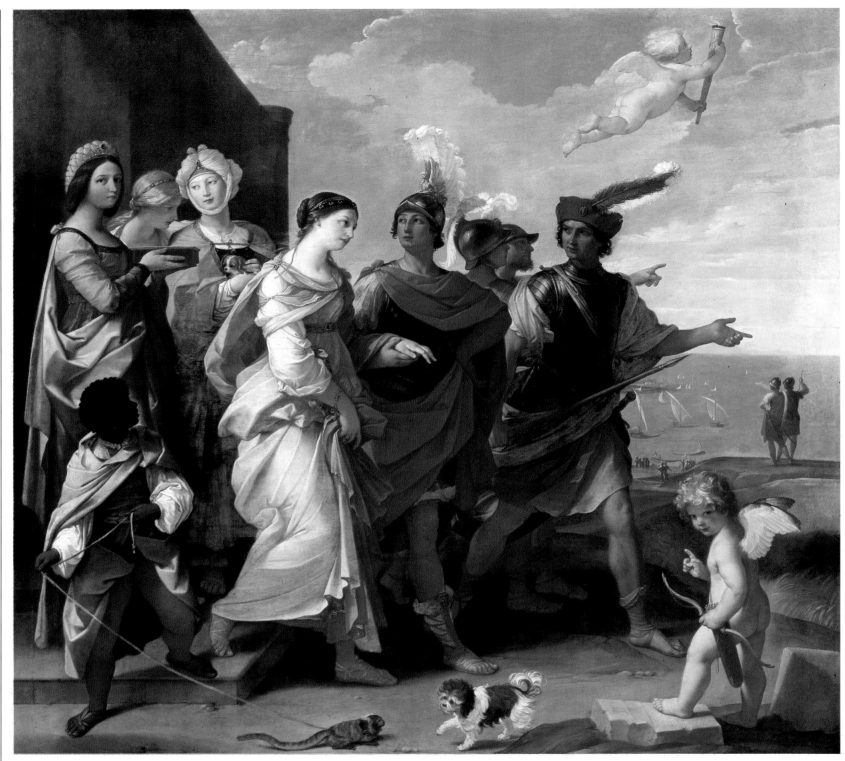

Guido Reni
The Abduction of Helen

1631
oil on canvas,
99½ × 104¼ in.
(253 × 265 cm)
Louvre, Paris

This work is another magnificently executed scene and evidently theatrical in inspiration.

We can almost hear the music of Baroque melodramas, which were often based on figures or episodes from classical poetry. The story unfolds in a finely balanced rhythm, giving the spectator time to enjoy each detail without losing track of what is happening. Each figure possesses and

expresses a noble beauty of its own, even the Moorish page with a monkey on a leash. But the charm of the various leading figures, beginning with the enchanting heroine in the center of the group, is harmonized and enhanced by their relation to all the others. The transparent blue of the sky makes

all the colors gleam, and the slightly exaggerated gestures can be traced back to the expressive repertoire of classicism. The one exception is the delightful Cupid standing alone on the right, who gives the viewer an amiable, understanding look.

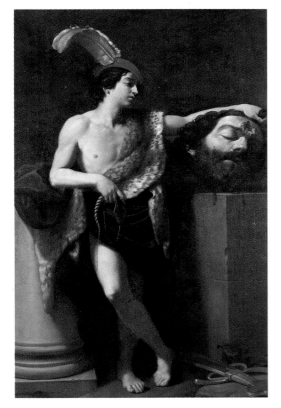

Guido Reni
David with the Head
of Goliath

1605
oil on canvas,
86½ × 57 in.
(220 × 145 cm)
Louvre, Paris

The possibility of directly
comparing not only the
style but also the subject of
this work with the painting
by Caravaggio is
particularly interesting in
regard to the important
relationship between the
two painters, in Rome, at
the beginning of the
seventeenth century. Reni
is influenced by
Caravaggio's vibrant use
of light (see the *David
and Goliath* in the Prado),
and accentuates the direct,
almost tactile realism of
the surfaces, the bodies,
and the descriptive details.
The pensive expression
of David, who is wearing
a plumed hat, is also
reminiscent of that of the
young soldiers seated at
the table in Caravaggio's
Calling of St. Matthew,
in the church of San Luigi
dei Francesi. But the
similarities end here. With
his academic training,
Reni creates an extremely
balanced and studied
composition, framed by
the geometric shapes
of a truncated, cylindrical
column and a six-faced
pilaster. David's relaxed,
casual pose expresses a
composed academicism,
and even Goliath's large
head seems almost pacified
and serene, far removed
from the tragic image
of death painted by
Caravaggio.

Guido Reni
Samson Victorious

1611–1612
oil on canvas,
102¼ × 87¾ in.
(260 × 223 cm)
*Pinacoteca Nazionale,
Bologna*

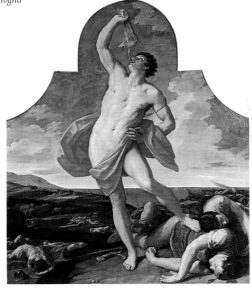

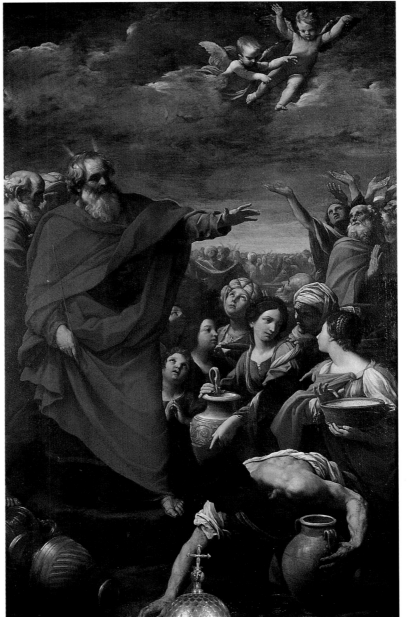

Guido Reni
Moses and the Gathering
of the Manna

1614–1615
oil on canvas,
110¼ × 67 in.
(280 × 170 cm)
Cathedral, Ravenna

Rome witnessed the most
important developments
in Reni's career, but we
must not overlook the
many imposing altarpieces
he executed in the region
where he was born.
Bologna and other major
cities in Emilia-Romagna
boast celebrated religious
paintings by this leading
local artist, who also
executed important works
in small provincial towns.
Thanks to this activity,
which was made even
more extensive by the
work of pupils and
followers, after Carracci,
Reni represented a figure
of continuity in Emilian
religious art. His
compositions are always
solemn and eloquent, and
the leading characters are
in full view and easily
recognizable from a
distance, while on closer
examination we can enjoy
the rich descriptive detail.

Guercino

Giovan Francesco Barbieri
(Cento, Ferrara, 1591–Bologna, 1666)

The works produced in Guercino's long career may appear contradictory. At one end, we have a style of painting full of dramatic impetus and chiaroscuro; at the other, smooth, precise images of perfect classicism. In actual fact, over decades of prolific activity, Guercino effectively summarizes the general developments in taste and the predominant trends in seventeenth-century Italian art. According to tradition, Guercino was practically self-taught, trained through his admiration for Ludovico Carracci. The early works, painted for his hometown or places in the surrounding area, are characterized by strong chiaroscuro, sharp contrasts, and broad vigorous brushwork, only superficially similar to Caravaggio and actually developed directly from the Ferrara school and Titian. Noted by

Cardinal Serra (the papal legate in Ferrara), Guercino painted a series of works characterized by intense personality and crude drama, very different from the work executed in Emilia at the time. In 1621 he was called to Rome by Pope Gregory XV. This began a period of reflection in which Guercino progressively attenuated his use of chiaroscuro, but without abandoning daring compositions, unusual perspectives, and dynamic gestures. This is the central period of the artist's career, a crucial phase if we are to understand not only the progressive development of his own style toward classicism but also the more general shift affecting all art in Rome, from Caravaggio to the "ideal" painting of the Bolognese school. On his return to Cento in 1623, Guercino was already an established master. His very active workshop produced altarpieces and religious paintings for towns large and small in such quantities as to establish consolidated iconographic traditions. On the death of Guido Reni

in 1642, Guercino left his hometown and moved to Bologna, where he became the new leader of the local school. This marked another step toward the controlled, noble classicism and intelligently academic approach that were to characterize all the works produced in the master's last years.

Guercino
Erminia Finding
the Wounded Tancred

1618–1619
oil on canvas, 57 × 73½ in.
(145 × 187 cm)
Galleria Doria Pamphili, Rome

Guercino was brought up on the poems written by Ariosto and Tasso for the Este family. Among the early works characterized by strong chromatic contrasts, this illustration of Tasso's *Jerusalem Delivered* stands out for its intense beauty, an interlude of amorous passion in the middle of the tragic tale. The wounded hero still wears part of his armor, and the metal contrasts effectively with Erminia's soft garments.

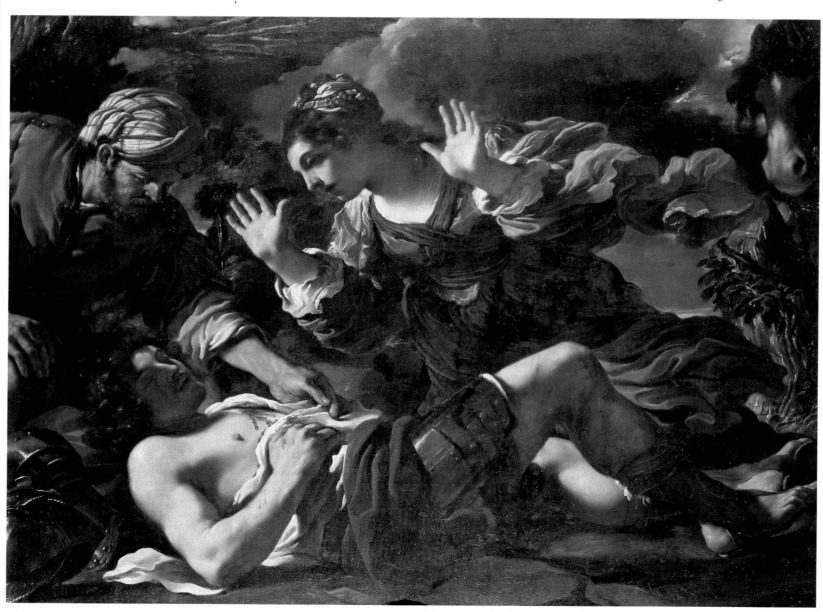

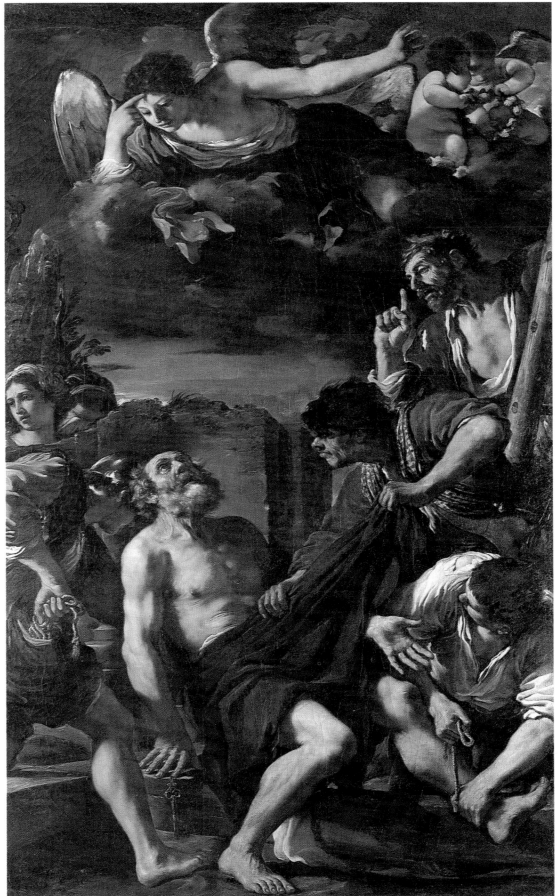

Guercino
Martyrdom of St. Peter

1618–1619
oil on canvas,
126 × 76 in.
(320 × 193 cm)
Galleria Estense, Modena

Again painted during
the first intense years
of activity, this great
altarpiece demonstrates
the quality of Guercino's
work at the beginning
of his career. Taking as his
starting point sixteenth-
century Venetian painting
(well documented in the
collections of the Este
family) and his own acute
observation of altarpieces
in the vicinity of Cento,
Guercino developed a
profoundly original style
of painting only apparently
linked to Caravaggio.
With convincing popular
realism, Guercino depicts
his scenes as though they
were episodes in a story
recounted in broad dialect.
The characters' gestures
are exaggerated and their
faces are extremely
expressive. Nonetheless,
the composition is
carefully studied and
the figures arranged in
a rhombus around a central
void.

Guercino
St. William of Aquitaine
Takes the Habit

1620
oil on canvas,
134¼ × 91¼ in.
(341 × 232 cm)
*Pinacoteca Nazionale,
Bologna*

Originally painted for
the church of San Gregorio
in Bologna, this great
painting marks Guercino's
spectacular entry into the
Bolognese school. Aware
of the importance attached
to this work, the painter
worked on its composition
at length, making repeated
sketches and drawings to
achieve a result that is
highly original and
effective. The entire scene
revolves around the figure
of the saint, who puts on
the white Carthusian habit
over his shining armor.
The interplay of gestures
(various figures are
pointing toward the center
of the scene) creates a
concentric vortex
underscored by the very
strong changes in color
from the darkest areas to
the friar in white on the
extreme right. According
to contemporaries, the
unveiling of the altarpiece
in the church was a stirring
event, as the great mass of
colors made all the other
works—including an
important altarpiece by
Ludovico Carracci—look
pale by comparison.

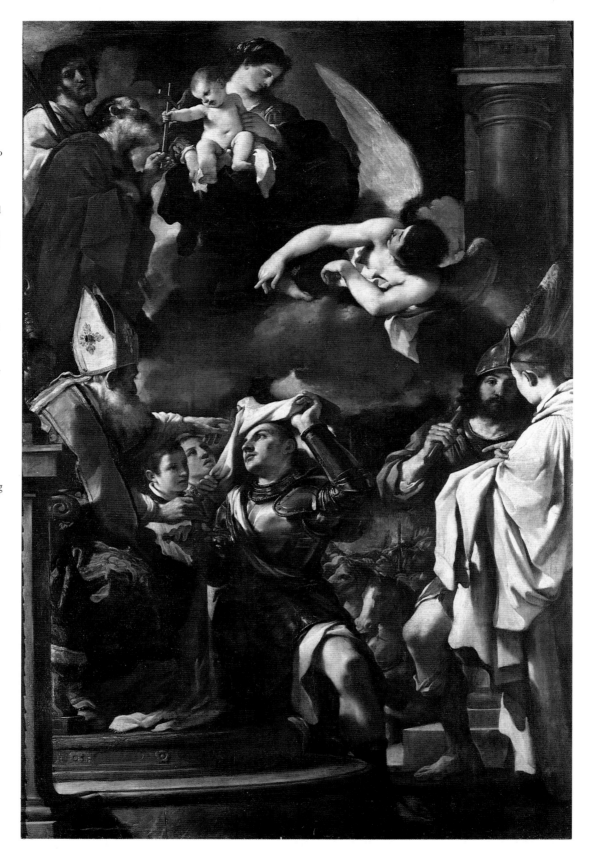

Guercino
St. Romuald

1640–1641
oil on canvas,
115 × 72½ in.
(292 × 184 cm)
Pinacoteca Comunale,
Ravenna

During the last few
decades of his career,
Guercino moved with
increasing determination
toward pure classicism,
eliminating the chiaroscuro
contrasts of his youth
and introducing sober,
restrained, noble gestures.
This radiant work,
dominated by the light
spreading out around
the white habit of
St. Romuald, defended
by an angel against the
snares of the devil, was
one of the last painted
in the workshop at Cento.
Guercino moved to
Bologna on the death
of Guido Reni in 1642.

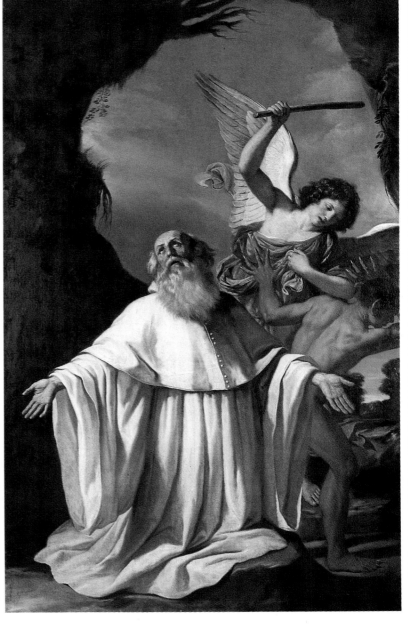

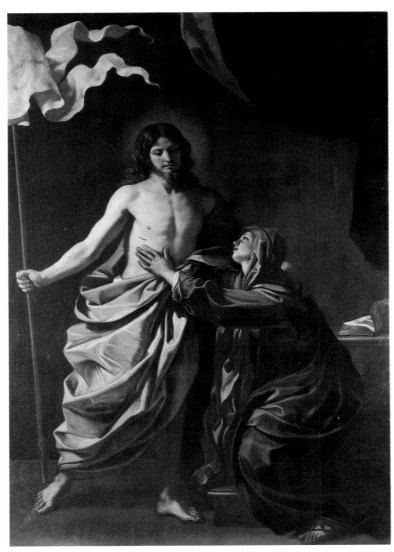

Guercino
The Risen Christ Appears
to Mary

1629
oil on canvas,
102¼ × 70½ in.
(260 × 179 cm)
Pinacoteca Comunale, Cento

This is one of the many
paintings by Guercino
that are still in his
hometown. The work
is a very significant
example of the period
of transition in the artist's
career, after the hectic
early phase and the stay
in Rome, but before the
first years of classicism.
Guercino maintains
a sharp contrast of light
and shade, with a strong
diagonal shaft of light
moving from left to right,
but the gestures are far
more restrained than those
in works executed before
1620. The somewhat rare
subject is drawn from
tradition and was also
interpreted by Titian
in an altarpiece at
Medole, in the province
of Mantua.

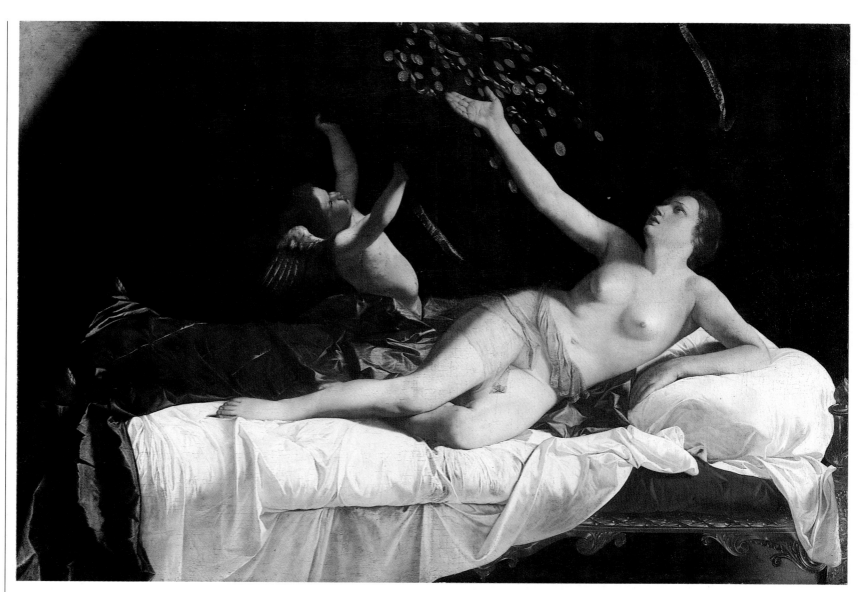

Orazio Gentileschi

(Pisa, 1563–London, 1639)

The central figure in an important family of artists, Orazio Gentileschi belonged to the same generation as Caravaggio, but his career took a decidedly different course. The pupil and assistant of an uncle who was a painter, in the first decade of the seventeenth century, steeped in the artistic atmosphere of Rome, Orazio Gentileschi "discovered" Caravaggio, and his work underwent a sudden change. Combining his own markedly Tuscan and classical training with Caravaggesque realism, he painted a series of important altarpieces in the Marches region, where he moved in 1612. In 1621 he moved to Genoa, where his career rapidly advanced. Aristocratic patrons appreciated the painter's particularly refined style. Turin, Paris, and London were the stages in his career as a court painter and intelligent mediator between the demands of noble patrons and the "modernity" of a realism that was fiery, immediate, and impassioned, but never brutal or vulgar.

Orazio Gentileschi
Rest on the Flight
into Egypt, after 1626
oil on canvas, 54¾ × 85½ in.
(139 × 217 cm)
Kunsthistorisches Museum, Vienna

Despite the humble intimacy of this family scene, the artist maintains an air of elegant composure together with unmistakable graphic and chromatic sophistication.

Orazio Gentileschi
Danaë

c. 1621
oil on canvas,
64¼ × 90 in.
(163.5 × 228.5 cm)
*Cleveland Museum of Art,
Cleveland*

Once in the imposing collection of the Doria princes in Genoa, this painting is one of the rare exceptions of a mythological subject among Gentileschi's mature works, which were predominantly religious. The episode is drawn from Ovid's *Metamorphoses* and was a favorite subject with both collectors and painters. It recounts how Zeus came to Danaë in the form of a shower of gold. This was one of the many stratagems devised by the father of the gods in the course of his countless amorous conquests. The eloquent gestures of Danaë and Cupid are framed by a rich, "sonorous" setting; we seem to hear the coins jingling as they pour down and the rustle of the draperies. The light is superbly handled, with a gleaming sheet juxtaposed to the dark background.

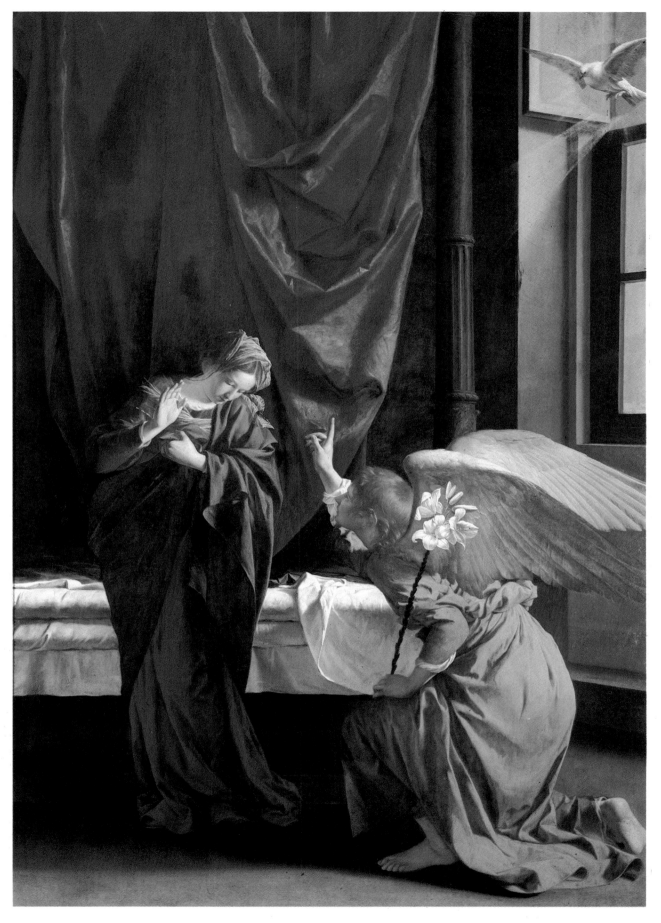

Orazio Gentileschi
The Annunciation

1623
oil on canvas,
112½ × 77¼ in.
(286 × 196 cm)
Galleria Sabauda, Turin

Orazio Gentileschi's masterpiece and a memorable work of European Baroque painting in general, this *Annunciation* was an immediate success. After the original version for the church of San Siro in Genoa, the painter made the copy reproduced here for the House of Savoy. It is a very effective compromise between the realism of Caravaggio (from whom Gentileschi takes the precise diagonal shaft of light and the chromatic effect of the large red curtain with deep folds at the top) and the tastes of international collectors, oriented toward richer compositions with more sumptuous colors. Apart from this successful "commercial" aspect, Gentileschi indicates clearly and poetically a possible direction for the development of painting after 1620. In a smoother style, the painting unfolds slowly and gently through an elegant series of compositional cross-references, such as the use of white. The dove representing the Holy Spirit, the lily of the archangel, and the chaste, immaculate sheet on the Virgin's bed thus combine to symbolize purity.

Bernardo Strozzi

(Genoa, 1581–Venice, 1644)

The leading figure in the Genoese school, Bernardo Strozzi was trained in the early Baroque style of painting then current in Genoa, but the crucial influence on his style came through contact with the great Flemish painters, first Rubens, and then, over a longer period, van Dyck, who was in Genoa during the early decades of the seventeenth century. Strozzi uses broad brushstrokes laden with paint and his relish for the physical medium of painting is clearly Flemish in origin. While devoting himself primarily to religious works (he was a Capuchin friar), Strozzi also produced impressive portraits, still lifes, and genre paintings with figures drawn from everyday life. In the 1620s, he was unquestionably the point of reference for Genoese artists and patrons, and his long series of works also includes frescoes for aristocratic villas. In 1630, after a bitter disagreement with the Capuchin Order, Strozzi left Genoa for Venice, where he was soon to become the leading figure on the local art scene.

Bernardo Strozzi
Mourning over the Dead Christ

c. 1615–1617
oil on canvas,
39 × 49½ in.
(99 × 125.5 cm)
Accademia Ligustica di Belle Arti, Genoa

A highly convincing example of the rich use of paint, thickly applied but perfectly controlled, which characterizes the best works by Bernardo Strozzi, who was influenced by the technique of the Flemish painters.

Bernardo Strozzi
St. John the Baptist

c. 1615–1620
oil on canvas,
41½ × 61¼ in.
(105.5 × 155.5 cm)
Accademia Ligustica di Belle Arti, Genoa

For all its apparent simplicity, this splendid painting encapsulates many features of Bernardo Strozzi's style: a vibrantly effective use of light, dense colors, and great sensitivity to the handling of the different surfaces.

Bernardo Strozzi
Madonna and Child
with St. John

c. 1620
oil on canvas,
62¼ × 49½ in.
(158 × 126 cm)
*Galleria di Palazzo Rosso,
Genoa*

As this splendid work
amply demonstrates,
Bernardo Strozzi was an
excellent painter of still
lifes, even though he
devoted his energies only
rarely to this specific
genre. Like Caravaggio and
Rubens, he preferred to
include an abundance of
descriptive detail in his
compositions with figures.
It is not infrequently the
case that objects and fruit
are not merely background
elements, but have such a
sharply defined, tangible
presence that they steal the
scene and overturn the
compositional hierarchy.
For all their charm, the
figures of the Madonna,
Child, and St. John
virtually pale into
insignificance beside the
exuberance and masterly
execution of the basket of
fruit and the Virgin's
sewing basket. The Child is
thus placed at the center of
the two diagonal lines that
cross the entire painting.

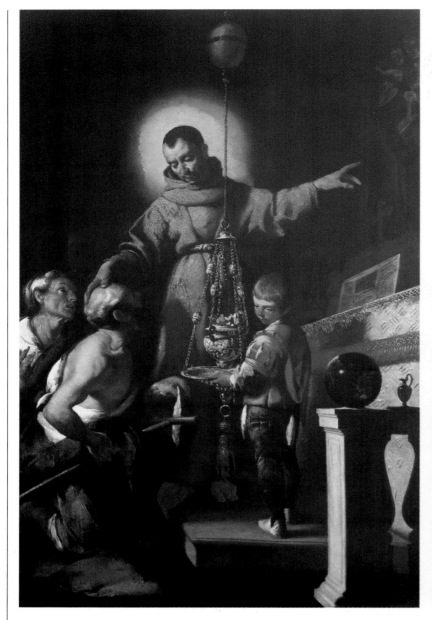

Bernardo Strozzi
St. Augustine Washing
the Feet of Christ

1629
oil on canvas,
122 × 78¾ in.
(310 × 200 cm)
*Accademia Ligustica di Belle
Arti, Genoa*

If we are to understand the origin and development of Bernardo Strozzi's art, it is essential to remember the intense artistic and cultural life of Genoa in the early seventeenth century, with its profusion of ideas and stimuli. In addition to the very solid traditional links with Antwerp, which took concrete shape in the presence of Rubens and van Dyck in Genoa, the school of Baroque painting in Liguria also encompassed the interpretation of Caravaggesque realism put forward by Orazio Gentileschi, links with the noble style of Tuscan drawing, and ties with the dramatic eloquence of seventeenth-century Lombard painters. All these elements can be traced in the work of Bernardo Strozzi, and are skilfully blended to create his own independent style.

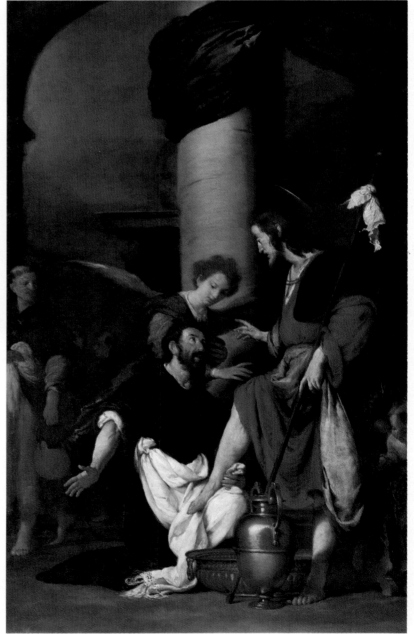

Bernardo Strozzi
Miracle of St. Diego
of Alcantara

1625
oil on canvas,
98½ × 67 in.
(250 × 170 cm)
*Church of the Santissima
Annunziata, Levanto*

In both the Genoese period and the subsequent Venetian phase, Bernardo Strozzi's activity can be divided into two main areas: paintings and frescoes for aristocratic patrons, and religious works, especially altarpieces and compositions for the Capuchin Order. In his large religious canvases, Strozzi always starts from a solid compositional structure based on the concrete presence of architectural elements in powerful relief or objects fully and realistically depicted. Around these fixed points he then arranges the gestures and actions of the figures, which recall the full-blooded physicality of Rubens.

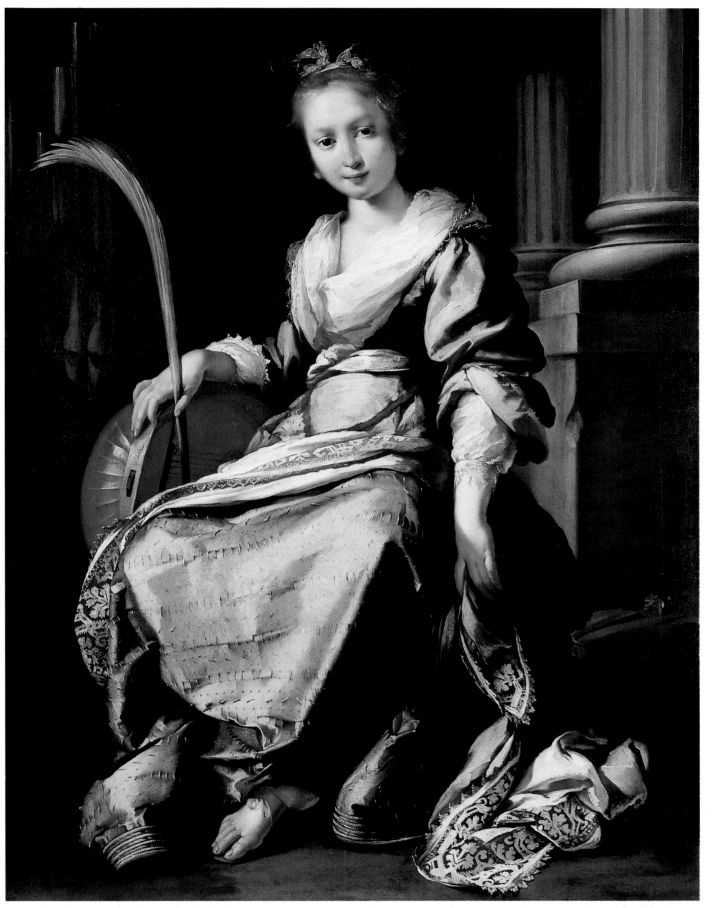

Bernardo Strozzi
St. Cecilia

1620–1625
oil on canvas,
68 × 48½ in.
(173 × 123 cm)
*Nelson-Atkins Museum of Art,
Kansas City*

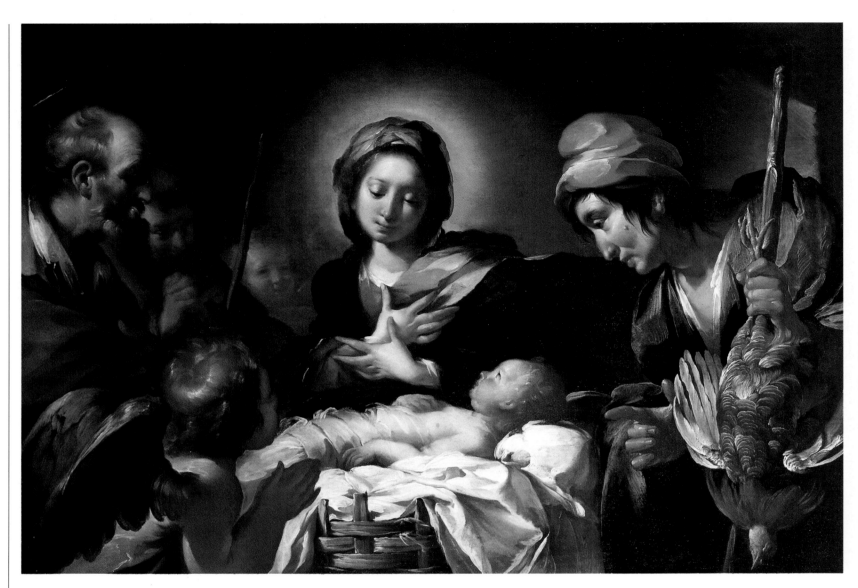

Bernardo Strozzi
Adoration of the Shepherds

c. 1616–1618
oil on canvas,
38½ × 55 in.
(97.8 × 139.4 cm)
Walters Art Gallery, Baltimore

This is another
quintessential work in
which Bernardo Strozzi
develops his own particular
poetical vein while
combining various trends
in Baroque painting. On
a foundation of solid
naturalism (see the
intensely lifelike portrait
of the gnarled peasant on
the right), Strozzi applies
color in thick, broad
brushstrokes to create an
explosion of tactile delight.

Bernardo Strozzi
The Cook

c. 1625
oil on canvas,
69¼ × 72¾ in.
(176 × 185 cm)
*Galleria di Palazzo Rosso,
Genoa*

This is unquestionably the
best known of Bernardo
Strozzi's works, and acts as
a bridge between Italian
and Flemish art. Kitchen
scenes were very common
in seventeenth-century
Dutch and Flemish
painting, and the Genoese
cook can be compared
with various northern
precedents (Aertsen,
Beuckelaer, and others).
In terms of spirit and style,
however, Strozzi displays
some significant
innovations. Like the
Flemish masters, he
reproduces the feathers,
the metal objects, and the
different surfaces with
painstaking care pushed
to the extreme of *trompe
l'oeil*, but his attention is
focused, above all, on the
girl, an attractive, living
presence, whose smiling
humanity sparkles amid
the flames and utensils
of this well-run kitchen.

Bernardo Strozzi
Joseph Explains the Dreams

1626
oil on canvas,
71¾ × 44 in.
(182 × 112 cm)
Pallavicino Collection, Genoa

Pietro da Cortona

Pietro Berrettini
(Cortona, Arezzo, 1596–Rome, 1669)

An eclectic artist, master architect of Baroque Rome, and imaginative painter, Pietro da Cortona provides the most brilliant and sumptuous examples of the most theatrical and rhetorical style of painting in seventeenth-century Europe. His abundant output of altarpieces, works for princely collectors, and vast cycles of frescoes, both religious and secular, always skilfully executed and never lacking in inspiration, make Pietro da Cortona a fundamental point of stylistic reference. He also completes the trio of major artistic trends characterizing seventeenth-century art: the naturalism of Caravaggio, the academic classicism of Carracci and Reni, and the High Baroque of Bernini and Pietro da Cortona.

Initially trained in Tuscany, Pietro da Cortona moved to Rome at the age of sixteen and immediately came into contact with Gianlorenzo Bernini, his near contemporary and an artist endowed with equally precocious talent. Both artists were noted by the Barberini pope, Urban VIII, who was to play an instrumental role in furthering their careers and who summoned them to work side by side in his family's magnificent palazzo. From the 1620s on, Pietro da Cortona began to receive commissions from aristocratic patrons, and he distinguished himself as a deft and inventive painter of frescoes. Taking as his starting point the noble classical approach of the Bolognese school, in his frequent choice of mythological or literary subjects, he added greater richness, color, and movement by including lively, dynamic elements. The stately, idealized approach of the academic painters is thus transformed into a festive, animated style with clearly theatrical overtones. The culmination of this is the decoration of the banquet hall of Palazzo Barberini in Rome (which now houses the Galleria Nazionale d'Arte Antica), a vast allegorical composition begun in 1633 and completed in 1639. This spectacular, radiant fresco with its wealth of symbolic figures and virtuoso foreshortening won Pietro da Cortona the title of "prince" of the Accademia di San Luca, an acknowledgment of his position as an artistic point of reference for the whole of Rome. With his productive workshop, Pietro da Cortona obtained another highly prestigious commission in Florence, where he was called to decorate the reception rooms of Palazzo Pitti. In his last years in Rome, Pietro da Cortona continued to produce frescoes (for Palazzo Pamphili and the Chiesa Nuova), although the actual execution was by now largely left to his pupils. Among his architectural works, attention should be drawn to the delightful reconstruction of the church of Santa Maria della Pace, with a semicircular portico on the façade, which is framed by a suitably remodeled urban setting.

Pietro da Cortona
Madonna and Saints

1626–1628
oil on canvas,
110¼ × 67 in.
(280 × 170 cm)
*Museo dell'Accademia
Etrusca, Cortona*

This work of the artist's
early maturity is a
sumptuous example
of the ostentatious richness

of Baroque altarpieces.
Pietro da Cortona depicts
a profusion of gilded
vestments, bright colors,
smiles, and gestures of
devotion in constant
motion and bathed in a
diffuse light. The painting
also contains a
sophisticated and difficult
dynastic "riddle." Produced
for the Passerini family,
it subtly introduces the

emblems of the chivalrous
orders to which the family
proudly belonged: the
Knights of St. Stephen
(whose cross appears
on the cope of the pope
St. Stephen), the Knights
of Malta (symbolized by
the figure of their patron
saint, John the Baptist,
and the cloak bearing
the unmistakable cross in
the center), and the

Calatrava Order (with the
figure of St. James the
Great behind John the
Baptist).

Pietro da Cortona
The Finding of Romulus
and Remus

1643
oil on canvas,
98¾ × 104¼ in.
(251 × 265 cm)
Louvre, Paris

Subjects drawn from
Roman antiquity and the
numerous historical legends
connected with the

founding of the Eternal City
were particularly relished
by elitist collectors in search
of confirmation of the
nobility of their dynasties
and of new masterpieces
for their family collections.
Pietro da Cortona willingly
played his part, painting
radiant and vividly colored
episodes of ancient history
with a tone of self-indulgent
theatrical verve.

99

Pietro da Cortona
The Rape of the Sabine
Women

1627–1629
oil on canvas,
110½ × 167¾ in.
(280.5 × 426 cm)
Pinacoteca Capitolina, Rome

The Roman career of
Pietro da Cortona was
furthered by the support
of the Sacchetti family,
one of the most important
seventeenth-century
patrician houses. This
canvas also results from
the Sacchetti family's
patronage of the Tuscan
painter, and more
generally indicates the new
trends emerging in the
taste of Roman collectors
after the first quarter of
the seventeenth century.
To the carefully balanced,
rigorous approach of the
classical painters
(especially Guido Reni
and Nicolas Poussin)
Pietro da Cortona adds
a dynamic form of
theatrical expressiveness.
The figures are seen
in mid-action, animated
by their exaggeratedly
twisted poses and bold
gestures. The obvious
references to works such
as *Apollo and Daphne* and
the *Abduction of Persephone*
clearly display the artist's
links with Gianlorenzo
Bernini.

Pietro da Cortona
The Triumph of Divine Providence

1633–1639
fresco
Palazzo Barberini, Rome

Pietro da Cortona's work for the Barberini pope, Urban VIII, marks the climax of his career and the period of closest contact with Gianlorenzo Bernini. The two masters worked together on the construction and decoration of the sumptuous palace of this powerful family, which now houses the Galleria Nazionale d'Arte Antica. Forty years after the decoration of Palazzo Farnese by Annibale Carracci, Pietro da Cortona puts forward a new model of aristocratic decoration. The calm and sophisticated sequence of classical subjects gives way to violent and highly animated, whirling movement. The central area is open to the sky and great clouds support groups of airborne figures bathed in a gilded light spreading downward from above. Pietro da Cortona takes up and develops the foundations laid over a century earlier by Correggio in the domes he painted in Parma, and transforms the fresco of the main reception hall into an extraordinarily rich spectacle that astounds the spectator and sweeps him away in a whirl of movement, in which all sense of a focal point is lost. The exuberance of his imagination oversteps all boundaries; thus, alongside the religious theme, ample space is also found for a celebration of the Barberini family, represented by the heraldic emblem of three bees with open wings.

Domenico Fetti
(Rome, 1589–Venice, 1623)

This singular artist, who worked in Mantua as painter to the Gonzaga court for practically the whole of his career, is still undergoing a process of critical reappraisal. With his late Renaissance training, Domenico Fetti found himself in a somewhat unusual position. While Mantua could boast a long and illustrious artistic and cultural tradition, on the eve of the seventeenth century, the ancient state of the Gonzaga family appeared to be drastically impoverished, and occupied a marginal position in both historical and economic terms. And yet, there was no lack of opportunity for encounters at the highest level. In fact, at the beginning of the seventeenth century, Rubens drew a salary from the Gonzaga family for a number of years, despite the fact that he worked mainly in Rome. Fetti independently developed an unusual and brilliant style of his own, which is a blend of influences and ideas from different sources. His direct relations with Rubens, and his taste for Dutch and Flemish painting in general, led him to adopt thick, rich brushstrokes, which can be clearly seen in the highly inventive series of small and medium-sized paintings of *Apostles*, or the delightful little images of his *New Testament Parables*, interpreted almost as genre scenes. In his larger works—including altarpieces, the frescoes in Mantua cathedral, and the enormous lunette with the *Miracle of the Loaves and Fishes*, now in the Palazzo Ducale in Mantua—the compositions are more complex, dynamic, and dramatic. Fetti remains best known, however, for his contemplative, solitary figures lost in ecstasy, in concentrated thought, or in a dream world. Such images won immediate success, to such a degree that the painter took to repeating them in a number of versions. Fetti spent the last years of his life in Venice, where he was instrumental in leading local painting to break away from the worn-out late-Renaissance tradition and move in the direction of the new Baroque models.

Domenico Fetti
Meditation
or Melancholy

c. 1622
oil on canvas,
70½ × 55 in.
(179 × 140 cm)
Gallerie dell'Accademia, Venice

This painting has come
to epitomize Fetti's work,
and various copies were
made by the artist himself
and turned out by his
workshop. It is an
attractive combination
of the concrete, realistic
tangibility of the shapely,
contemplative girl and
sophisticated intellectual
references to the
allegorical theme. The
image is in fact the
figurative transposition
of the state of mind known
as the "melancholy humor"
in Renaissance medico-
philosophical doctrine.
Fetti provides a crisp
Baroque reworking of a
subject already depicted
by others, including Dürer
in a famous engraving.

Domenico Fetti
David

c. 1620
oil on canvas,
69 × 50½ in.
(175 × 128 cm)
Gallerie dell'Accademia, Venice

Fetti also repeated this
composition in various
versions, which is evidence
of its success with
collectors of the period.
The figure of the
victorious David frequently
recurs in seventeenth-
century art, and is given
a variety of different
interpretations. Fetti
offers an appealing and
unconventional treatment.
David's attire and pose are
those of a young
swordsman and are very
reminiscent of the soldiers
with plumed hats and
puffed sleeves in
Caravaggio's *Calling
of St. Matthew*. The
reference to Caravaggio,
however, is diluted by a
casual, even impudent,
approach, undoubtedly
deriving from Fetti's direct
contact with Rubens's
works in Mantua.

Domenico Fetti
Hero and Leander

c. 1622–1623
oil on wood,
16½ × 37¾ in.
(42 × 96 cm)
*Kunsthistorisches Museum,
Vienna*

The mythological scenes
and illustrations of New
Testament parables, mainly
painted for the Gonzaga
family, and, already in the
seventeenth century,
unfortunately scattered over
half of Europe in various
princely collections, are
characterized by a brilliant
freedom of expression and
very vigorous execution.
The stormy, rapid
brushwork creates highly
imaginative effects that are
dramatic and attractive.

Mattia Preti

*(Taverna Calabra, near Catanzaro, 1613–
La Valletta, Malta, 1699)*

The third centennial of the death
of Mattia Preti (which occurred quite
by chance from a cut inflicted by a barber
early in 1699) has led to fresh attention
being focused on this singular protagonist
of southern Italian painting in the mid-
seventeenth century. This original and,
in his own way, unconventional master is
difficult to fit into the rigid framework
of a particular school, even though he can
be generally associated with the broad
radius of Neapolitan painting, or with the
Caravaggesque tradition. After receiving his
initial training in the family workshop in
Calabria, Mattia Preti moved to Rome at a
very young age to work with his brother
Gregorio. His brilliant talent and unusually
extroverted personality soon led to his
being noted in the artistic and aristocratic
circles of the Eternal City. He quickly
made his way up the ladder of success.
In 1642, aged only twenty-nine, he was
admitted to the Order of the Knights
of Malta, an honor Caravaggio had won
almost forty years earlier. In fact, it is
Caravaggio's influence that dominates
throughout the oeuvre of this Calabrian
painter, who adopted the Lombard
master's direct realism and handling
of light. However, in the mid-seventeenth
century, Mattia Preti "laced" the harsh,
naturalistic style of Caravaggio with a
series of other stimuli. In the frescoes for
the choir of the church of Sant'Andrea
della Valle in Rome, he was influenced
by the classicism of the Bolognese school
and the theatrical Baroque style of
Pietro da Cortona and created dynamic,
monumental compositions. Attracted
by the colors of the sixteenth-century
Venetian masters, Mattia Preti journeyed
to the north of Italy. In 1653 he was in
Modena, where he frescoed the apse and
dome of the church of San Biagio. At the
same time, he never lost contact with his
hometown in Calabria, where he
periodically sent canvases. The churches
of Taverna thus offer a rich gallery of the
painter's works. In 1656 (the year of a
terrible outbreak of the plague) he moved
to Naples. This stay was not long (it came
to an end in 1660), but certainly decisive,
since it coincided with the central and
most active period of his career. During his
five-year spell in Naples, Mattia Preti
painted practically all his major works,
which reveal extraordinary imaginative
flair and skill in execution. By combining
Caravaggesque tenebrism and the
sumptuous richness of sixteenth-century
painters such as Titian and Paolo Veronese in
a truly unusual but unquestionably effective
way, Mattia Preti brought about a turning
point for the Neapolitan school, which
abandoned the crude and brutal realism
of Ribera to move toward the fluid eclectic
compositions of Luca Giordano. In 1661
he was summoned to Malta to become the
official painter of the Order. Apart from a
few trips to Taverna, Mattia Preti never
again left the island, where he spent nearly
forty years producing works to decorate
churches and private residences.

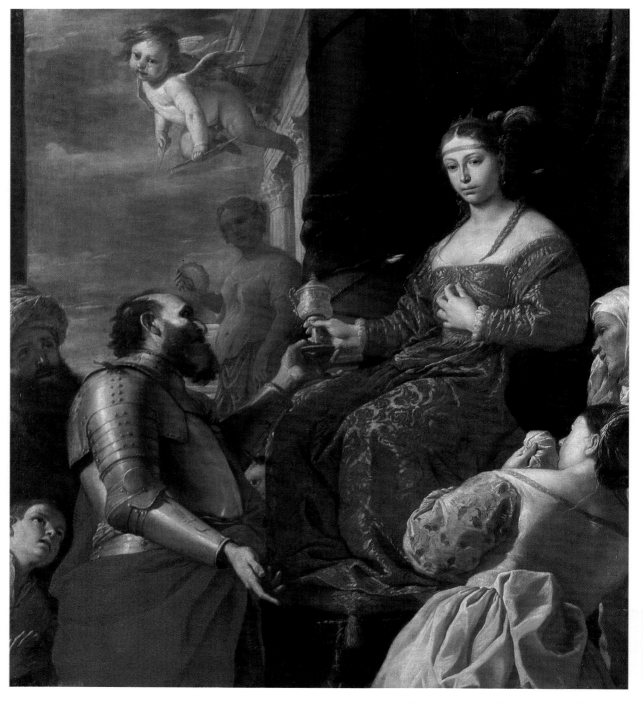

Mattia Preti
Sophonisba Receives
the Poison

c. 1670
oil on canvas,
78 × 68½ in.
(198 × 174 cm)
*Musée des Beaux Arts,
Lyons*

The heroine, faithful
to her husband to the
death, dominates this
melodramatic
composition, where the
influence of the Neapolitan
school is combined
with a sumptuousness that
recalls sixteenth-century
Venetian painting.

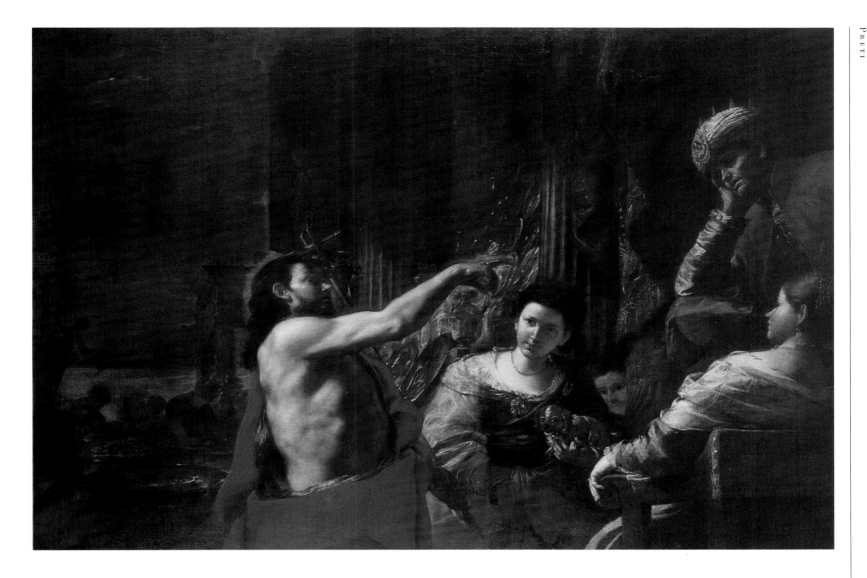

Mattia Preti
John the Baptist Appearing
Before Herod

c. 1665
oil on canvas,
35½ × 74¾ in.
(90 × 190 cm)
Private collection, New York

Once again, Mattia Preti
draws his initial inspiration
from Caravaggio, but then
proceeds by independently
blending themes from his
considerable figurative
culture with a delight in
descriptive detail, as
exemplified by the objects
portrayed in perspective in
the background. A
memorable effect is
created by the statuesque
pose of the saint, whose
dynamic, athletic body
swathed in light contrasts
with the indolent pose of
Herod and the scandalized
amazement of the women.

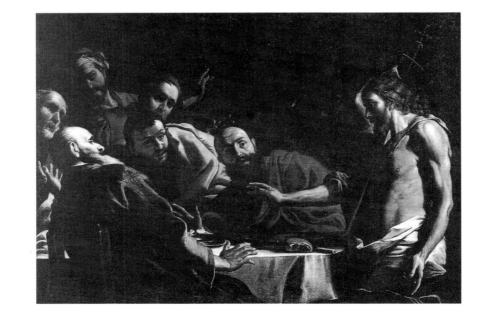

Mattia Preti
John the Baptist Rebukes
Herod

1662–1666
oil on canvas,
55 × 79½ in.
(140 × 202 cm)
Museo de Bellas Artes, Seville

This is another version of
the same subject. The
canvas was painted during
the long years in the
service of the Knights of
Malta, whose patron saint
was John the Baptist.
Movement is conferred
on Caravaggesque
compositional structures
by brilliant emotional
handling.

Luca Giordano
(Naples, 1634–1705)

Luca Giordano's proverbial speed of adaptation has sometimes led to this important painter, a key figure in a period of transition, being seen as a kind of sideshow freak. This is a serious mistake that gives no insight into the truly pivotal role played by Luca Giordano not only in the painting of his hometown, but, more generally speaking, in the renewal of Italian art, from the mid-seventeenth century to the eve of the eighteenth century. As a boy, he was trained in Naples in the workshop of the aging Jusepe de Ribera, from whom he acquired a taste for naturalism distantly derived from Caravaggio, but interpreted with almost brutal realism. In 1652 he left on the first of his many journeys. After a stay in Rome, which was indispensable for seventeenth-century artists, he went on to Florence and Venice. He thus developed a broad, rich, and up-to-date culture. He practiced his art by imitating masters of the past, with results that were sometimes so surprising that they deceived experts for centuries. Attracted by the spectacular vein of Pietro da Cortona, and fascinated by the Venetian tradition to which Mattia Preti was also drawn, Luca Giordano abandoned his original chiaroscuro for work of a lighter, more brilliant, and dynamic nature. Tried and tested in the numerous paintings produced for churches, Luca Giordano's new style of painting, a happy blend of various experiences, was a resounding success during his second journey to Florence and Venice (1665–1667), when his relationship with the local schools was reversed. First he had traveled to learn; now he was a master to be admired and imitated. By alternating periods of work in Naples with journeys to other cities, Luca Giordano extended his influence over an increasingly large radius. In 1682, he painted one of his masterpieces, the luminous frescoed gallery of the Palazzo Medici Riccardi in Florence, a surprising work, especially in view of its location in what had been the residence of Lorenzo il Magnifico. Luca Giordano broke with the canons of classical art to paint free figures against a background of sky, almost foreshadowing eighteenth-century painting. Having become an important figure for princely patrons and collectors in most of Europe, in 1682 he moved to Madrid, where he worked for almost a decade. At the age of nearly seventy, he returned to Naples, where he succeeded in producing one last radiant masterpiece, the *Triumph of Judith*, a fresco executed in 1704 on the vault of the Tesoro Chapel in the Carthusian Monastery of San Martino.

Luca Giordano
Triumph of Judith
1703–1704
fresco
Tesoro Chapel, Carthusian Monastery of San Martino, Naples

Luca Giordano
Perseus Fighting Against
Phineus and His
Companions

c. 1680
oil on canvas,
112¼ × 144 in.
(285 × 366 cm)
National Gallery, London

Armed with the terrible
severed head of Medusa,
whose gaze turns her
enemies to stone, Perseus
bursts onto the scene as a
dynamic champion in an
intensely powerful whirl
of dizzying movement
and flashing light.

Luca Giordano
Jesus Among the Doctors

c. 1670
oil on canvas,
34¾ × 53¼ in.
(88 × 135 cm)
*Galleria Nazionale d'Arte
Antica, Rome*

This work is an
important example of
Luca Giordano's
chameleon-like style.
The painter covers the
composition with a sort
of haze that blurs the
outlines and features,
but allows sudden flashes
of color to emerge and
suggests a vast, indistinct
spatial dimension.

Andrea Pozzo

(Trento, 1642–Vienna, 1709)

With the superb and highly imaginative use of perspective in works executed for the vast spaces of churches in Rome and Vienna, the Jesuit Andrea Pozzo marks a phase of scenographic development in Baroque art, understood in this case as a moving and convincing affirmation of belief in the Catholic faith and its heroes. Painter, architect, scenographer, and supplier of designs for sculptures and ornamentation, Father Pozzo was an extremely active, versatile artist of great importance in the development of Baroque religious art in the Catholic countries. He received his early training in northern Italy, and made journeys to study in Milan, Genoa, and Venice. Andrea Pozzo assimilated the best elements of Counter-Reformation figurative culture, and put his early training to good use during a long stay in Turin and Piedmont. In response to the requirements of the Jesuit Order, he produced a significant number of altarpieces, many for provincial towns, and successfully tried his hand at perspective frescoes in the church of San Francesco Saverio (or Chiesa delle Missioni) in Mondovì. He moved to Rome, where his career reached its climax with the work on the Chiesa del Gesù, including the astonishing polychromatic altar of precious materials, devoted to St. Ignatius. Andrea Pozzo thus took over the legacy of Bernini by continuing the idea of a "total work of art." His absolute masterpiece is the ceiling of the church of Sant'Ignazio, a memorable work of great importance for the future development of painting, especially in Austria and Germany, where Andrea Pozzo is a well-known figure. In 1703 he moved to Vienna, where he continued to work for the Jesuits (producing frescoes in the college of the Order and in the old university building, and restructuring the inside of the church), but also for the counts of Liechtenstein and for other patrons.

Andrea Pozzo
The Glory of St. Ignatius of Loyola

1691–1694
frescoed ceiling
Church of Sant'Ignazio, Rome

Built by the Jesuits as their second church in Rome after the historic Chiesa del Gesù, the church of Sant'Ignazio is one of the most interesting late seventeenth-century buildings in the city. Its very pleasing architecture is set within the brilliantly renovated surrounding urban fabric. The huge frescoed ceiling of the nave greatly alters our perception of space.

In this virtuoso work, Andrea Pozzo reflects the architecture of the church in illusionistic architectural elements that project upward into an open sky thronged with countless figures. The work is based on a rigorous iconographic design with allegorical figures and details corresponding to precise doctrinal requirements. What really counts, however, is the overall effect of what is unquestionably one of the most spectacular inventions in European High Baroque art.

Seventeenth-Century Flanders

Jan Bruegel the Elder
and Peter Paul Rubens
Allegory of Sight,
detail
1618
oil on wood,
25½ × 43 in. (65 × 109 cm)
Prado, Madrid

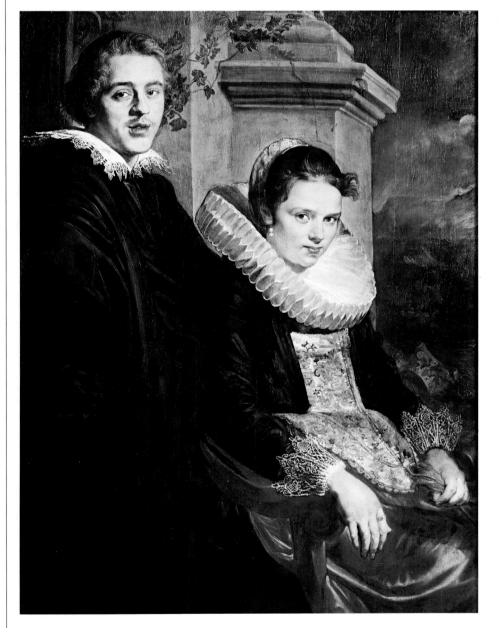

Jacob Jordaens
Double Portrait
c. 1620
oil on wood,
48½ × 36½ in.
(123 × 93 cm)
Museum of Fine Arts,
Boston

The second half of the sixteenth century was a difficult and turbulent period in the Netherlands. Flanders and the northern provinces (which later became Holland) repeatedly experienced cruel wars, revolts, and attempts to gain independence from Spanish domination. These bitter and dramatic events culminated in the repression of the Duke of Alba, plenipotentiary of Spain. The decapitation of the counts of Egmont and Hornes, the leaders of the rebellion, in the Grande Place in Brussels, and the assassination in Delft of William of Orange, known as William the Silent, *stadtholder* of Holland, were the most famous episodes at that time. These were terrible scenes, but they were played out against a backdrop of flourishing economic expansion. In fact, thanks to their well-organized ports and their advanced nautical and commercial development, the coastal cities on the North Sea were quicker and more efficient in understanding the extraordinary potential of the overseas routes. During the sixteenth and early seventeenth centuries, Antwerp was probably the wealthiest center in Europe, and the quays of the port on the River Scheldt must have been a cosmopolitan and exotic picture of ceaseless activity. Soon, other northern ports (Rotterdam and, above all, Amsterdam) joined Antwerp in competitive trade on seas throughout the world. Rather than the Spanish ports, Antwerp was the main place where colonial merchandise was distributed and traded. Many of the city's inhabitants had lucrative opportunities for making money, and they formed the nucleus of the very solid middle class that was to become the chief market for seventeenth-century Flemish art. Antwerp was an international, extremely cultured, open, and tolerant city, with a major multilingual publishing industry, but it remained tenaciously linked to Catholicism, and became an outpost of the Counter-Reformation against the rebel United Provinces (future Holland) that embraced the Calvinist faith. In Antwerp, around the imposing late-Gothic cathedral, surmounted by Rombout Keldermans's imaginative, soaring spire, rose the large monasterial complexes of various religious orders, including the powerful Jesuits. The dashed hopes of independence (unlike what happened in the northern provinces), did not jeopardize economic development in Antwerp and Flanders during the seventeenth century. Though the old historic centers

Peter Paul Rubens
Jan Bruegel's Family
1613–1616
oil on canvas,
49 × 37½ in.
(124.5 × 95 cm)
Courtauld Institute
Galleries, London

of Bruges and Ghent went into economic and commercial decline, Antwerp and Brussels enjoyed a period of extraordinary expansion, which was also reflected in the varied, ingenious, and novel civic architecture, in which traditional elements (like the pediments on the façades of the houses) were designed with a decorative flair that is typically Baroque.

It is important to take into consideration this historical and cultural context in order to understand the spread of Antwerp's art and the close network of international relations established by artists and collectors that gave rise to the most magnificent and extraordinary school of painting in seventeenth-century Europe. Certainly Flemish painting during the second half of the sixteenth century had seen the disillusioned style of Pieter Bruegel, heir to Bosch's dense moral allegories, but it had not been particularly impressed. By contrast, in the last decades of the sixteenth century, the Antwerp school proposed decisive innovations. Taking Gospel subjects as their starting point (such as the episode of Christ in the house of Martha and Mary or various miracles performed in public), some artists began to paint kitchen interiors, market scenes, and realistic compositions drawn from everyday life, with realism and an abundance of

Peter Paul Rubens
Triptych of the Descent from the Cross
1612–1614
oil on wood,
165¼ × 122 in.
(420 × 310 cm)
(central panel with
The Descent from the Cross);
165¼ × 59 in.
(420 × 150 cm) each
(side panels with
The Visitation and
The Presentation at the Temple)
Cathedral of Our Lady, Antwerp

113

Anthony van Dyck
Alessandro Giustiniani (?)
Dressed as a Senator
1621–1623
oil on canvas,
78¾ × 45¾ in.
(200 × 116 cm)
Gemäldegalerie, Berlin

circumstantial detail. Soon religious painting was super-seded by the splendid period of genre painting and still life, mainly aimed at the bourgeois market. However, in Antwerp there was also a constant and increased demand for spectacular altarpieces, sumptuous Madonnas rising to heaven, rejoicing angels, or gesticulating martyred saints, images that the Catholic Counter-Reformation used to combat the severe intellectual Christology of the Protestant Reformation.

In this artistic ferment, which was also nourished by the flow of Italian paintings on the burgeoning antique market, there were no truly outstanding artists, and what was needed was a personality who dominated the scene and became a point of reference. At the beginning of the seventeenth century this role was played, to overwhelming effect, by Peter Paul Rubens. After a long period of training, culminating in a lengthy stay in Italy in the service of the Duke of Mantua, Rubens returned to Antwerp in 1609, to find a very stimulating situation. He was immediately given the commission to paint the imposing altars in the cathedral, an enormous task that brought him extraordinary acclaim. Rubens assimilated the influences gleaned from his study of ancient art and the European Renaissance, and developed them into an extremely individual style that became the quintessence of "Baroque." It was full, rich, generous, expressing the joy of painting and of seeing color on the canvas. Hence, Rubens was particularly in demand for vast religious compositions and, later, paintings celebrating illustrious personages, but he also liked to try his hand at the most varied subjects and formats. He imitated Titian not only in his pictorial style, but also in his overt commercial attitude to his work. Rubens soon became very rich and displayed his wealth by constructing an impressive Italianate palace and atelier, one of the greatest attractions for visitors to Antwerp. He was surrounded by a crowd of pupils, assistants, and artists of various kinds. Rubens (like some sports personalities today) was "big business." The engravings, statues, and tapestries made from his drawings were all covered by copyright, and his most skillful assistants played the role of specialists and worked alongside the master on the more complex compositions. Numbering over a hundred workers, around 1620, Rubens's atelier was extremely productive and exported works throughout Europe. Inevitably, all the most

Jacob Jordaens
Offering to Ceres
c. 1620
oil on canvas,
65 × 44 in.
(165 × 112 cm)
Prado, Madrid

important artists were attracted to this hive of activity. Jan Bruegel, known as Velvet Bruegel, added the details of flowers and fruit; Frans Snyders specialized in depicting animals; the very young van Dyck soon became an outstanding portraitist; and Jacob Jordaens was the master's alter ego in the large paintings with figures, on mythological, allegorical, or religious subjects.

Between 1620 and 1640, Rubens was probably the artist who was most influential and most in demand in Europe. As had happened in the case of Titian (a permanent point of historic reference), his art set him above the often dramatic wars and conflicts that ravaged the principal states. Courts vied for his presence, and Rubens traveled willingly. London, Paris, Madrid are only some of the stages on his journey, but his heart was always in Antwerp. Rubens could speak five languages fluently, he had an impeccable manner and a natural elegance that had been further refined by having spent time at court, and his skill in diplomacy was generally admired. All things considered, as well as being an extraordinary painter, he became a social role model that was the opposite of that put forward by the unfortunate *artistes maudits* like Caravaggio and, in his old age, Rembrandt. In his free and profitable relations with royalty and the court, Rubens is reminiscent of the great masters of the Italian Renaissance, while his expansive, sensual paintings flooded collections throughout Europe. No princely collection could be said to be truly complete without works by Rubens, or by his school. Rubens's workshop produced most of seventeenth-century Flemish painting, and it is not merely by chance that after the master's death a curtain seems to have come down over Antwerp and Flemish art. His taste for spectacle and for exuberant richness was assimilated by his pupils and assistants, and was adapted to various needs. Anthony van Dyck, an outstanding international portraitist, taking the master's style as his starting point, independently arrived at an exceptional model for the celebratory, aristocratic portrait by achieving a balance between the stately air of the personages and the brilliantly natural rendering of faces, expressions, attitudes, and fleeting smiles. Jan Bruegel (son of the great Pieter Bruegel and known in Italy as Velvet Bruegel) in his youth was predominantly a meticulous landscapist. Then, first to meet the demand of Italian patrons and later thanks to Rubens's encouragement, he

Peter Paul Rubens
*The Head of Cyrus
Taken to Queen Tomyris*
c. 1622–1623
oil on canvas,
80½ × 141 in.
(204.5 × 358 cm)
Museum of Fine Arts,
Boston

became famous as one of the greatest flower painters of all time, since he was skillful in handling very complex compositions, but also in depicting every single petal lovingly and painstakingly. To conclude this brief overview, Jacob Jordaens was a painter who has perhaps been underestimated and too often seen as Rubens's "shadow," whereas he should be considered in all his rich variety as an artist capable of tackling the most diverse subjects with humor and tenderness.

The success of the Antwerp school was indissolubly connected with Rubens's workshop, and after the master's death (closely followed by that of van Dyck) the seventeenth-century Flemish school as a whole began to wane and was superseded by the Dutch school.

However, it is important to take into account the simi-larities and differences between these two schools in the Netherlands. In both cases the development of art was supported by a very extensive market consisting of an emerging social class: the bourgeoisie of merchants and entrepreneurs that formed the first nucleus of modern capitalism. This was so to a lesser extent in the case of Rubens and van Dyck, since they usually worked for the aristocracy and the reigning families. But the abundant output of genre, still-life, and landscape paintings in Flanders, and even more so in Holland, was evidently destined for the middle class in the wealthiest cities.

Nearly always, these works were not executed "on com-mission," namely, as a result of a precise, detailed re-quest, and with a contract between the artist and the buyer, but were put on a market that was not unlike the

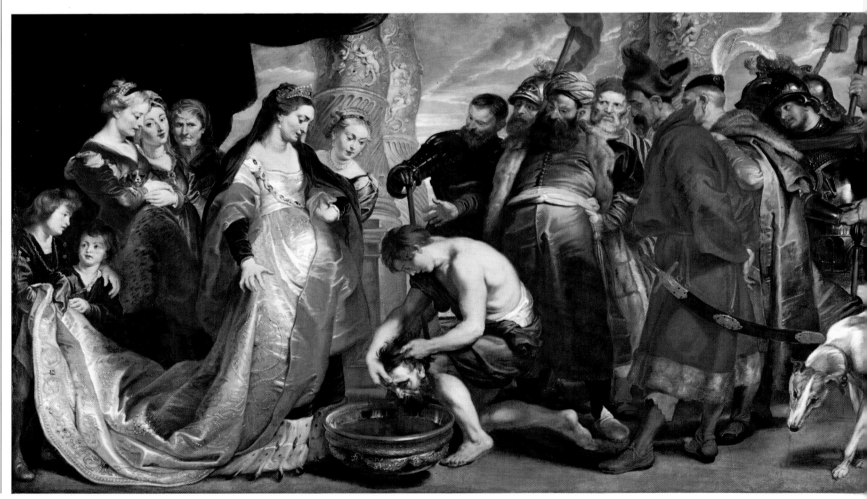

Anthony van Dyck
Bettina Balbi Durazzo
"The Golden Lady"
1621–1622
oil on canvas,
85¾ × 57½ in.
(218 × 146 cm)
Private collection, Genoa

one today, involving art dealers and auctions.

Thus, the figure of the art dealer and antique dealer began to emerge, since they had become indispensable in these new circumstances. Yet again we have to go back to Titian, since it was this great Venetian master who laid the foundations for the profession of the dealer, who acted as an intermediary between the artist and the buyer. In seventeenth-century Flanders and Holland, gallery owners played a major role in the careers of certain painters. For instance, Hendrick van Uylemburch, a competent art dealer, invited Rembrandt to Amsterdam and put him under contract. The seventeenth-century gallery owners gauged the tastes of the public and succeeded, at least partially, in piloting significant changes in the choices made by collectors, influencing the developments of whole schools, and putting important works of art in circulation. Seventeenth-century Flemish art is therefore to be remembered not only for the splendid works by great masters, but also for developing an art market that was completely new with respect to the previous century.

Jan Bruegel the Elder

(Brussels, 1568–Antwerp, 1625)

The son, though not the pupil, of the great Pieter Bruegel the Elder (who died before Jan was one year old), the future leading exponent of the first period of still life in Europe was raised by his grandmother, Maria Bessemers—a painter of considerable talent—together with his brother, Pieter the Younger, who also trained as a painter. Jan Bruegel showed great talent and considerable independence at an early age. He made the rather surprising decision to abandon his father's style (which his brother Pieter followed), and to travel in order to discover for himself the international developments in art at the end of the sixteenth century. After a stay in Cologne in 1589, Jan Breugel went to Naples in 1590, where he began an intense five-year period of work and study in Italy. He spent most of the time in Rome, where he became one of the leading members of the increasingly large colony of northern artists. He and his painter friend Paul Brill drew numerous views of the ancient monuments (the study of Jan Bruegel's exceptional drawings is relatively recent and they are proving to be a valuable source of information on the former appearance of ruins that have since been altered or destroyed), and he successfully tried his hand at the independent genre of landscape. Stormy seas, Alpine views with rustic hermits, or red-tinged mountains were his first subjects. These were nearly always small works, painted on copper, and executed with typically Flemish meticulous precision. The small works in which Bruegel paints countless objects or all kinds of animals verge on pure virtuosity. This aptitude for painstaking execution, which is almost miniaturistic, can also be seen in the religious and allegorical works painted in tandem with Hans Rottenhammer. The German painter executed the figures and Jan Bruegel was responsible for the naturalistic details and, in particular, the flowers, which were his specialty. After being noted by Cardinal Federico Borromeo, a great connoisseur of the arts and one of the first to appreciate the emerging genre of still life, Jan Bruegel began to paint bunches of cut flowers and in a very short space of time became a true specialist in this field. In 1595, Cardinal Borromeo invited him to Milan and became his patron, a relationship that continued even after the painter's return to Antwerp, when it developed into a regular correspondence. Jan Bruegel painted a considerable number of works for the cardinal, which are still housed in the Pinacoteca Ambrosiana in Milan, founded by Federico Borromeo in 1618. During the years he spent in Antwerp, the demand for Bruegel's work from collectors throughout Europe increased. He therefore set up a large studio in which his son Jan the Younger was also an apprentice. Around 1615, Rubens invited Bruegel to join his workshop as his specialized assistant.

Jan Bruegel
The Original Sin

c. 1620
oil on wood,
20½ × 32¾ in.
(52 × 83.5 cm)
Museum of Fine Arts, Budapest

Repeatedly depicted by Bruegel and his school, this surprisingly fresh painting belongs to the "encyclopedic" genre of the Baroque. The aim was to contain within a single work a whole universe of scientific and natural observations. Domestic animals and exotic beasts, the representatives of all the continents and of all the species, are depicted with precision, the pretext being the reference to the garden of Eden.

Jan Bruegel
Mouse with Roses

1605
oil on copper,
3 × 4 in.(7.2 × 10.2 cm)
Pinacoteca Ambrosiana, Milan

This very unusual work of extremely fine draftsmanship was particularly admired by Cardinal Borromeo, and the painter gave it to him as a gift.

Jan Bruegel
Small Bunch of Flowers

c. 1607
oil on wood,
20 × 15¾ in.
(51 × 40 cm)
Kunsthistorisches Museum,
Vienna

Jan Bruegel's fame rests above all on his extraordinary skill in depicting and arranging luxuriant bunches of flowers, sometimes accompanied by other unusual items, such as coins, insects, jewels, and so on. In the letters he wrote from Antwerp and Brussels, Bruegel underlines the great effort it took to compose these bunches that often contained dozens of different kinds of flowers. In fact, he was in the habit of painting flowers from life; therefore he had to wait for the various species to bloom, and sometimes they flowered months apart. However, thanks to his good relations with the ruling Archduchess of the Netherlands, he had access to the royal greenhouses, where valuable botanical grafts were cultivated, including the first tulips.

Jan Bruegel
Hearing, Touch, Taste

1618
oil on wood,
25½ × 42 in.
(65 × 107 cm)
Prado, Madrid

The extraordinary
allegories of the five
senses constitute the most
celebrated cycle of
paintings by Bruegel,
who was known in Italy
as Velvet Bruegel because
of his almost tactile,
illusionistic rendering of
the most varied surfaces.
Bruegel executed the
allegories of the senses
when he was working
with Rubens, and some
were painted in direct
collaboration with Rubens
himself, who was
responsible for the figures.
This cycle is typically
Baroque in its translation
of concepts into images
through an overabundance
of detail.

Jan Bruegel
Smell

1618
oil on wood,
25½ × 42 in.
(65 × 107 cm)
Prado, Madrid

The sense of smell
is traditionally symbolized
by a flowering garden to
convey the idea of
countless scents and
perfumes. In this case,
too, it is important to
stress Bruegel's ability
to be both analytic and
synthetic. He succeeds
in bringing together
in a single, unitary,
coherent context a myriad
of details, each of which is
depicted with painstaking
care.

Jan Bruegel
Jesus and the Disciples
on the Sea of Galilee

1595
oil on copper,
10¼ × 13¾ in.
(26 × 35 cm)
Pinacoteca Ambrosiana, Milan

During the time he
spent in Italy, Bruegel
frequently painted
landscapes. Perhaps
influenced by themes
and styles of the High
Renaissance or by his
father, Pieter Bruegel the
Elder, Jan Bruegel liked
painting grandiose, stormy
scenes, sometimes using
the pretext of mythological
or religious subjects.
Here he draws inspiration
from the storm on the
Sea of Galilee, described
in the Gospels, and
depicts the contrast
between the sleeping
Christ and the agitated
disciples in the boat with
St. Peter at the helm.

Jan Bruegel
Ceres with the Allegories
of the Four Elements

1605
oil on copper,
10¼ × 14¼ in.
(26 × 36 cm)
Pinacoteca Ambrosiana, Milan

Here, too, Bruegel has left
the execution of the figures
to a different artist and he
has concentrated on the
images of nature. The
support he frequently
chooses, a smooth copper
plate, offers the
opportunity to use
particularly bright colors
and create clear, enameled
effects.

Jan Bruegel
Vase of Flowers with
Jewel, Coins, and Shells

1606
oil on copper,
25½ × 17¾ in.
(65 × 45 cm)
Pinacoteca Ambrosiana, Milan

Federico Borromeo's
written comments on
Bruegel's paintings and
their high price are very
interesting. Concerning
a picture of a bunch of
flowers, the cardinal notes,
"he painted a diamond in
the lower portion of the
picture. When we noticed
it, we realized what we
were supposed to
understand: the painter
wanted to indicate that the
value of his work equalled
that of the precious stone,
and that is the price we
paid the artist."

121

Peter Paul Rubens

(Siegen, 1577–Antwerp, 1640)

Born in Germany, where his father—
a wealthy man from Antwerp who had
embraced the Calvinist religion—had
gone into exile, Rubens acquired the first
rudiments of art in Cologne, but his real
training took place in Antwerp. In 1598,
at the age of nineteen, he joined the Guild
of St. Luke, the corporation of painters in
Antwerp. Two years later he left for Italy.
For a gifted painter like Rubens, going to
Venice and Rome in the year 1600 marked
a decisive turning point in his career.
During the early years, Rubens studied
art history voraciously. He followed the
traditional method of copying the old
masters to learn their style, and Holbein,
Lucas van Leyden, and Dürer were the

inevitable points of reference for a
northern artist, but in Italy he added
Raphael, Michelangelo, Correggio,
Tintoretto, Leonardo, and, most important
of all, the great Titian. Rubens also studied
classical antiquities. He was extremely
interested in Caravaggio's work and
became one of the first to admire him. He
entered the service of the Duke of Mantua
and stayed in Italy until 1608, making
frequent trips from Genoa to Rome. His
Italian journey was marked by memorable
works, including a group of altarpieces that
allow us to follow the different stages in
the development of an individual style,
based on figures that fill the space and the
use of rich colors, in which he was clearly
influenced by the Venetian school. In 1608,
his mother died and Rubens hastily left
Italy to return to Antwerp. He very soon
became the leading painter in the country

and this was confirmed by the grandiose
works executed for the cathedral. The
triptych of the *Descent from the Cross*, one
of the most moving works in religious
Baroque painting, is the synthesis of all his
early training, but also the key turning
point that led to the rapid development
of his career. After his marriage to the
beautiful Isabella Brandt, Rubens extended
his fine house in Antwerp by converting it
into an Italianate palace and studio, with a
garden containing elegant pavilions. Thanks
to the patronage of the grand dukes of the
Netherlands, Rubens's commissions
increased and he extended his workshop to
over a hundred assistants. Rubens's atelier
was the largest "mine" of Baroque art;
all the most famous Flemish artists went
through the experience of working there.
During the second decade of the
seventeenth century, he was living

permanently in Antwerp, but he sent
works to patrons who were increasingly
high-ranking. Then, from 1620 on, he
traveled to the great European capitals.
In Paris he executed the spectacular series
of canvases for Marie de' Medici and
Henry IV, twenty-one vast compositions
now in the Louvre. Then he visited
Holland, Madrid, and London between
1627 and 1630. During this period,
Europe was being devastated by the
Thirty Years' War, and Rubens drew up a
well-thought-out peace plan. He was now
one of the most famous men in Europe.
After the death of Isabella Brandt, he
married Hélène Fourment and painted
several delightful portraits of her. Rubens
became very wealthy as the result of his
highly successful career.

Peter Paul Rubens
Juno and Argos

1610–1611
oil on canvas,
98 × 116½ in.
(249 × 296 cm)
*Wallraf-Richartz Museum,
Cologne*

Rubens's great feeling for
narrative and his extremely
sensual style achieve full
expression in his highly
imaginative and spectacular
secular paintings. Here the
artist takes as his starting
point an episode from
Ovid's *Metamorphoses*
(Jupiter's love for the
nymph Io) and
sumptuously depicts the
macabre, pathetic subject
of the killing of the
mythical herdsman Argos,
who has one hundred eyes
so that he can keep good
watch over the herd in his
keeping. After he has been
decapitated by the wily
Mercury, Juno
commemorates the faithful
Argos by symbolically
placing his eyes in the
peacock's tail.

Peter Paul Rubens
Self-Portrait with Isabella
Brandt Under a
Honeysuckle Bower

1609–1610
oil on canvas,
70 × 56¼ in.
(178 × 143 cm)
Alte Pinakothek, Munich

Self-satisfied and confident,
this is how Rubens paints
himself with his first wife,
Isabella Brandt, in this
superb canvas celebrating
their marriage. With
his left hand resting on
the hilt of his sword,
Rubens appears as a
refined gentleman in his
early prime. He looks
impeccably genteel and
wealthy enough to be able
to afford the extravagance
of the gaudy orange
stockings enveloping his
shapely calves. A work by
an obviously successful
man, charmingly
accompanied by a woman
of enviable beauty,
Rubens's self-portrait can
be compared with similar
pictures by other leading
seventeenth-century
painters, including, first
and foremost, Rembrandt.

123

Peter Paul Rubens
The Judgment of Paris

c. 1605
oil on canvas,
35¾ × 45 in.
(91 × 114 cm)
Prado, Madrid

An early work, painted
during his years in Italy,
this can be considered one
of the artist's first pictures
of a subject he was
extremely fond of, the
shapely female nude. This
is a very famous episode,
in which Mercury presents
the three goddesses
(respectively, from left to
right, Minerva, Venus, and
Juno) to Paris for him to
choose the most beautiful.
The golden apple that will
indicate the winner glitters
at the center of the
composition, but a little
cupid bearing a crown can
already be seen hovering
over Venus's head. The
composition, with the
figures set in a semicircle
against the backdrop of a
luminous landscape, is still
inspired by the canons of
the Italian tradition.
Rubens painted the same
subject several times.

Peter Paul Rubens
Madonna of the Vallicella
Worshipped by Angels

1608
oil on slate,
167¼ × 98½ in.
(425 × 250 cm)
*Church of Santa Maria in
Vallicella, Rome*

The execution of the
works for the high altar
proved to be particularly
complicated. Finally, after
various attempts and
reworkings, Rubens chose
a deliberately archaic
approach and painted a
choir of worshipping
angels supporting and
crowning an oval frame
containing the Madonna
and Child in fixed, frontal
poses, like an icon.

Peter Paul Rubens
Adoration of the Shepherds

1608
oil on canvas,
118 × 75½ in.
(300 × 192 cm)
Pinacoteca Comunale, Fermo

Executed for the church of
San Filippo Neri in Fermo,
this canvas confirms
Rubens's contact with the
Confraternity of the
Oratorians, the order
founded by St. Philip Neri.
This little-known
altarpiece is perhaps the
most fascinating work
painted by Rubens in Italy.
It is beautifully poised
between evocative
Caravaggesque light effects
and echoes of the style
of Correggio.

Peter Paul Rubens
St. Gregory the Great with
Saints Domitilla, Maurus,
and Papianus

1606
oil on canvas,
57½ ×46¾ in.
(146 × 119 cm)
Gemäldegalerie, Berlin

While engaged in the
important work of
decorating the high altar
in the church of Santa Maria

in Vallicella, Rome, Rubens
painted many sketches for
the various sections of the
composition. He was
evidently aware of
establishing himself in
Rome with a pivotal work
in the history of painting.
Hence, the large
preparatory studies for the
two side wings of the
triptych are to be
considered independent
compositions, in which

Rubens experiments with
sumptuous settings and
broad planes of color
and drapery.

Peter Paul Rubens
Maria Serra Pallavicino

1606
oil on canvas,
95 × 55 in.
(241 × 140 cm)
*National Trust, Kingston Lacy
(Dorset)*

Rubens's female portraits,
particularly in his youth
and early maturity, are
striking in their stately,
detached magnificence.
This large canvas was
executed during one of the
painter's visits to Genoa,
the fundamental prelude
to the later arrival of
van Dyck. Rubens loved
Genoa; he was fascinated
by the urban fabric of the
Strada Nuova, designed
by Galeazzo Alessi,
and by the luxurious
lifestyle of the great
aristocratic families.
Rubens executed
memorable works for
the churches and princely
collections of the city,
some while he was there
and others that were later
sent from Antwerp;
however, not all of them
remained in Genoa. Here
the monumental size of
the figure, who is virtually
overpowered by the
sumptuous, glittering
gown and enormous lace
ruff, is offset by the
strange, almost caricatural,
small parrot clinging
to the back of the chair.

Peter Paul Rubens
Equestrian Portrait
of Giovanni Carlo Doria

c. 1606
oil on canvas,
104¼ × 74 in.
(265 × 188 cm)
Galleria Nazionale della
Liguria (Palazzo Spinola),
Genoa

A great collector and early
conoisseur of the art of the
period, whose intuitions
were ahead of his time,
Prince Doria succeeded
in amassing an incredible
collection of paintings that
included major works by
Caravaggio, Gentileschi,
Vouet, and leading early
Baroque artists. The most
outstanding work, and one
that in a sense synthesizes
the whole collection, is
this life-size equestrian
portrait by Rubens. This
picture is impetuous in
style, almost verging on
the exaggerated in the
long-haired little dog
attempting to imitate the
horse's gait. Rubens's
handling of the
composition is masterly;
it is dominated by a perfect
diagonal that starts from
the horse's tail, in the
bottom right-hand corner,
and moves upward to the
dark foliage of the tree,
top left.

Peter Paul Rubens
Portrait of Jan Vermoelen

1616
oil on wood,
50 × 38¼ in.
(127 × 97 cm)
Prince of Liechtenstein Collections, Vaduz

Composed and serious, the young man looks suspiciously askance at the viewer. Even the composition, with the character standing slightly to the right, as though he had just gotten up from the chair, creates an unsettled feeling.

Peter Paul Rubens
Portrait of Brigida Spinola Doria

1606
oil on canvas,
59¾ × 39 in.
(152 × 99 cm)
National Gallery of Art, Washington

This is another portrait painted in Genoa and further evidence of Rubens's compositional skill. Perhaps, in the past, the painting was cut on all four sides; today the figure is seen—to use a cinematic term—in "a middle-distance shot," from the knees up. The noblewoman is in a three-quarter pose against an architectural background that disappears in perspective toward the right. The resulting effect is that the figure is seen from below, like a large flower opening out into the enormous corolla of the starched collar; the head and elaborately curled hair appear to be resting on a ruffled tray. And yet, despite all this dazzling magnificence, despite the sumptuous satin gleaming in the light, Rubens still succeeds in capturing a spark of humanity, an embarrassed blush, a flash of psychological insight.

Peter Paul Rubens
The Lion Hunt

1616
oil on wood,
98 × 147¾ in.
(249 × 375.5 cm)
Alte Pinakothek, Munich

Painted for Duke
Maximilian of Bavaria,
the panel has remained
in the collections of the
court of Munich. Rubens's
inexhaustible love of life
and curiosity for every
aspect of the world led
him to look for exotic
subjects, unusual themes,
singular characters, and
animals from other
continents, a task made
much easier by the
continual arrival of ships
full of wonders from
every corner of the world
in the port of Antwerp.
In this search, the master
from Antwerp anticipated
modern attitudes.
His work would be an
important source of
inspiration for nineteenth-
century painting: the
reworking of this painting
by Delacroix is a perfect
example.

Peter Paul Rubens
Battle and Death of Decius
Mus

1616
oil on canvas,
113½ × 204¼ in.
(288 × 519 cm)
*Collection of the Prince
of Liechtenstein, Vaduz*

A scene from the cycle
devoted to episodes from
the life of the Roman consul
Decius Mus. This cycle,
kept in Vaduz, is one of
Rubens's first great works
in the field of painting from
literary sources.

Peter Paul Rubens
The Rape of the Daughters
of Leucippus

c. 1618
oil on wood,
87½ × 82¼ in.
(222 × 209 cm)
Alte Pinakothek, Munich

This episode, drawn from
Theocritus, represents the
abduction of the girls by
Castor and Pollux; if the
identification of the subject
is correct, then this is the
only painting depicting this
particular scene of the
story. It shows a deed of
love and violence; the
small cupid on the left has
a rather sinister
expression. However, the
illustration of the theme is
very much overshadowed
by the imposing
composition and the
opulent brushwork.
Rubens presents the
enormous group
composed of the girls, the
divine twins, the horses,
and the cupids as a single
quivering unit. Everything
turns, perfectly balanced,
like a colossal mechanism
masterfully controlled by
the artist. The result is one
of the great examples of
the pictorial representation
of mythological subjects,
interpreted not in terms
of intellectual elegance but
as a sensual wave of forms
and colors. The voluptuous
nudes of the girls tend to
fill the surrounding space,
reflecting the sunlight.
Rubens plays with the
reflections: the gleam of
the silk and of the blond
hair of the girl still lying
on the ground is
reminiscent of sixteenth-
century Venetian painting.
The horses add an animal
force to the scene, while
the Dioscuri are very
similar to classical
prototypes. On the basis
of the observation that
the two men do not seem
to be twins and that the
horses are of different
colors, it has recently been
suggested that the title
should be changed from
*The Rape of the Daughters
of Leucippus* to the more
frequent *The Rape of the
Sabines.*

Peter Paul Rubens
The Head of Medusa

c. 1617–1618
oil on canvas,
27 × 46½ in.
(68.5 × 118 cm)
*Kunsthistorisches Museum,
Vienna*

Monstrous, yet fascinating,
the head of Medusa still
seems to have the power to
turn her enemies to stone.
This terrifying and
extremely successful
painting gives us an idea of
the particular tastes of
certain collectors. It is
rather gruesome, not only
because of the serpents
writhing around the head
(part of the classical myth),
but also because of the
additional reptiles that
Rubens seems to have
relished depicting, perhaps
with the assistance of
Jan Bruegel.

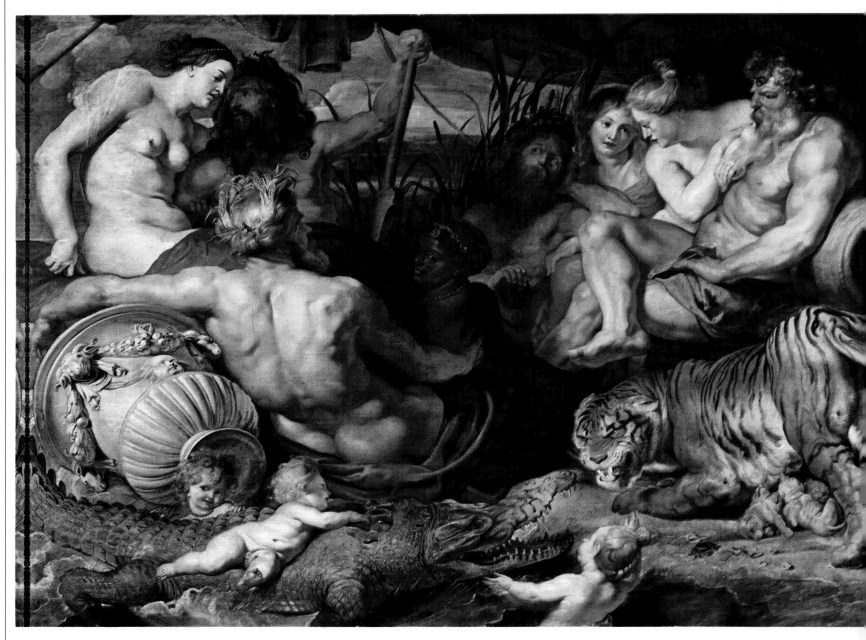

Peter Paul Rubens
The Four Continents

c. 1612–1614
oil on canvas,
82¼ × 111¾ in.
(209 × 284 cm)

*Kunsthistorisches Museum,
Vienna*

Enriched by Rubens's
direct observation of
exotic animals like the
crocodile and the tigress
suckling her young, which
must certainly have been
an astonishing sight on the
quayside in the port of
Antwerp, this painting
is an exemplary Baroque
allegory on the theme of
geography. In the century
that witnessed the birth of
scientific method,
knowledge was mostly
imparted through symbols,
emblems, complex and
fascinating images. Thus,
on Rubens's canvas, as well
as the animals, plants, and
archaeological references
that indicate the parts of
the world, the four women
symbolizing the continents
are embraced by the
images of the main rivers:
on the left, Europe with
the bearded Danube; in the
center, black Africa with
the fertile Nile crowned
with ears of corn; on the
right, in the foreground,
Asia with the muscular
Ganges; and, in the
background, America
with the Amazon.

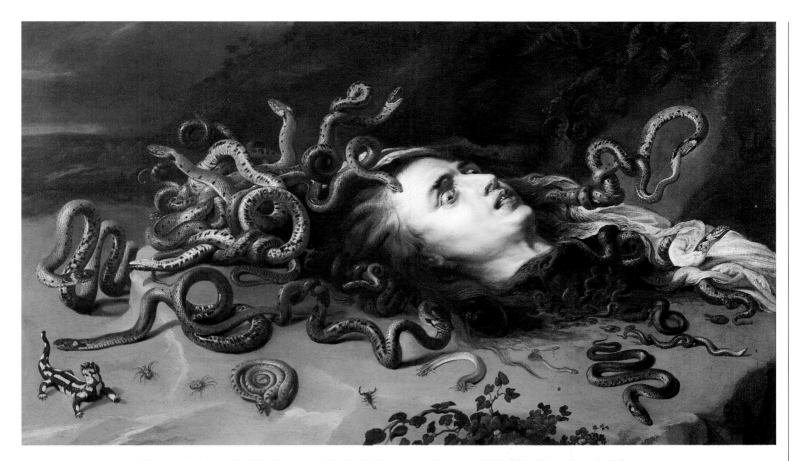

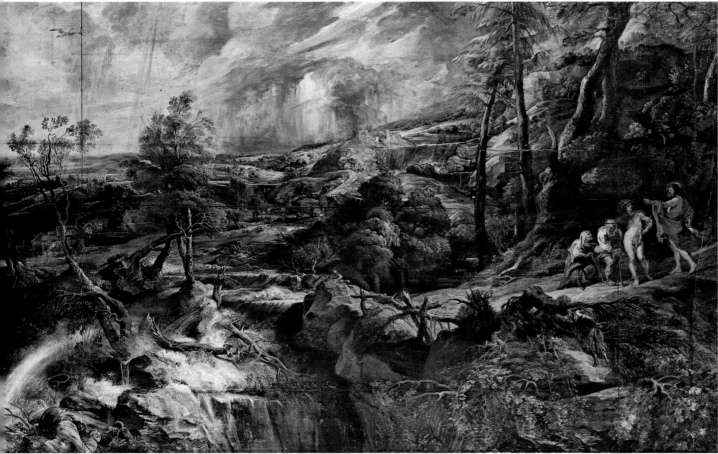

Peter Paul Rubens
The Tempest

1624
oil on wood,
57¾ × 82¼ in.
(147 × 209 cm)
Kunsthistorisches Museum,
Vienna

This extraordinary
landscape, in which a
violent tempest is abating
and the sky is changing
from dark stormy shades
to the colors of the
rainbow, is inspired by the
myth of the visit of Jupiter
and Mercury, disguised as
simple wayfarers, to the
elderly couple Philemon
and Baucis. Moved by the
welcome they have
received, the two gods
(seen on the right) save the
old people's home from the
storm, which has caused
considerable damage. In the
bottom left-hand portion of
the picture, a woman and
baby are attempting to flee
to safety, a cow is trapped
in the branches swept along
by the flood waters, and a
man is attempting to hold
fast. The landscape thus
acquires a "romantic"
atmosphere, enhanced by
the dramatic tones of the
background.

131

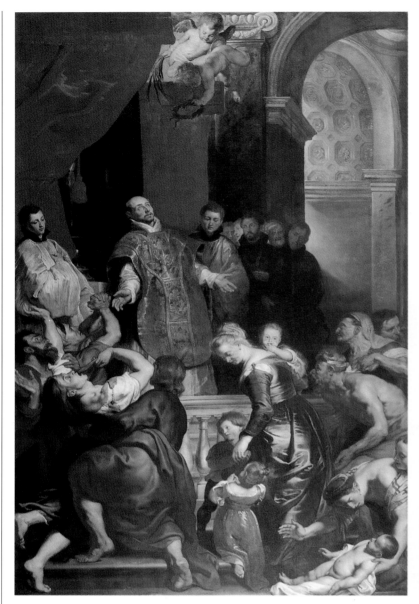

Peter Paul Rubens
Miracles of St. Ignatius

1612–1620
oil on canvas,
157½ × 108¼ in.
(400 × 275 cm)
Chiesa del Gesù,
Genoa

Rubens sent this canvas
from Antwerp for a side
altar in the beautiful
church in Genoa, where he
had previously painted a
Circumcision for the high
altar. It is brilliant evidence
of the evolution of the
master's religious painting.
Always inclined toward
grandiose, spectacular
compositions, Rubens
focuses on the figure of St.
Ignatius of Loyola, founder
of the Jesuit Order, who is

enveloped in sumptuous
gold vestments. Standing
between a red curtain and
the imposing architecture
sketched in the
background, St. Ignatius
raises his arms in a gesture
of invocation, but also as
though to protect himself
from the group of people
pleading for divine
intervention. There is a
sharp contrast between the
convulsed group on the
left, with muscular figures
attempting to restrain a
madwoman, and the quiet,
luminous portrayal of a
mother, in the center,
wearing an attractive
velvet gown and
surrounded by delightful
children.

Peter Paul Rubens
Isabella Brandt

c. 1625
oil on canvas,
33¾ × 24½ in.
(86 × 62 cm)
Galleria degli Uffizi, Florence

Fate held great happiness
in store for Rubens, and
his marriage to Isabella
Brandt, a woman of
unusual intelligence and
spirit, doubtless
contributed to this. This
unforgettable portrait,

painted at the time
of the wedding, is a most
magnificent tribute
to marital bliss, but the
subsequent portraits of his
first wife also express a
loving understanding, and
the relationship between
Rubens and Isabella was
undoubtedly both sensual
and intellectual. His wife's
death from the plague, in
1626, was the only real
tragedy in the painter's
life.

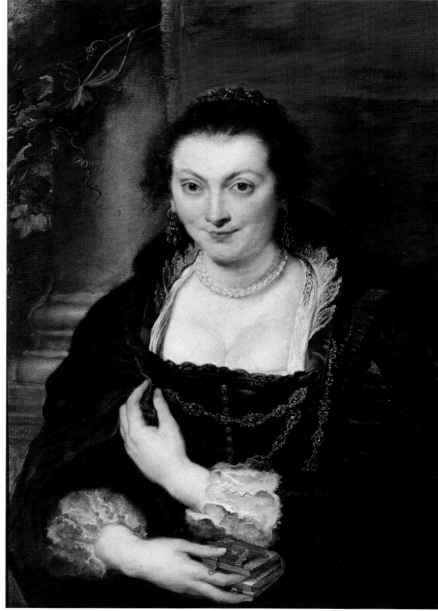

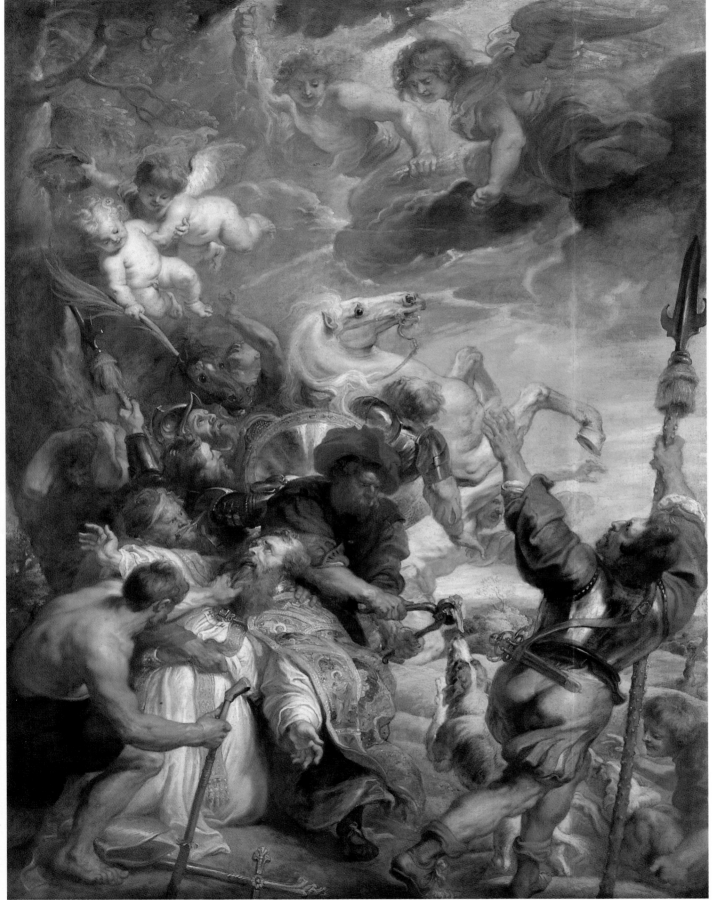

Peter Paul Rubens
Martyrdom of St. Livinus

1633
oil on canvas,
179¼ × 136½ in.
(455 × 347 cm)
Musées Royaux des Beaux-Arts, Brussels

The religious equivalent of *The Rape of the Daughters of Leucippus*, this painting of the atrocious martyrdom of the saint also centers on a whirling movement, dominated by the large rearing horse. The scene acquires the atmosphere of a *danse macabre*, performed by ugly actors whose faces are almost caricatures. The horrifying focal point of the composition is the saint's tongue that has been torn out with large pincers and presented as a trophy of bleeding flesh to an eager dog.

Peter Paul Rubens
The Straw Hat

1630
oil on wood,
31 × 21½ in.
(79 × 55 cm)
National Gallery, London

The traditional title of this magnificent work, certainly one of the most intriguing seventeenth-century portraits, does not correspond to the subject. The hat the young girl is wearing is certainly not made of straw, and the mistake may be the result of a copying error or a misunderstanding of the French title (*Chapeau de poil* has become *Chapeau de paille*). Quite apart from this, the portrait palpitates with the feeling emanating from the girl's expression, and it is animated by the shadow cast by the brim of the hat, and the contrast between the light blue of the ground and the warm, hazy red of the sleeves. Titian's influence can be seen in the extraordinary immediacy of this figure full of warmth and life. The girl is probably Suzanne Fourment, the sister of Rubens's second wife.

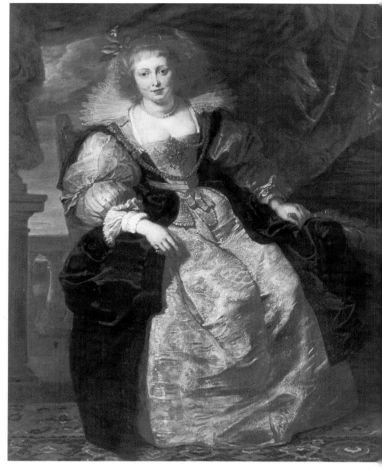

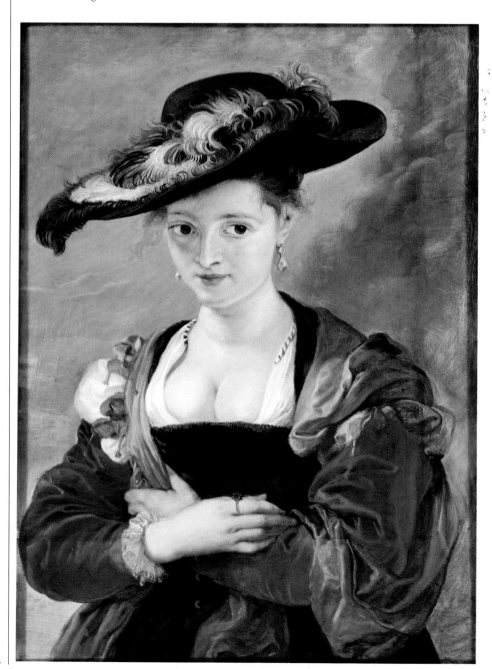

Peter Paul Rubens
Hélène Fourment in her Wedding Gown

1630–1631
oil on wood,
64½ × 53¾ in.
(163.6 × 136.5 cm)
Alte Pinakothek, Munich

Isabella Brandt left Rubens a widower when he was nearly fifty and he began to frequent a distant relative of his first wife. She was a fair-haired, shapely girl, perhaps not as intelligent as Isabella, but certainly very pretty and very attractive to a sensual man like Rubens. In 1630, sixteen-year-old Hélène married Rubens, who was then fifty-three. This was an injection of youth and vitality for Rubens during the last ten years of his life and work. The portrait of Hélène in her wedding gown exudes tenderness and cheerfulness. The girl, with her rosy cheeks and blond bangs, looks happy but almost intimidated, and she is leaning slightly toward the left, as though she is trying to be self-possessed and not finding it easy.

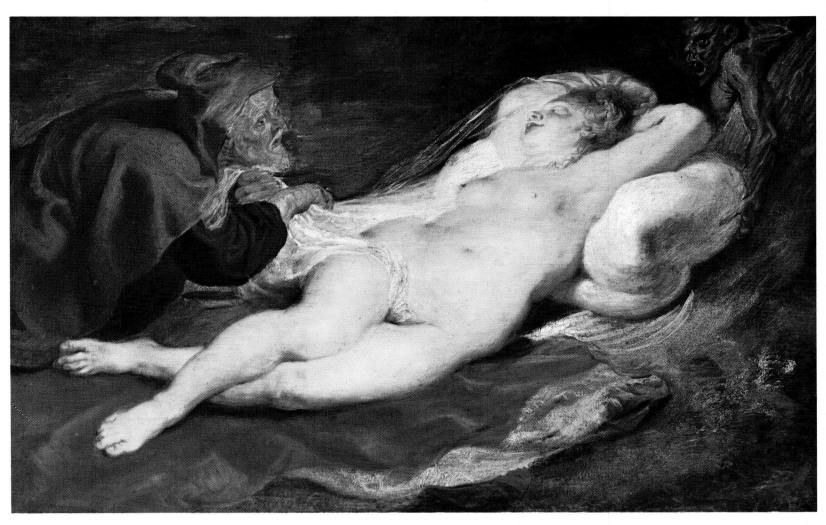

Peter Paul Rubens
Angelica and the Hermit

c. 1630
oil on wood,
17 × 25 in. (43 × 66 cm)
Kunsthistorisches Museum,
Vienna

This small, but very
beautiful, late work depicts
an episode from *Orlando*
Furioso: the sleeping
Angelica is carried to an
island by a demon
conjured up by a hermit's
magic art. The painting is
so exquisitely refined that
it is reminiscent of the

early works by Rembrandt,
who was already then
greatly admired by men
of culture like Constantijn
Huygens. Rubens's
admiration for Titian is also
evident here (he studied
the mythological
masterpieces in the King
of Spain's collections). In
fact, Rubens himself stated
that he drew inspiration
from Titian not only for
the beautiful reclining girl,
who is almost completely
nude, but also in his use
of thick paint and dense,
resonant color.

Peter Paul Rubens
The Garden of Love

1638
oil on canvas,
78 × 111½ in.
(198 × 283 cm)
Prado, Madrid

A late work of vibrant freshness, this is a convincing expression of Rubens's great *joie de vivre* even toward the end of his life. The work is an allegorical rendering of the Castle of Steen, in the environs of Antwerp, the sumptuous summer residence of the painter and his family. The nobleman on the extreme left is a self-portrait.

Anthony van Dyck
(Antwerp, 1599–London, 1641)

A great specialist in Baroque portraiture, van Dyck is one of the most refined painters of the early seventeenth century. A real child prodigy, he began painting at a very early age as a pupil of the famous Antwerp artist Hendrick van Balen, but in 1615, when he was only sixteen, he opened his own independent workshop. The great Rubens soon noted the young man's talent and his already evident success with local collectors. As soon as he became a member of the painters' guild, van Dyck joined Rubens's studio not as a pupil, but as the master's assistant. Rubens and van Dyck worked together, side by side, on some works, then the older master began to realize that the young artist might become a dangerous rival and he encouraged him to specialize in portraiture. However, van Dyck also continued painting mythological subjects, altarpieces, and religious and literary works all his life. From 1620 on, his fame as a portraitist quickly spread throughout Europe. In 1621, after a brief journey to England, van Dyck moved to Italy and chose to settle in Genoa; he was to stay there until the end of 1626. During his long and prolific Italian period, van Dyck also visited Venice, Rome, and Palermo for study purposes, but his base remained Genoa, which had a flourishing colony of Flemish painters and maintained close links with Rubens's workshop. Van Dyck's direct observation of Titian's works was to be pivotal in his development, and he clearly drew inspiration from him. During the years he spent in Genoa, van Dyck painted the portraits of members of the Genoese aristocracy. Decrepit old men and tender children, young noblewomen and haughty noblemen, all sat before the easel of the master, who usually painted the face and hands from life, and completed the elaborate garments and details of the setting in his studio. Van Dyck worked at a dizzying pace and consequently earned a great deal of money. When he returned to Antwerp (he was still very young, only twenty-six) he set himself up as Rubens's rival and encroached on the master's terrain. He painted several monumental and very successful altarpieces that were evidently influenced by Titian, and, in 1628, he became court painter to Archduchess Isabella. In 1632, despite his sucessful career in his homeland, he decided to move to England, and he sold the Castle of Steen to Rubens; it was to be the great master's "garden of love" during the last years of his life. In London, van Dyck was soon chosen as court painter to Charles I. Surrounded by a large group of pupils, during the years spent in England, van Dyck painted hundreds of pictures, nearly all of them portraits. Except for two visits to the continent (Antwerp in 1634, Paris in the last year of his life), van Dyck permanently settled in England and was knighted.

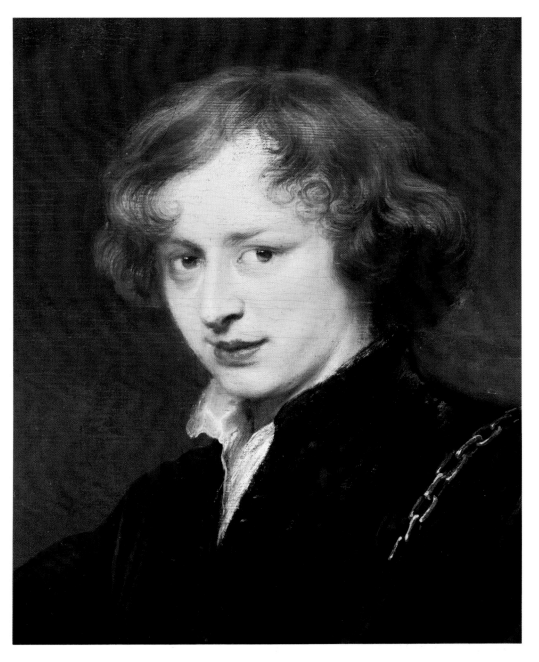

Anthony van Dyck
Self-Portrait

1621–1622
oil on canvas,
32 × 27¼ in.
(81 × 69.5 cm)
Alte Pinakothek, Munich

Van Dyck, a strikingly good-looking young man with a brilliant, precocious talent, often painted his own portrait. They are all very fresh works, executed with rapid, almost casual brushstrokes, in which a smiling youth at the outset of his career looks on the world with confidence and a feeling of eager participation.

Anthony van Dyck
Elena Grimaldi Cattaneo

1622
oil on canvas,
96¾ × 682 in.
(246 × 1732 cm)
National Gallery, Washington

This portrait, almost a
symbol of the painter's
stay in Genoa, is both
sumptuous and delicate,
showing perfect harmony
between the magnificence
of the scene and the
sensitive characterization
of the sitter. The young
noblewoman is portrayed
in front of the loggia of a
villa during a walk in the
garden. The solemn figure
passes by, rustling the
grass, while a dark-skinned
page tries to protect her
face from the sun. It is
clear from her fair hair
and pale skin that the sun
might be bothersome for
the duchess, but van Dyck
turns the delicate skin
into a striking detail of his
inventive composition.
The large red sunshade
glows like a profane halo
around her face, creating a
spectacular wheel of color.

Anthony van Dyck
Portrait of an Old Man

c. 1618
oil on wood,
42 × 29 in.
(106.5 × 73.7 cm)
Collection of the Prince of Liechtenstein, Vaduz

We have deliberately chosen two male portraits from the beginning and end of van Dyck's career in order to analyze the variation in style, especially in the use of paint and the free brushwork. This painting belongs to the earliest stage of his career, when he was just nineteen, in the year of his admission to the St. Luke Guild of Antwerp. The dominant influence is that of Rubens (who was also echoed by Jordaens in the same years), with an almost chronicle-like attention to descriptive detail and a full-bodied use of color. The background is neutral, as was the custom in the recent tradition of Caravaggio, while in the much later portrait of Nicolas Lanier, executed when the artist had already settled in England, the background is a distant landscape.

1632
oil on canvas,
44 × 34 in.
(111.5 × 86.2 cm)
Kunsthistorisches Museum, Vienna

A musician at the court of King Charles I of England, Nicolas Lanier was a court artist, exactly like van Dyck. Thus the painter presents a reflection of himself in the image of the refined courtier, capable of expressing his good taste simply in his attitude, his expression, his intelligence, and his culture.

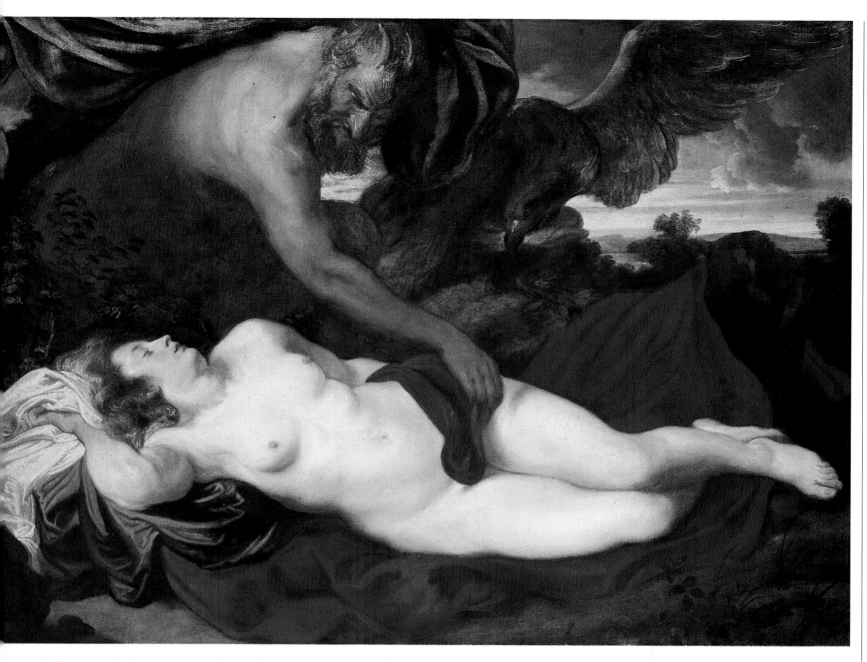

Anthony van Dyck
Jove in the Form of a Satyr
near Antiope

c. 1630
oil on canvas,
44¼ × 59½ in.
(112.5 × 151 cm)
*Wallraf-Richartz Museum,
Cologne*

The excellence of his
countless portraits should
not lead us to overlook van
Dyck's abundant work as a
"figure painter." However,
in the mythological
compositions and the
altarpieces, the influence of
Rubens is much more
evident, and van Dyck does
not always find the spark of
lively originality and
freshness that illuminates
his portraits. In this case,
too, he does not hesitate
to seek inspiration in the
profane painting of the
sixteenth century. Titian,
once again, is the closest
stylistic reference point,
and in any case is the
yardstick for all painters
who set out to depict
reclining female figures.
Among the works present
in this volume, similar
characteristics can be seen
in the paintings of Rubens,
Velázquez, and Rembrandt:
all of them pay homage to
Titian, who played a
decisive role in the
development of the history
of painting and increasingly
became the most important
Renaissance master for the
painters of the Baroque era.

Anthony van Dyck
Madonna and Child
with St. Catherine
of Alexandria

shortly after 1627
oil on canvas,
43 × 35¾ in.
(109.2 × 90.8 cm)
*Metropolitan Museum
of Art, New York*

Executed in Antwerp
in the brief period
following his return
to his native country
before he moved for good
to London, this fine
painting is a clear tribute
to Titian and the Venetian
tradition.

141

Anthony van Dyck
A Genoese Lady Known
as "Marchesa Balbi"

1622–1623
oil on canvas,
72 × 48 in.
(183 × 122 cm)
*National Gallery of Art,
Washington*

According to a very true
saying, in the seventeenth
century Genoa did not
have a king, but many
queens. The features and
sumptuous gowns of the
Genoese ladies whose
portraits van Dyck painted
give them a regal air. The
identity of this young
representative of the
Ligurian aristocracy is
unknown, but she is
certainly one of the most
captivating figures van
Dyck ever painted in the
shadow of the historic
lighthouse that dominates
the port of Genoa and
has become the emblem
of the city. Here the
painter has chosen the
setting of a softly lit
interior in order to
enhance the truly magical
effect of the intricate gold
embroidery decorating the
young woman's gown.
The hands stand out
beautifully against this
sartorial magnificence, and
the fresh face emerges like
a flower, illuminated by
dark, piercing eyes
and a smile it is difficult
to forget.

Anthony van Dyck
Portrait of Agostino
Pallavicino

1622
oil on canvas,
85 × 55½ in.
(216 × 141 cm)
J. Paul Getty Museum, Malibu

The radiant portraits
of beautiful Genoese
noblewomen triggered
spicy stories of handsome
young van Dyck's amorous
conquests. Apparently he
was even challenged to a
duel by the husband of one
of these young members
of the aristocracy. The tone
of the male portraits,
in which van Dyck
concentrates so effectively
all the virtues and vices of
Liguria, is quite different.
Senator Agostino
Pallavicino, one of the most
ambitious nobles in Genoa,
gazes rather suspiciously at
the spectator. His
sumptuous attire (bursting
with light and color) seems
to set up a barrier between
the privacy of the
personage and the visitor,
who feels uncomfortably
like an intruder.

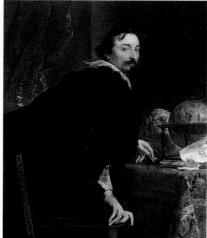

Anthony van Dyck
Lucas van Uffel

1621–1626
oil on canvas,
49 × 39½ in.
(124.5 × 100.6 cm)
*Metropolitan Museum
of Art, New York*

A famous art dealer and
collector, Lucas van Uffel
worked in Venice. The
painter has cleverly
captured him in the act
of getting up from his
desk, on which valuable
objects can be seen.

Anthony van Dyck
The Lomellini Family

1625
oil on canvas,
104¼ × 97¾ in.
(265 × 248 cm)
*National Gallery of Scotland,
Edinburgh*

A canvas of pivotal importance in the history of family portraiture, this large composition portrays the members of the noble Genoese family at a time of danger. The city runs the risk of being attacked and besieged and the inhabitants are preparing for war. Hence the head of the family, on the extreme left, is dressed from head to foot in armor, ready to play his role as defender of civic liberty. He is seen on the threshold of his home, since he has to leave his family to occupy himself with state affairs. His brother, armed with a sword, is turning toward the interior of the house; it is his duty to protect his sister-in-law and her children. The matronly, self-possessed mother represents stability. Seated in the center of the composition, she is the pivot of the painting and of the Lomellini family. The two children are close to their mother: while the daughter seems to realize her father is about to leave, and observes him with a worried expression on her face, her younger brother has only a vague idea of the danger and looks questioningly at his elder sister. The portrait thus becomes a masterly emotional and psychological work.

Anthony van Dyck
Portrait of Cardinal
Bentivoglio

1623
oil on canvas,
77¼ × 57 in.
(196 × 145 cm)
*Galleria Palatina, Palazzo
Pitti, Florence*

This extraordinarily immediate, yet extremely official, portrait is one of the painter's major works. van Dyck, at the height of his Italian period, shows with what great finesse he can interpret the models of the past and translate them into an original, individual style. The painting is, in fact, influenced by Titian (the figure turning to gaze out of the frame, the extraordinarily rich and varied range of reds), but there are also echoes of Raphael, in particular the portrait of Pope Leo X, in the carefully studied composition, with the cardinal seated at a table bearing elegant objects that indicate his good taste and wealth. Nonetheless, these references to the Italian Renaissance blend in a style that is unmistakably personal, highly refined, and charged with energy, capable of broad sweeps of color, but also of expressing the subtle changes of expression and the psychology of this interesting personage.

Anthony van Dyck
Equestrian Portrait
of Prince Thomas of Savoy

1634
oil on canvas,
124 × 93 in.
(315 × 236 cm)
Galleria Sabauda, Turin

Toward the end of his stay in Italy, van Dyck came into contact with the Savoy family. The reigning house of Turin commissioned works from the Flemish painter in subsequent years, even when he was far away in London. This equestrian portrait, one of the most representative of Savoy historic paintings and a model for Piedmontese official portraiture, already displays the characteristics of van Dyck's English period: the figure is no longer seen in close-up and there is a broad view of the countryside.

Anthony van Dyck
James Stuart, Duke
of Richmond and Lennox

after 1632
oil on canvas,
85 × 50¼ in.
(215.9 × 127.6 cm)
*Metropolitan Museum
of Art, New York*

Van Dyck's numerous
English paintings are
among the most important
in the history of
aristocratic portraiture.
They also laid the
foundations for the future
development of the English
school of painting,
discussed in the last
chapter of this book.
In order to meet the
overwhelming demand,
van Dyck employed
assistants, and the works
executed in London are
not always entirely painted
by him. In contrast,
this large canvas, an
extraordinary masterpiece,
is all his own work. The
slim figure of the young
nobleman, dressed in an
extremely elegant suit
with delicate touches
of light blue, is enhanced
by the thin greyhound.

Anthony van Dyck
Portrait of Charles I

c. 1635
oil on canvas,
104¾ × 81½ in.
(266 × 207 cm)
Louvre, Paris

In Genoa, van Dyck
had become "Italian";
in London he changed
into a perfect English
gentleman of the court. In
traveling from one country
to the other, the highly
sensitive van Dyck knew
how to interpret the
different characteristics
of his patrons, but also of
the climate, the landscape,
the style of dress, and the
social attitudes. Intuitively
van Dyck captured the
English love of the
countryside and sport.
The king readily had his
portrait painted in
comfortable hunting
clothes, in the middle
of a green landscape.
His nobility is revealed
through his expression
and the innate elegance of
the pose, and not through
ostentatious attire. This
is the complete opposite
of the portraits of the
Sun King, like the
extremely pompous one
by Rigaud. This kind of
portrait remained a
fundamental model for
the English school. Over
a hundred years later, in
the late eighteenth century,
the relationship between
figures and landscape
established by van Dyck
was to be taken up and
developed by
Gainsborough.

439

Jacob Jordaens

(Antwerp, 1593–1678)

Jacob Jordaens is the third of the great masters of the Antwerp school, after Rubens and van Dyck, who led the city on the Scheldt to the height of European painting in the first half of the seventeenth century. Unlike his two famous colleagues, Jordaens did not spend long periods studying in Italy. His art remains attached to the firmly established, flourishing Flemish tradition, while the many ideas drawn from Italian art are always filtered through his completely independent style. Jordaens was drawn into the orbit of Rubens's vast workshop and soon became established as a versatile painter, not as a specialist in a particular genre like his fellow artists Jan Bruegel (still life) and van Dyck (portraiture). He therefore closely collaborated with Rubens, but was also, above all, an independent master, highly skillful at developing the stimulating innovations of Caravaggio and Michelangelo, in a style based on broad brushwork, thick with paint. Caravaggio's influence, which is most evident in the light effects of his early works, becomes more attenuated as the years pass, and is replaced by a style of painting that is more popular and immediately enjoyable, simple and full-bodied. Among his religious works, the scenographic altarpiece with the *Martyrdom of St. Apollonia* deserves a special mention, but his paintings of rustic subjects or natural produce are also very noteworthy. Late in life Jordaens often returned to subjects that were dear to him, such as crowded festive scenes and Aesop's fable about the peasant and the satyr. After the death of Rubens in 1640 and of van Dyck in 1641, Jordaens became the leading Flemish painter of his day.

Jacob Jordaens
Self-Portrait of the Painter
with His Family

1621–1622
oil on canvas,
71¼ × 73 ½ in.
(181 × 187 cm)
Prado, Madrid

This memorable painting,
belonging to the widespread

and endearing genre of the
self-portrait with family,
does not depict the artist
at his easel or in his
painter's smock, but in
extremely elegant attire,
holding a lute, not a palette.
Every detail indicates his
high social and financial
standing, so much so that
the work may be compared

with the eloquent *Self-
Portrait with Isabella Brandt*
painted by Rubens ten years
earlier. The Jordaens family
is enjoying the relaxing
atmosphere and shade
of a garden in full bloom
at the end of summer, with
a gushing fountain, and a
young maid carrying a
basket of ripe grapes.

The delightful little blond
girl, the painter's beloved
daughter, is portrayed
smiling and timid, with a
gentle blush suffusing her
cheeks, and an expression
that is a blend of coyness
and curiosity. A figure truly
equal to Renoir's little girls.

Jacob Jordaens
The Holy Family

c. 1625
oil on canvas,
46¾ × 44½ in.
(118.5 × 113.1 cm)
*Romanian National Museum
of Art, Bucharest*

This work belongs to the
genre of "candlelit"

painting, greatly favored
by collectors of the time
and considered explicit
proof of a painter's
virtuosity. The food
prepared for the Baby Jesus
is also part of the Flemish
tradition and it enhances
the delicate atmosphere
of domestic intimacy.

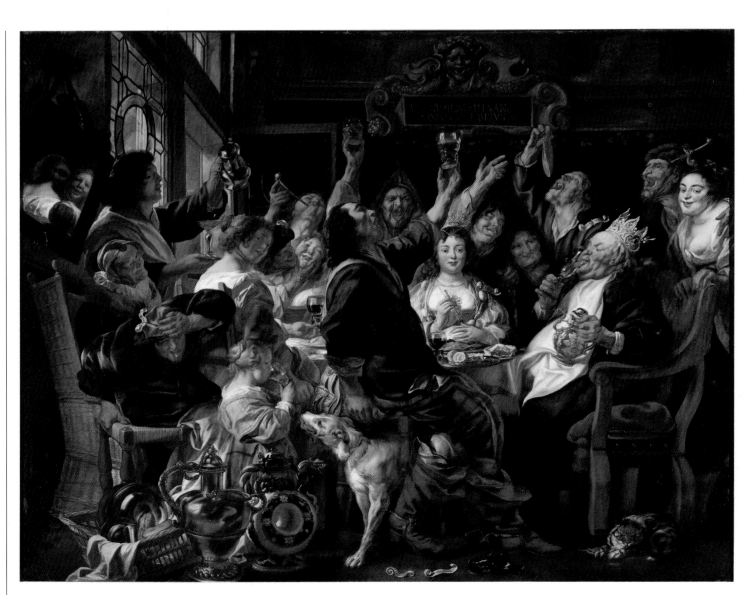

Jacob Jordaens
The Feast of the Bean King

before 1659
oil on canvas,
95¼ × 118 in.
(242 × 300 cm)
*Kunsthistorisches Museum,
Vienna*

Scenes of parties and
banquets are very typical
of Jordaens's oeuvre. There
were many occasions for
celebrating: feast days and
holidays, marriages,
anniversaries, or other
celebrations were an
excuse for abundant eating
and drinking. A famous
Flemish feast took place on
the day of Epiphany. A
bean was hidden in a cake

or pie, and the person who
found it in their slice
became king of the feast
and master of ceremonies.
Similar scenes are also to
be found in the work of
the Dutch painter Jan
Steen, who often morally
stigmatized excess and
intemperance. Though
Jordaens celebrated
abundance and jollity, he,
too, underlined the
dangers of drunkenness: a
Latin inscription reminds
us that "None resembles a
madman more than a
drunkard," while a little
girl is about to drink a
glass of wine, between a
growling dog and a
vomiting man.

Jacob Jordaens
The Holy Family
with the Shepherds

1616
oil on canvas, transferred
from wood,
42 × 30 in.
(106.7 × 76.2 cm)
*Metropolitan Museum of Art,
New York*

Small religious paintings are
a genre apart, not only in
Jordaens's oeuvre but also
in that of Rubens and other
Baroque masters. In

this early canvas it is
interesting to note the
blend of echoes of the
European Caravaggists
(filtered through the
Rubens school in Antwerp)
and of Dutch painting.
Well-known and admired
by local collectors, Jordaens
became a point of reference
and a means of comparison
for the so-called
"Caravaggists of Utrecht,"
including van Honthorst
and Terbrugghen.

Jacob Jordaens
The Peasant and the Satyr

c. 1625, oil on canvas,
74¾ × 65 in.
(190 × 165 cm)
Museum of Fine Arts, Budapest

Here Jordaens gives a charming, realistic interpretation of a theme often dealt with by Flemish and Dutch artists in the seventeenth century, and which he himself painted in various clever versions at different times during his career. According to one of Aesop's fables, in the dim and distant past, satyrs lived on the earth. One evening a satyr was invited to dinner by a peasant, who, when he came home feeling cold, blew on his hands to warm them up. At the table, the peasant blew on his spoonful of soup, this time to cool it down. Astounded by the ambivalence of this gesture, the satyr jumped up, reprimanded the peasant, and from that evening on decided never again to live with human beings, since they were so dangerously false and hypocritical.

Seventeenth-Century Holland

Willem Kalf
Still Life with Nautilus Shell Goblet, detail
1662
oil on canvas,
31 × 26¼ in. (79 × 67 cm)
Thyssen-Bornemisza
Collection, Madrid

Rembrandt van Rijn
Portrait of Jan Six
1654
oil on canvas,
44 × 40¼ in.
(112 × 102 cm)
Six Collection,
Amsterdam

At the end of the sixteenth century, after a long, grueling war against Philip II of Spain, seven United Provinces of the Netherlands won independence. Holland was really only one of these seven areas, but it had the largest concentration of cities and industries. The United Provinces were a republic, ruled by the *stadtholders* (governors) of the House of Orange, but they had a great deal of local autonomy. Lacking in great art and culture, except for the outstanding figure of Erasmus of Rotterdam, Holland almost unexpectedly became one of the powers of Europe. That small population, constantly battling against the sea, living in a flat, monotonous landscape that the ingenious system of canals and windmills had transformed into rich agricultural land, emerged from anonymity and won the envious admiration of the whole continent in only a few decades.

Thanks to the extraordinary enterprise of the East India Company, at the beginning of the seventeenth century, the ports of Amsterdam and Rotterdam were the most flourishing financial and commercial centers in Europe, and with this solid basis of widespread wealth the Dutch people found many reasons for cohesion and national pride. The Dutch language, which spread thanks to an intensive and intelligent literacy campaign, became completely autonomous and definitively separate from the German, and acquired literary dignity. Calvinism became the official religion that imposed a temperate lifestyle and firm moral principles. However, strong Catholic and Jewish minorities were welcomed with unusual tolerance and made their own original cultural contributions to the society. The rapport between home life and moments of socialization was governed by a precise calendar in which holidays and days of penance alternated; love of the family and care of the household was offset by a brilliant social life. The risky commercial exploits on oceans throughout the world were compensated for by the peace and comfort of daily life. In other words, during the seventeenth century the Dutch enjoyed a private prosperity and social harmony that were unique. Without a real court or an aristocracy, and devoid of ecclesiastic privileges, seventeenth-century Holland saw the establishment of a bourgeoisie of entrepreneurs, professionals, merchants, and financiers, and can be considered the first modern capitalist democracy. Among the more precise indicators of the flourishing situation in Holland, apart from the daily consumption of calories and the literacy figures, was the fact it had the highest ratio in Europe of works of art, particularly paintings, to number of inhabitants.

The Dutch school perfectly followed the course of history and the creative development of the principal masters. Between the end of the sixteenth and the beginning of the seventeenth century, when the country became autonomous, it began to become independent and distinguishable as a school. During the first half of the century, it continued to become enriched by new themes and personages, mostly linked to the pleasure and pride taken in a precise identity, but also connected with the unusual availability of merchandise and of exotic influences brought by overseas trade. After 1660, when the greatest painters, Vermeer, Frans Hals, and Rembrandt, had died, and tastes had swung to more ordinary, classicizing themes, Dutch art began to

Jan Vermeer
The Letter
c. 1666
oil on canvas,
17¼ × 15¼ in.
(44 × 38.5 cm)
Rijksmuseum, Amsterdam

go into a decline, and military and political affairs of the state took a downward turn.

The first artistic school that was completely Dutch, namely detached and different from the Flemish school and the general influences of international Mannerism, was the group of painters active in the important Catholic and university city of Utrecht at the beginning of the seventeenth century. Having trained toward the end of the Renaissance, artists like Hendrick Terbrugghen and Gerard van Honthorst were irresistibly attracted to Italy and spent many years of their careers in Rome. The Utrecht painters, however, did not show a great interest in classical antiquity or Renaissance art; by contrast, they were extremely taken by Caravaggio's realism and contributed decisively to the spread of Caravaggism in Europe. Van Honthorst and Terbrugghen (who, precisely because they came from Utrecht, continued to paint important religious commissions) were also fascinated by Caravaggio's subjects: teeth-pullers, street musicians, fortune tellers, soldiers, and passers-by—scenes of daily life drawn from the street and everyday reality. This was to become a predominant theme of Dutch seventeenth-century art, which is distinguished by its cordial and amiably truthful representation.

Another major genre in the art of the Netherlands was the portrait. This was the typical result of the extension of the art market to a new and larger clientele. Apart from expressing the self-satisfaction of the wealthy Dutch bourgeiosie, portraiture spread rapidly, giving an idea of the fashions and feelings, the stricture and license of a happy, well-ordered society. The greatest portraitist, Frans Hals, is somewhat paradoxically one of the most extravagant and liberated painters of the seventeenth century. Inevitably tied to fixed subjects and schemes, Frans Hals escapes monotony thanks to his vigorous brushwork and use of color. The legendary rapid execution of his works (Hals did not make sketches or preparatory drawings, but applied the paint directly to the canvas) gives his portraits a fresh, new vitality that was to be noted and imitated by nineteenth-century painters, including the Impressionists. The most striking works in Hals's oeuvre are his complex, imposing, large group portraits that depict the meetings and banquets of the civic militia companies,

which were widespread in Dutch society. In the hands of other painters, these scenes become monotonous rows of static faces; by contrast, in Frans Hals, action and movement, the interchange of looks, expressions, and gestures predominate. However, even Frans Hals's brilliant approach pales in comparison with the dramatic, inspired *Night Watch*, Rembrandt's absolute masterpiece.

Rembrandt marks a high point and turning point in seventeenth-century Dutch painting. A truly versatile genius, Rembrandt adopted many different genres and techniques, always producing the finest results. His

מתת וס
נקפ ס
א אלר ת

Rembrandt van Rijn
The Feast of Balthazar
c. 1636
oil on wood,
65¾ × 82½ in.
(167 × 209.5 cm)
National Gallery, London

ambition was to tackle the great historic subjects and the style of the Italian masters, so much so that he decided (the only one of the many Dutch painters) to sign his works with his Christian name, like Titian, Raphael, and Leonardo. Rembrandt also went against the general trend because he did not make the customary journey to Italy, particularly Rome; in fact he traveled no farther than Amsterdam, twenty-five miles from Leyden. And yet his horizons were truly extensive, as was his fame. Whatever his subject (mythological scenes, episodes from the Bible, allegories, or portraits), Rembrandt interprets painting as a direct, intense participation in human emotions, sensations, and feelings. Rembrandt painted many self-portraits that give an explicit, striking impression of the often dramatic

events of his life, but one might even say that "all" Rembrandt's pictures are, in a sense, self-portraits, given the emotional charge and human involvement that they convey. The master's style changed greatly during his career of more than forty years. If we did not know the course of its development, it would be difficult to attribute the precise, delicate brushwork of his early works and the heavy, dense planes of color in the works of his maturity and old age to the same hand. Rembrandt's late paintings, which we consider today to be some of the most moving and intense works in the whole history of art, perplexed the Dutch patrons of his day. The development of the master's art toward an extremely expressive and deliberately sketchy style coincided with a change in taste that favored meticu-

Frans Hals
The Laughing Cavalier
1624
oil on canvas,
32¾ × 26½ in.
(83 × 67.3 cm)
Wallace Collection,
London

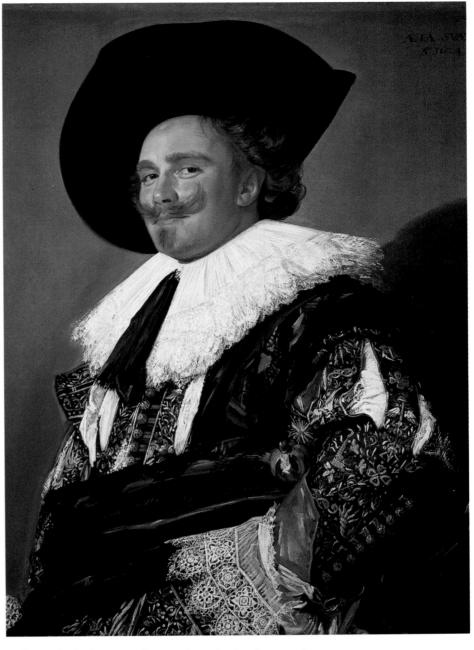

lous, clean, precise works. At the same time, while Rembrandt arrived at a universal dimension, with paintings and characters that had the timeless power of classical poetry, the Dutch people preferred to hang in their homes serene, pleasant pictures portraying the typical features of their society and way of life. Artists like Pieter de Hooch and Jan Steen specialized in scenes of Dutch life, in perfectly swept houses, tidy city streets, the familiar, comfortable and well-loved places of everyday experience. An elegiac, domestic poetry dominates de Hooch's world, where everything seems to belong to a kind of higher order and everything that happens follows calm, familiar patterns. De Hooch depicts with tranquil charm spotlessly clean floors; cupboards containing folded, scented bed linen; small, well-kept gardens; and swept doorsteps. Seventeenth-century Dutch society found in him its most impassioned and direct exponent. Jan Steen was also inspired by everyday subjects, but with increasing frequency he depicted the opposite aspect: whining, snotty-nosed children, coarse old men, and seductive girls disrupt the neat and tidy order, creating confusion. Some of Steen's best paintings are brilliant satires of society, where everything is the opposite of what it should be. De Hooch's polite world is transformed into chaotic pandemonium, perhaps not without its own diabolic gaiety.

The greatest painter of Dutch interiors, Jan Vermeer of Delft, avoids this mirror game of reality and satire. In fact, describing Vermeer as a mere "painter of interiors" is very reductive, not only because his not very prolific output also includes landscapes, portraits, religious, and mythological scenes with large figures, but also, and most importantly, because in his domestic interiors and his characters Vermeer does not merely depict what he sees. Vermeer was a friend of the inventor of the microscope, and he seeks and finds the secret life, the soul of things and people. This great poetic master transfixes images in a suspended silence, at a moment when time stands still, in a passing ray of light. With infinite tenderness and unprecedented understanding, Vermeer captures the inner life of men and women, cavaliers and girls, high-ranking ladies and simple servants. Certainly his scenes are set in the meticulous context of seventeenth-century Holland. Interiors, de-

tails, and clothes are depicted with absolute realism. And yet Vermeer's figures are not limited to their time and country; they become eternal images of feelings and passions. Vermeer's exquisite painterly technique, based on a masterly handling of light effects, makes his canvases always fresh and bright, and they convey an unfailing, moving sense of modernity.

Hendrick Terbrugghen

(Deventer, 1588–Utrecht, 1629)

The major exponent of the Utrecht school, Terbrugghen played a decisive role in the history of Dutch painting by leading the transition from the late sixteenth-century Mannerist tradition to the Caravaggesque style, which was spreading throughout Europe. It is important to remember that the city of Utrecht, the episcopal center of Holland, had remained mostly Catholic, in a country that had almost entirely converted to Calvinism. For this reason Terbrugghen and his colleagues (like van Honthorst) frequently painted traditional religious subjects, which were far rarer in the rest of Holland. During the years of his training with Abraham Bloemaert, the young Terbrugghen made a close study of Renaissance prints by Dürer and Lucas van Leyden, thus acquiring a taste for distinctive expressions, unusual physical types, and strongly marked features. In 1604 he moved to Rome where he made the personal acquaintance of Caravaggio. Terbrugghen spent ten years in Italy and during this time he mastered the technique of painting large canvases, with strong contrasts of light and shadow, and great dramatic intensity. The subjects, light effects, and compositions are directly influenced by Caravaggio, but the painter adds his personal interest in physiognomy and his characters reappear in various contexts in different pictures. On his return to Utrecht in 1614, Terbrugghen became the driving force in the local school of painting and he encouraged all the young artists to spend a period of study in Italy. He himself returned there in 1620, and found a new artistic climate in which the paler and more luminous tones of the Bolognese school predominated. Terbrugghen's painting also became lighter, and he began to paint genre scenes and to give a more realistic and picturesque rendering of religious subjects.

Hendrick Terbrugghen
Calling of St. Matthew

c. 1616
oil on canvas,
41¾ × 50½ in.
(106 × 128 cm)
Museum of Fine Arts, Budapest

This is one of the painter's favorite subjects, inspired by the famous canvas by Caravaggio in the church of San Luigi dei Francesi in Rome, though his compositions constantly vary.

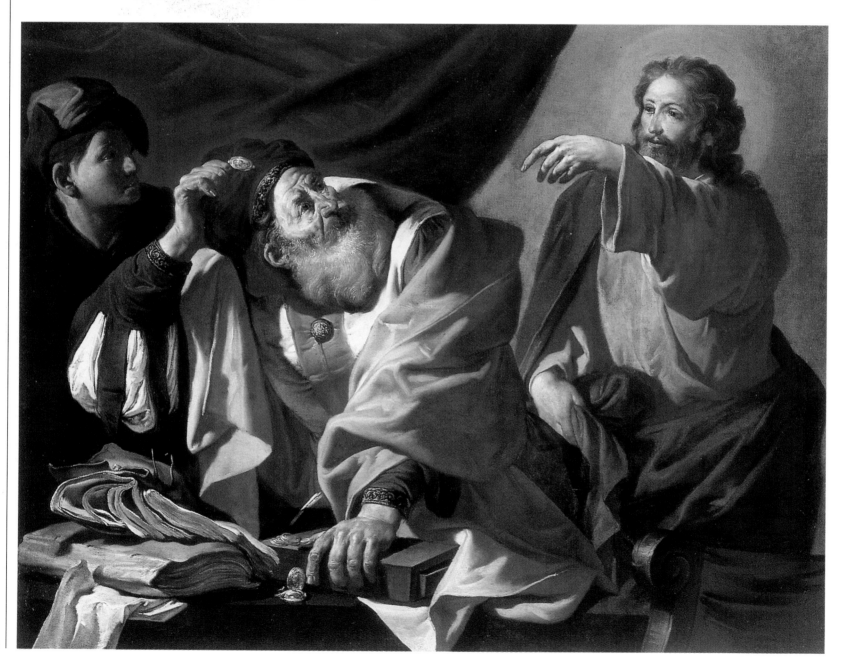

Hendrick Terbrugghen
Incredulity of St. Thomas

c. 1604
oil on canvas,
42¾ × 53¾ in.
(108.8 × 136.5 cm)
Rijksmuseum, Amsterdam

This important early work
shows Terbrugghen's
particular interest in
expressions and physical
features. The emphasis
on portraiture, which
sometimes verges on the
grotesque, is based on his
close study of northern
engravings. The influence
of Leonardo da Vinci is
also equally evident, and
was transmitted through
the brilliant work of
Italian-style Flemish
painters like Quentin
Metsys. Terbrugghen's
painting, therefore,
though modern in its
Caravaggesque aspects,
remains rooted
in the artistic tradition
of the sixteenth century,
transposed in a new key.

Hendrick Terbrugghen
Calling of St. Matthew

1621
oil on canvas,
40¼ × 54 in.
(102 × 137 cm)
Central Museum, Utrecht

Considered one of
the painter's greatest
masterpieces, this painting
synthesizes the two main
aspects of Terbrugghen's
style: the influence of his
long stay in Rome blended
with the typical Dutch
tendency to represent
reality. Religious subjects
are treated in an
unconventional way
and the devotional feeling is
replaced by an intense need
to convey human truth. The
faces, expressions, light
effects, and descriptive
details are drawn from
everyday life; they are part
of the ordinary, though
touching, daily experience.

159

Hendrick Terbrugghen
Woman with Monkey

c. 1620
oil on canvas,
33¾ × 25½ in.
(86 × 65 cm)
J. Paul Getty Museum, Malibu

Though he preferred
dynamic, monumental
scenes, Terbrugghen also
painted a considerable
number of half-figures,
which are reminiscent of
Caravaggio's early works,
like the genre scenes
before 1600, for example,
the *Boy with a Basket of Fruit*
or the *Bacchus*.

Hendrick Terbrugghen
King David Playing
the Harp

1628
oil on canvas,
59 × 74¾ in.
(150 × 190 cm)
Muzeum Narodwe, Warsaw

The introduction of
magnificent costumes
and bright colors increased
Terbrugghen's popularity
on an international level.
Works like this one were
evidently destined for
princely collections.

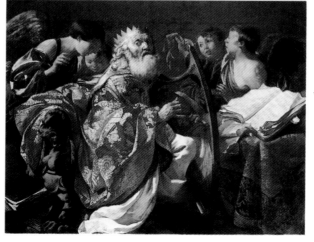

Hendrick Terbrugghen
Boy Lighting His Pipe
with a Candle

c. 1625
oil on canvas,
26½ × 21¾ in.
(67.6 × 55 cm)
*Dobó István Vármúzeum,
Eger (Hungary)*

Terbrugghen, too, tried
his hand at "candlelit"
painting, the kind of scene
van Honthorst excelled in,
which had become an
almost obligatory test
of an artist's bravura.

Terbrugghen's painting
therefore belongs to
a genre that became
widespread from the end
of the sixteenth century
on and was mistakenly
considered Caravaggesque.
However, here he
introduces the new
"sub-theme" of tobacco.
Tobacco smoking began
in Holland, since it was
imported by the East India
Company, and it spread
to Europe, where it
soon became a popular
fashion.

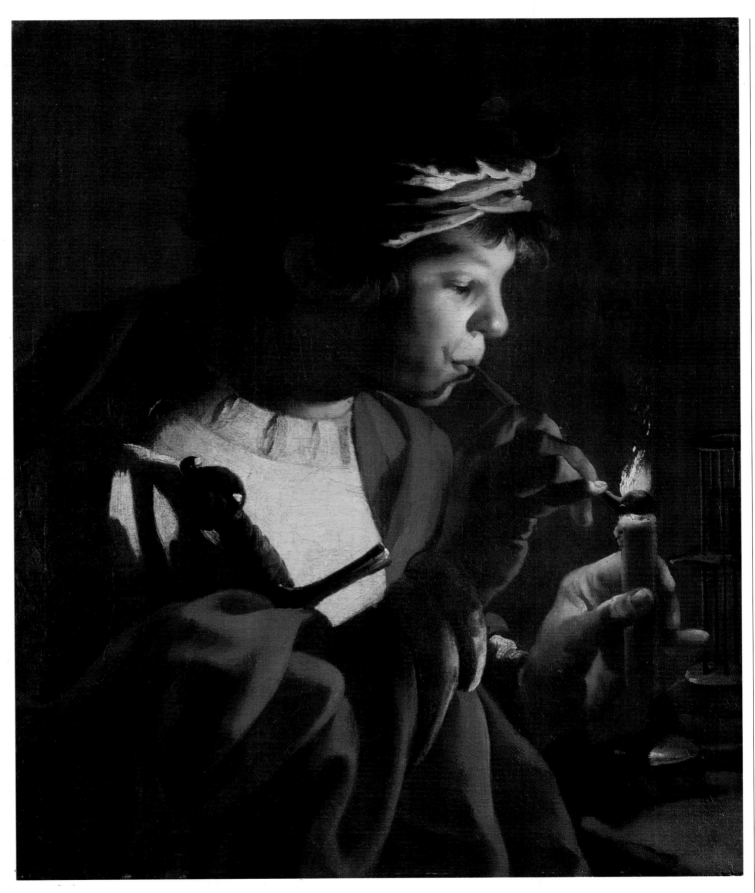

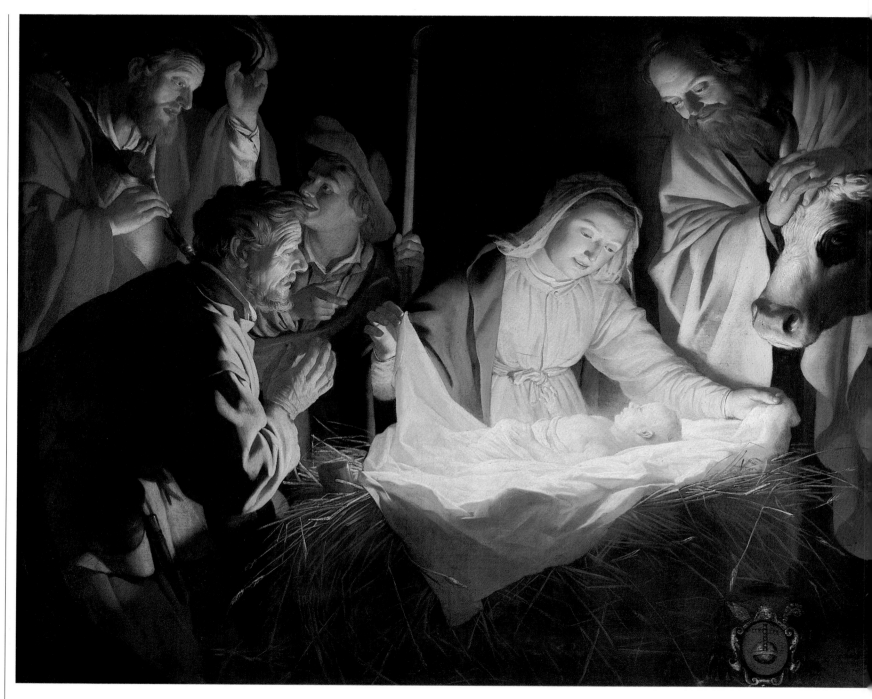

Gerard van Honthorst

(Utrecht, 1590–1656)

Van Honthorst and Terbrugghen synthesize the development of Dutch painting that followed Italian models. Van Honthorst lived longer than his colleague, hence he witnessed the decline of Caravaggism and the subsequent revival of classicizing themes in the Netherlands. After his early training with the Mannerist master Abraham Bloemaert, in Utrecht, van Honthorst moved to Rome in 1610 and remained in Italy for ten years. During this period of intense study and work, he mastered the Caravaggesque style, to which he added echoes of Guido Reni's classicism. Van Honthorst specialized in the execution of evocative night scenes, with tones that were sometimes delicately poetic and sometimes dramatic, which earned him the nickname in Italy of "Gerardo delle notti," by which he is still known today. On his return to Utrecht he alternated vast canvases on religious subjects with genre scenes, always influenced by the great Italian masters. After the death of Terbrugghen in 1629, and as a result of Rembrandt's increasing popularity, the Utrecht school began to lose favor with the Dutch patrons. Van Honthorst, however, continued to enjoy great personal success and ended his career as court painter to stadtholder Frederick Henry of Orange, in The Hague.

Gerard van Honthorst
Adoration of the Shepherds

1622
oil on canvas, 64½ × 74¾ in.
(164 × 190 cm)
Wallraf-Richartz Museum, Cologne

Like his colleague and friend Terbrugghen, van Honthorst sought to convey a sense of delicate poetry in his works, through scenes of touching, pleasant lyricism. The Nativity is one of the painter's favorite themes, and some versions have become famous.

Gerard van Honthorst
Christ Before the High Priest

c. 1618
oil on canvas,
107 × 72 in.
(272 × 183 cm)
National Gallery, London

A specialist in night scenes, van Honthorst frequently uses the emotional device of a candle as the source of light, illuminating the composition from within.

In the seventeenth century this idea became very popular with collectors, and many painters often copied it; consequently this poetic solution became a mere expression of bravura. This is not the case with van Honthorst, who uses the wavering, unsteady light as an unusual and effective way of sensitively rendering psychological insights.

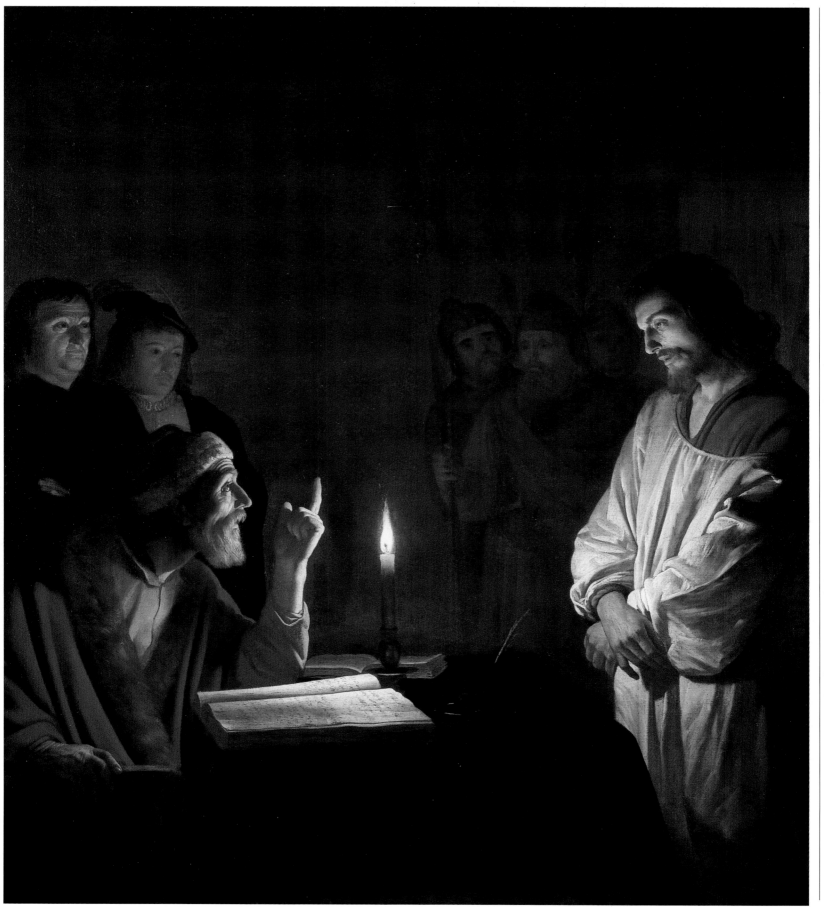

Frans Hals
(Antwerp, c. 1580–Haarlem, 1666)

Born in Antwerp, though he moved to
Haarlem when still a child, Frans Hals is
one of the most appealing portraitists in
the whole history of art. He was a painter
who specialized in one genre of painting,
and yet he was so imaginative and brilliant
that he always invented new compositions,
ranging from the bust of a single person
to vast scenes representing large animated
groups of people. Some of his major works
are still in the city of Haarlem, where
Frans Hals spent nearly the whole of his
long career. Little is known of his training
and early work, though it was influenced
by his studies with the painter and scholar
Karel van Mander, who still followed the
High Renaissance tradition. In 1616,
when he was no longer young, Frans Hals
painted his first large group portrait,
*Banquet of the Officers of the St. George
Militia*, now in the Frans Hals Museum
in Haarlem. After this work, the painter
displayed great freedom from the earlier
rigid schemes, portraying groups in
movement, rendered vibrant and lively by
his rapid brushwork and rich use of color.
The dazzling chromatic effects and rapid
execution, which does not linger over
details but captures the fleeting expressions
of the characters, are characteristic of
Frans Hals's portraits until 1640. Having
become acquainted with the Carvaggesque
style through the painters of the Utrecht
school, Frans Hals often uses diagonal light
and neutral grounds, while his dense, thick
color is reminiscent of Rubens and the
Antwerp school. A painter of great renown
(he had an efficient workshop with many
pupils and followers), Frans Hals painted
large official portraits as well as pictures
of aristocratic patrons or, in some cases,
models taken from everyday life, such as
common people, drinkers, fishermen, and
young women, all depicted with an
emotional and communicative immediacy.
Without making preparatory drawings or
sketches, Frans Hals painted his canvases
using a technique that we might call
"impressionistic," and that was, in fact,
studied by some nineteenth-century
French masters. After 1640, as in
Rembrandt's late painting, Frans Hals
developed a cool palette and tended
to concentrate on black and white,
which at times created an emotional
dramatic tension.

Frans Hals
Portrait of Willem
van Heythuysen

c. 1635
oil on canvas,
80½ × 53 in.
(204.5 × 134.5 cm)
Alte Pinakothek, Munich

Frans Hals
Married Couple

1622
oil on canvas,
55 × 65½ in.
(140 × 166.5 cm)
Rijksmuseum, Amsterdam

This is one of the master's earliest works, as can be seen from the Italianate garden with pavilions and fountains in the background, which is still Mannerist in style. The married couple are Frans Massa and Beatrice van der Laen. Hals portrays them with an appealing freshness and gaiety. The double marriage portrait was a well-known genre that developed in sixteenth-century painting and became more widespread in the first decades of the seventeenth century, thanks to outstanding portraitists like Rubens. However, only in few cases do the artists succeed in avoiding official poses and expressions. Frans Hals, however, conveys spontaneity through the happy, carefree expression of the man and the subtle, knowing, yet embarrassed smile of the girl, who is resting her hand on her husband's shoulder.

Frans Hals
Portrait of a Woman

1643
oil on canvas,
48½ × 38½ in.
(123 × 98 cm)
Yale University Art Gallery, New Haven

His exceptionally rapid execution enabled Frans Hals to capture and fix all kinds of expressions, including the unforgettable restrained grimace of this middle-aged woman, who is keeping her lips tightly closed and attempting to appear dignified by gripping the arm of the chair.

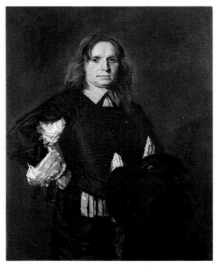

Frans Hals
Portrait of a Man

c. 1650
oil on canvas,
43½ × 34 in.
(110.5 × 86.4 cm)
Metropolitan Museum of Art, New York

In time Hals's painting lost the rich color and brilliance of his early period. With increasing frequency he preferred to paint in black and white, and to explore the psychological aspect of his portraits. While in his early works the characters are usually smiling, in the late ones their expressions are often tired or worried.

165

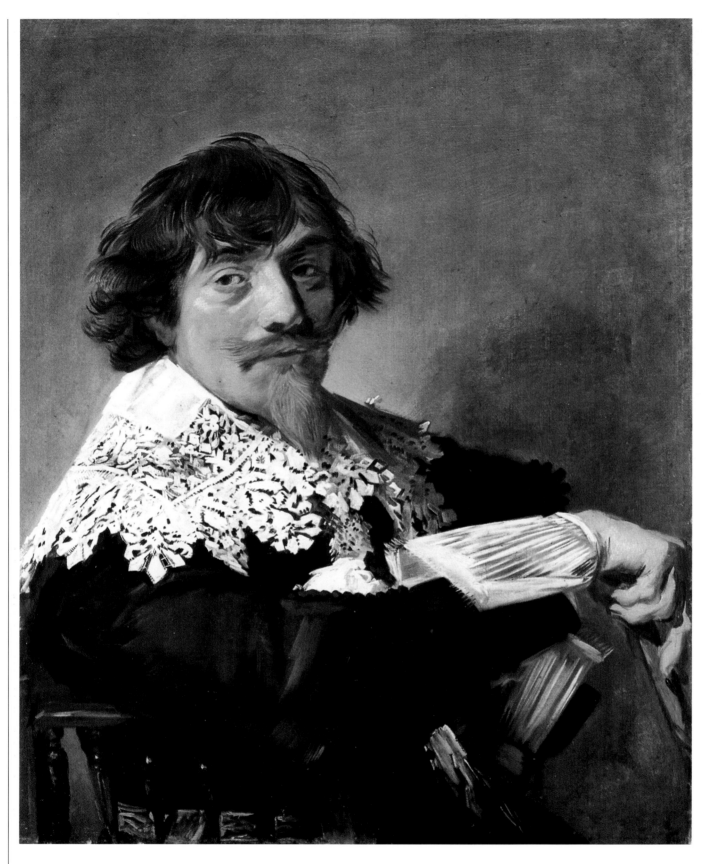

Frans Hals
Portrait of Nicolaes
Hasselaer

1630–1635
oil on canvas,
31¼ × 26¼ in.
(79.5 × 66.5 cm)
Rijksmuseum, Amsterdam

This personage was very
high-ranking; he was, in
fact, the mayor of
Amsterdam, who died in
1635 at the age of forty-
three. His ostentatious lace
collar indicates his status,
but the dynamic, fluid pose
the painter has chosen is
definitely not official. The
painting is extremely
vivacious, and rendered
masterly by Hals's typically
thick, rapid brushwork.
The sitter has stopped
reading for a moment and
is turning toward the
spectator. He is leaning on
the arm of the chair as
though about to engage in
conversation. Movement is
indicated by his ruffled hair
and the raised edge of his
collar. He has hastily put a
finger in between the pages
of the large book to mark
his place. However, his
eyes are not focused on us;
he is looking up and he
has the vague expression
of a man who appears
abstracted, lost in the
reflections and the
decisions of his public
office.

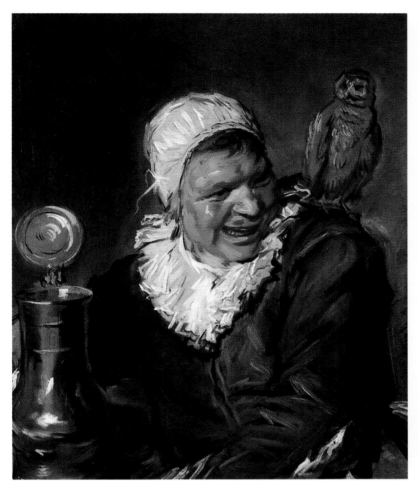

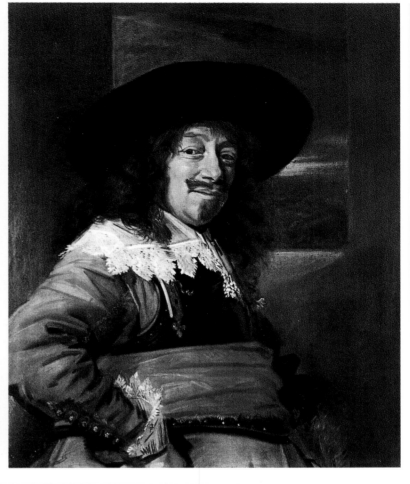

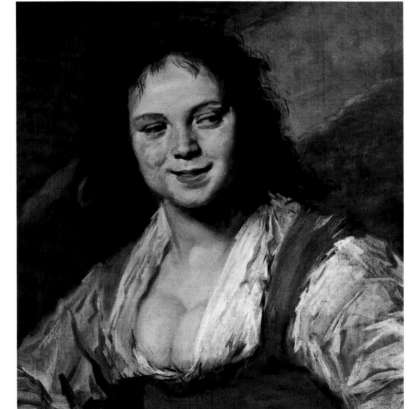

Frans Hals
Malle Babbe

c. 1635
oil on canvas,
29½ × 25¼ in.
(75 × 64 cm)
*Gemäldegalerie, Staatliche
Museen, Berlin*

In addition to his
commissioned portraits,
quite a number of Hals's
small canvases depict
characters from the street:
gypsies, fishermen, drinkers.
This old woman nicknamed
"Malle Babbe" was a familiar
figure in Haarlem's taverns.
Frans Hals portrays her with
an enomous tankard of beer
and a paradoxical owl on
her shoulder. This nocturnal
bird symbolizes wisdom,
but here it takes on the
opposite meaning; unused
to the light of day, it is
perching unsteadily like a
drunkard. Apart from the
subject (not unusual in
Flemish and Dutch painting
from Bruegel on),
stylistically speaking the
painting is extraordinarily
powerful despite its small
range of colors. As usual
Frans Hals has painted it
without making a
preparatory drawing or
sketch. More so than in his
commissioned portraits or
in the paintings of grand
Company banquets, here the
painter uses freely flowing,
broad brushstrokes, rich in
color. The devilish vivacity
of the old hag is heightened
by a spontaneous style,
which foreshadows the
artistic movements of the
nineteenth century.

Frans Hals
Gypsy Girl

c. 1630
oil on wood,
22¾ × 20½ in.
(58 × 52 cm)
Louvre, Paris

This canvas, with its
remarkable naturalness
and unbridled exuberance,
is one of Hals's freest
paintings, executed for
pleasure and not on
commission. Works like
this were to make a great
impact on nineteenth-
century French painting,
particularly that of Manet.

Frans Hals
Portrait of an Officer

c. 1645
oil on canvas,
33¾ × 27¼ in.
(86 × 69 cm)
*National Gallery of Art,
Washington*

This painting dates from
the middle period of Frans
Hals's output, between the
magnificent chromatic
richness of his early period
and the severe almost
monochrome works of his
last years. The pleasant
character (an officer who
does not look very military
and is evidently a *bon
vivant*, as emphasized by
the red sash around his
protruding stomach) is
depicted in three-quarter
profile, one of Hals's
favorite poses, with his
hand on his hip and
wearing a broad-brimmed
hat. The colors that are
predominantly shades
of brown, yellow, and rust
are reminiscent of
Rembrandt's.

Frans Hals
Portrait of a Young Man

between 1639 and 1650
oil on canvas,
31 × 26¼ in.
(78.5 × 66.5 cm)
Kunsthistorisches Museum,
Vienna

The correct chronological
order of Frans Hals's
paintings (especially when
there is no information
about the sitters) is often
difficult to determine.

Frans Hals
Officers and Non-
Commissioned
Officers of the St. George
Militia

1639
oil on canvas,
85¾ × 165¾ in.
(218 × 421 cm)
Frans Hals Museum,
Haarlem

Hals excels in the genre
of group portraits.
Frequently they are of civic corporations and militias
that dated from the time of
the wars of independence
and were established to
protect the Dutch cities;
they later became an
excuse for enjoyable
reunions. Hals's large
paintings depict the
banquets, meetings, and
parades of these civic
guards and avoid the
monotony of static groups
of people by introducing a
fresh, animated note.

Frans Hals
Portrait of Catharina Hooft
and Her Nurse

c. 1620
oil on canvas,
34 × 25½ in.
(86.4 × 65 cm)
Gemäldegalerie, Staatliche
Museen, Berlin

The daughter of a famous
Amsterdam jurist,
Catharina was just over
one year old when she
came to Haarlem to stay
for a while with her
grandparents. It was then
that Frans Hals was
commissioned to paint this
charming portrait of the
little girl in her nurse's
arms. Certainly more at
ease looking after the
delightful child than posing
for the painter, the nurse is
wearing a simple black
dress and cap, in striking
contrast with Catharina's
rich Italian damask dress,
with collar, cuffs, and cap
in Brussels lace. The child
only posed twice for Frans
Hals, who succeeded in
brilliantly capturing the
tenderly curious
expression of the chubby
little girl, who is looking
at the painter, but also
instinctively clinging
to her nurse's dress.
Catharina Hooft later
became the wife of the
mayor of Amsterdam,
and she would always look
on the painting with great
affection. In effect, this
work demonstrates the
artist's extraordinary skill
in applying colors and
brushstrokes to create a
vitality that continues to
live on regardless of time,
fashions, and styles.

Rembrandt Harmenszoon van Rijn

(Leyden, 1606– Amsterdam, 1669)

A miller's son who grew up with a lower-middle-class, provincial background, Rembrandt determinedly pursued his vocation for painting, and was prepared to follow a difficult and arduous path when he was young to reach artistic heights. Though he never left Holland and only traveled the short distance between Leyden and Amsterdam, he measured himself against international painters. A truly versatile artist, he tackles the most varied themes, subjects, and formats with remarkable energy and originality. A highly skilled draftsman, Rembrandt is also one of the greatest engravers in history and specialized in etchings. His prodigious oeuvre follows a human and individual course and the long series of self-portraits, executed over a period of forty years, provides the most direct, moving, emotional testimony of his life. After learning the rudiments of his art in Leyden, the young Rembrandt went to Amsterdam. He trained with the Italianate master Pieter Lastman and learned the style and composition of great classical painting. He made the decision to devote himself mainly to historical subjects and compete with the Italian models. In fact, following the example of artists like Titian, Raphael, and Leonardo, he decided to sign his paintings with his first name only. On his return to Leyden, he collaborated with Jan Lievens, and for several years the two young painters worked side by side, often exchanging roles and painting similar subjects. Because of his commissions, Rembrandt painted what the Leyden customers preferred: small works on biblical and literary subjects, executed with finesse and precision down to the tiniest detail. Noted by intellectuals and art dealers, Rembrandt was urged to leave the provincial environment of Leyden and

work in the capital, Amsterdam. The riveting *Anatomy Lesson of Dr. Tulp* (1632, Mauritshuis, The Hague), Rembrandt's first major public commission in Amsterdam, marked his passage from youth to maturity. Promoted by a competent art dealer, Rembrandt soon became known as an impassioned portraitist. His fame constantly increased, and so did his wealth, which he mostly used to amass a confused though impressive collection of art works and natural curiosities. Rembrandt married Saskia van Ulyenburch and their early years together were the happiest of his life. He was then engaged in painting a series of canvases depicting the *Passion of Christ* for the stadtholder Frederick Henry of Orange. During the 1630s Rembrandt abandoned the meticulous style of his early works and turned to monumental compositions, similar to those by Italian Renaissance masters, but characterized by a highly individual play of light and shadow, and color. In 1642, the painter's career reached its height with the execution of the imposing group portrait known as *The Night Watch* (Rijksmuseum, Amsterdam). However, in the same year, the death of Saskia marked the beginning of a ruinous series of personal misfortunes, which led Rembrandt through endless legal wrangles to complete bankruptcy and the auction of all his possessions. Rembrandt's decline was also linked to the changing tastes of the Dutch public, which was little inclined to accept the artist's late works, that appeared to be merely sketched and unfinished because of their free brushwork and thickly applied paint. Rembrandt did not receive further public commissions until his last years, and these included the historical painting *The Conspiracy of the Batavians*. Rembrandt's style toward the end of his life is similar to the late manner of Titian. He painted outstanding masterpieces like the *Prodigal Son* and *The Jewish Bride* that are intensely human and have a depth of feeling that becomes almost unbearable. The death of his beloved son Titus, in 1668, was the final blow in an exemplary, unique life.

Rembrandt van Rijn
The Night Watch

1642
oil on canvas,
41¼ × 172½ in.
(359 × 438 cm)
Rijksmuseum, Amsterdam

The title of Rembrandt's most famous masterpiece, a landmark in the history of art, is not a true description of the scene, which does not take place at night, but in broad daylight, and depicts a festive parade rather than a watch. The protagonist is Captain Frans Banning Cocq, at the center of the composition, who is inviting his extremely elegant lieutenant, Willem van Ruytemburg, to line up the company for the parade. The painting was destined to decorate the meeting room of the Amsterdam civic militia, and was in the tradition of group portraits of the Companies that defended the city, a genre in which Frans Hals excelled. Compared with Hals's already very animated scenes, Rembrandt renders this painting even more dynamic and full of action. Twenty-eight adults and three children are moving confusedly in this scene. The striking contrasts of light and color, the individual portrayal of all the various characters, and the total mastery of this complicated composition set this painting at the height of Rembrandt's career. This large work also contains some disturbing and unusual details, like the little fair-haired girl on the left, with a chicken tied to her belt, running away in fear, and the face of Rembrandt himself between the standard bearer and the helmeted man to the right of him. Because the painter was short, only the top part of his face is visible, but this is enough to recognize his unmistakable features that were made famous by his many self-portraits.

Rembrandt van Rijn
Self-Portrait with Gorget

c. 1629
oil on wood,
14¾ x 11¼ in.
(37.7 x 28.9 cm)
Mauritshuis, The Hague

Rembrandt never joined civic militias or the army; the piece of armor symbolizes the pride of the young Dutch nation and indicates the painter's fondness for disguise and striking exaggerated poses. This painting dates from the artist's early period, when he was still living in his hometown Leyden, where he worked with his colleague and contemporary Jan Lievens. The free style and frank, direct expression are typical of the master's early works.

Rembrandt van Rijn
Portrait of the Artist's Mother as the Prophetess Anna

1631
oil on wood,
23½ × 19 in.
(60 × 48 cm)
Rijksmuseum, Amsterdam

In his youth, Rembrandt often used members of his family as models. His parents are usually portrayed as very old characters from the Holy Scriptures. In this painting Rembrandt's mother is as wrinkled as an old tortoise, but the work is very moving. The trepidation with which the woman is turning the pages of the Bible, as though she were understanding them by touch rather than reading them, imbues the picture with the solemnity and mysticism of the Holy Word.

Rembrandt van Rijn
Jeremiah Mourning the Destruction of Jerusalem

1630
oil on wood,
22¾ × 18 in.
(58 × 46 cm)
Rijksmuseum, Amsterdam

The subject of this small, delicate work is taken from the Old Testament. The prophet Jeremiah is mourning the future destruction and burning of Jerusalem by the Babylonian king Nebuchadnezzar. The old man has the features of Rembrandt's father, Harmen van Rijn. This is one of the painter's most important early works mainly because of the extremely unusual treatment of light. The gold objects in the foreground are most skillfully executed. Rembrandt gives a masterly rendering of the precious metal, which seems to reflect the flames of the fire devastating Jerusalem, on the extreme left of the picture.

Rembrandt van Rijn
The Last Self-Portrait

1669
oil on canvas,
23¼ × 20 in.
(59 × 51 cm)
Mauritshuis, The Hague

The forty years that have passed since his early *Self-Portrait with Gorget* are clearly visible in the portrayal of Rembrandt's face and body. The confident, erect youth has become a weak, bent old man with heavy, still-recognizable features marked by a prominent nose. The style of painting has greatly changed; the small, precise touches in the early self-portrait with its striking reflection of light on metal have been replaced by thick, dense brushwork with heavy paint that absorbs the light. Rembrandt does not hide the ravages of time and adversity, though his expression has a touching dignity, the wisdom of the man and the artist.

Rembrandt van Rijn
The Anatomy Lesson
of Dr. Tulp

1632
oil on canvas,
66¾ × 85 in.
(169.5 × 216 cm)
Mauritshuis, The Hague

This masterpiece marks a turning point in Rembrandt's career; in fact it is the painting that gained the twenty-six-year-old artist entry into the artistic circles of Amsterdam, which resulted in his consequent departure from Leyden. The work, originally painted for the seat of the surgeons' guild in Amsterdam, depicts a lesson given by Dr. Tulp, one of the most celebrated physicians in Holland. The seven men gathered around the dissecting table are not doctors but town councilors (their names are on the piece of paper one of them is holding). Their expressions are a mix of scientific interest and repulsion. Dr. Tulp is dissecting the left arm of the corpse, exposing the tendons; his left hand is miming the contractions and movements of the fingers. The anatomical precision indicates Rembrandt's direct observation; he is interested in movement and has a knowledge of the human body equal to Leonardo's.

Rembrandt van Rijn
The Blinding of Samson

1636
oil on wood,
93 × 119 in.
(236 × 302 cm)
Städelsches Kunstinstitut, Frankfurt

This is the most violently dramatic work in the whole of Rembrandt's oeuvre. The artist gave it to the celebrated scholar Costantijn Huygens, as a sign of his esteem and gratitude for the support he had received at the court of The Hague. Huygens was a connoisseur and admirer of Italian art, and for this reason Rembrandt is inspired by the dynamism and diagonal light of Caravaggio. This religious painting depicts Samson captured and blinded by the Philistines. In the background, the traitress Delilah is seen holding the cut hair of the hero.

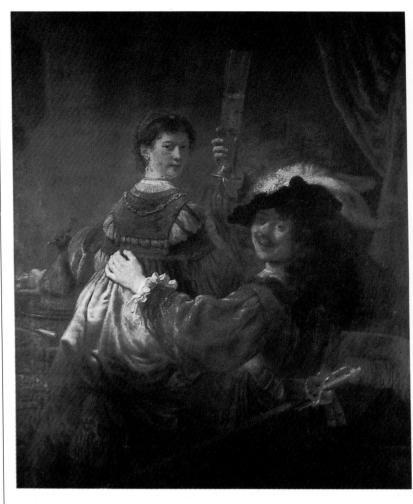

Rembrandt van Rijn
The Happy Couple
c. 1635
oil on canvas,
63½ × 51½ in.
(161 × 131 cm)
Gemäldegalerie, Dresden

This painting is a self-portrait of Rembrandt with his wife Saskia sitting on his knee. It depicts a moment of complete happiness and the painter has cheerfully chosen, without any moral undertones, a pose reminiscent of the Gospel episode of the prodigal son who wasted his wealth on pleasures.

Rembrandt van Rijn
Lady with a Fan

1633
oil on canvas,
49½ × 39¾ in.
(126 × 101 cm)
*Metropolitan Museum of Art,
New York*

So far it has not been possible to identify the elegant young lady in this painting. The portrait dates from Rembrandt's early years in Amsterdam, during which he soon became very successful, thanks to the precision of his style, the true likeness of the portraits, and the fascinating play of light and chromatic contrasts. Throughout his career Rembrandt enjoyed painting women of all ages and in the most diverse poses.

Rembrandt van Rijn
Saskia as Flora

1634
oil on wood,
49¼ × 39¾ in.
(125 × 101 cm)
Hermitage, St. Petersburg

Rembrandt's favorite model is doubtless his wife Saskia, whom he married on July 22, 1634. The love story between the painter and Saskia is one of the most famous in the history of art, and we know about their tender engagement, the great affection during their happiest moments, and the tragic ending with the illness and death of Saskia in 1642, after giving birth to their last son, Titus. In this extremely fine portrait inspired by Titian, Saskia's gown and pose give the impression that she is pregnant. In fact, in 1635, she gave birth to a boy who only lived for two months.

Rembrandt van Rijn
Girl at the Window

1645
oil on canvas,
30½ × 24½ in.
(77.5 × 62.5 cm)
*Dulwich College Gallery,
London*

This painting is one of a series of fresh images of women freely drawn from reality and painted with impassioned spontaneity. The free technique and the striking expressiveness of pictures like this were later greatly admired by the Impressionists.

Rembrandt van Rijn
Danaë

1636–1654
oil on canvas,
72¾ × 80 in.
(185 × 203 cm)
Hermitage, St. Petersburg

Painted in 1636 and
reworked several times
in the course of eighteen
years, this canvas is one
of the major seventeenth-
century mythological
works. Some years ago it
was seriously damaged
by a mythomaniac who
threw acid on it. Lengthy,
delicate restoration has
permitted the partial
recovery of the
masterpiece, and it has
been on exhibit to the
general public since 1998.
Rembrandt once again
challenges the Italian
Renaissance and Titian in
particular. The mythical
shower of gold that falls
into the maiden's lap has
been ingeniously replaced
by a flood of golden light
that caresses the nude's
soft curves, and illuminates
the exquisite details of the
furnishings and fabrics.

Rembrandt van Rijn
Saskia Wearing a Hat

c. 1635
oil on wood,
39¼ × 31 in.
(99.5 × 78.8 cm)
Staatliche Galerie, Kassel

Rembrandt van Rijn
Little Girl with Dead
Peacocks

c. 1639
oil on canvas,
57 × 53¼ in.
(145 × 135.5 cm)
Rijksmuseum, Amsterdam

The seventeenth-century
Dutch art market
particularly favored still
life, which was a genre
Rembrandt rarely painted,
since he preferred
narrative scenes. In this
case, he creates an effective
composition by adding
to the two large dead birds
a little girl in the
background, who has
an expression of curiosity
and fear.

175

Rembrandt van Rijn
Saskia as Flora

1635
oil on canvas,
48½ × 38½ in.
(123.5 × 97.5 cm)
National Gallery, London

A theater lover, over the years Rembrandt amassed an imaginative wardrobe of costumes and accessories, which he used to dress himself and his wife, his models. For Saskia, at the height of her Junoesque beauty, Rembrandt has chosen an arcadian, mythological costume and a pose clearly inspired by Titian's painting. Twenty years later, he was to paint a similar canvas of the woman who took the place of Saskia in his heart (see bottom right).

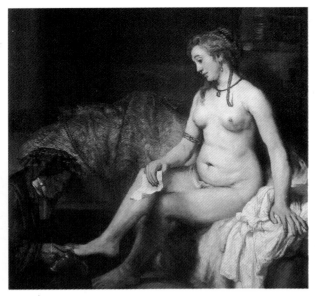

Rembrandt van Rijn
Bathsheba with the Letter from David

1654
oil on canvas,
56 × 56 in.
(142 × 142 cm)
Louvre, Paris

Though based on major precedents in Dutch painting and on classical bas-reliefs, Rembrandt adds psychological insight to this biblical picture of Bathsheba, wife of Uriah, who appears perplexed at receiving a love letter from David. The model is probably Hendrickje Stoffels, the woman who took Saskia's place in the life and family of Rembrandt.

Rembrandt van Rijn
Hendrickje as Flora

1657
oil on canvas,
39¼ × 36¼ in.
(100 × 91.8 cm)
Metropolitan Museum of Art, New York

As is evident from the works reproduced on these pages, Rembrandt frequently painted the women he loved in various costumes and poses. Here he has chosen to depict Hendrickje as Flora, once again inspired by Titian.

Rembrandt van Rijn
The Adultress

1644
oil on wood,
33 × 25¾ in.
(83.8 × 65.4 cm)
National Gallery, London

Returning to a religious
theme, Rembrandt adopts
the finesse of execution of
his Leyden years, enriched,
however, by a monumental
sense of light and by
a completely new
relationship between the
figures and architecture.

Rembrandt van Rijn
Woman Paddling
in a Stream

c. 1654
oil on wood,
24¼ × 18½ in.
(61.8 × 47 cm)
National Gallery, London

This is another intimate
painting. Here Rembrandt
has captured an amused
Hendrickje Stoffels
paddling in a stream. The
canvas is so spontaneous it
has been thought to be
unfinished. On the
contrary, this is a splendid
example of the
inexhaustible freshness of
Rembrandt's brushwork,
and one of the
masterpieces that explains
the French Impressionists'
admiration of Rembrandt.

Rembrandt van Rijn
Saskia with a Red Flower
in Her Hand

1641
oil on wood,
38¾ × 32½ in.
(98.5 × 82.5 cm)
Gemäldegalerie, Dresden

This extremely sweet yet
tragic picture is the last
portrait of Saskia, painted
when she was sick, weak,
and haggard. The gift

of the red flower, a token
of love and faithfulness,
is extremely moving,
since a few months
later on June 14, 1642,
at the age of thirty,
Saskia died after giving
birth to Titus. This is
a very intimate painting,
expressing great affection,
in which an awareness
of imminent death
becomes a declaration
of eternal love.

Rembrandt van Rijn
Young Woman in Bed

c. 1645
oil on canvas,
32 × 26¾ in.
(81 × 68 cm)
*National Gallery of Scotland,
Edinburgh*

This delightful painting has
been celebrated through
the centuries. Its fame is
perfectly justified by the
subtle, appealing ambiguity

of the work. It is very
likely that it is based
on a biblical subject
(Sarah waiting for Tobias
on their wedding night,
while he spent it praying
and making sacrifices to
remove the evil spell that
had affected his previous
marriages). But the figure
is irresistibly spontaneous
and exudes the *joie de vivre*
of a girl on the threshold
of life.

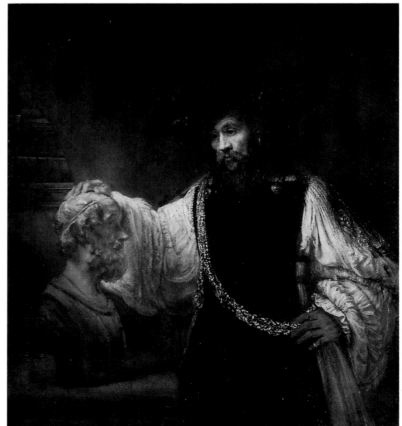

Rembrandt van Rijn
Portrait of Titus Studying

1655
oil on canvas,
30¼ × 24¾ in.
(77 × 63 cm)
*Museum Boymans van
Beuningen, Rotterdam*

Portrait of Titus Reading

c. 1658
oil on canvas,
26¼ × 21¾ in.
(67 × 55 cm)
*Kunsthistorisches Museum,
Vienna*

Titus's smile brings a ray
of hope to the elderly
Rembrandt. The artist

painted a whole series
of portraits of his beloved
son in childhood and
adolescence, which are
among the most delicate
and touching in the whole
history of art. Titus, the
only child of his marriage
to survive, reminded
Rembrandt of Saskia.
Rembrandt lovingly
observes the fair-haired,
delicate, intelligent child
growing up. The portraits
express a feeling of
affection and protection,
as though Rembrandt
wanted to embrace the
child with the best part
of himself, his colors
and brush.

Rembrandt van Rijn
Aristotle Contemplating
the Bust of Homer

1653
oil on canvas,
56½ × 53¾ in.
(143.5 × 136.5 cm)
*Metropolitan Museum of Art,
New York*

Painted for the Sicilian
collector Antonio Ruffo,
this work is an
extraordinary meditation
on culture, on the
significance of classical
antiquity, and on illustrious
men. Aristotle's caressing
hand and gaze seem to
bring the bust of Homer
back to life. In the
melancholy atmosphere
bathed in a faint light, the
gold chain on Aristotle's
chest gleams brightly.

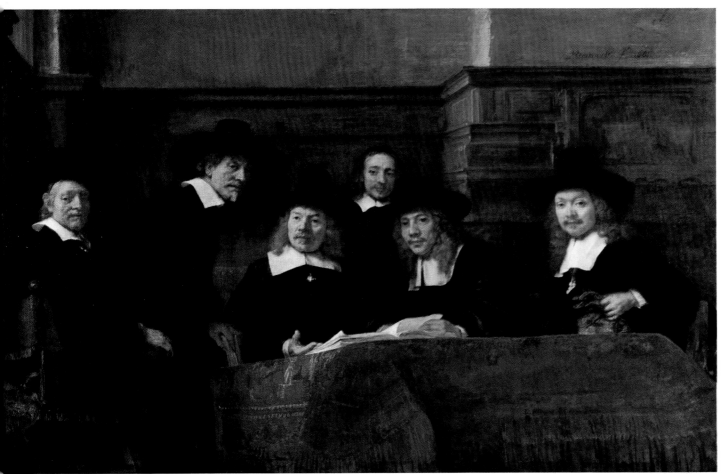

Rembrandt van Rijn
The Syndics of the Cloth Guild

1662
oil on canvas,
75¼ × 109¾ in.
(191 × 279 cm)
Rijksmuseum, Amsterdam

In 1662, as a sign of his return to favor with the patrons of Amsterdam, Rembrandt was commissioned to paint a group portrait (the last one had been *The Night Watch*, twenty years earlier). The syndics of the Cloth Guild are depicted around a table looking through a book of samples. The group, which the painter studied at length in drawings and sketches, is rendered extremely dynamic by the free, broad handling typical of Rembrandt's last years. The pose of the man on the left, who is captured rising to go to a meeting, is a very effective way of rendering the scene even more lively.

Rembrandt van Rijn
The Conspiracy
of the Batavians

1661
oil on canvas,
77¼ × 121¾ in.
(196 × 309 cm)
Nationalmuseum, Stockholm

Like the portrait of the group of syndics of the Cloth Guild, this marks Rembrandt's return to large, important works for public commissions. The painting depicts the conspiracy of Guido Civile who led the Batavians of Holland against the Roman invaders, and it was executed for the town hall in Amsterdam (now the Royal Palace). This is only the central portion of a much larger composition, which was seriously damaged and has since been long forgotten.

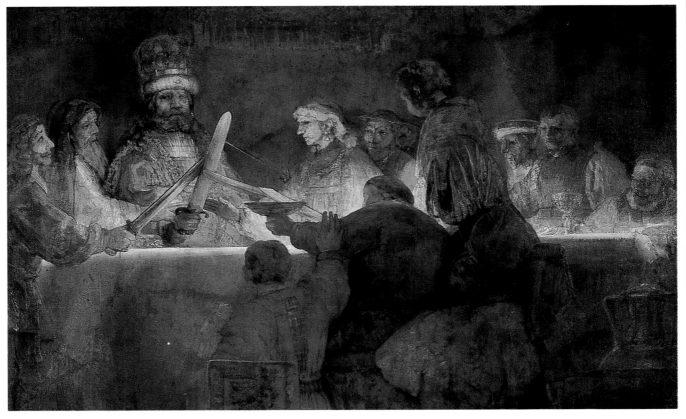

Rembrandt van Rijn
Self-Portrait

1658
oil on canvas,
52¼ × 40¾ in.
(133 × 103.8 cm)
Frick Collection, New York

This painting is truly exceptional both in style and moral content. The artist is going through an extremely difficult period, and his bankrupty has exacerbated personal problems and legal wrangles. He has seen everything he possessed and the collections he had amassed over the years sold for a song in a ruinous series of auctions. But Rembrandt reacts to these disasters with self-possession and solemn dignity, clinging to his stature as an artist. Perhaps he has consciously imitated Titian's late style by using broad handling and thick pigment, and every brushstroke on the canvas is a display of vitality, energy, and conscious presence.

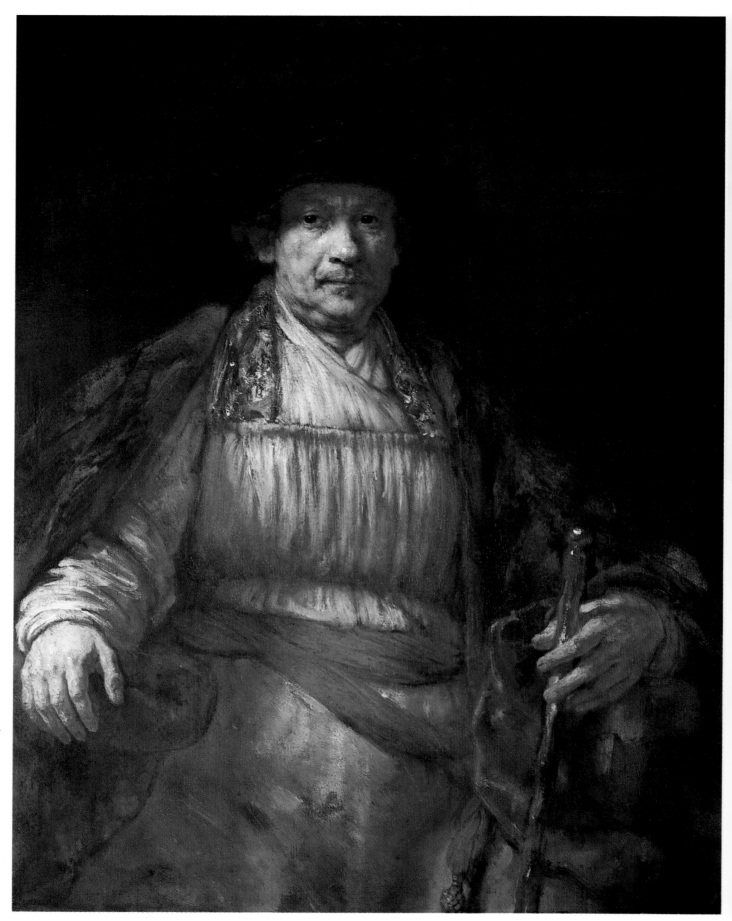

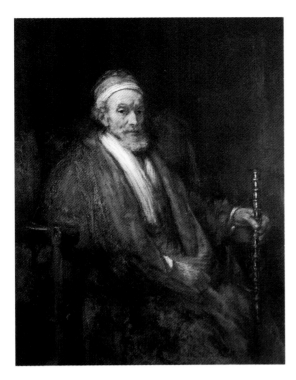

Rembrandt van Rijn
Jacob Trip

1661
oil on canvas,
51¼ × 38¼ in.
(130.5 × 97 cm)
National Gallery, London

Jacob Trip, a rich merchant from Dordrecht, decided to have his portrait painted by Rembrandt soon after being portrayed accurately and precisely by Nicolaes Maes. Rembrandt's work is striking. While Maes faithfully depicts the appearance and wealth of his sitter, Rembrandt goes beyond a mere "photographic" likeness and confers on Jacob Trip the dignity of a biblical patriarch.

Rembrandt van Rijn
The Family Group

c. 1668–1669
oil on canvas,
49½ × 65¾ in.
(126 × 167 cm)
Herzog Anton Ullrich-Museum, Brunswick

Painted shortly after *The Jewish Bride* (see following page), this touching family portrait depicts an intense web of affectionate family relationships, which is reflected in the analogous filiform, golden rays of light that play on the red fabrics.

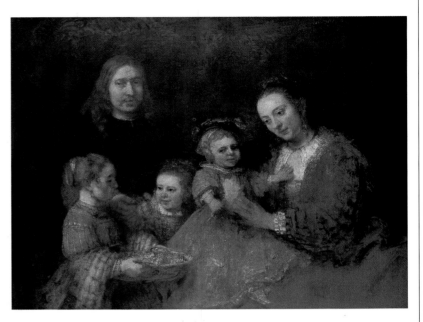

Rembrandt van Rijn
Juno

c. 1665
oil on canvas,
50 × 42½ in.
(127 × 108 cm)
Armand Hammer Collection, Los Angeles

This strong, finely executed, mythological figure of the goddess shows how Rembrandt's artistic powers had not declined with age.

Rembrandt van Rijn
Aman Sees His End

c. 1665
oil on canvas,
46 × 50 in.
(117 × 127 cm)
Hermitage, St. Petersburg

In Rembrandt's late works, passions and emotions are restrained and not displayed openly and dramatically as in his early painting. Profound meditation, the fruit of long human experience, replaces the impetus and theatrical flair, creating works of striking intensity.

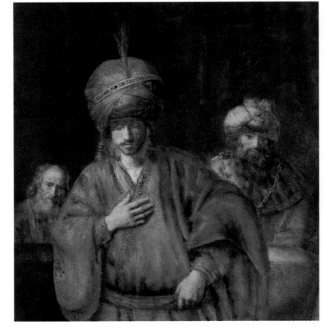

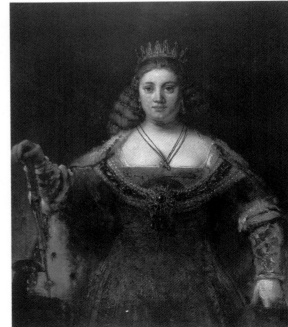

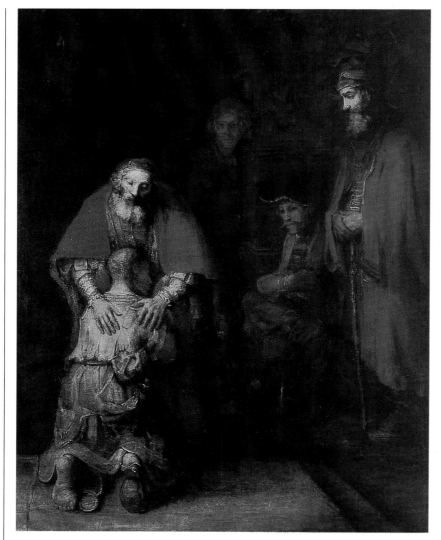

Rembrandt van Rijn
The Return of the Prodigal Son

1668
oil on canvas,
103¼ × 79½ in.
(262 × 202 cm)
Hermitage, St. Petersburg

The painter's last monumental work is an almost indescribable masterpiece. Rembrandt projects onto the Gospel parable his own tragic experience of being an elderly father abandoned by his son, but he can no longer embrace him, unlike the father of the prodigal son. The death of Titus in 1668 was the tragedy that brought the painter's life to a close.

Opposite page:
Rembrandt van Rijn
The Jewish Bride

1666
oil on canvas,
47¾ × 65½ in.
(121.5 × 166.5 cm)
Rijksmuseum, Amsterdam

The identity of these two figures has been much discussed and is still being debated. This painting may depict the marriage of a Jewish poet, though it is not certain. However, the affectionate, intimate gesture the couple exchange remains imprinted on the memory. The handling of the pigment, interwoven with gold, is a further brilliant confirmation of Rembrandt's total creative freedom in his last years.

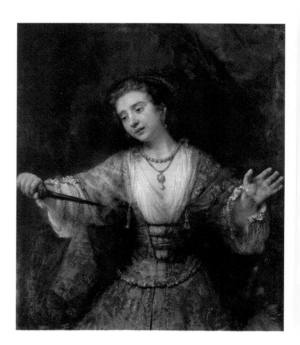

Rembrandt van Rijn
The Suicide of Lucretia

1664
oil on canvas,
47¼ × 39¾ in.
(120 × 101 cm)
National Gallery of Art, Washington

Rembrandt was fascinated by the world of the theater. Frequently his works feature scenes and characters that seem to have been directly inspired by plays and actors. In his youth, Rembrandt himself had taken part in public performances. In this case, too, the elaborate costume and melodramatic gesture remind one of an actress or singer.

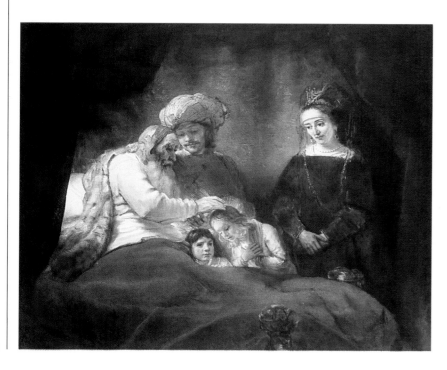

Rembrandt van Rijn
Jacob Blessing His Sons

1656
oil on canvas,
69 × 82¾ in.
(175.5 × 210 cm)
Gemäldegalerie, Kassel

This remarkable canvas, depicting an unusual subject, clearly illustrates the change in Rembrandt's style in his last years; the brushstrokes tend to be broken and no longer define the details, but only the masses, colors, and action. The elderly patriarch Jacob is blessing one of his grandsons, the fair-haired Ephraim and entrusting Israel to him. Joseph, Jacob's son, seems to be reprimanding his father for not having chosen Manasseh, the eldest son.

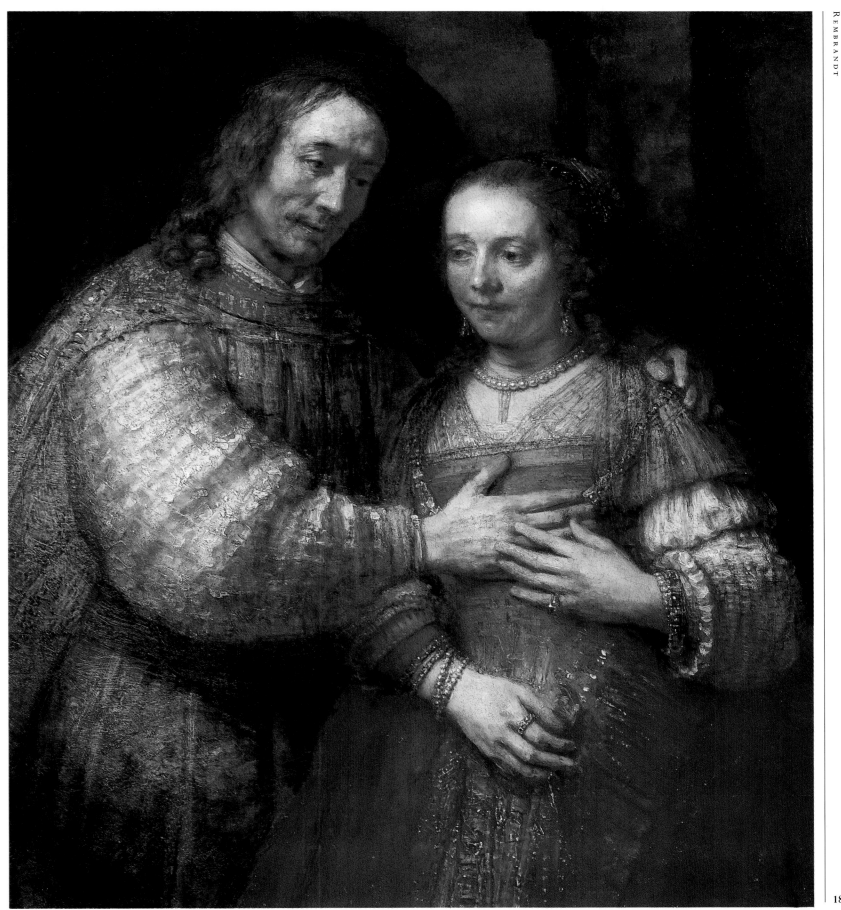

Gerard Dou
(Leyden, 1613–1675)

Dou has gone down in history for being Rembrandt's first pupil, between 1628 and 1630. He is one of the most typical exponents of the *Fijnschilderei* or "fine painting" characteristic of Leyden. Rembrandt's early precise, meticulous style remained Dou's point of reference throughout his career, to the extent that it became an actual mania. According to sources, Rembrandt and Dou worked together on several paintings, but it has been very difficult to identify these to date.

Dou was obsessed by formal clarity, and his extremely accurate small or very small works are painstaking. Naturally such paintings took a very long time to complete, and their market price during the seventeenth and eighteenth centuries was extremely high, which encouraged imitators who were not always so successful. The son of a glass painter, from 1632 on Dou was the most famous painter in Leyden after Rembrandt moved to Amsterdam and Jan Lievens left for England. He established the local painters' guild in 1648. Dou frequently set his pictures in an arched window frame or an illusionistic picture frame.

Gerard Dou
The Young Mother

1658
oil on wood,
29 × 21¾ in.
(73.5 × 55.5 cm)
Mauritshuis, The Hague

The descriptive details are painted with a remarkable accuracy that is reminiscent of Jan Bruegel's crowded allegories and the earlier paintings and miniatures of the Flemish "primitives."

Gerard Dou
The Seller of Game

c. 1670
oil on wood,
22¾ × 18 in.
(58 × 46 cm)
National Gallery, London

Dou's gifts of patience and minute handling in the representation of details and surfaces clearly emerge in the exuberant still lifes that he often paints in the foreground, creating almost illusionistic effects despite their small size. There are no particular variations in style throughout the painter's career and he always remains faithful to his early manner acquired in Rembrandt's studio in Leyden.

Gerard Dou
Self-Portrait in the Artist's Studio

1647
oil on wood,
17 × 13½ in.
(43 × 34.5 cm)
Gemäldegalerie, Dresden

The apparent confusion reigning in the painter's studio is merely "poetic license," a pretext to display his skill in depicting art objects, musical instruments, and diverse valuable items. In actual fact, Dou's studio was proverbially clean and tidy. According to experts Dou had an obsession for order that was virtually manic. Sources of the time record his efforts to keep his atelier spotless; he even limited visits from strangers to a minimum. When a supplier or a buyer came to the studio, Dou stopped painting until the next day because (according to him) of the dust and dirt they brought into the ascetic room.

Jan Steen

(Leyden, 1626–1679)

A painter of great originality and narrative force, Steen is one of the major exponents of seventeenth-century Dutch art. His favorite subjects were scenes from daily life, observed with a certain disenchanted, amused irony. Unlike most of his fellow artists, Steen did not have permanent residence in one city, but moved frequently, thus detaching himself from the local schools. He prolific output was the result of his confident rapid execution. Thanks to his varied training, Steen succeeds in conferring a solid monumentality and compositional complexity on his genre subjects, and in developing his own individual style. Though he was born in the same city as Rembrandt, Steen completed his apprenticeship in Utrecht and Haarlem, where he acquired a fair knowledge of Italian painting, and admired the free manner of Frans Hals and the picturesque subjects painted by Adriaen van Ostade. In 1648, he married the daughter of the landscapist Jan van Goyen, and acquired from his father-in-law a taste for refined, atmospheric, light effects. In 1649, he moved to The Hague, but his earnings from painting were meager, so he moved to Delft (Vermeer's city), where he divided his time between painting and running a brewery. After further travels, and particularly a long, profitable stay in Haarlem, Steen spent the last years of his life in his hometown. During his career, Steen painted the same scenes several times, but with variations. His very enjoyable canvases sometimes have a tone of underplayed realism, amused detachment or critical moralism.

Jan Steen
The Feast of St. Nicholas

c. 1660
oil on canvas,
32¼ × 27¾ in.
(82 × 70.5 cm)
Rijksmuseum, Amsterdam

Steen is an observant, respectful, and amused painter of children. The day of Santa Claus, in northern Europe, is when gifts are exchanged; it is the tender moment that brings together grandparents and grandchildren. At the center of the painting a fair-haired little girl is happily hugging her new doll. Baroque painting rarely has scenes of such smiling tenderness. By contrast, on the left a boy is crying desperately; he has been naughty and has not received any presents, and his little brother impishly points this out to his grandmother. The old woman's amused expression makes one think that soon an unexpected gift will appear for her punished grandchild. One of the many details of this delightful picture is the figure, in the background on the right, with a baby who is holding his present with an expression of astonishment.

Jan Steen
The Cheerful Family

1668
oil on canvas,
43½ × 55½ in.
(110.5 × 141 cm)
Rijksmuseum, Amsterdam

In effect, the real title of this work should be the Dutch proverb written on the piece of paper, top right: "As the old people play, so the young people sing," which alludes to the example adults should set children. The family in this picture is certainly no model of order and discipline;

confusion reigns and is increased by the general uproar. Despite its moralizing undertone, there is a feeling of good relations between the generations, as can be seen from the doddery old drinker and the rosy, chubby baby. Steen's work in his tavern and brewery was an endless source of human experience, which is abundantly reflected in his paintings.

Jan Steen
The Morning Toilet

c. 1665
oil on canvas,
14½ × 10¾ in.
(37 × 27.5 cm)
Rijksmuseum, Amsterdam

This small painting is executed with admirable finesse and is a notable example of the intimate, private scenes Steen likes to alternate with his larger compositions with many characters. In the pale light of early morning, the girl has just gotten up and is putting on her stockings. Steen is famous for rather licentious paintings that give the impression he is peeping through the keyhole. But here the poetic feeling for everyday gestures pervades the painting and precludes the possibility of sensual allusions. The little dog curled up on the bed is a loving true-to-life detail.

Jan Steen
The World Turned Upside Down

c. 1665
oil on canvas,
41¼ × 57 in.
(105 × 145 cm)
Kunsthistorisches Museum, Vienna

On careful observation this painting expresses severe moral criticism; it is an indignant representation of the physical and material degradation of a family with drunken parents. But how can one consider this masterpiece a serious sermon? Steen always identifies with his characters and depicts them affectionately and with amusement. It is true that everything is chaotic, but all it takes is a little discipline to put it straight, and one needs some enjoyment in life! This painting is in a genre that was very popular in Flemish and Dutch art and goes back to Bosch and Bruegel the Elder, and the culture of proverbs and popular wisdom that nourished the art of the Netherlands for centuries. Some details (like the pig with the rose in its mouth, the overturned pitcher, and the glass of red wine) are specific references to local sayings. The more extravagant notes include the monkey playing with the clock on the wall, the duck perched on the shoulder of the pensive doctor, and the dog on the table wolfing down the cake. All the children are very appealing, from the youngest in the high chair to the eldest stealing sweets from the cupboard, the door of which has been carelessly left open.

Jan Steen
The Lovesick Girl

c. 1655
oil on canvas,
24½ × 20½ in.
(61.5 × 52 cm)
Alte Pinakothek, Munich

"No doctor has a remedy for the pains of love": this is the text on the piece of paper the pale girl is holding, and another proverb that helps us to understand one of Steen's works and strip it of any dramatic quality. The girl, dressed in a robe, is receiving the visit of a severe doctor. Her wan cheeks and tired pose appear in a different light when we realize that she is merely lovesick. The painter gives a masterly rendering of the domestic interior and lingers over every detail.

Gerard Ter Borch

(Zwolle 1617–Deventer 1681)

Portraitist and refined painter of domestic interiors, Ter Borch has many of the stylistic and poetic characteristics of seventeenth-century Dutch art. He moved to Amsterdam when he was just fifteen, and first studied with a local painter, but soon, attracted by the echoes of Italian painting that reached him from Utrecht and Haarlem, and stimulated by Rembrandt's monumental manner, he began to travel. From 1635 to 1642, he studied abroad, and came in contact with all the major European schools and great masters. He went first to London where he met van Dyck, then to Rome and Spain. On his return to Amsterdam, he immersed himself in local painting and became acquainted with Rembrandt's use of light effects and, later, with the early works of Vermeer; they must have struck up a friendship since he was best man at Vermeer's wedding. In 1654 he moved to Deventer, where he quietly spent the rest of his life. As well as portraits, executed above all during his second stay in Amsterdam, Ter Borch painted peaceful, delicate domestic scenes, which display great finesse of execution and a very effective feeling for calm depiction, which is not limited to virtuosity for its own sake (as sometimes happens in Dou's works), and deliberately does not venture into psychological analysis in the manner of Vermeer, but remains within the sphere of precise, sympathetic representation.

Gerard Ter Borch
The Guitar Lesson

c. 1660
oil on canvas,
26½ × 22¾ in.
(67.6 × 57.8 cm)
National Gallery, London

The remarkable characterization of the figures reflects Ter Borch's consummate skill as a portraitist. The scene is reminiscent of the interiors of Vermeer, an artist with whom Ter Borch was definitely in direct personal and professional contact.

Gerard Ter Borch
Interior with Figures

c. 1650
oil on canvas,
28 × 28¾ in.
(71 × 73 cm)
Rijksmuseum, Amsterdam

Also entitled *The Father's Admonishment*, this is one of Ter Borch's favorite subjects and he painted it frequently. A typical feature is the silvery reflections of the girl's silk gown that gleams softly in the serene, dim light of the domestic interior.

Opposite page:

Gerard Ter Borch
Woman Peeling Apples

1651
oil on wood,
14¼ × 12 in.
(36.3 × 30.7 cm)
Kunsthistorisches Museum, Vienna

The perfect balance of the composition, the rigor, the serenity, and the studied simplicity of the objects on the table make this painting a symbol of the Calvinist morality that dominated seventeenth-century Dutch culture.

Pieter de Hooch

(Rotterdam, 1629–Amsterdam
or Rotterdam, c. 1684)

A poetic painter of peace and quiet,
of the calm cleanliness of Dutch domestic
interiors, de Hooch is an artist who has
always been well-known, but has recently
been receiving greater attention. In fact,
though not possessing Vermeer's gift of
psychological penetration, de Hooch
reveals in all his works great lyrical finesse,
and a poised elegance of composition,
color, and expression, which make him
one of the greatest genre painters of all
time. De Hooch was a pupil of Nicolaes
Berchem, and ever since his youth he was
attracted to simple, serene themes. He
completed his artistic training by spending
some time in Leyden where the legacy
of Rembrandt and the example of Dou led
him to refine his painting further, making it
even more subtle and precise. The turning
point in his career was his lengthy stay in
Delft (nearly a decade from 1654 on),
during which he measured himself directly
with Vermeer. Some of his themes are
similar, in particular the secret world
of domestic intimacy, but the feeling is
different. Vermeer always captures the
human element of the situation; de Hooch
affectionately and meticulously depicts
the context, the episodes and the figures,
creating, in his most successful works,
symbolic images of Dutch culture in the
mid-seventeenth century. Around 1663
he moved to Amsterdam, where his works
met with the approval of bourgeois
collectors, partly because of his remarkable
handling of perspective. In his later works
he tends to comply with the tastes of the
new Dutch clientele, who are attracted
by affected gestures and somewhat cold,
aristocratic ostentation.

Pieter de Hooch
The Mother

c. 1660
oil on canvas,
20¾ × 24 in.
(52.5 × 61 cm)
Rijksmuseum, Amsterdam

The magic of the light
shining through the
window and spreading
through the house is
depicted with a perfect
mastery of perspective,
stressed by the converging
lines on the floor. The
mother is looking for
possible lice in the hair
of her little daughter,
who is kneeling at her feet.
A necessary and private
task, which in figurative
Dutch culture of the
seventeenth century
was considered the symbol
of the mother's role, the
metaphor of lice indicates
that the mother was
responsible for removing
all manner of physical
and moral "dirt" from
the home and the children.

Pieter de Hooch
The Linen Cupboard

1663
oil on canvas,
28¼ × 30½ in.
(72 × 77.5 cm)
Rijksmuseum, Amsterdam

One of de Hooch's
most famous works,
this painting dates from
between the end of the
period spent in Delft and
his move to Amsterdam.
Since he was working
for a public with more
demanding tastes, one can
understand why there is
greater monumentality
than in his earlier works.
However, the painting is
extremely appealing. The
lady is tidying the linen,
helped by her housekeeper,
while the little girl, who
is supposed to be learning
how to do household tasks,
seems to be irresistibly
attracted by the sunlight
outside, on this bright
spring day.

Pieter de Hooch
House in the Country

c. 1665
oil on canvas,
24 × 18½ in.
(61 × 47 cm)
Rijksmuseum, Amsterdam

Bourgeois interiors
predominate in de Hooch's
oeuvre, but there is also
a very pleasing group
of works depicting
exteriors. As always the
action is slow and serene,
never hasty or dramatic.
De Hooch depicts peaceful
episodes such as this one,
where, taking advantage
of the fine weather, a man
and woman are taking
some refreshment at
a table in the garden
of a house in the country.
It is not a luxurious
mansion, but the kind
of place where a well-off
middle-class family would
go for a trip or to spend
a vacation. Every detail
alludes to the small
decorous, justified
pleasures of a break
from work or domestic
chores.

Pieter de Hooch
Courtyard of a Dutch
House

c. 1660
oil on canvas,
29 × 24¾ in.
(73.7 × 62.6 cm)
National Gallery, London

Based on a perfect
depiction of space seen
in perspective, this
painting has an open,
airy atmosphere.
De Hooch once more
shows his great skill
in rendering materials
realistically and giving
the spectator an almost
tangible impression
of the whitewashed walls,
brick flooring, and wooden
roofs.

Pieter de Hooch
Interior with Figures

c. 1660
oil on canvas,
29 × 25½ in.
(73.7 × 64.6 cm)
National Gallery, London

The checkerboard floor
and beamed ceiling give
the impression that this
interior can be precisely
measured. The figures
are arranged in a studied
manner reminiscent of
Italian and Flemish painters
of the fifteenth century,
who came back into
fashion as a consequence
of seventeenth-century
studies of physics, optics,
and geometry.

Pieter de Hooch
Couple with Parrot

1668
oil on canvas,
28¾ × 24½ in.
(73 × 62 cm)
*Wallraf-Richartz Museum,
Cologne*

Following the model
of some of Vermeer's
paintings, the spectator
views the picture from
a room in the foreground
that is darker than the
room where the scene
is taking place. The pail
and broom suggest the
standpoint of a maid,
who is watching what
her master and mistress
are doing.

Jan (Johannes) Vermeer

(Delft, 1632–1675)

Vermeer's works disappeared for a long time and were completely lost in the prodigious output of Dutch painting. His name only re-emerged in the nineteenth century, and he gradually became established as one of the most precious and best-loved painters of all time. Vermeer's fame rests on a few small, or very small, works, but in a century and a school of painting that produced so many charming pictures of daily life Vermeer captures the magic, the deep and intimately human aspect of everyday tasks. A painter of the soul, of peace, and of light, Vermeer was the son of an innkeeper. His father was a member of the painters' guild, an essential requirement if one was to practice the profession of art dealer. From his childhood on, Vermeer saw countless paintings pass through his father's shop. They may not all have been top quality, but they certainly provided an effective range of styles, fashions, and trends. On his father's death in 1632, Vermeer inherited his business and became an innkeeper and art dealer. He had a preference for Italian painting or at least works that were influenced by Caravaggio. He also began to paint, in the artistic climate influenced by Carel Fabritus. Vermeer's early works, which already displayed extremely fine brushwork, were religious (in mainly Calvinist Holland, he was probably Catholic, or became a convert after his marriage) and mythological scenes. His contact with various artists of the period, including Gerard Ter Borch, led him, from 1656 on, to abandon the elevated subjects of his early works and tackle more ordinary themes, to which he brought a new creative vein. He painted consummate masterpieces, the result of a painstaking and highly refined technique, in which the echoes of fifteenth-century Flemish painting, especially in the use of light and the importance given to the minutest detail, blend with an awareness of the tendencies in the art of his day. Vermeer led a brief and uneventful life (he died when he was only forty-three), though he had no less than thirteen children. He was dean of the Delft painters' guild, made brief trips into the environs of the city and, in the end, had contracted so many debts that his widow had to sell his paintings to pay back the baker. He had no public commissions, and only sporadic and indirect links with other countries. Very few of his works can be dated with certainty, and their chronological order is very difficult to determine. His was a simple, modest life, but he established important friendships, particularly with Antonie van Leeuwehock, the great Delft scientist who invented the microscope. This may be an interesting key to understanding the miracle of Vermeer's painting, which lies in the revelation of the secret life hidden in little things that light unveils to those who have eyes, a heart, and patience.

Jan Vermeer
Artist and Model
(Allegory of Painting)

c. 1675
oil on canvas,
47¼ × 39¼ in.
(120 × 100 cm)
Kunsthistorisches Museum, Vienna

Painted toward the end of Vermeer's brief career, this magnificent painting almost has the significance of a spiritual testament. This is a self-portrait of the painter, seen from behind, sitting at his easel, but, at the same time, he takes the viewer's standpoint and has folded back the heavy curtain on the left to be able to see the interior of the studio. In the sharp clarity of the bright room, a young woman is posing in classical attire like an ancient Muse. All is peace, beauty, contemplation that becomes action. A large map of Holland decorates the back wall.

Jan Vermeer
Young Lady Sitting
at a Spinet

c. 1671
oil on canvas,
20¼ × 17¾ in.
(51.5 × 45.4 cm)
National Gallery, London

A true music lover, Vermeer often paints instruments and players, but never public concerts or recitals. Vermeer seems to imply that music is first and foremost an inner emotion, something that can only be truly enjoyed in solitude or in the company of very few other people who have the same tastes. It is interesting to note, on the back wall, the reproduction of a painting by the Dutch Caravaggesque artist Dirck van Baburen that still exists today. The same picture reappears in another interior by Vermeer, and it is likely that it was in the painter's private collection.

Jan Vermeer
The Procuress

1656
oil on canvas,
56¼ × 51¼ in.
(143 × 130 cm)
Gemäldegalerie, Dresden

This is one of the few dated paintings, and it marks a turning point in Vermeer's art. Regarding its size and style, it is linked to his early works featuring large figures, but the contemporary subject makes it the prelude to Vermeer's mature and more characteristic period. The scene is the interior of a brothel, and it is not unlikely that the painting alludes to the parable of the prodigal son who dissipated his father's wealth. At the other extreme, it is also possible (though this is more improbable) that the picture contains a subtle autobiographical reference, given that the procuress's features resemble those of Maria Thyns, the painter's disagreeable mother-in-law.

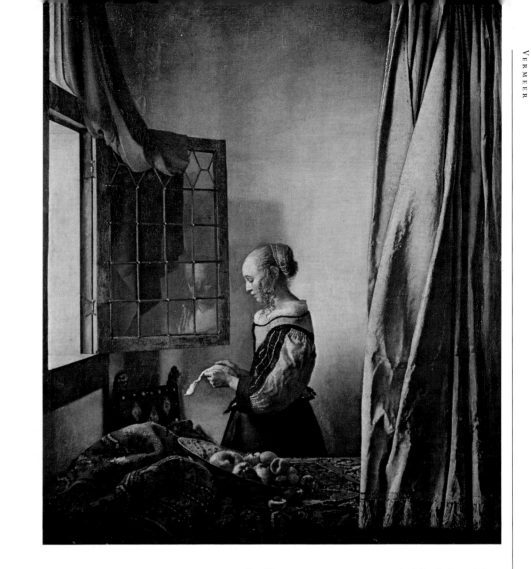

Jan Vermeer
The Lacemaker

c. 1669–1670
oil on canvas,
9½ × 8¼ in.
(24 × 21 cm)
Louvre, Paris

This is one of Vermeer's most famous paintings, though it is somewhat atypical. In fact, unlike the scenes of interiors, the girl intent on her lacemaking is depicted in close-up; thus the picture concentrates on the figure, while the surrounding space is reduced to a neutral ground. Perhaps it is this simplicity that gives the painting its exquisite, delicate charm. The theme is not very rare; there are several sixteenth-century precedents, and the lacemaker can also be compared with Velázquez's embroideress. However, no other painting can match its silent, metaphysical atmosphere.

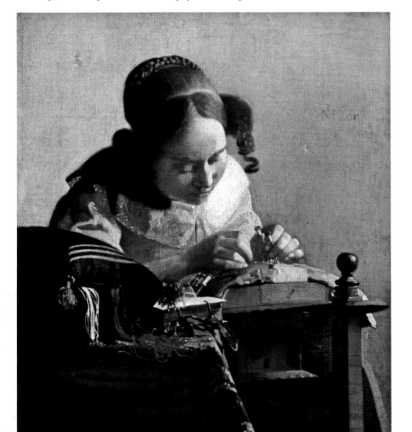

Jan Vermeer
Girl Reading a Letter

c. 1657
oil on canvas,
32¾ × 25½ in.
(83 × 64.5 cm)
Gemäldegalerie, Dresden

This is another work linking Vermeer's early style with that of his maturity, and it anticipates the most typical features of his art. From the compositional standpoint, it establishes an arrangement that became customary, with the light entering through a window on the left, the immobile figure in the center of the space, and a close-up of remarkable still-life details. Above all, it is in this painting that Vermeer begins his calm, insistent exploration of the secrets of the female soul, which he conducts with absolute charm and discretion. We shall never know what is written in the letter; we can only sense the sentiments it expresses, which are barely perceptible in the stillness of the room.

Jan Vermeer
View of Delft

1660–1661
oil on canvas,
38½ × 46¼ in.
(98 × 117.5 cm)
Mauritshuis, The Hague

Vermeer painted
landscapes very rarely, but
this vista of his hometown
is his absolute masterpiece.
Proust was very fond of it,
and it led to the general
public's rediscovery of the
painter. This work offers an
excellent explanation of
Vermeer's poetic and
stylistic choices. It is by no
means a precise, objective
view. Only some buildings
correspond to the actual
architecture of Delft,
which is depicted from
outside the walls and
beyond the canals that
surround the historic
center. Vermeer blends
reality and fantasy,
affection and free-ranging
memory. For him, it is not
top priority for the view
to be instantly recognizable
(as it was to be in the
views of Amsterdam by
van der Heyden, a few
years later); on the
contrary, Vermeer depicts
the city as a place that is
really lived in. The
harmony of light and color
is unforgettably beautiful,
as is the limpid relationship
between the line of
buildings, the cloudy sky
above, and the reflection
of the brick walls in the
canal.

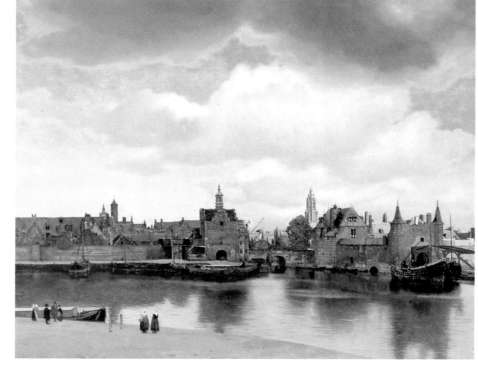

Jan Vermeer
Street in Delft

around 1661
oil on canvas,
21¼ × 17¼ in.
(54.3 × 44 cm)
Rijksmuseum, Amsterdam

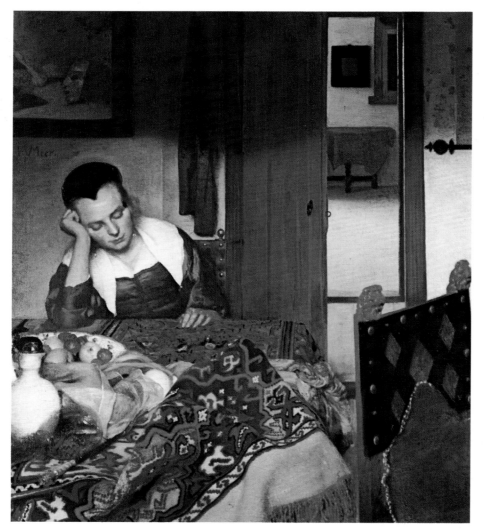

Jan Vermeer
Girl Asleep

c. 1660
oil on canvas,
30 × 34½ in.
(76.5 × 87.6 cm)
*Metropolitan Museum of Art,
New York*

Bold perspectives executed
to perfection, fascinating
descriptive details, a still
life seen in close-up,
casually placed on the
colorful folds of the carpet
on the table, consisting
of a jug and tray of a
pictorial immediacy
and plastic density worthy
of Cézanne: all this serves
as a frame for the delicate
picture of the drowsy girl.
Perhaps she is tired or
dreaming; whichever, the
figure has an impalpable
appeal.

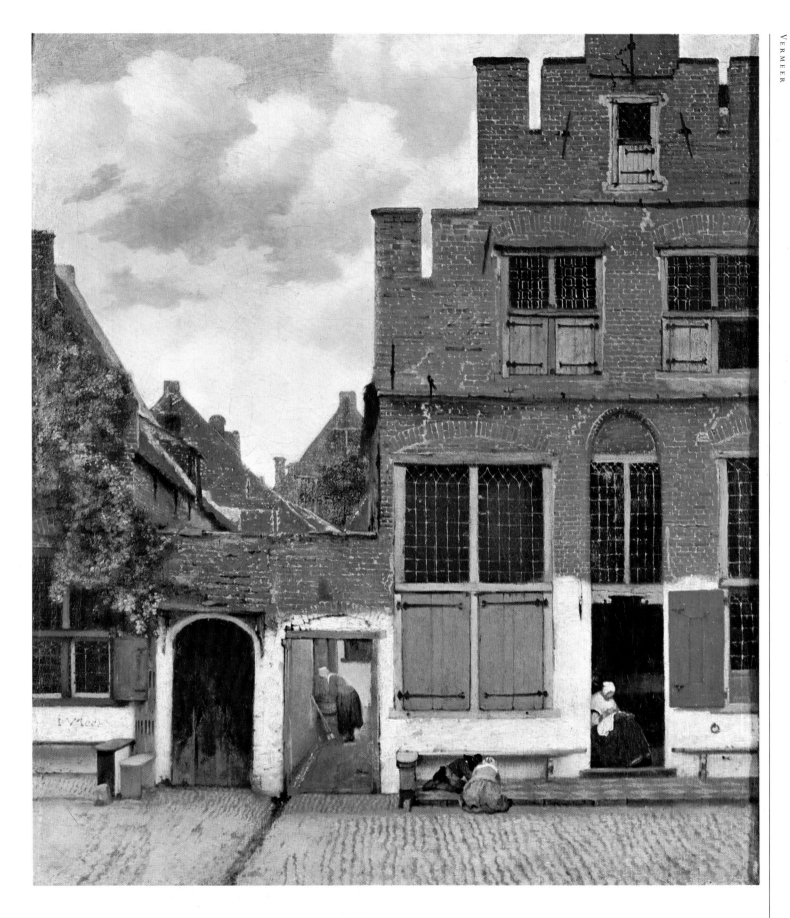

Jan Vermeer
Allegory of the Faith

1675
oil on canvas,
45 × 35 in.
(114.3 × 88.9 cm)
*Metropolitan Museum of Art,
New York*

This allegorical figure
symbolizes the Catholic
faith, and very many details

have a precise symbolic
reference, for instance, the
picture of the Crucifixion
on the back wall and the
serpent of Evil. Though the
whole picture is to be
given a symbolic and
doctrinal interpretation,
Vermeer still succeeds in
rendering the scene
concrete, tangible, and
immediate.

Jan Vermeer
Young Woman
with a Water Jug

c. 1670
oil on canvas,
18 × 16 in.
(45.7 × 40.6 cm)
*Metropolitan Museum of Art,
New York*

This painting, too, can be
interpreted symbolically,

though it expresses
a touching human,
psychological, and
luministic truth.
In fact, the figure of
Temperance appears
on the stained glass
window and this virtue
is reflected in the girl
holding the polished,
gleaming jug.

Jan Vermeer
The Astronomer

c. 1670
oil on canvas,
20 × 18¼ in.
(50.8 × 46.3 cm)
Louvre, Paris

Generally Vermeer prefers
painting women, but his
pictures featuring men
are also memorable. His
personal ties with men
of science make him
particularly interested in
philosophers and scholars.
Intelligence, application,
intuition, and
concentration traverse
his canvases following
the spread of a ray of light
and of knowledge.

Opposite page:

Jan Vermeer
Young Lady Standing
in Front of a Spinet

c. 1671
oil on canvas,
20¼ × 17¾ in.
(51.7 × 45.2 cm)
National Gallery, London

Another canvas devoted
to the theme of music and
another harmonious blend
of Vermeer's inimitable
yellows and blues. The
figure in the picture within
the picture is unusually
in evidence. The Cupid
is holding a playing card
in his hand, an allusion to
faithfulness in love, and
on this subject there is
a Dutch saying according
to which there is only
one card to play and you
cannot cheat.

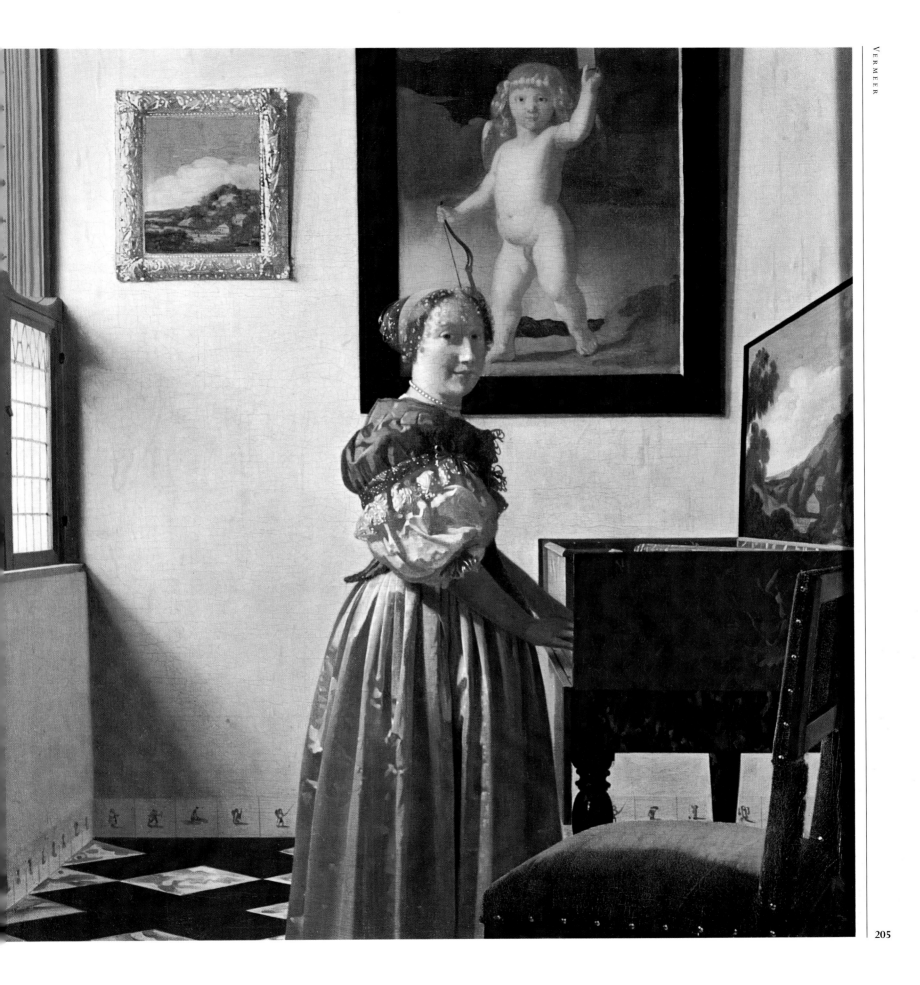

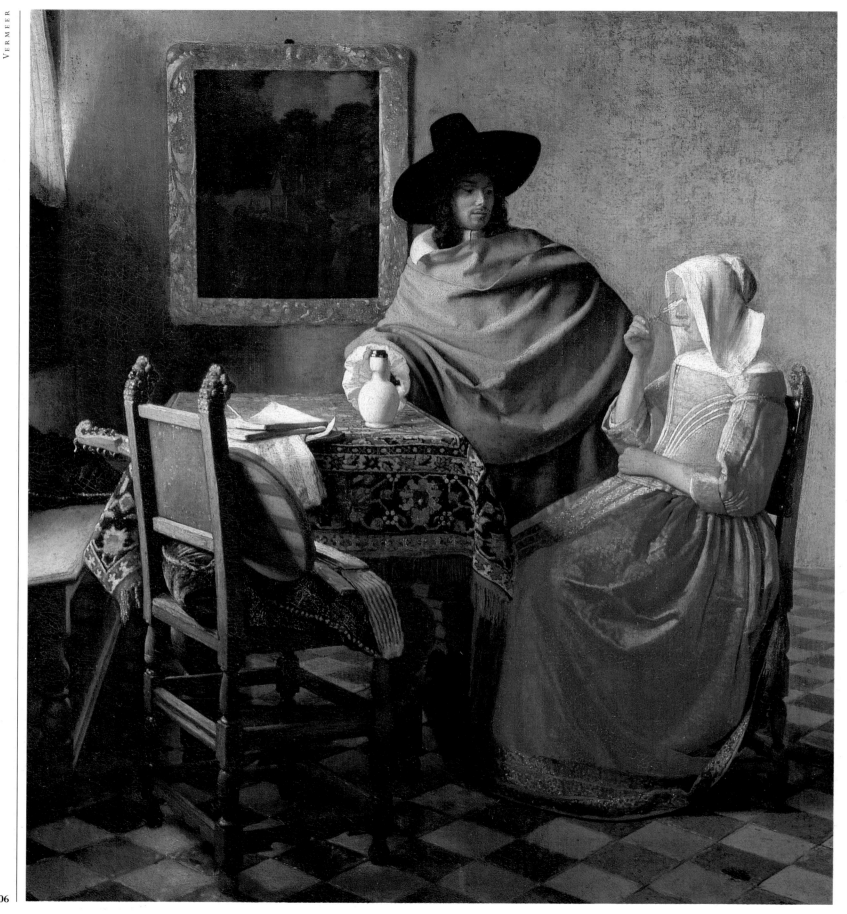

Jan Vermeer
Girl with a Glass of Wine

1659–1660
oil on canvas,
30½ × 20¼ in.
(77.5 × 66.7 cm)
Herzog Anton Ulrich-Museum, Brunswick

The girl's unusual expression indicates the effects of the wine, which is often stigmatized by painters and Dutch moralists like Jan Steen. According to a widespread symbology, the offer of a cup full of wine was a sexual invitation, and the man's insinuating attitude certainly underscores this interpretation. But perhaps the most extraordinary part of this picture is the background. A man is leaning heavily on a table, covered with a deep blue tablecloth on which is set a tray with two oranges, a shiny ceramic jug, and a white napkin. This blend of color, texture, and light has few equals in the history of art.

Opposite page:
Jan Vermeer
The Glass of Wine

1658–1660
oil on canvas,
26 × 30 in.
(66.3 × 76.5 cm)
Gemäldegalerie, Berlin

Scenes such as this were a great success with upper-middle-class collectors in Holland during the seventeenth century and can be compared with similar compositions executed in the same period by Pieter de Hooch. However, Vermeer always introduces the theme of the psychological relations, of the passions of the soul, that are reflected in the characters.

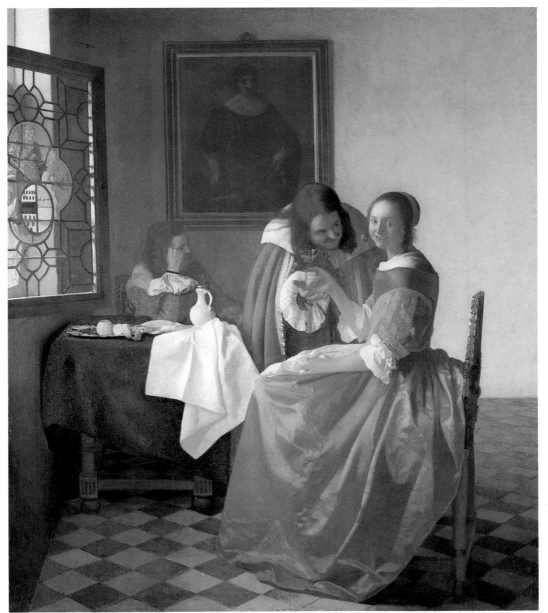

Jan Vermeer
Portrait of a Young Woman

c. 1665
oil on canvas,
17½ × 15¾ in.
(44.5 × 40 cm)
Metropolitan Museum of Art, New York

Vermeer's female figures have given rise to a great deal of speculation in an attempt to identify them with his wife, sister, or other relatives. As their identity remains questionable, it is best to examine the paintings closely and try to discover a few secrets. In this case,

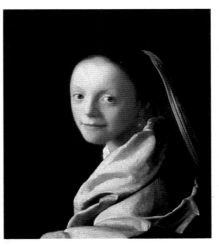

the unnatural position of the shoulder and arm, which do not appear to be normally aligned with the face, suggest that Vermeer painted the face from life and the body from a mannequin.

207

1660–1665
oil on canvas,
16¾ × 15 in.
(42.5 × 38 cm)
*National Gallery of Art,
Washington*

The traditional title of this work (*Woman Weighing Pearls*) has proved to be incorrect. There is nothing on the two pans of the balance held lightly and precisely in perfect equilibrium. The pearls are lying on the table in a small, precious cascade that catches the light. The young woman appears to be in late pregnancy (we have this impression in other female figures painted by Vermeer), and is standing in front of a painting depicting *The Last Judgment*. It is to be remembered that the Archangel Michael holding a balance always appears in the center of Flemish pictures representing *The Last Judgment*. Hence, there is once again a mysterious link between the scene painted by Vermeer and the "counter-melody" in the picture hanging on the wall.

Jan Vermeer
Girl with a Red Hat

c. 1665
oil on canvas,
9 × 7 in.
(23 × 18 cm)
*National Gallery of Art,
Washington*

Vermeer certainly cannot be considered a portraitist, and neither can he be considered a landscapist. Yet there are magnificent examples of portraits and landscapes in his oeuvre, which are sufficient to set him apart as a first-rate exponent of these genres. Here, the extremely fine, powdery reflection of the broad, bright red hat is exquisitely executed. The detail on the right (the carved arm of the chair, almost liquefied by the light) is an example of Vermeer's "impressionistic" brushwork.

Jan Vermeer
Young Woman
with a Turban

1660–1665
oil on canvas,
18¼ × 15¾ in.
(46.5 × 40 cm)
Mauritshuis, The Hague

Despite the fact that the young woman's identity is unknown, this portrait has become the symbol of Vermeer's painting. It is a work of great precision and freshness, in which the light penetrates the pigment and seems to give it an inner warmth and make it live independently, by becoming concentrated in details like the pearl gleaming in the girl's ear.

Jan Vermeer
The Milkmaid

c. 1658
oil on canvas,
17¾ × 16¼ in.
(45.4 × 41 cm)
Rijksmuseum, Amsterdam

Held by the great
museum in Amsterdam,
the fundamental "temple"
of the Dutch painting
of the "golden age,"
The Milkmaid and *The Letter*
almost form a diptych,
since they have in common
a similar composition, the
customary light entering
from the left, the vigorous
beauty of a lower-class
girl and a young lady.
The Milkmaid gives an
extraordinary rendering
of many different surfaces,
ranging from the basket
of bread to the mousetrap
on the floor, the hanging
woven basket and the
polished metal. Despite
the exceptional beauty
of the still life, the picture
concentrates on the girl's
robust beauty. The white
trickle of milk coming out
of the jug is the luminous
focus of the action.

Jan Vermeer
The Letter

around 1663
oil on canvas,
18¼ × 15¼ in.
(46.5 × 39 cm)
Rijksmuseum, Amsterdam

Silence, concentration,
and an almost metaphysical
purity of the image create
a rarefied atmosphere,
heightened by the fact that
every element is perfectly
set in an ideal pattern of
volumes, voids, and colors.
This work is yet again a
masterpiece of evocative
poetry, in which even
someone's absence is felt;
we sense the distance
between the person who
wrote the letter and the
girl who is now reading it.
The empty chair and the
map allude to someone
who is not there, whose
presence is evoked by the
piece of paper on which
a dazzling light falls.

211

Jan van der Heyden

(Gorinchem, 1637–Amsterdam, 1712)

A typical exponent of Dutch painting in the second half of the seventeenth century, van der Heyden trained with the still-life painter Job Berckheyde. Though he was not interested in the flowers and sumptuously laid tables painted by the master, van der Heyden acquired from this experience a taste for great pictorial precision and the accurate representation of objective reality. A great traveler, van der Heyden visited Cologne, Brussels, and London, but his favorite subject is without doubt Amsterdam, with its canals and imposing buildings, monuments and simple houses. Van der Heyden can be considered a forerunner of vedutism, both in his original approach to the image and in his use of technical and scientific instruments in order to reproduce his urban contexts with accuracy. In fact, his paintings are nearly always townscapes, depicted with a taste for documentation, so much so that he can be considered a very important precedent for van Wittel. During his last years, around 1700, the painter also painted still lifes and landscapes, but without ever equaling the limpidity of his views of Amsterdam.

Jan van der Heyden
The New Town Hall
in Amsterdam

after 1652
oil on canvas,
28¾ × 33¾ in.
(73 × 86 cm)
Louvre, Paris

Erected by Jacob van Campen to replace the earlier building that was destroyed by fire, the imposing Town Hall in Dam Square in the center of Amsterdam marks the swing toward classicism in architecture and more generally in Dutch taste in the second half of the seventeenth century. Van der Heyden depicted the building several times from different angles, and he was evidently fascinated by the precision of the forms, by the smooth surfaces, by the studied elegance of relations and proportions, but also by the play of light and shadow on the octagonal tower.

Jan van der Heyden
The Martelaarsgraft
in Amsterdam

c. 1670
oil on wood,
17¼ × 22¾ in.
(44 × 57.5 cm)
Rijksmuseum, Amsterdam

Landcsape is one of the most popular genres in seventeenth-century Dutch art. Van der Heyden's interpretation of it is lucid, precise, and as objective as possible. Hence the painter was far-removed from the highly evocative "Romanticism" of van Ruisdael and from the generic views of the countryside or sea. On the contrary, he wants the viewpoint to be precisely recognizable and the place depicted to be compared with reality. In order to obtain this effect he pioneered the use of a scientific instrument called the *camera obscura*, which allowed him to observe the landscape through a lens that cast the image onto a flat surface.

Gaspar van Wittel

(Amersfoort, 1653–Rome, 1736)

Founder of the *veduta* genre, which was to be enormously successful in the eighteenth century, van Wittel moved to Italy in 1675 at the very young age of twenty-two, and virtually divided his whole career between Rome and Naples. However, he assimilated the typically northern taste for objective, precise, clear landscapes, as opposed to the "ideal landscapes" of the Bolognese and French artists active in Rome. His concern for natural and architectural truth can be seen to derive from the success of van der Heyden's views of Amsterdam, but van Wittel developed and extended this in a direction that his predecessors could never have foreseen. Fascinated by the Mediterranean sunshine, drawn by the ancient monuments, enraptured by the relation between nature and architecture in central and southern Italy, van Wittel exploited his great scenographic skill to create images that are truly monumental in range and panoramic. Van Wittel's technique is based, first and foremost, on extremely accurate drawings from life, and then on a blend of faithful realism and narrative elements, through the introduction of figures, animals, and means of transport. Working at the turn of the century, van Wittel assimilated the tastes of the new traveling public who wanted

to buy impressive souvenirs of their Grand Tour in Italy. Thus he painted outstanding views of the great cities of art (Florence, Venice, and, above all, Rome, an inexhaustible source of monumental and picturesque vistas), destined to be the model for the eighteenth-century *vedutisti*, beginning with Canaletto, who did his training in Rome. The son of van Wittel, whose name was Italianized to Vanvitelli, was to become one of the greatest architects of the eighteenth century. He was active particularly in Naples and Campania, and designed the impressive royal palace at Caserta.

Gaspar van Wittel
View of Florence
from Via Bolognese

c. 1695
oil on canvas,
18 × 29½ in.
(46 × 75 cm)
*Duke of Devonshire
Collection, Chatsworth*

Van Wittel succeeded in unforgettably capturing the major sights of the Grand Tour, the cultural journey that was to become indispensable for every young European aristocrat at the turn of the eighteenth century. In Italy, one of the musts was a "room with a view" in Florence. The blend of nature and monuments, geographical context and city created by van Wittel contributes toward spreading a knowledge of Italian cities of art.

Gaspar van Wittel
Villa Aldobrandini
in Frascati

c. 1720–1725
oil on canvas,
38½ × 68½ in.
(98 × 174 cm)
Private collection, Rome

The villas, ruins, and
natural landscape of the

Alban Hills are a constant
source of inspiration for
Baroque landscapists.
Masters like Annibale
Carracci, Poussin, and
Lorrain had depicted these
places as the perfect
setting for idealized
classical scenes. Van Wittel,
over a century after the
dawn of the genre, notes

first and foremost the
realistic, rather unassuming
aspect of faded glory and
transforms the old towns
into the first and most
convincing backcloths
of that "lesser" Italy, to
which eighteenth-century
scholars were somewhat
indifferent.

Gaspar van Wittel
The Docks

painted during his first
visit to Naples
oil on copper,
17¾ × 38½ in.
(45 × 98 cm)
Private collection, London

The Neapolitan views
constitute a very
interesting section
of van Wittel's oeuvre.
The paintings of the
historic center (often
featuring imposing ancient
monuments) contrast with
pleasant country scenes.

Gaspar van Wittel
The Apse of St. Peter's

c. 1711
oil on canvas,
22½ × 43¾ in.
(57 × 111 cm)
*Richard Green Collection,
London*

Today van Wittel's
Roman views arouse
strong emotions and some
regrets. The monuments
depicted with analytical
precision and a great love
for ancient, Renaissance,
and Baroque architecture
are always immersed
in green vegetation,
in a context that enhances
them and surrounds them
with the colors and
atmosphere of a garden.

Gaspar van Wittel
Castel Sant'Angelo
Seen from the South

c. 1690–1700
oil on canvas,
34¼ × 45¼ in.
(87 × 115 cm)
*Richard Green Collection,
London*

Thanks to their explicit
accuracy, many of
van Wittel's views are
valuable for reconstructing
the appearance of buildings
or parts of the city that
have radically changed
today. The port along the
Tiber, for example, has
completely disappeared
and the banks of the
historic river are now
very different. From the
standpoint of art history,
it is interesting to note
that van Wittel's views
were a precise point of
reference for the abundant
later production of *vedute*
of Rome, which began
with Piranesi's engravings.

Seventeenth-Century France

Georges de La Tour
The Cheat
c. 1632
oil on canvas,
38½ × 61½ in. (98 × 156 cm)
Kimbell Art Museum,
Fort Worth

When Galileo separated science from philosophy and theology, this marked a profound transformation in the way of considering the problem of knowledge. Particularly in France, the extension of the mathematical method to the sciences of the spirit was the starting point for Descartes's rationalism and for his deep need for *clarté*, which was to have a great influence on the development of the figurative arts.

During this period secular society was engaged in an intense dialogue with religious society. Themes of faith and religion confronted those of philosophy. The relationship between grace and arbitrary freedom, between man's will and predestination was interwoven with Cartesian philosophical problems, as the scientist Blaise Pascal in particular testifies in his work *Lettre escrite à un provincial*, which defends the Jansenist movement against the authoritarian conformity and moral laxity of the Jesuits.

There is no doubt that Pascal took the new Cartesian principles as his starting point. For him, too, man's true being lies in thought; however, for him the concept of self-awareness assumes an essential ethical and religious significance, following the legacy of Augustine. Unlike Montaigne, with whom he shares a lucid interpretation of the human condition, Pascal exposes the tragic conflict that is at the root of human existence; therefore he cannot stop at the conclusions of skepticism or acquiesce to dogmatism. Hence Pascal's "bet."

The clash between passion and reason that is evident throughout his *Pensées* (1670) finds its most complete expression in Racine's great plays, one of the most sublime testimonies of a century of theater par excellence. Scenographic research, apart from that specific to the theater, is in fact one of the most outstanding aspects of the Baroque figurative arts. The churches with their rich stucco ornamentation, their elaborate baldachins, and the "glory" of their luminous heavens, the squares with their fountains, the wings and backdrops of the buildings, which open up different perspectives, become a varied, festive stage where the rites of political power, of the sacred and the profane, are performed.

In France it was the court that determined the stylistic orientation of the arts, through personalities like Cardinal Richelieu, and, in particular, Cardinal Mazarin, who gave new vigor to artistic and cultural activities by pro-

Valentin de Boulogne
St. John the Baptist
c. 1628–1630
oil on canvas,
51¼ × 35½ in.
(130 × 90 cm)
Santa Maria in Via,
Camerino

Georges de La Tour
The Hurdy-Gurdy Player
c. 1631–1636
oil on canvas,
63¾ × 41¼ in.
(162 × 105 cm)
Musée des Beaux-Arts,
Nantes

Philippe de Champaigne
Ex voto
1662
oil on canvas,
165 × 90¼ in.
(165 × 229 cm)
Louvre, Paris

Nicolas Poussin
David Victorious
c. 1627
oil on canvas,
39¼ × 51¼ in.
(100 × 130 cm)
Prado, Madrid

moting the foundation of the Académie Royale des Arts (1648). The founders, alongside Charles Lebrun, a personality who dominated French Baroque classicism and was a follower of Poussin, included Philippe de Champaigne, a portraitist who successfully combined French elegance with Flemish psychological penetration. Hyacinthe Rigaud was also to move in this direction in his famous portraits of Louis XIV, in which the influence of van Dyck is combined with the theatrical Baroque style. The initiatives promoted by Cardinal Mazarin included the establishment of workshops and manufacturies such as that of the Gobelins (1662–1667), directed by Charles Lebrun and specializing in products of top-quality craftsmanship.

The Palace of Versailles became the vital center; it was connected to the town along a central axis and with it formed an urban fabric that was to become the model for the city of absolutism.

In the interior of the palace the *décor* was combined with Vitruvian *utilitas* to create a perfect equilibrium between furnishings and space, between the requirements of social status and comfort, in a fusion of monumentality and rationality, luxury and convenience. The focal point of the palace is the great Galerie des Glaces, opening onto the garden and designed by Lebrun. Here the decoration blends with the architecture in the common intent to celebrate and glorify the king. There is a new relationship between the different arts, though the leading role is played by architecture and theater, which by their very nature coordinate the heterogeneous materials and techniques.

Baroque art, particularly in France, displayed a great interest in contemporary technical and scientific discoveries, in the image they proposed of a universe without a center, which raised doubts as to the possibility of containing the whole history of the world within the brief space conceded by religious orthodoxy.

At the center of the cultural debate was the theme of the different relationship to be established with tradition. Being old ceased to be a value in itself, yet there was not a total break with the past, but a new, very complex, and problematic relationship with it was established. Poussin's work is very illuminating in this regard, since he filters every element of his extensive culture to create new forms, modulated according to almost mathematical

Hyacinthe Rigaud
Portrait of Louis XIV
1694
oil on canvas,
109 × 76¼ in.
(277 × 194 cm)
Louvre, Paris

rhythms, and he demonstrates a taste for abstraction that is underscored by his refined interplay of color. His works are mental constructs in which the individual elements are poised within a solid internal architecture, which is reminiscent of Cartesian *clarté*. His natural landscapes give a new interpretation of the classics in a manner that was to be adopted by Claude Lorrain. Taking as his starting point the ideal of ordered harmony, he arrives at a vision that is true to life, but idealized at the same time, in which distant backgrounds and foregrounds are linked in an articulate spatial continuity, thanks to his skillful interplay of light and color. What results is a new pictorial style, pursued with determined vigor, which imbues his art with a spirituality and an indefinite quality that anticipate Romantic landscapes.

While Lorrain is disinterested in figures—in his pictures they are painted by other artists—Louis Le Nain is at the opposite extreme. He succeeds in conferring great human dignity on his humble characters, who are nearly always country folk, captured in interiors or out of doors, in a kind of popular counterpoint to Poussin's aristocratic world, beyond any intellectualism, though not without a certain clumsiness, unconfident draftsmanship, and considerable compositional ingenuity.

Far more skilled, though still within the sphere of realism clearly influenced by Caravaggio, in which Simon Vouet and Valentin de Boulogne also worked, is Georges de La Tour's depiction of humble folk. His *Hurdy-Gurdy Player*, in which Stendhal noted "a terrifying, plebeian truth" that can be read as a loud denouncement of proletarian misery, exhibits an ability to explore the surfaces and outlines of things that, though influenced by Caravaggio, are also reminiscent of northern stylizations. He exhibits the flair of an experimenter who is striking in his bold colors and arbitrary use of light. In the works of his maturity, despite his refusal of abstract models and his habit of depicting his characters, even biblical figures, in contemporary dress, in actual fact it is no longer possible to speak of realism, nor of a Caravaggesque style. His nocturnal scenes are more in line with Parisian taste, which inclined toward a stoic conception of existence that rejected uncontrolled passions and appealed to willpower and moral law.

Georges de La Tour's pictorial oeuvre thus fits perfectly into a context where the points of reference are

Claude Lorrain
Landscape with Abraham Driving Away Agar and Ishmael
1668
oil on canvas,
41¾ × 55 in.
(106 × 140 cm)
Alte Pinakothek, Munich

Corneille's *Le Cid*, Descartes's *Discourse on Method*, and Poussin's *Manna*, and he bases his creativity on the model offered by the tragic playwright.

Poussin sets himself openly against Cravaggesque realism, since he maintains that art constitutes first and foremost a mental construct. Poussin is classical in Gide's sense of the word, according to whom classicism is above all tamed Romanticism, and he is the most outstanding exponent of seventeenth-century French painting.

Simon Vouet
(Paris, 1590–1649)

Having made his name as a portraitist when he was very young—it is said that he followed a French lady to London to paint her portrait when he was only fifteen—Vouet moved to Italy in 1613. He went first to Venice where he became acquainted with the painting of Titian, Veronese, and Tintoretto, and was impressed, above all, by the great compositions in the Doges' Palace, then to Rome where he frequented the circle of the Dutch Caravaggists. He received major commissions in several Roman churches from Pope Urban VIII. In 1624, he painted the canvases of *The Temptation of St. Francis* and *The Investiture of the Saint* for the church of San Lorenzo in Lucina, examples of a compositional style rich in theatrical effects, in which Caravaggesque influences blend with the Baroque. That same year Vouet was elected president of the Accademia di San Luca and, in 1627, now a famous artist, he returned to France where Louis XIII appointed him "first painter to the king" and gave him an apartment in the Louvre and an annual stipend. Having set up a studio frequented by the greatest artists of the day, Vouet devoted himself to the decoration of Parisian churches and palaces, in which Baroque eloquence was tempered by Poussin-style classicism.

Simon Vouet
Crucifixion

1622
oil on canvas,
147¾ × 88½ in.
(375 × 225 cm)
Chiesa del Gesù, Genoa

This painting, executed in Rome, was sent to Genoa in 1622, where Vouet had spent a year in the service of Paolo Orsini and the Doria family. His stay in Genoa, and above all his contact with Orazio Gentileschi, who was also in the city in 1621, encouraged Vouet gradually to abandon the Caravaggism of his early manner for a Baroque style that is light, vigorous, and chromatically extraordinarily refined.

Simon Vouet
Magdalene

c. 1614–1615
oil on wood,
24¾ × 19¼ in.
(63 × 49 cm)
Palazzo del Quirinale, Rome

Simon Vouet
St. Catherine

c. 1614–1615
oil on wood,
24¾ × 19¼ in.
(63 × 49 cm)
Palazzo del Quirinale, Rome

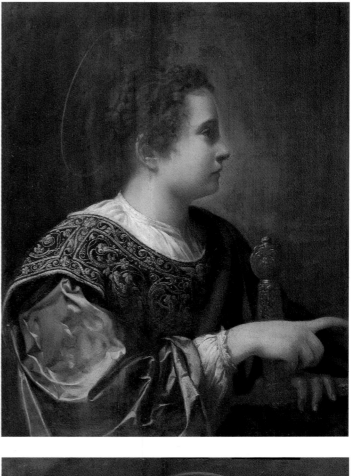

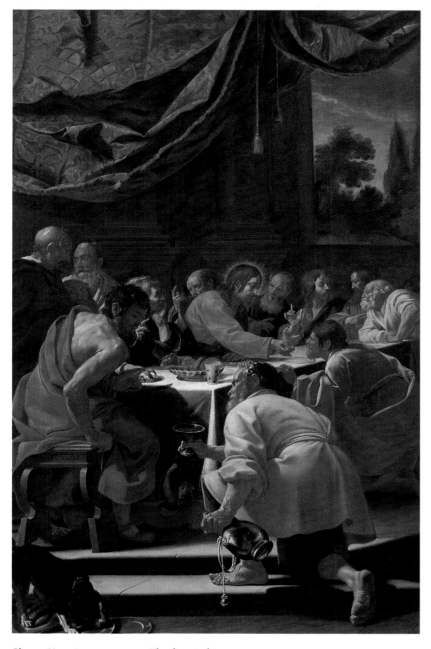

Simon Vouet
The Last Supper

c. 1615–1620
oil on canvas
Palazzo Apostolico, Loreto

The theatrical scene and the carefully studied arrangement of the figures on several planes anticipate Vouet's large Parisian compositions.

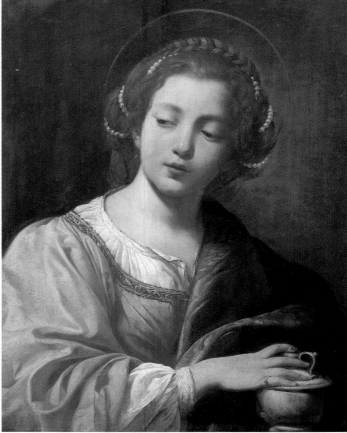

Valentin de Boulogne

(Coulommiers, 1591–Rome, 1632)

Born into a family of Italian artists, after his apprenticeship in France, he moved to Rome in 1613 where he met Simon Vouet and was attracted by the Caraveggesque painting that was still in vogue. He entered the Bemtvögel circle under the nickname "Innamorato" and painted works that, though their subjects—for example, *The Cheat*, now in Dresden—are reminiscent of the carefree climate of the Dutch circle, depart from this to anticipate the composed, tragic quality of Louis Le Nain's figures. As a tavern habitué, even when he tackles biblical and religious themes, he is always concerned with depicting everyday reality in its most humble aspects. In Rome the artist enjoyed the protection of such illustrious patrons as the Barberini family, who were reputedly francophiles. Thanks to the support of Cardinal Francesco Barberini, nephew of Pope Urban VIII, de Boulogne was commissioned to work alongside Vouet, Poussin, and Subleyras in the basilica of St Peter's. He died tragically in Rome in the summer of 1632.

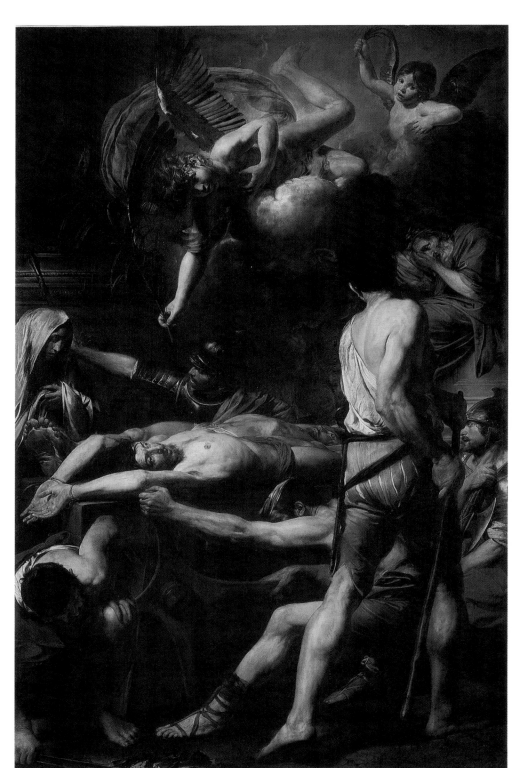

Valentin de Boulogne
Martyrdom of Saints Processus and Martinian

1629
oil on canvas,
119 × 75½ in.
(302 × 192 cm)
Pinacoteca Vaticana, Rome

Painted for the basilica of St. Peter's, it was placed on an altar as a pendant to Poussin's *Martyrdom of St. Erasmus*, executed during the same period. The late influence of Poussin's classicism can still be discerned alongside the newly acquired Caravaggesque style in this work by Valentin, despite the conflicts and quarrels between the two artists.

Valentin de Boulogne
The Last Supper

c. 1625–1626
oil on canvas,
54¾ × 90½ in.
(139 × 230 cm)
Galleria Nazionale d'Arte Antica, Rome

In a scene that is deliberately empty, attention is fully focused on the twelve apostles surrounding the rapt Christ. Each of them reacts differently to the Savior's words. Their expressions of astonishment, anguish, and sadness convey an extraordinary psychological intensity.

Valentin de Boulogne
The Concert

c. 1620
oil on canvas,
68 × 84¼ in.
(173 × 214 cm)
Louvre, Paris

A bourgeois interior, characterized solely by a classical bas-relief, is the setting for this concert. Caravaggio's influence is evident not only in the choice of subject, but also in the melancoly air of the figures, the realistic faces, the violent contrasts of light and shadow, the warm tones, and the thick pigment.

Valentin de Boulogne
Judith and Holofernes

c. 1626
oil on canvas,
41¾ × 55½ in.
(106 × 141 cm)
National Museum, La Valletta (Malta)

The starkly illuminated figures emerge from the dark background, in a spatial arrangement that is closely linked to the work of the Caravaggists, especially Bartolomeo Manfredi.

Valentin de Boulogne
The Fortune Teller

c. 1628
oil on canvas,
49¼ × 69 in.
(125 × 175 cm)
Louvre, Paris

This is an astonishing work for its intense psychological insight, conveyed through a play of looks and disturbing silences. Around the table—the pivot of the composition—the characters are arranged randomly, some with their backs to the viewer, some facing him, in a complex scheme of conflicting lines and rapid changes of axis.

Georges de La Tour

(Vic, 1593–Lunéville, 1652)

A painter who was long overlooked, La Tour's oeuvre has only recently been reconstructed and assessed by modern criticism. This revival, which began in the Twenties, has reattributed to La Tour works that were previously considered to be by other Caravaggesque painters, especially Valentin and Honthorst. The 1972 exhibition in Paris, the first devoted to La Tour, was pivotal in this respect since it displayed over thirty original paintings by the artist. His biography is also uncertain. Little or nothing is known of his training, which is likely to have taken place in Nancy. It is possible that he journeyed to Italy between 1610 and 1616, which would explain his knowledge of Caravaggio's works and his circle, whose influence can be seen in his painting. However, recent studies have revealed that he was an unusual artist who developed an individual, consistent, extremely modern language. Though

in his early years La Tour faithfully followed Caravaggio's model, in his maturity he moved toward a simplification of composition and a stylization of the figures, attributing a moral value to realism, in line with the severe style of French classicism. From 1620 on, his presence is documented at Lunéville, his wife's hometown, where he spent a happy period and established himself both socially and artistically. In the following decade Lorraine was devastated first by the plague and then by war. Lunéville, a garrison center, was put to fire and sword and plundered; thus all traces of the artist and most of his early works were lost. In 1643 La Tour was back in Lunéville, where he remained until he died from an epidemic fever, contracted in 1652, which had already caused the death of his wife. Though the chronological order of his paintings is uncertain, it is possible to trace a line of development from the "daytime" paintings to the large "nocturnal" compositions, in which candlelight is a kind of leitmotif.

Georges de La Tour
The Fortune Teller

c. 1632–1635
oil on canvas,
40¼ × 48½ in.
(102 × 123.5 cm)
Metropolitan Museum of Art, New York

Three young women and an old gypsy are symmetrically arranged around a young gentleman with whom they are exchanging intense glances. Here La Tour combines the Caravaggesque theme of the fortune teller, which was relatively common during the first half of the seventeenth century, with the originally French theme of the prodigal son robbed by women.

Georges de La Tour
The Paid Money

c. 1630–1635
oil on canvas,
39 × 59¾ in.
(99 × 152 cm)
*Museum of Fine Arts, Lwow
(Ukraine)*

Originally attributed to
Honthorst during the
nineteenth century, it was
attributed to La Tour only
in 1970 and dated, though
this is doubtful, to the
beginning of his career.
The subject is a religious
one, perhaps the payment
of tribute money.

Georges de La Tour
Musicians' Fight

c. 1625–1630
oil on canvas,
37 × 55 in. (94 × 140 cm)
*J. Paul Getty Museum,
Malibu*

The studied symmetry of
the figures conveys a moral
lesson. The desperate
woman on the left is offset
by two laughing musicians
on the right to express the
crude reality of life.

Previous page:

Georges de La Tour
Magdalene with a Lamp

c. 1638–1643
oil on canvas, 50½ × 37 in.
(128 × 94 cm)
Louvre, Paris

Georges de La Tour
The Penitent Magdalene

c. 1638–1643
oil on canvas,
52¾ × 36¼ in.
(134 × 92 cm)
*Metropolitan Museum of Art,
New York*

La Tour opposes the
dignity of moral asceticism
to the vanity of the world.
Of the four canvases the
artist devoted to the saint

This is the only signed
canvas devoted to the saint.
It presents a more severe
image than the others;
having chosen solitude and
austerity, Mary Magdalene
is depicted in tranquil
poverty.

this is the only one that
depicts her at the dramatic
moment of her conversion.
Mary Magdalene is seen in
front of a mirror, the
symbol of vanity, in which
is reflected the flame of a
candle, the symbol of time
passing. She has made her
choice; this can be seen
from the jewelry she has
laid aside and from her
crossed hands on the skull
in her lap.

Georges de La Tour
Christ with St. Joseph
in the Carpenter's Shop

c. 1640
oil on canvas,
54 × 39¾ in.
(137 × 101 cm)
Louvre, Paris

A saint particularly
venerated in Lorraine,
Joseph is represented in a
kind of mute dialogue with
the Christ Child. The old
Joseph absorbed in his
work, who does not realize
that the piece of sawn wood
is taking on the shape of a
cross, is offset by the Child
who symbolizes innocence
and hope.

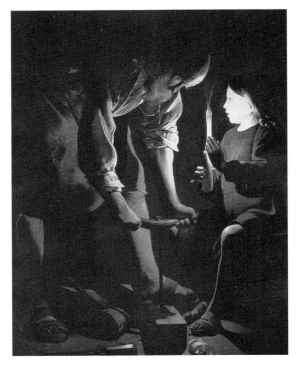

Georges de La Tour
Woman Removing Fleas

1630–1634, oil on canvas,
47¼ × 35½ in.
(120 × 90 cm)
*Musée Historique, Nancy,
Lorraine*

La Tour takes up a theme
that was popular with
the *Bambedocianti* and
he transforms it by
emphasizing with simple,
calm gestures and a skillful
use of light the solitude of
a moment of daily privacy.

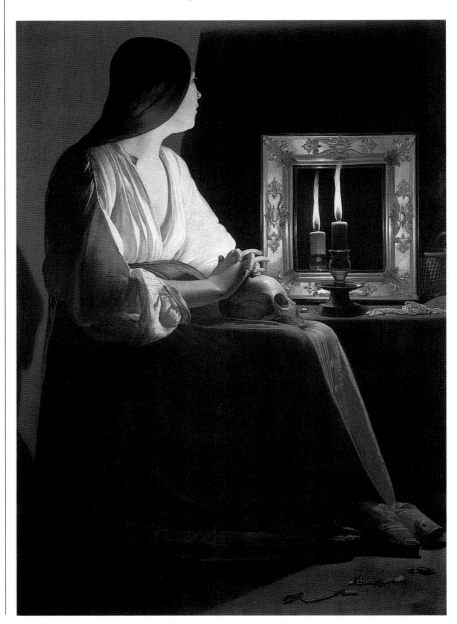

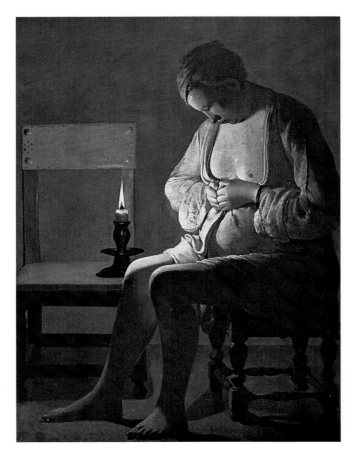

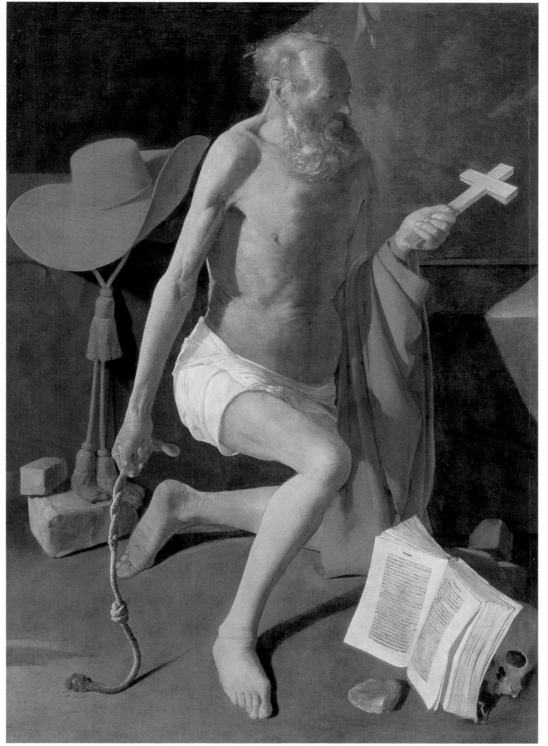

Georges de La Tour
The Penitent St. Jerome
(with Cardinal's Hat)

c. 1630
oil on canvas,
59¾ × 43 in.
(152 × 109 cm)
Nationalmuseum, Stockholm

One of the most noble
figures painted by the
artist, the nude, weak old
saint clasps the cross in one
hand and the blood-stained
rope he has used to
flagellate himself in the
other.

Georges de La Tour
The Newborn Baby

c. 1648
oil on canvas,
30 × 35¾ in.
(76 × 91 cm)
Musée des Beaux-Arts, Rennes

In an intense and rarefied atmosphere, an arbitrary light models the figures, causing them to resemble geometric shapes. Thus the composition acquires a severe monumental and dramatic quality that makes this the most famous painting in the artist's oeuvre.

Georges de La Tour
St. Sebastian Attended
by St. Irene

c. 1649
oil on canvas,
63¾ × 50¾ in.
(162 × 129 cm)
Staatliche Museen, Berlin

This painting, discovered
in 1945 in the small
church at Bois-Anzeray,
dates from the Lorraine
painter's late period. At
first thought to be a work
by his assistants, unlike
the other version held in
Berlin, it is now widely
accepted as an original
and considered of superior
quality. Within the small
space lit by a lantern,
La Tour breaks up the
scene by setting every
figure on a different plane.
In the foreground lies
St. Sebastian with St. Irene
at his side, and behind her
stand three women
captured in attitudes of
pity, grief, and prayer.

Nicolas Poussin

(Les Andelys, 1594–Rome, 1665)

Poussin was born into a noble family that had seen better days. Against the wishes of his father, who wanted him to become a magistrate, Poussin became involved, at an early age, with the workshop of Quentin Varin, a modest Mannerist painter who was in Les Andelys from 1611 to 1612. This experience confirmed him in his vocation, and on Varin's departure, he ran away to Paris to begin a difficult period of training. In 1622 he met the Italian poet Giovan Battista Marino, who appreciated his painting and offered him protection and friendship.
Although Poussin's fame was beginning to spread in Paris, where he received important commissions, he left the city for Rome in 1624. There he was reunited with Marino, who helped him secure the patronage of Cardinal Barberini, and he

continued his training through the study of Raphael and Roman sculpture, with an eye also on the Caravaggesque school and Bolognese classicism as exemplified by Guido Reni and Domenichino.
In 1628 Poussin was commissioned by Cardinal Barberini to paint an altarpiece of the *Martyrdom of St. Erasmus* for an altar in St. Peter's, where Vouet and Valentin de Boulogne were also working. In 1630, having failed to secure an important commission for the church of San Luigi dei Francesi, he decided to abandon large-scale official works and devoted his energies to paintings on a smaller scale for rich art lovers. He thus regained the favor of French collectors, who became his main admirers and patrons. Urged by friends to return to France, he hesitated until 1640, when the promptings became still more insistent and the promises of work more attractive. On his arrival in Paris, Poussin was, in fact, warmly welcomed by Cardinal Richelieu and by Louis XIII himself, who appointed

him "first painter to the king" and placed him in charge of all painting and decorative work for the royal residences. Poussin soon found the obligations of this demanding life at court irksome and left Paris in 1642, turning his back on the extraordinary advantages of his position to take refuge in Rome. The deaths of Cardinal Richelieu at the end of the year and the king in the following year convinced Poussin that it would be better to remain in Rome, where he led a life devoted to work and enlivened only by visits from friends and French patrons. The last period of his career was marked by increased interest in the natural landscape. The Louvre series of *Four Seasons,* painted between 1660 and 1664 for the Duc de Richelieu, constitutes his artistic and spiritual testament. The short cycle, closing with the remarkable *Winter,* again features the fundamental themes of his painting, such as the fecundity of nature and the sense of human existence.

Nicolas Poussin
Bacchanalian Revel
Before a Herm of Pan

c. 1631–1633
oil on canvas,
39¼ × 56 in.
(100 × 142.5 cm)
National Gallery, London

Poussin drew inspiration
from the bacchanalian
scenes painted by Titian
in the Villa Aldobrandini
in Rome. The composition
is based on a diagonal line
stretching from the tree
trunk to the fallen nymph,
a vertical line formed by the
statue of Pan and the trees
behind it, and a horizontal
line linking the dancers
in the foreground to the
distant plain.

Nicolas Poussin
Apollo and Daphne

after 1625
oil on canvas,
38½ × 51¼ in.
(98 × 130 cm)
Alte Pinakothek, Munich

Inspired by Ovid's
Metamorphoses, this
work depicts Apollo's
unsuccessful pursuit
of the nymph Daphne, who
is a votary of Artemis and
cannot accept the god's
love. Having taken refuge
with her father, the river
god Peneus, she finally
turns herself into a laurel
to escape Apollo. The
painting is unanimously
regarded as a pendant to
the *Midas and Bacchus* by
virtue of their similarities
in terms of format, subject
(the Golden Age), and
compositional layout.

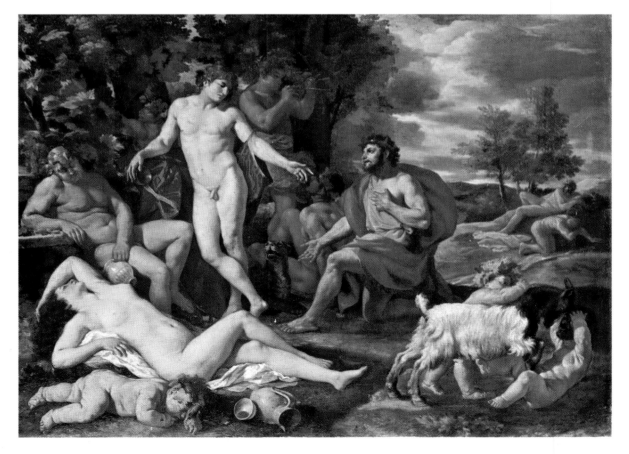

Nicolas Poussin
Midas and Bacchus

c. 1629–1630
oil on canvas,
38¼ × 51¼ in.
(98 × 130 cm)
Alte Pinakothek, Munich

Poussin was strongly
attracted to the theme of
Midas, drawn from Ovid,
and based a number of
paintings on it. Having
obtained from Bacchus the
gift of turning everything
he touches into gold, the
hungry, thirsty king Midas
soon regrets his greed.
Bacchus grants him release
by having him bathe at the
source of the Pactolus
River. Poussin depicts the
part of the myth where
Midas thanks Bacchus for
liberating him. In the
background, a youth can
be seen collecting gold
from the Pactolus.

Nicolas Poussin
The Death of Germanicus

1627
oil on canvas,
58¼ × 78 in.
(148 × 198 cm)
Minneapolis Institute of Art,
Minneapolis

Commissioned in 1626 by
Cardinal Barberini for his

family palace, this is one of
Poussin's most celebrated
and best documented
works. The subject, drawn
from the *Annals* of Tacitus,
combines moral teaching,
archaeological research,
and the expression of
emotions. The poses,
gestures, and rhythm of
the bodies together with

the orchestration of the
composition demonstrate
the artist's self-control
and natural instinct
for the heroic.

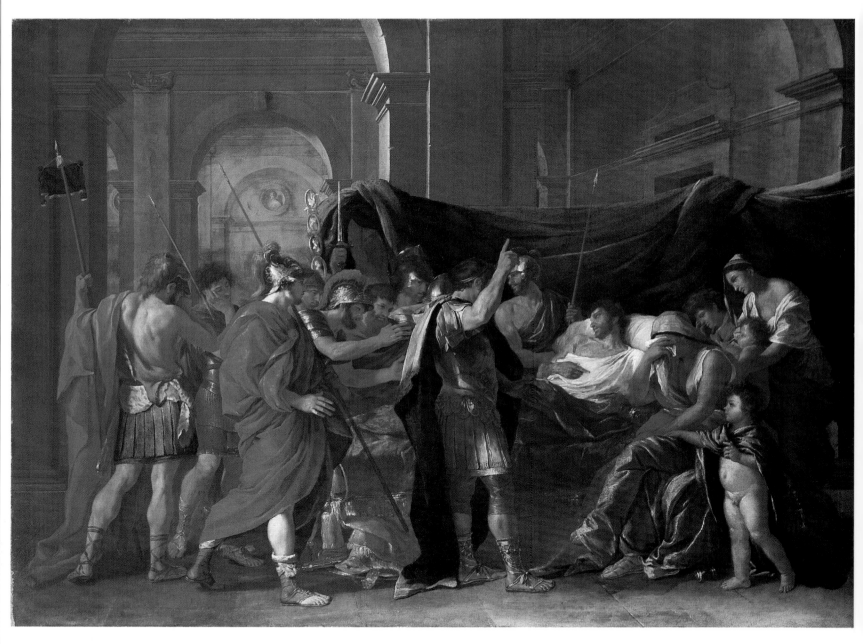

Nicolas Poussin
Martyrdom of St. Erasmus
1628
oil on canvas,
126 × 73¼ in.
(320 × 186 cm)
Pinacoteca Vaticana, Rome

Commissioned by Cardinal
Barberini for the basilica
of St. Peter's, this painting
stands out from the rest
of Poussin's work by virtue
of both its size and subject
matter. It appears to have
been greatly influenced by
Italian Baroque painters
such as Caravaggio,
Guido Reni, and Giovanni
Lanfranco, above all as
to the colossal rendering
of the figures and the
dramatic nature of the
scene. The strong light
emphasizes the powerful
muscles of the saint and his
executioners.

Nicolas Poussin
The Reign of Flora

1631
oil on canvas,
51½ × 71¼ in.
(131 × 181 cm)
Gemäldegalerie, Dresden

In the center of the canvas,
Flora, the goddess of
springtime blossoming,
scatters flowers in the
company of mythological
characters drawn from
Ovid's *Metamorphoses*,
whose myths are
associated with certain
flowers. Framed by a
Giorgionesque boulder
and a slender arbor, we
can see Narcissus gazing
at his reflection in a jug
of water brought by
the nymph Echo, Smilax
and the nymph Crocus,
Hyacinth and Adonis.

Nicolas Poussin
The Rape of the Sabine
Women

c. 1634–1635
oil on canvas,
60½ × 81 in.
(154 × 206 cm)
*Metropolitan Museum of Art,
New York*

The founding of Rome
episode, when the Romans
abducted Sabine women
to make them their wives.
The isolated figure
of Romulus set above
the bustling scene
represents reason as
opposed to the irrational
behavior of the mob.

Nicolas Poussin
The Rape of the Sabine
Women

1637–1638
oil on canvas,
62½ × 81 in.
(159 × 206 cm)
Louvre, Paris

The main figures are
the same as those in the
Metropolitan version,
but the architectural
background is richer
and Romulus is now
emotionally involved,
as indicated by his solemn,
theatrical advance before
the wild throng of men
and women.

Nicolas Poussin
The Adoration
of the Magi

1633
oil on canvas,
63 × 71¾ in.
(160 × 182 cm)
*Gemäldegalerie,
Dresden*

This renowned work,
several copies of which
exist, is highly complex in
layout. In the foreground,
before the imposing ruins
of a temple, an agitated
throng of gesticulating
figures contrasts with
the severe composure
of the Nativity group.

Nicolas Poussin
Landscape with the Body
of Phocion Carried Out
of Athens

1648
oil on canvas,
45 × 69 in. (114 × 175 cm)
*Earl of Plymouth's Collection,
Oakly Park, Shropshire*

The proportions of the
human figures blend in
with those of the landscape
in a harmony of line and
color. The body of
Phocion, the Athenian
general accused of treason
and sentenced to death, is
seen in the foreground.

Nicolas Poussin
Winter

1660–1664
oil on canvas, 46½ × 63 in.
(118 × 160 cm)
Louvre, Paris

The last work of an
exhausted painter in poor
health, this ends the cycle
of the *Seasons* inspired
by the *Georgics* by Virgil,
Poussin's favorite author
together with Ovid.
Originally commissioned
by the Duc de Richelieu,
the series formed part
of Louis XIV's collection
and is now in the Louvre.
It represents an extreme
declaration of faith in
nature together with
an absolute awareness
of the relentless operation
of dark forces almost
foreshadowing the end
of lucid Cartesian
optimism. The ark
glimpsed beneath the
faint sun half-concealed
by the leaden sky in the
background symbolizes
the continuation of life
after death, while the
snake slithering through
the shadows on the left is
an allusion to the eternal
fertility of the earth.

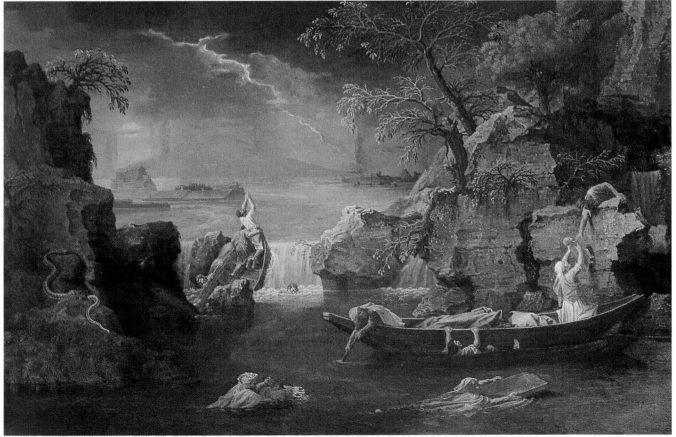

Nicolas Poussin
Landscape with Orpheus
and Eurydice

1648
oil on canvas,
47¼ × 78¾ in.
(120 × 200 cm)
Louvre, Paris

The dramatic separation
of the two lovers of
Greek myth is depicted
in a Roman setting
that includes Castel
Sant'Angelo. This is
hardly surprising given
Poussin's view of painting
as primarily a mental
construct. In any case,
the discrepancy regards
the organization of the
canvas, but not the
depiction of the individual
elements, where the artist
never loses contact with
truth and nature.

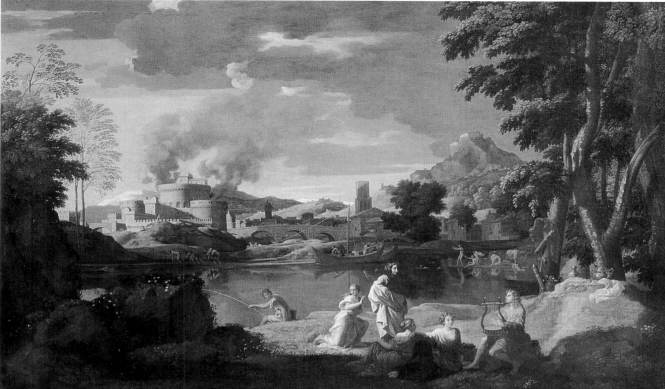

Nicolas Poussin
Landscape with
Polyphemus

1649
oil on canvas,
59 × 78 in.
(150 × 198 cm)
Hermitage, St. Petersburg

This is one of Poussin's
most important
landscapes, and indeed
contains no trace of the
dramatic Homeric episode.
The wholly idyllic scene
alludes to, if anything,
Virgil's bucolic world
and a sort of primitive
communion between
man and nature.

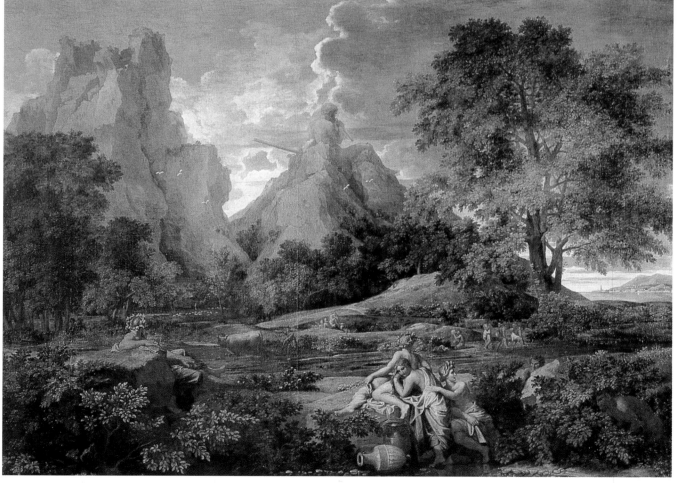

EFFIGIES NICOLA POVSSINI ANDEL
YENSIS PICTORIS ANNO ÆTATISS
ROMÆ ANNO IVBILEI
1650.

Nicolas Poussin
Self-Portrait

1650
oil on canvas,
38½ × 29¼ in.
(98 × 74 cm)
Louvre, Paris

While Poussin painted no portraits, he did execute two self-portraits between 1649 and 1650 giving very different images of himself. The first (Bodemuseum, Berlin) shows the artist holding a book with the words "De lumine et colore," and constitutes a tranquil celebration of himself and his painting. The second was considered the better likeness by Bernini, who saw them both in 1665. This severe, austere image conveys a sense of the intellectual rigor of Poussin's art through the monumental pose and the expression, which betray anxiety and concern.

Claude Lorrain

(Chamagne, Nancy, 1600–Rome, 1682)

One of the greatest seventeenth-century landscape painters, Claude Lorrain moved to Rome in 1613 and remained there until his death except for one stay in Naples from 1619 to 1621 and another in his native Lorraine from 1625 to 1627. His apprenticeship took place in the workshop of the Roman landscape painter Agostino Tassi. 1629 saw the beginning of his association with Joachim von Sandrart, with whom he learned to draw from life, and freed himself from Tassi's academic models. He gradually developed a tendency to give concrete shape to nature through the continuity of space and light. The remains of classical architecture, the great trees silhouetted against the sky, the distant peaks, and the still seaports combine to produce an ideal and yet recognizable landscape based on the

Roman countryside or *campagna*, the hills of Latium that the artist never tired of exploring and recording in hundreds of precious drawings. The extraordinary series of *Morning*, *Afternoon*, *Dusk*, and *Night* at the Hermitage demonstrates Lorrain's highly personal use of light in relation to the specific hour dictated by the subject. Light from the left indicates morning and suggests cold tones for the landscape and the sky. Light from the right represents evening and allows the use of warm tones with skies ranging from fiery pink to orange. The cosmopolitan atmosphere of seventeenth-century Rome had a positive effect on Lorrain's long career, enabling him to combine very different experiences—Poussin's classical restraint, the landscapes of the Bolognese school from Carracci to Guercino, and the Caravaggesque handling of light— in a synthesis of remarkable originality that anticipates Turner and the Impressionists.

Claude Lorrain
Landscape with
the Marriage of Isaac
and Rebekah

1648
oil on canvas,
58¾ × 77½ in.
(149 × 197 cm)
National Gallery, London

Under the influence of Domenichino and Annibale Carracci, Lorrain's style became more elevated and serene. Having abandoned fantastic *vedute* (views) and picturesque motifs, the artist began to base his landscapes on the nearby Roman *campagna*.

Claude Lorrain
Seaport with Villa Medici

1637
oil on canvas,
40¼ × 52¼ in.
(102 × 133 cm)
Uffizi, Florence

Painted for Cardinal de'
Medici, this work has a
personal significance as it
portrays Villa Medici in the
foreground as well as a
ship in the port flying the
flag of the Knights of St.
Stephen, an order founded
by the Medici in 1562 to
combat heretics in the
Mediterranean.

Claude Lorrain
Landscape with the Rest
on the Flight into Egypt

1647
oil on canvas,
40¼ × 52¾ in.
(102 × 134 cm)
Gemäldegalerie, Dresden

The structure of this work
is based on a precise
geometrical plan. Dense
masses of vegetation
provide a frame and the
movement of the trunks
and foliage serve to
underscore the actions
of the figures.

Previous page:

Claude Lorrain
Landscape with Apollo
Guarding the Herds
of Admetus and Mercury
Robbing Him

1645
oil on canvas,
21¾ × 17¾ in.
(55 × 45 cm)
*Galleria Doria-Pamphili,
Rome*

This painting stands out
among the various versions
of the subject by virtue of
its vertical compositional
layout. Though treated as
a pastoral subject, the
work draws new strength
from the mythological tale.
Following Ovid, Lorrain
represents Apollo as a
simple shepherd being
robbed by Mercury,
depicted with the
customary attributes of the
caduceus and the winged
sandals and helmet.

Claude Lorrain
The Trojan Women Setting
Fire to Their Fleet

1643
oil on canvas,
41¼ × 59¾ in.
(105 × 152 cm)
*Metropolitan Museum of Art,
New York*

The painting shows the
Trojan women obeying
Juno's prompting and
setting fire to their ships
after seven years of
wandering in order to halt
Aeneas's progress toward
Italy. The subject is taken
from Virgil's *Aeneid* and
constitutes a sophisticated
literary metaphor alluding
to the difficulties
encountered by Lorrain's
patron, Girolamo Farnese,
as apostolic nuncio in the
service of Urban VIII.

Claude Lorrain
Seaport with Acis
and Galatea

1657
oil on canvas,
39¼ × 53¼ in.
(100 × 135 cm)
Gemäldegalerie, Dresden

This mythological subject
is taken from Ovid's
Metamorphoses. In the
center of the composition,
Acis and Galatea, hidden
beneath an awning, conceal
their embraces from the
Cyclops Polyphemus, who
can be glimpsed lurking
threateningly in the woods
on the right.

Claude Lorrain
Seaport

1674
oil on canvas,
28¼ × 38¼ in.
(72 × 97 cm)
Alte Pinakothek, Munich

A recurrent subject in Lorrain's oeuvre is the seaport, where the reflecting surface of the water offers the artist an opportunity to play with the shimmering effect of the rising sun. He uses this imaginary spot at the foot of a triumphal arch inspired by the Arch of Titus in the Forum as a setting for a genre scene. The leading role is, however, played as always by the landscape.

Claude Lorrain
Imaginary View of Tivoli

1642
oil on copper,
8½ × 10¼ in.
(21.6 × 25.8 cm)
*Courtauld Institute Galleries,
London*

This work, marking one of the last appearances of the *capriccio* in Lorrain's production, is an imaginary view of the Temple of the Sibyl at Tivoli, with Rome and the dome of St. Peter's in the background. The scenic layout, with an enormous bridge separating the pastoral subject in the foreground from the landscape in the background, is unusually complex given the small size of the copper plate.

Louis Le Nain

(Laon, 1593–Paris, 1648)

Diametrically opposed to the classical school of French painting represented by Poussin, Louis Le Nain distinguishes himself as the leader of the school specializing in paintings of an elegiac rural life, a seventeenth-century form of genre painting better known in Italy through the work of the so-called *Bamboccianti*. We have little information regarding Louis Le Nain's life. Born in the country near Laon, a town in northern France, with one older and one younger brother who were also painters, Le Nain spent his childhood in close contact with the peasant world. Little is known about his artistic training. After a period in the workshop of a Flemish master in his hometown, he probably made a journey to Rome between 1629 and 1630 before settling in Paris, where he soon acquired a certain

reputation. He worked throughout his life in the same workshop as his brothers, where all the works were signed with the surname alone, thus making attribution of the paintings often difficult, despite the difference in their artistic temperaments. Antoine is traditionally indicated as a painter of miniatures and portraits. Louis produced mythological and religious works, but his fame rests on his canvases portraying the peasant world with measured realism. Mathieu devoted his energies to historical and religious subjects and continued the peasant genre after his brother's death.

Louis Le Nain
Peasant Family

1642
oil on canvas,
44½ × 62½ in.
(113 × 159 cm)
Louvre, Paris

This is a sober, rustic setting with austere figures frontally arranged, like actors on a stage, their intense, severe gaze directed toward the viewer. The soft, still light and the sober coloring of browns and grays combine to give an interpretation of the peasant world that is both authentic and solemn.

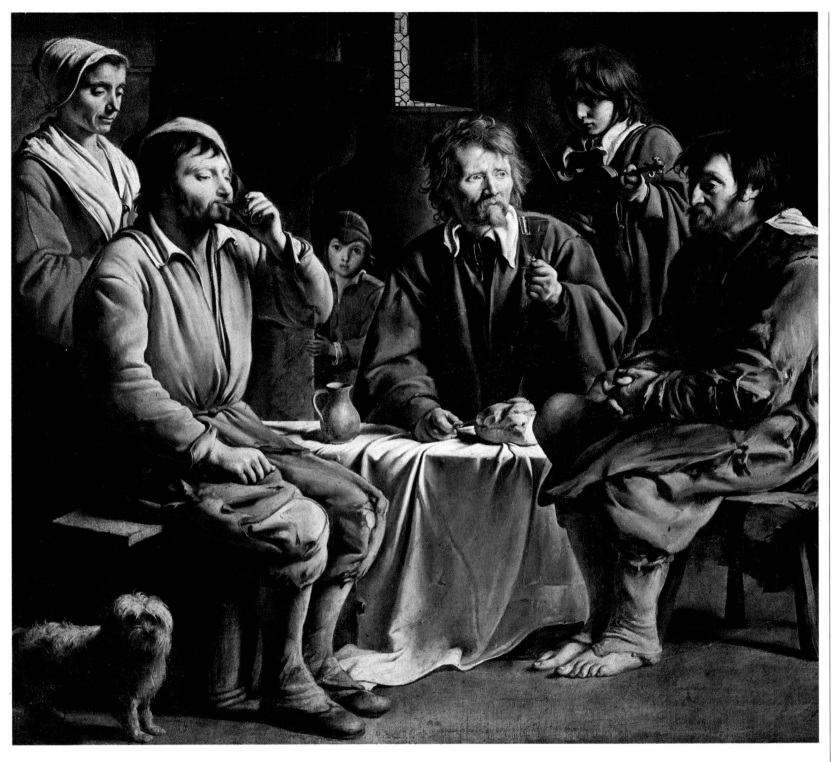

Louis Le Nain
Peasants' Repast

1642
oil on canvas,
38¼ × 48 in.
(97 × 122 cm)
Louvre, Paris

Le Nain also employed the everyday simplicity of his peasant scenes for religious subjects, as in this case, where the biblical episode of Christ's supper with two disciples in the town of Emmaus is set in a rustic interior and is represented as a peasants' meal.

Philippe de Champaigne

(Brussels, 1602–Paris, 1674)

After serving his apprenticeship in his hometown, in 1621 Philippe de Champaigne moved to Paris, where he met Poussin and was commissioned to work with him on the decoration of the Palais de Luxembourg. In 1628 Marie de' Medici appointed him court painter, a position he was to retain also during the reign of Louis XIII.

His portraits, especially those of Louis XIII and Richelieu, were renowned both for their grandiose conception and for their acute insight, demonstrating a capacity to combine French elegance with a psychological penetration of Flemish origin.

Richelieu commissioned him to decorate his Parisian residence (1636) and the church of the Sorbonne (1644) as well as his properties in the country.

In 1648 he was one of the founders of the Academy together with Lebrun, but began to turn gradually away from official painting as he became more involved with the Jansenist movement. The intense spirituality and strict rules of moral conduct observed at Port-Royal by the followers of Abbé Antoine Arnauld, including the great mathematician and philosopher Blaise Pascal, gave renewed vigor to Champaigne's paintings. This is demonstrated by his portrait of *Pascal* (Moussalli Collection, Paris) and the *Ex-Voto* (Louvre, Paris) painted for the miraculous cure of his daughter, a nun in the convent of Port-Royal. Eliminating all Baroque gratification, his painting achieved a formal purity in its portrayal of ascetic, immobile figures, while retaining the grandeur of his early portraits.

Philippe de Champaigne
Triple Portrait of Richelieu

oil on canvas,
22¾ × 28¼ in.
(58 × 72 cm)
National Gallery, London

Richelieu, the supremely competent, taciturn, cold, subtle, and tenacious minister, was made a cardinal in 1623. Master of the destinies of the French monarchy, he inspired and directed the events of Louis XIII's reign. The system of the triple portrait is adopted in this case not as an artistic device but as an opportunity for greater analytic insight.

Philippe de Champaigne
Portrait of Henri Groulart

1654
oil on canvas,
36½ × 29¾ in.
(92.5 × 75.5 cm)
Museum of Fine Arts, Budapest

A celebrated portrait painter, Champaigne combined psychological penetration with an analytic technique drawn from the Flemish tradition. The artist, who became more involved with the Jansenist movement in his maturity, offers an austere and severe image of his sitter.

Charles Lebrun

(Paris, 1619–1690)

The dominant personality in the French school of Baroque classicism, Lebrun was the supreme arbiter of taste at the court of Louis XIV. In 1634, at the age of just fifteen, he entered the workshop of Simon Vouet, where he produced paintings revealing an already acquired mastery of technique. In 1642, despite his appointment as court painter, Lebrun decided to complete his artistic apprenticeship in Rome on a grant provided by Chancellor Séguier. Between 1642 and 1646 he studied sixteenth-century Roman works with Poussin and also came under the influence of the painters working in the capital at that time. Poussin's teaching had a decisive impact on his style that can be seen in his mature works, where dramatic feelings are depicted with calculated poise and proportion.
On his return to France, he received important commissions for religious paintings, but especially for decorative works. He decorated the castle of Hesselin in 1649, the palace of President Lambert in 1650, the castle of Vaux between 1658 and 1661, and the Apollo Gallery in the Louvre in 1663. As a protégé of Jean-Baptiste Colbert, Louis XIV's superintendant of finances, he was appointed first painter to the king in 1662 and began the most fertile period of his career. He was made a chancellor in 1664 and prince of the French Academy two years later. Between 1671 and 1684 he decorated the Galerie des Glaces in the palace of Versailles. He produced canvases glorifying the sovereign for the ceiling and colored marbles, gilded bronzes, and mirrors for the walls that became part of the architecture in a quest for the sublime that makes the sumptuous character of Versailles unique. On Colbert's death in 1683, Lebrun fell into disgrace. In the last years of his life, deprived of important commissions by Pierre Mignard, he devoted his energies to easel painting.

Charles Lebrun
The Holy Family with the Sleeping Child
1655, oil on canvas,
34¼ × 46 ½ in.
(87 × 118 cm)
Louvre, Paris

Both the religious and the academic subjects are characterized by a composed solemnity, a noble rhetorical tone, and restrained passion.

Charles Lebrun
Chancellor Séguier

c. 1656
oil on canvas,
116¼ × 137¾ in.
(295 × 350 cm)
Louvre, Paris

Accompanied by pages and squires, the chancellor advances with all the pomp due his position as though in a theatrical scene. The order and symmetry of the composition underscore the calm and severe magnificence of the new social class to which the chancellor belongs, that of the élite forming the royal entourage. In this work the artist shows his gratitude to Chancellor Séguier, his first protector, by depicting himself as the squire holding the parasol.

Hyacinthe Rigaud

(Perpignan, 1659–Paris, 1743)

Rigaud was a shrewd observer of the Parisian aristocracy orbiting around the court of the Sun King and his work provides singular documentation of this world. Having completed his artistic apprenticeship in Montpellier and Lyons, in 1681 Rigaud moved to Paris, where he was admitted to the Royal Academy of Art three years later with the help of his protector Charles Lebrun. Influenced by the Flemish tradition, he modeled his portraits on those of van Dyck. Noticed by the king's brother, who commissioned a portrait of himself and one of his son, Rigaud was appointed court painter in 1688. He painted two portraits of Louis XIV, in 1694 and 1701, creating an image of the king that has become established in the collective memory. In the portrait of Louis XIV in the Louvre, the pomp of the drapery and the bright range of colors offer a distinct image of regality. As court painter, Rigaud was a resounding success, and his list of clients expanded to include all the European courts. In order to cope with the ever increasing flow of commissions, he employed assistants and divided his workshop on a specialized basis, Sevin de la Pennaye being responsible for clothing, Monnoyer for inserts with flowers, Charles Parrocel for battles, and François Desportes for landscapes and animals.

Hyacinthe Rigaud
Portrait of Louis XIV

1701
oil on canvas,
109¾ × 74¾ in.
(279 × 190 cm)
Louvre, Paris

In 1701 Louis XIV ordered his official court painter to paint a portrait intended as a gift for Philip V of Spain. He then decided, however, that he would keep the work, a pompous and rhetorical painting exemplifying the parade portraits of the Grand Siècle. The sumptuous materials and hangings, the royal cloak of ermine and the royal insignia all feature in this official portrayal of the Sun King, the subject of which plays a secondary role with respect to the royal attributes. The dais, the throne, the classical column, and the theatrical hangings all contribute to the grandiose effect of the scene.

The German and Austrian Baroque

Franz Anton Maulbertsch
Last Supper, detail
1754
oil on canvas, 30½ × 56¼ in.
(77.5 × 143 cm)
Residenzgalerie, Salzburg

Cosmas Damian Asam
Vision of St. Bernard
after 1720
fresco
Abbey Church,
Aldersbach

This chapter examines developments connected with painting in a vast geographical and cultural area that can be described, with some over-simplification, as the German-speaking world. It should, however, be made clear from the outset that, despite a number of undeniable common traits, there are great artistic and political differences between Germany and Austria. For both nations, the seventeenth century was a difficult period, characterized by war and the looming threat of Turkish invasion from the southeast. The siege of Vienna in 1683 marked the dramatic climax but also the end of this age-old nightmare. Freed from the pressure of a long Dark Age, Germany (especially the eastern regions of Saxony and Prussia) and Austria enjoyed a period of great brilliance in the seventeenth century, when the figurative arts provided a splendid frame for Rococo culture.

The history of painting in Germany and central Europe in the seventeenth and eighteenth centuries is thus strongly influenced by the historical situation and, to some extent, by the incompletely resolved question of relations both between Catholics and Lutherans and between the various local centers of power making up the fragmented German empire. The whole of central Europe was disrupted by the long and tragic Thirty Years' War (1618–1648), which halted every possible cultural movement and brought appalling devastation. The sacking of Prague by the Swedes and the resulting dispersal of Emperor Rudolph of Hapsburg's spectacular and varied collection is only the best known of a whole series of events that drastically redrew the map of German art in the seventeenth century. The end of the Renaissance (which actually went on longer in Germany than elsewhere) also marked the end of the tradition of Mannerist classicism adopted in many princely mansions, its place being taken by an interesting variety of ideas and influences reflecting German polycentrism. Some of the leading seventeenth-century artists were influenced by Italian painting and spent longer or shorter periods of study in Venice, Rome, or Naples. By contrast, the eighteenth century saw a complete reversal of this trend, as Venetian painters sought work at German courts. The influence of Venetian and Roman painting can be seen in the brief but poetical career of Adam Elsheimer, a painter of rare and precious talent, capable of giving a lyrical and indeed almost "Romantic" interpretation of the new seventeenth-century style of painting. Johann Liss, a highly exuberant painter clearly inspired by his studies of Rubens, found a second home in Venice, and his luminous, ebullient paintings constitute some of the more successful achievements in the difficult period of seventeenth-century Venetian art. Johann Carl Loth and Johann Heinrich Schönfeld benefited greatly from their contact with the centers of production of Italian art.

While the artists displayed a certain predilection for the south, German collectors appear to have shared the taste of their middle-class counterparts in Flanders and Holland for genre painting (still lifes, landscapes, scenes and episodes of everyday life, and portraits). The production of still lifes thus flourished in the seventeenth century in Germany, where it displayed some highly distinctive features. Didactic and ultra-precise, Georg Flegel exemplifies the

Sebastian Stosskopf
Summer or *Allegory of the Five Senses*
1633
oil on canvas,
44½ × 71 in.
(113 × 180.5 cm)
Musée de L'Oeuvre de
Notre-Dame, Strasbourg

widespread taste for "moralized" still lifes with symbolic references, whereas Abraham Mignon's work resembles the illustrations for scientific treatises on botany and entomology. The most fascinating of all, however, is the enigmatic Sebastian Stosskopf, a painter from Alsace (and as such claimed by both French and German painting), the author of deeply evocative metaphysical compositions.

Despite the presence of interesting artists, seventeenth-century central European painting did not give rise to an authentic unified school. This came in the next century, a time of feverish activity in the fields of architecture, ornamentation (stucco and inlaid wood), and of course painting in Austria and the Catholic regions of Germany. This brilliant period can be divided into two parts. On the one hand, we have the monumental (and at times a little monotonous) decorative work carried out for princely patrons or the great reconstructed Benedictine abbeys,

where the Asam brothers played the leading role; on the other hand is a rich harvest of small paintings, some sketches for larger works, but others independent compositions with the same freshness and immediacy as sketches, almost as though painted "in one go." Among the many eighteenth-century Austrian artists recognized as great masters of the Rococo style, attention should be drawn to Paul Troger and Franz Anton Maulbertsch, perhaps the most brilliant of them all. Then, in the second half of the century, a movement to "moralize" art began to spread from Germany.

The very country that gave birth to some of the brightest and most imaginative Rococo works also provided theoretical foundations and concrete examples for neoclassicism, a rigorous style of art based on the example of classical antiquity. Anton Raphael Mengs was one of its earliest and most committed exponents.

Adam Elsheimer

(Frankfurt, 1578–Rome, 1610)

A great artist of the same generation as Caravaggio, Rubens, and Guido Reni, Elsheimer unfortunately died very young, thus interrupting the development of a poetical style of painting that had begun with great delicacy in works of rarity and charm. Attracted from an early age by Italian Renaissance art, he moved to Venice in 1598, where he came into contact with Hans Rottenhammer (who had worked with Jan Bruegel in previous years) and studied Tintoretto's work. This Venetian experience gave rise to Elsheimer's most ambitious religious works, whirling celestial visions directly inspired by Tintoretto's paintings in the Doges' Palace in Venice. In the fateful year of 1600, a

watershed that was not merely symbolic but also real for many early Baroque masters, Elsheimer moved to Rome, where he spent the last ten years of his short life. In the lively circles of "Romanized" Nordic painters, Elsheimer altered his style to focus primarily on landscape painting, as did his friend Paul Brill.
In this field, Elsheimer struck a note of intense expressive originality that was both classical and romantic, idealized and scientific. Keenly interested in the artistic movements of his day, Elsheimer was familiar both with the Caravaggesque handling of light and the tranquil sweeping views of the Roman countryside by Annibale Carracci. His own technique was, however, to remain firmly linked to his northern roots, and was characterized by exquisite, painstaking execution and impeccably suffused with light.

Adam Elsheimer
Flight into Egypt

1609
oil on copper,
12¼ × 16¼ in.
(31 × 41 cm)
Alte Pinakothek, Munich

This enchanting nocturnal elegy is unquestionably Elsheimer's best-known work. Despite its small size, it can be regarded as one of the most fascinating paintings

produced in the early seventeenth century, as well as a real cornerstone in the early history of landscape painting. The perfect depiction of the heavenly vault, where the Milky Way and the constellations sparkle in a sky illuminated by a full moon, demonstrates Elsheimer's great interest in the world of science, and the work of Galileo in particular.

Adam Elsheimer
The Good Samaritan
c. 1605, oil on canvas,
8¼ × 10½ in.
(21.2 × 26.5 cm)
Louvre, Paris

Elsheimer's small canvases form a delightful compendium of the trends to be found in painting in early seventeenth-century Rome. This landscape

is reminiscent of the sixteenth-century Venetian masters, especially Tintoretto's late works in the Scuola di San Rocco in Venice.

Adam Elsheimer
Holy Family with Angels and the Young John the Baptist

c. 1599
oil on copper,
14¾ × 9½ in.
(37.5 × 24.3 cm)
Gemäldegalerie, Berlin

Elsheimer's small paintings on religious subjects

clearly demonstrate his links with Tintoretto's late sixteenth-century work, and were reinforced in particular by the two years he spent in Venice in his youth. However, this influence is combined with his own exquisite handling of light to create the effect of a golden sunset.

Adam Elsheimer
Jupiter and Mercury in the House of Philemon and Baucis

1608
oil on copper,
6½ × 8¾ in.
(16.5 × 22.5 cm)
Gemäldegalerie, Dresden

The visit paid by Jupiter and Mercury in disguise to the humble dwelling of the aged couple is a mythological and literary episode frequently depicted in seventeenth-century painting. While Rubens uses it as a pretext for a spectacular stormy

landscape, Elsheimer focuses on the delicate human element. The kindly, rustic hospitality of the elderly hosts and the welcome rest taken by the two divine wayfarers are set in the calm, precisely portrayed interior of a peasant's dwelling illuminated by shafts of light. In the early years of the seventeenth century, Elsheimer thus established a model of realism in the handling of human figures, environment, and light that was to be taken up by painters from all the European schools.

Georg Flegel
(Olomuc, 1566–Frankfurt, 1638)

Little is known about the training and career of this artist, who was a fundamental point of reference for the early development of "archaic" still-life painting north of the Alps. The evident links with the Flemish painting of the fifteenth century and the Renaissance period make it very likely that he initially worked in the Netherlands. This tradition also accounts for Flegel's delight in the precise reproduction of objects, accurately observed and painted with respect to shape, volume, material, and differences in the refraction of light. Flegel's works also mark a significant step forward compared to late sixteenth-century Flemish and Dutch painting, since they are among the first examples of pure still life without figures. Stress should also be laid on his complete independence with respect to Italian art, which exercised great influence on many German masters in the early seventeenth century.

Georg Flegel
Cabinet with Shelf

c. 1610
oil on canvas,
36½ × 24½ in.
(92 × 62 cm)
Národní Galerie, Prague

One interesting compositional invention by Flegel consists of paintings depicting cupboards, cabinets, or display cases with various objects arranged like small collections of rare items. This was a very popular genre in the seventeenth century, particularly with art collectors in central and northern Europe, and some masters developed these compositions so that they practically verged on *trompe-l'oeil*. Flegel conveys a sense of order, satisfaction, harmony, and delight in the painstaking representation of elegant objects, feelings that were to be subtly undermined by the disquieting impact of Stosskopf's metaphysical canvases.

Georg Flegel
Still Life with Stag Beetle

1635
oil on wood,
9¾ × 15 in.
(25 × 38 cm)
*Wallraf-Richartz Museum,
Cologne*

For all its apparent
simplicity, this still life,
directly inspired by a
modest snack, lends itself
to a whole variety of
interpretations, including
a possible religious
allusion to the Redeemer's
sacrifice and Lenten
fasting, bread and wine
being prominently
displayed together with
a fish, the age-old symbol
of Christ. In more
specifically art-historical
terms, it is possible to
detect echoes of the
German tradition, for
example in the exact
naturalistic depiction of
the stag beetle inspired
by Dürer.

Johann Liss

(Oldemburg, c. 1595–Venice, 1629)

Like his friend and near contemporary
Domenico Fetti, Liss died very young.
The few short years of his career were,
however, generously filled with work
spanning a broad range of subjects and
stylistic points of reference, journeys, and
close relations with the collectors of the
time and other artists. As a result of his
delight in travel and contact with different
cultures, Liss became an intelligent
exponent of various forms of figurative
expression, especially during the third
decade of the seventeenth century. While
his best-known works draw inspiration
above all from sixteenth-century Venetian
art, his career began with a series of
journeys to the Netherlands and stays in
Antwerp, Amsterdam, and Haarlem.
These provided important opportunities
for contact with Rubens's studio, and
Flemish and Dutch Caravaggesque painters
like Jordaens and Terbrugghen. His taste
for genre scenes and peasant festivities
of clearly Flemish derivation dates from
this period. He arrived in Italy in 1621
and studied in Rome from the following
year to 1624, thus gaining first-hand
experience of the different versions
of the Caravaggesque style produced
by the northern masters. The decisive
turning point came with his move to
Venice. In a somewhat mediocre period
of Venetian painting characterized by the
tired repetition of models drawn from
Tintoretto, the arrival of Liss was a breath
of fresh air. His richly sparkling, luminous
painting inspired by Veronese and Titian
gave the Venetian school a timely jolt, thus
paving the way for the imminent arrival of
Bernardo Strozzi and, in the longer term,
laying the foundations for the renewal of
Venetian art in the eighteenth century.

Johann Liss
The Finding of Moses

c. 1626–1627
oil on canvas,
61 × 41¾ in.
(155 × 106 cm)
Musée des Beaux-Arts, Lille

The presence of similar
canvases in various
princely collections is
explained by the fact that
Liss painted various copies,
with few variations,
of his more successful
compositions. Scenes such
as this amply justify the
painter's popularity with
the art lovers of his day.
The scene is flooded with
an all-enveloping wave of
soft, radiant color, from
which the shapely forms
of scantily clad maidens
emerge with sensual force,
despite the remote biblical
source of the subject.

Johann Liss
Vision of St. Jerome

c. 1627
oil on canvas,
88½ × 69 in.
(225 × 175 cm)
*Church of San Nicolò
dei Tolentini, Venice*

The masterpiece of Liss's
religious works, this is
perhaps the most original
and important altarpiece
painted in Venice in the
whole of the seventeenth
century. Comparison with
the great religious
paintings produced
in the same period in Italy,
Flanders, and Spain
demonstrates the German
painter's absolute creative
freedom. Centering on
the conversation between
St. Jerome and the
splendid angel on the left,
the scene expands into
the billowing clouds
and the gradual
progression of soft, refined
colors from the dark,
bottom right-hand corner
to the luminous apotheosis
above.

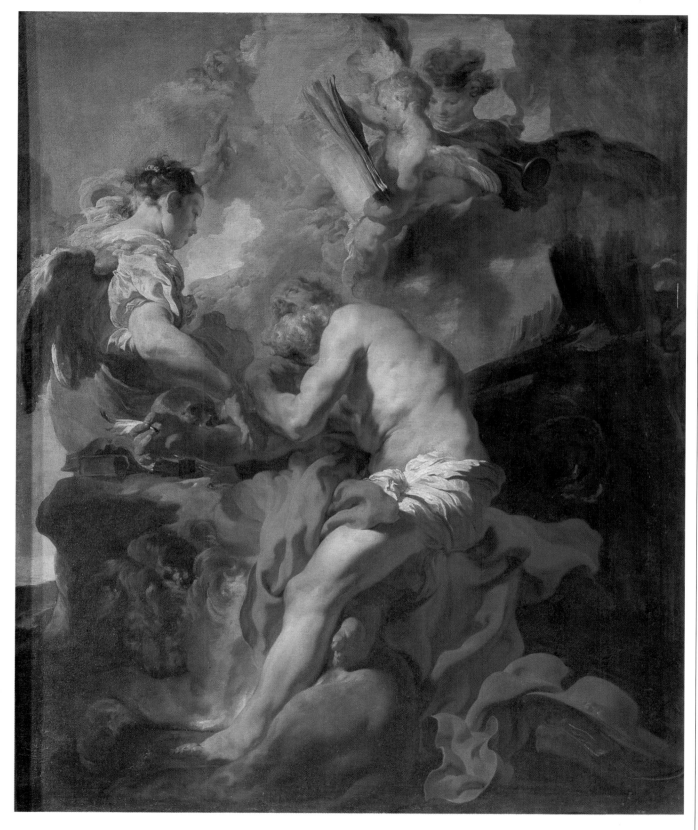

Johann Liss
Peasants Fighting

c. 1620
oil on canvas,
26½ × 32¾ in.
(67.4 × 83 cm)
*Germanisches
Nationalmuseum, Nuremberg*

The two works on this
page show the "other side"
of Liss's work. Trained
in the Dutch-Flemish
tradition, Liss was led
to try his hand at the
characteristic genre scenes
that were popular with the
artists and collectors of
Amsterdam and Antwerp,
but also appreciated in
Rome. The German master
always uses rich, thick
paint, and his monumental
approach differs sharply
from the milder treatments
of similar subjects
produced by the
Bamboccianti.

Johann Liss
Peasant Wedding Feast

c. 1620
oil on canvas,
25¾ × 32 in.
(65.5 × 81.5 cm)
Museum of Fine Arts, Budapest

In his genre and peasant
scenes, Liss does not
hesitate to accentuate
coarse, almost caricature-
like effects comparable
to those found in works
by Jordaens and later
Steen, but he eschews
the explicit moral
messages of his Dutch
and Flemish colleagues.
The staggering inebriated
dancers are realistically,
though somewhat
unpleasantly, juxtaposed
to the drunken man
vomiting on the left.

Johann Liss
Venus Dressing

c. 1627
oil on canvas,
32¼ × 27¼ in.
(82 × 69 cm)
Uffizi, Florence

Such enchanting scenes
as this make it all the more
regrettable that Liss died
so young, thus prematurely
barring the way to an
original development in
Baroque painting. While
the echoes of Titian and
the unquestionable links
with Rubens's sumptuous
style must be pointed out,
this delightful composition
is a fresh, independent
expression of the radiant
talent of a brilliant young
master. The artist's
anticipation of themes
and devices characteristic
of eighteenth-century
Venetian painting is
particularly striking.

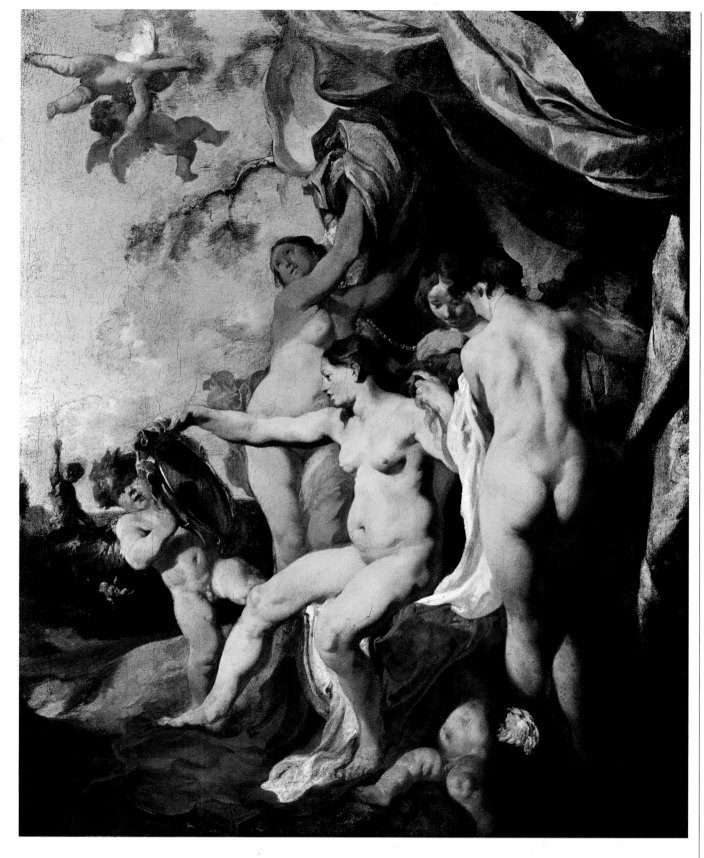

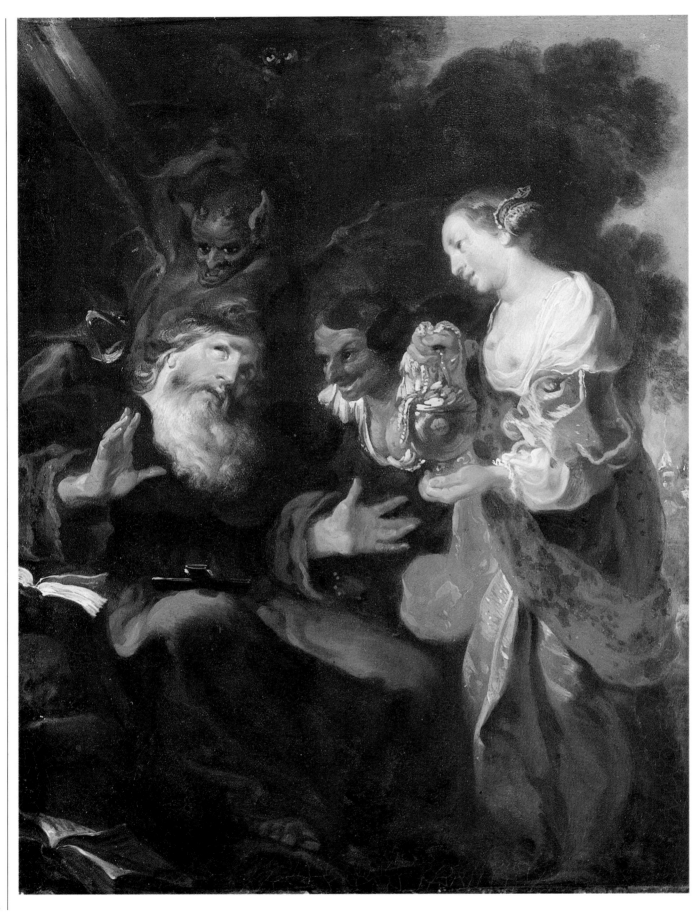

Johann Liss
Vision of St. Anthony

c. 1620
oil on wood,
9¼ × 7 in.
(23.3 × 17.8 cm)
*Wallraf-Richartz Museum,
Cologne*

In his handling of this
subject, which was very
popular in northern
European painting and
traditionally seen as an
opportunity to conjure
up bizarre creatures from
hell, Liss returns to the
characteristic features of
his genre works, painted
with wild and deliberately
excessive exuberance.

Johann Liss
Judith

c. 1625
oil on canvas,
50¾ × 41 in.
(129 × 104 cm)
Museum of Fine Arts, Budapest

Portrayed as a flamboyant
Baroque heroine, Liss's
Judith graces the walls of
various European museums
thanks to the copies made
by the artist himself for
different princely
collections. The spectacular
work hinges on the
contrasting momentum
of the terrible decapitated
body of Holofernes and
the twisting body of
Judith. Her dress, wide
and rippling like a sail
swelling in the wind,
is a wave of color that
illuminates the whole
painting. The eye follows
the swirling movement
of folds and creases until
it comes to rest on the
round neckline and the
soft, smooth, gleaming
skin of the exotic,
seductive, yet terrifying
young woman.

Johann Carl Loth

(Munich, 1632–Venice, 1698)

Loth has been placed immediately after his fellow countryman Liss, though this slightly alters the correct chronological sequence of the artists presented in this chapter, because of the similarities between their respective careers. After initial training in the north, Loth also moved to Venice, where he spent most of his working life and became so Italianized that he was also known as "Carlotto," a delightful quasi-dialect version of his name. There are, however, substantial differences between the styles of the two artists. Loth arrived in Venice around 1650, at a very distinct time, artistically speaking. Following Liss's death a good many years before, the deaths of Fetti and Strozzi had interrupted the development of a rich, luminous style of painting, which was reminiscent of Titian and the Flemish painting of the period. Seventeenth-century Venetian art was characterized by the work of the *Tenebristi*, painters of dense, weighty compositions in predominantly dark colors. Loth took up this form of expression in his eclectic quest for dramatic impact and a carefully planned chromatic range. Studies in Rome and other cities helped in later years to attenuate his style and keep it in line with the latest developments.

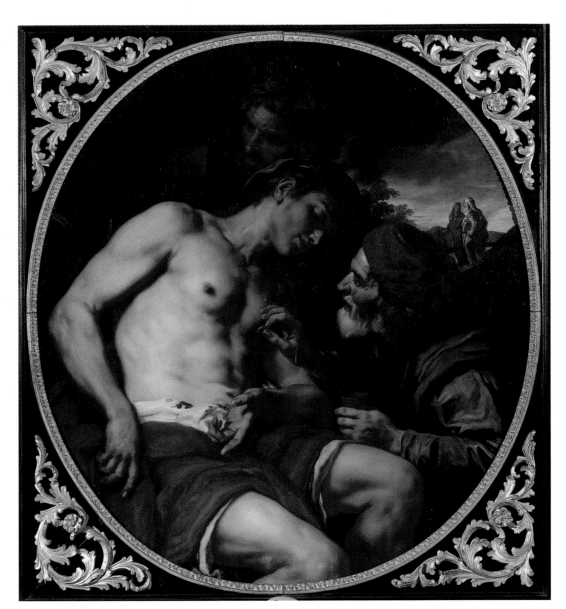

Johann Carl Loth
The Good Samaritan

before 1676
oil on canvas,
49 × 42½ in.
(124.5 × 108 cm) (oval)
*Graf von Schönborn
Collection, Pommersfelden*

Still held by the historical family collection of the prince-bishops of Würzburg, this painting provides excellent proof of Loth's popularity with aristocratic collectors of the European Baroque period. While the subject is drawn from the well-known New Testament parable, its treatment is in line with the tastes of a cultured, sophisticated public capable of grasping the rich series of formal references on which the work is based. The relaxed, classical, nude figure of the wounded youth, drawn directly from ancient sculpture, is particularly effective.

Johann Carl Loth
Jupiter and Mercury
in the House of Philemon
and Baucis
before 1659
oil on canvas,
70 × 99¼ in.
(178 × 252 cm)
*Kunsthistorisches Museum,
Vienna*

We have already
encountered this subject
from Ovid's *Metamorphoses*
in paintings by Rubens and
Elsheimer. Loth focuses on
the conversation between
Mercury and Jupiter about
the reward to be bestowed
on the pious and hospitable
peasants. While the

massive, full-blooded
figures are reminiscent
of seventeenth-century
Flemish-Genoese painting
(in other words, Rubens
and Strozzi), the
squawking duck on the left
lends an amusing everyday
touch to the mythological
scene.

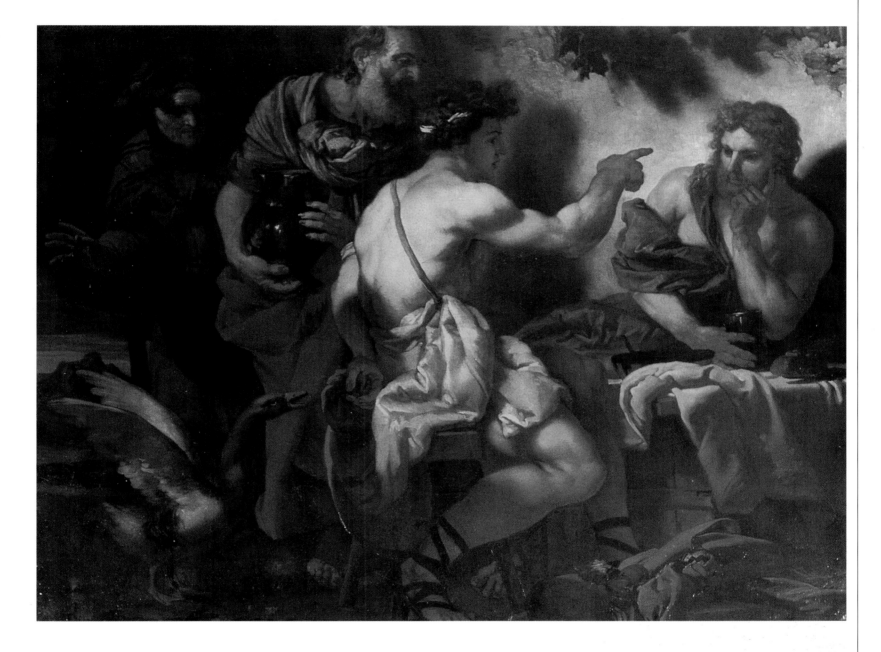

Johann Heinrich Schönfeld

(Biberach an der Riss, 1609–Augsburg, 1683)

Like his fellow countrymen Liss and Loth, Schönfeld is a German painter who spent very important periods of his working life in Italy. In addition to the unquestionable attraction of Rome and the other Italian cities, one should not forget the tragic consequences of the devastating Thirty Years' War, which constituted a very concrete obstacle to the development of painting and the art market in Germany. It is significant that shortly after the war came to an end with the Treaty of Westphalia in 1648, Schönfeld returned to Germany, where he was very successful both with collectors and in terms of commissions for religious works. His work as a highly regarded engraver also contributed to his fame throughout the seventeenth century. Having completed his artistic training in southern Germany, he settled in Rome in 1633. It should be noted that the popularity of Caravaggio

and his followers had by then declined. They had been replaced by the classicism of the French masters, the triumphant Baroque of Bernini and Pietro da Cortona, and the small paintings of everyday subjects produced by the northern *Bamboccianti* and the members of the *Schildersbent*, the association of Dutch painters in Rome founded by Cornelis van Poelemburgh. In this context, Schönfeld became a leading artist thanks to his exquisite workmanship and the unusual compositional device of causing his figures to recede toward the background. This success was repeated during his long and important stay of over a decade in Naples, where he moved in 1638. In Naples he apparently took little interest in Ribera's full-bodied and occasionally brutal realism. If anything, he was attracted by Bernardo Cavallino's success in producing scintillating, dynamic effects capable of illuminating generally brownish, somber settings. He gained considerable experience in the composition of very large, theatrical canvases, suitable for representing the triumph of ruling houses.

Johann Heinrich Schönfeld
Hippomenes and Atalanta

1650–1660
oil on canvas,
48½ × 79 in.
(123 × 200.5 cm)
Brukenthal National Museum, Sibiu, Romania

Johann Heinrich Schönfeld
Scythians at the Tomb of Ovid

c. 1640
oil on canvas,
43¼ × 36¾ in.
(110 × 93.5 cm)
Museum of Fine Arts, Budapest

Prolonged contact with the northern painters present in seventeenth-century Rome stimulated Schönfeld to try his hand at depicting the everyday world to be found in the shadow of the ancient ruins. Unlike the *Bamboccianti*, he did not linger over the realistic

It is interesting to compare this work with Guido Reni's historic interpretation of the same subject, with which Schönfeld was probably familiar. While the classical Bolognese master focuses on a monumental depiction of the two nudes, Schönfeld prefers to distance the

portrayal of common folk, but captured the poetic and evocative force of the classical ruins. This painting (which includes the exotic touch of an unusual group of eastern "tourists") is also particularly significant in view of the future development of European art and culture, not only in the later seventeenth century but also in the eighteenth century, when Roman ruins became a characteristic background for paintings from the Enlightenment to German Romanticism.

viewer and give a narrative representation of the episode including the running track, the arrival, and the spectators. The paint, applied lightly with the tip of the brush and almost transparent in some parts, seems to foreshadow certain eighteenth-century effects.

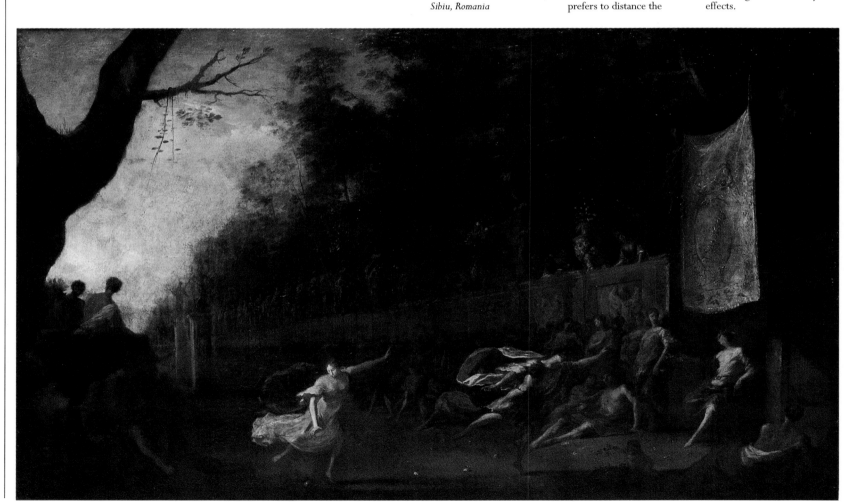

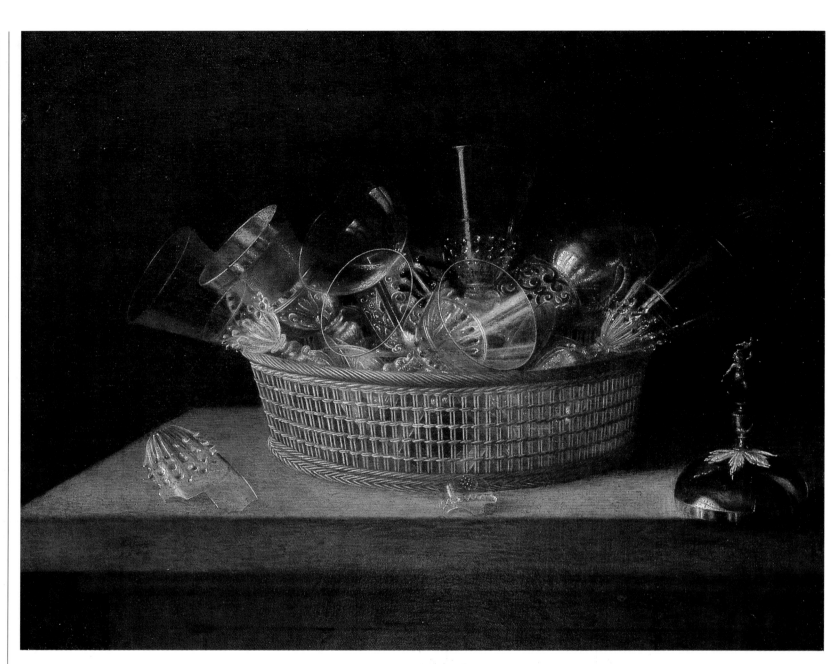

Sebastian Stosskopf

(Strasbourg, 1597–Idstein, 1657)

A painter working on the "borderline," as befits an artist born in Alsace, Stosskopf is one of the most mysterious and fascinating specialists in Baroque still life. He trained in the Rhineland and Flanders, but a series of parallels can be drawn with other painters of the period, including Georg Flegel and Jan Davidszoon de Heem.

At the same time, Stosskopf's work remains totally original. With his almost maniacal passion for precision, Stosskopf often verges on *trompe-l'oeil*. All his works explore the inner nature of things. The objects appear as though metaphysically transfixed, immobile, and yet precarious, threatened by the possibility of imminent disaster. Fragile, precious, and defenseless, Stosskopf's rare paintings are like a moment of silence in the often deafening concert of Baroque art.

Sebastian Stosskopf
Still Life with Basket
of Glass Objects

1644
oil on canvas,
20½ × 24½ in.
(52 × 62 cm)
*Musée des Beaux-Arts,
Strasbourg*

Reserved for an elite group of patrons, some of Stosskopf's works depict precious collections of sophisticated,

aristocratic objects. The crystal glasses in the straw basket are all different and do not form a single set but a small, select collection, depicted with astonishing imitative skill. One of the glasses is broken, however, and the slivers of crystal, now completely useless, introduce the poignant theme of the fleeting nature of beauty.

Sebastian Stoskopff
Trompe-l'oeil
(etching of the Triumph
of Galatea attached to
a tablet with sealing wax)

1643–1644
oil on canvas,
25½ × 21¼ in.
(65 × 54 cm)
*Kunsthistorisches Museum,
Vienna*

Abraham Mignon

(Frankfurt, 1640–Wetzlar, 1679)

Abraham Mignon's still lifes belong to
a highly characteristic seventeenth-century
genre of illustration poised midway
between art and science. His precise,
exquisite, and perfectly legible technique
make them excellent examples of a cross
between Baroque exuberance and the taste
for analytic, naturalistic representation.
The result of unquestionable talent and
an assured sense of composition, Mignon's

works were to remain milestones in
German taste and were to be constantly
imitated right up to the Biedermeier
period in the late nineteenth century. After
training in his hometown, Mignon left for
Utrecht in 1659, together with the master
Jacob Morel, to work with Jan Davidszoon
de Heem, an excellent Dutch painter of
still life in the mid-seventeenth century.
From then on, Mignon alternated periods
of residence in Frankfurt with stays in
Utrecht, where the records show that
he was a member of the Guild of St. Luke
in 1669.

Abraham Mignon
Nature as a Symbol
of Vanity

1665–1679
oil on canvas,
31 × 39 in.
(78.7 × 99 cm)
*Hessisches Landesmuseum,
Darmstadt*

The moist undergrowth
teeming with small
animals, reptiles,

and insects is filled with
the color and fragrance
of magnificent flowers.
However, these flowers are
surrounded by countless
deadly snares.
The painting can thus be
interpreted
as an allegory of the vanity
of earthly things, the
fading of beauty, and
the all-devouring passage
of time.

Abraham Mignon
Still Life with Fish
and Quail's Nest

c. 1670
oil on canvas,
35 × 28¼ in.
(89 × 71.5 cm)
Museum of Fine Arts, Budapest

The distinguishing feature
of Mignon's art is its
clarity, based on
meticulous drawing
and painstaking attention
to detail. Experts have also
put forward interesting
allegorical interpretations
of his still lifes, which can
often be read as a choice
between good and evil.
In fact, "negative" creatures
such as voracious snails
are juxtaposed to "positive"
ones like the butterfly,
a symbol of the soul
freeing itself from the
cocoon of sin.

Paul Troger

(Monguelfo in Val Pusteria, 1698–Vienna, 1782)

Born in Alto Adige and an outstanding figure in the eighteenth-century Austrian school, Troger took up and developed the motifs of Italian Baroque painting in the brilliant context of Viennese Rococo, of which he is a leading exponent. He settled in Vienna in 1728 and spent much of his working life there, obtaining important official positions and becoming the director of the Academy of Figurative Arts. Troger was born into a family of artists and successfully combined the imaginative approach of Rottmayr and other Austrian colleagues with the Venetian and Neapolitan traditions, drawing particularly on Solimena's works, which were highly regarded in Vienna. The result is a vigorous style of painting with an energetic handling of light and shade in sketches and small canvases, but also a great ability to tackle huge decorative works suffused with light. Among the painter's most celebrated fresco compositions, attention should be drawn to the decorations for the library of the Benedictine Abbey of Melk, on the Danube (*Triumph of Reason*, 1731–1732) and the ceiling of Bressanone cathedral (*Adoration of the Mystic Lamb*, 1748–1750). The main groups of canvases by Troger are held by museums in Vienna (especially the Austrian Baroque Museum, Belvedere Castle) and the Museo Diocesano in Bressanone.

Paul Troger
Christ Comforted
by an Angel
c. 1730
oil on canvas,
*Museo Diocesano,
Bressanone*

Intense popular feeling, charged with pathos and dramatic emphasis, is developed within a highly refined pictorial format, in which elongated figures are swathed in light.

276

Franz Anton Maulbertsch

(Langerargen, 1724–Vienna, 1796)

German by birth but Austro-Hungarian in terms of style and where he was active, Maulbertsch is one of the most interesting exponents of European Rococo. He trained in Vienna, where he assimilated Troger's teaching and admired Andrea Pozzo's bold style. Maulbertsch was an international artist, capable of appreciating the brilliant taste of the southern German courts and the rapid, fragmented, luminous brushstrokes of Venetian masters such as Sebastiano Ricci and Piazzetta. He made a particularly close study of Giambattista Tiepolo's works, and actually met the Venetian master during his stay at Würzburg. Tiepolo was a twofold source of inspiration for Maulbertsch, both for his impetuous style as an easel painter and for his decoration of vast spaces with light, airy frescoes. Aristocratic and imaginative, Maulbertsch had a brilliant career at court and with ecclesiastical patrons in Austria (attention should be drawn to the frescoes in the Piarist church in Vienna and the Hofberg in Innsbruck), Bohemia, Slovakia, and Hungary.

Franz Anton Maulbertsch
The Education of Mary

c. 1755
oil on canvas,
23½ × 11¾ in.
(60 × 30 cm)
Kunsthalle, Karlsruhe

Maulbertsch's most characteristic work consists of easel paintings that display all the briskness and momentum of sketches, but are independent compositions in their own right. The subject, repeatedly painted in the history of art in the customary terms of delicate domestic intimacy, is treated by Maulbertsch as an opportunity for a highly imaginative work featuring a flight of angels, a handling of light that illuminates some parts but leaves others in shadow, and an all-enveloping sense of dynamism that is brilliantly controlled.

Franz Anton Maulbertsch
Allegory of Dawn

c. 1750
oil on canvas,
26¼ × 20¾ in.
(67 × 53 cm)
*Wallraf-Richartz Museum,
Cologne*

Maulbertsch makes no
distinction between
religious subjects and
mythological or allegorical
themes. His painting
always strikes a lofty note
of imaginative idealization.
Whenever possible, he
introduces whirling
airborne figures in wildly
unpredictable athletic
poses in line with
the light-hearted taste
of Rococo art.

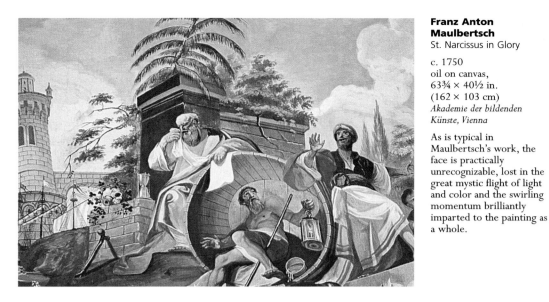

Franz Anton Maulbertsch
St. Narcissus in Glory

c. 1750
oil on canvas,
63¾ × 40½ in.
(162 × 103 cm)
Akademie der bildenden Künste, Vienna

As is typical in Maulbertsch's work, the face is practically unrecognizable, lost in the great mystic flight of light and color and the swirling momentum brilliantly imparted to the painting as a whole.

Franz Anton Maulbertsch
Allegory of the Sciences (detail with figure of Diogenes)

1794
fresco
Library of Strahov Abbey, Prague

As often happens, Maulbertsch's frescoes prove more static and contrived than his effervescent sketches. This tendency is accentuated in the later works, which also had to take into consideration the new neoclassical style.

In the decoration of large areas of wall or ceiling, Maulbertsch again uses the lighter palette of Tiepolo and the international Rococo artists.

Franz Anton Maulbertsch
Abduction Scene

c. 1760
oil on canvas,
29 × 20½ in.
(73.5 × 52.4 cm)
Moravská Galerie, Brno

Franz Anton Maulbertsch
Sacrifice of Iphigenia

c. 1750–1752
oil on canvas,
48½ × 36¼ in.
(123 × 92 cm)
Muzeum Narodowe, Warsaw

Franz Anton Maulbertsch
Marriage of the Virgin

c. 1760, oil on canvas,
23¼ × 14 in. (59 × 35.5 cm)
Private collection, Vienna

In a dazzling aura of divine splendor, the shining Madonna is set at the intersection of the perspective diagonals on which the painting is expertly based.

279

Cosmas Damian and Egid Quirin Asam

(Benediktbeuren, 1686–Munich, 1739)
(Tegernsee, 1692–Mannheim, 1750)

Born to the craft (their father Georgera was a reputable painter of frescoes), the Asam brothers played the leading role in the period of great Rococo decoration in the predominantly Catholic regions of southern Germany. Architects, painters, and decorators, they translated the scenographic feeling of late Baroque into charming exuberant forms. They worked above all on the majestic abbeys, executing both the reconstruction work and the perfectly integrated decoration of stucco, frescoes, and furnishings. After their father's death in 1711, the two brothers spent a couple of years in Rome, where they made an intelligent and careful study

of the great Baroque architecture, especially Bernini's creative output. After returning to Germany in 1714, they always worked closely together, often exchanging roles. Their most important works include the churches of Andernach, Rohr, Weingarten, Weltenburg, and Straubing, all masterpieces of Bavarian Rococo. Egid Quirin, who showed a talent for sculpture and moldings, produced altars, groups of statues, and ornamental stuccos. Cosmas Damian worked primarily as a painter; his work was based on his studies in Rome but developed freely to include forms, colors, and perspectives leading away into the open sky. In 1733, the brothers began work on the construction and decoration of the church of St. John Nepomuk in Munich. Built at their own expense, a few steps away from their home, the church (also known as the Asamkirche) is designed as a dazzling theatrical work that culminates in the apotheosis of the saint above the high altar.

Cosmas Damian and Egid Quirin Asam
Interior of the Abbey Church, Aldersbach

after 1720
fresco
Abbey Church, Aldersbach

It is very difficult to capture in photographs the striking effect of the churches built and decorated by the Asam brothers. The light interiors of the Rococo abbeys and their particular theatrical effects should be seen and appreciated dynamically by moving around inside the vast spaces and enjoying the succession of spectacular views.

Cosmas Damian and Egid Quirin Asam
Assumption of the Virgin

after 1720
fresco
Cupola, Abbey Church, Aldersbach

The cupola over the high altar creates a highly effective optical illusion of piercing the ceiling. Here we can see the continuity established between the sculptural elements and the paintings through the close collaboration between the two brothers.

Anton Raphael Mengs

(Aussig, 1728–Rome, 1779)

A painter and theorist of great importance
in the history of art, Mengs is rightly
regarded as one of the founders of
Neoclassicism or, to be more precise, as
the leading figure in the phase of transition
between the late Baroque and the changes
brought about in art and culture by the
Enlightenment. Trained by his father Ismael
(a miniaturist at the Saxon court), Mengs
spent his childhood and early youth
between the Dresden of Augustus III
of Saxony, and Rome. During his travels in
Italy, the young Mengs developed a passion
for the study of archaeology and came
under the spell of Raphael's painting.
While such interests are hardly unheard
of—similar tastes were displayed a century
earlier by Guido Reni and Poussin—in this
case they constitute a theoretical stance
intended as a radical alternative to the
dynamic virtuosity and animated, but
often excessive, style of Baroque art.
Even a journey to Venice, where the great
eighteenth-century school of Tiepolo was
then developing, did nothing to change
Mengs's mind. After settling in Rome,
Mengs became the advocate of a return to
a serene, intellectual form of art grounded
in the classical rules of decorum, harmony,
and composure, and imparted these
precepts as director of the Accademia
Capitolina. In 1755, the arrival in
Rome of the philosopher and writer
Winckelmann marked the beginning
of a noble period devoted to the study and
revival of ancient art. The fresco *Parnassus*
on the ceiling of Villa Albani (1761)
summarizes the return to Raphael and
classicism. The spreading of Enlightenment
ideas and aesthetics paved the way
for a radical change in taste.
In 1762, Mengs published the first edition
of his treatise *Reflections on Beauty and Taste
in Painting*, a fundamental theoretical
study soon known throughout Europe,
and he established himself as an
outstanding cultural authority in the fields
of art and ideas. His highly controlled and
aristocratic frescoes for the royal palace
in Madrid, where he worked for two long
periods, gave the definitive *coup de grâce*
to Tiepolo's creative exuberance and
put forward a new model that ushered
in the neoclassical era.

Anton Raphael Mengs
Glory of St. Eusebius

1757
fresco
*Ceiling, Church
of Sant'Eusebio, Rome*

Mengs could not sever
all ties with Baroque art
in his public works,
and especially those
commissioned for churches
in Rome. It is, however,
possible to detect an
emphasis on formal and
intellectual control over
the painting that curbs
excessively bold
foreshortening and
subdues dramatic impetus.

Anton Raphael Mengs
Self-Portrait with Red Cloak

1744
pastel on paper,
21¾ × 16¾ in.
(55.5 × 42.5 cm)
Gemäldegalerie, Dresden

Mengs was also highly
regarded as a portraitist.
This early work, painted
when he was only sixteen,
is still partly influenced
by the free brushwork
of Venetian art. Mengs
subsequently painted a
number of self-portraits,
which he sent to the courts
of Europe in order to
spread his fame.

Eighteenth-Century France

François Boucher
The Toilet
1742
oil on canvas, 20¾ × 25¾ in.
(52.5 × 65.5 cm)
Thyssen-Bornemisza
Collection, Madrid

François Boucher
The Toilet of Venus
1751
oil on canvas,
42¾ × 33½ in.
(108.3 × 85 cm)
Metropolitan Museum
of Art, New York

P aris, the intellectual capital of Europe: a title that was incontestable from 1715 on, when Philip of Orléans assumed the regency on behalf of Louis XV and the refined, intellectual atmosphere of Parisian drawing rooms was preferred to the solemn ceremony of the Versailles court. It was this period that saw the rapid spread of the *Querelle des anciens et des modernes*, which had already emerged at the end of the seventeenth century, and the birth of the Enlightenment, a cultural movement that was to extend to the rest of Europe. A whole range of directions and interests converged around the dominant role assigned to reason. History was understood as the slow process of civilization, and as the liberation from the sway of the sacred and the irrational, which meant that the principal targets were religious confessions, considered to be the source of ignorance. The new figure of the intellectual began to play a leading role. He was fundamentally eclectic and willing to explore new disciplines and to share his ideas in a constant relationship with the public. Two particularly influential figures were Voltaire, the author of *Candide* (1759), whose irony was an effective weapon against hatred, fanaticism, and passion, and Baron de Montesquieu, whose *De l'esprit des lois* (1748) describes the regulatory mechanisms of society, beyond religious and metaphysical influences. The ideas of Jean-Jacques Rousseau, the most problematic and complex figure of the Enlightenment, evolved in a substantially opposite direction. His first writings, *Discours sur les sciences et les arts* (1750) and *Discours sur l'origine de l'inégalité* (1755), consider history as a gradual decline and corruption compared to an original state in which men were innocent and equal. The most significant cultural achievement of the Enlightenment was, however, a collective work, the *Encyclopédie ou Dictionnaire raisonné des sciences, des arts et des métiers* (1751–1772), to which Voltaire, Rousseau, and the major French intellectuals all contributed, united by a common desire to fight the obscurantism and the prejudices of traditional culture. The editor of the encyclopedia was the writer and philosopher Denis Diderot, author of the *Paradoxe sur le comédien*, a major contribution to the lively debate on the theater that developed in the eighteenth century, which led to the revaluation of genres such as farce and the *drame bourgeois*, traditionally considered to be inferior. Also important in this sense is the painter

Jean-Honoré Fragonard
The Love Letter
c. 1770–1780
oil on canvas,
32¾ × 26¼ in.
(83.2 × 67 cm)
Metropolitan Museum
of Art, New York

Watteau, whose theatrical vocation finds its fullest expression in *Embarkation for Cythera* (Louvre, Paris). The subject, based on Dancourt's play *Les trois cousines*, or rather on the comedy ballet *La Venitiène*, is a theatrical scene that represents the various levels of amorous initiation. The unattainable and mysterious Eros is, in fact, one of his favorite themes, together with that of theater masks, such as *Gilles* (Louvre, Paris). However, Watteau's interest in the depiction of scenes from the *Commedia dell'Arte* does not stem from a desire to record the life of the contemporary stage, but aims rather to carry out a process of symbolic transfiguration. His work seems to move effortlessly from the enclosed, artificial, and ironic world of the theater to the magnificent foliage of parks inhabited by Arcadian ghosts whose only concern seems to be to capture the fleeting moment. Here there appear to be curious affinities with music, especially with that of Mozart, whose pictorial counterpart Watteau can be considered. The figures captivate us not because of the theme, but for the order in which they are arranged: they seem to have been born under the lights of opera or comedy ballet performances and to pursue an almost pre-Wagnerian dream of a fusion of the various arts.

The work of Jean-Baptiste-Siméon Chardin is far from the artificial fantasies of Watteau's *fêtes galantes*, country balls, and comedy actors, representing instead everyday aspects of life. His disarming simplicity, balanced composition, and delicate use of colors, with a preference for white and light blue, are evidence of a refined technique and an extraordinary lucidity of analysis, in a manner that seems in some ways to anticipate Cézanne. His four versions of *Boy Playing With Cards*, for example, recall the same silent, immobile world as Cézanne's series of *Card-Players*. In his late maturity, Chardin abandoned oil painting in favor of pastel, a technique that had been introduced into France in the second decade of the eighteenth century by the Venetian painter Rosalba Carriera, and that met with great favor among portrait painters. Maurice Quentin de La Tour appreciated the rapidity of execution, which allowed him to seize aspects of his figures that would otherwise be indefinable, such as the spontaneity, freshness, and immediacy of expressions.

The work of Liotard, on the other hand, moves in a completely different direction, using the technique of pastel not in order to exploit nuances of semi-tones and subtle

Jean-Baptiste-Siméon
Chardin
Still Life with Cat
c. 1728–1730
oil on canvas,
28¾ × 41½ in.
(73 × 105 cm)
Metropolitan Museum
of Art, New York

blending but, on the contrary, to define the figures with firm, clear strokes free from any lyrical effects.

An itinerant court painter, Liotard worked for Austrian, French, English, and Dutch nobles, avoiding the grave poses that characterized Baroque portraits. Among the objects he preferred as accessories were furs, tables, chairs, books, letters, and baskets of fruit: against a plain ground, often gray-brown, the image is still, in a light without chiaroscuro. Examples are the *Self-Portrait* and *The Chocolate Girl* (both in the Gemäldegalerie, Dresden), painted around 1745.

Much more brilliant and inventive, although uneven, is François Boucher, who was free of the tyranny of models or schools. However, he was to some extent influenced by Watteau, especially in works such as the *Birth of Adonis* and the *Death of Adonis* (both in the Matthieu Goudchaux Collection, Paris), painted around 1730. The mythological scenes that form the essential and most successful part of his output are accompanied by the fine portraits and landscapes in which his extraordinary decorative ability is most evident. As well as painting, he also practiced drawing, set design, and tapestry, giving a new lease on life to the Gobelins factory.

While Watteau took delight in painting *fêtes galantes* and Boucher preferred allegories and pastoral scenes, Jean-Honoré Fragonard, the last of the great French painters of the eighteenth century, combined all these, depicting scenes of family life with lively taste and a realistic,

though by no means sentimental, spirit.

"A genius of virtuosity," the Goncourts were to call him. Fragonard's appeal stems from the refinement and at the same time the seemingly improvised spontaneity of his works, executed in magnificent reds and deep rust tones, anticipating the great art of the Impressionists, especially Renoir, who was his spiritual heir. An eclectic painter, long undervalued, Fragonard is probably the finest representative of the sensual, courteous eighteenth century that was to end with the revolutionary deeds of the bourgeoisie, who populate his work throughout his long career until his death in 1806.

Jean Antoine Watteau
Gilles
c. 1717–1719
oil on canvas,
72½ × 58¾ in.
(184 × 149 cm)
Louvre, Paris

Jean Antoine Watteau

(Valenciennes, 1684–Paris, 1721)

The greatest French artist of the early eighteenth century, he chose the intimacy of genre scenes, the witty improvisation of the *Commedia dell'Arte*, and the frivolous or pathetic idyll of *fêtes galantes*, in open contrast with the rhetorical and pompously classical style of the Academy. In the *Querelle des anciens et des modernes*, which raged at the beginning of the century in France, he immediately showed himself to be anti-Academy. He frequented the workshop of Pierre and Jean Mariette, collectors and printers, representatives of a trend that opposed the official taste of the court and the Academy, preferring the most free and open currents of French and Flemish-Dutch painting. In opposition to the classical style of Poussin he favored the wide, free rein of the imagination, whose fullest expression was in the theater—not in classical theater, but in the contemporary genres of *comédies-ballets* and *Comédie Italienne* (*Commedia dell'Arte*), performances of which resumed after the death of Louis XIV in 1715. This type of theater, populated by comedians, clowns, and masks, constituted the main theme of his work. A fundamental experience in his development was his stay with Claude Audran, the keeper of the Luxembourg Palace, the home of the great Rubens cycle of the *Life of Marie de' Medici*. This contact with the work of the Flemish master was to prove decisive from a thematic and formal standpoint. His style became more free and immediate, his painting ductile and rapid, the tones delicate and bright, and the figures fluid and light. While it is impossible to order his works chronologically, it is possible—from a thematic point of view—to identify two main lines: theater scenes and *fêtes galantes*, imaginary gatherings of ladies and gentlemen evoked in a sweetly nostalgic atmosphere and in a swift, ductile manner that combines the warm colors of Rubens with the iridescent tones of the Venetian school. It was precisely as a painter of *fêtes galantes* that he was received into the Academy.

Almost the whole of Watteau's output was executed in the last six years of his life, between 1717, the date of *Embarkation for Cythera*, and 1721, the date of *Gersaint's Shop Sign*, a eulogy of modern painting and of its most illustrious predecessors (from Rubens to van Dyck), considered to be his artistic testament.

Jean Antoine Watteau
Réunion Champêtre

1717–1718
oil on canvas,
23½ × 29½ in.
(60 × 75 cm)
Gemäldegalerie, Dresden

In a natural setting, Watteau arranges single groups like frames in a collage. Unlike in classical composition, there are no main characters and no hierarchy of figures. The imaginative, rhythmic composition and the magical atmosphere make Watteau resemble a brilliant theater director.

Jean Antoine Watteau
Mezzetin

1717–1719
oil on canvas,
17 × 21¾ in.
(43.1 × 55.2 cm)
*Metropolitan Museum of Art,
New York*

Here the painter employs
his favorite theme of masks
for a highly effective
psychological investigation.
A *Commedia dell'Arte* mask,
Mezzetin is represented
as he sings, accompanying
himself on the guitar—an
elegant image, with a
subtle veil of melancholy.

Jean Antoine Watteau
Embarkation for Cythera

1717
oil on canvas,
50½ × 76 in.
(128 × 193 cm)
Louvre, Paris

The painting can be read
as a theatrical scene that
unfolds from right to left,
from the rose-garlanded
bust of Venus to the
couples of lovers who
are about to board the boat
for the island of Venus,
the goddess of love, born
in the sea off Cythera.
The scene, perhaps based
on a play by Dancourt, is
to be read as an invitation
to embark for the island
of love, and every detail
is a variation on this
invitation: the boat is a
magnificent golden
gondola and the journey is
easy and direct. Finally, the
light, vaporous touch used
to represent nature adds
an evanescent, sensual
atmosphere to the scene.

Jean Antoine Watteau
La Game d'Amour

c. 1717
oil on canvas,
20¼ × 23½ in.
(51.3 × 59.4 cm)
National Gallery, London

The painting, which
belongs to the genre
of *fêtes galantes*, is set
against a background
of luxuriant nature
in an atmosphere pervaded
by iridescent light, and
displays a complex
composition.
In the foreground is
the main group, oblique
and evasive, behind them
a statue of Pan, which
creates a double
perspective. The feeling
of psychological absence
and separation in the main
figures in the scene is
strikingly original.

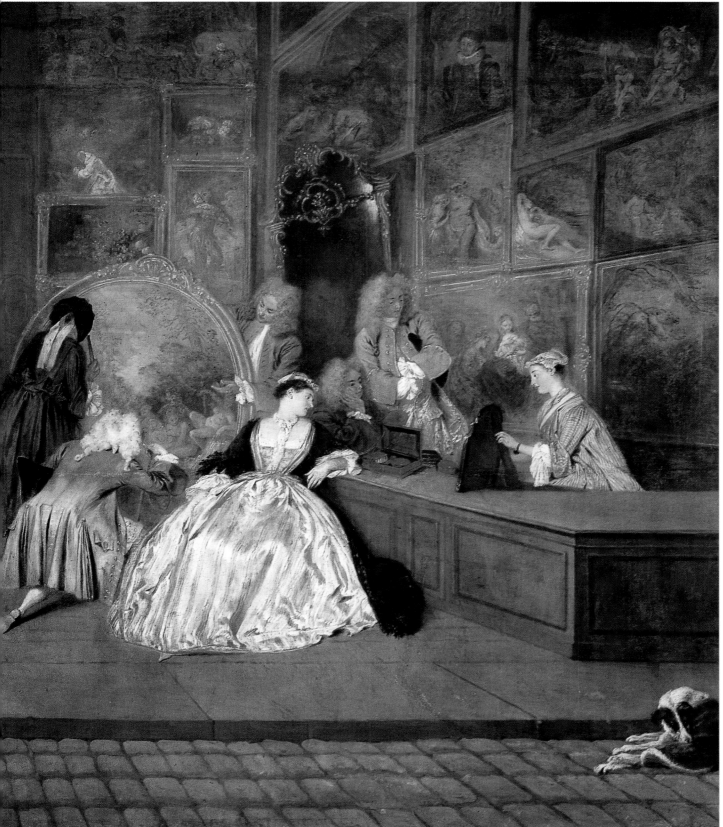

Jean Antoine Watteau
Gersaint's Shop Sign

1720
oil on canvas,
64¼ × 120½ in.
(163 × 306 cm)
Charlottenburg Castle, Berlin

One of his last
masterpieces, it was
painted for his friend
Gersaint, the art dealer
with whom he stayed from
1719, when he was already
very ill with tuberculosis.
The unusual breadth of the
composition raises genre
painting to new heights;
to the left some assistants
place a portrait of Louis
XIV (attributable to
Lebrun) in a box, while
a gentleman, perhaps
Watteau himself, invites
a lady to admire examples
of modern painting
hanging on the wall.
To the right Gersaint and
his wife are busy showing
items to their customers,
probably the artist's main
patrons. The sobriety
and originality of the color
combinations, and the
brushwork, at times
nervous and rapid, at times
applied calmly in wide,
subtly modulated sections,
are precursors of
Impressionism.

Jean-Baptiste-Siméon Chardin

(Paris, 1699–1779)

A controversial artist, at times almost a precursor of Cubism in his use of space, but at times capable of tender, contained emotion, Chardin was perhaps the only great painter of the eighteenth century who had no Academy training and who never traveled to Italy. The Academy did, however, manage to win him back: his painting *The Ray* (Louvre, Paris), shown in 1728 in Place Dauphine in an open-air exhibition, won him admission to the Academy as a "painter of animals and fruit." Success, however, only came after 1737, when he exhibited seven genre scenes at the Salon, including the *Girl with Racket and Shuttlecock* (Uffizi, Florence). In 1743 Chardin was elected counselor of the Academy, in 1755 he became treasurer, and from 1761 he was the "hanger" of the Salon, an event of international renown. Taken up by these increasingly time-consuming duties, he reduced his output and began to paint copies and variations of previous works. From 1771, still animated by a desire to change and to surprise, Chardin turned to pastel, a medium that he used only for portraits, analyzing the features of his models with the same careful attention he had brought to fruit and game in his still lifes.

Before him only Vermeer had matched the particular pictorial treatment evident in the *Bunch of Flowers* in a white china vase decorated with a blue pattern (National Gallery of Scotland, Edinburgh), with the subtle interplay of white and blue, in a milky light, that demonstrates an almost magical ability to combine great power and great simplicity.

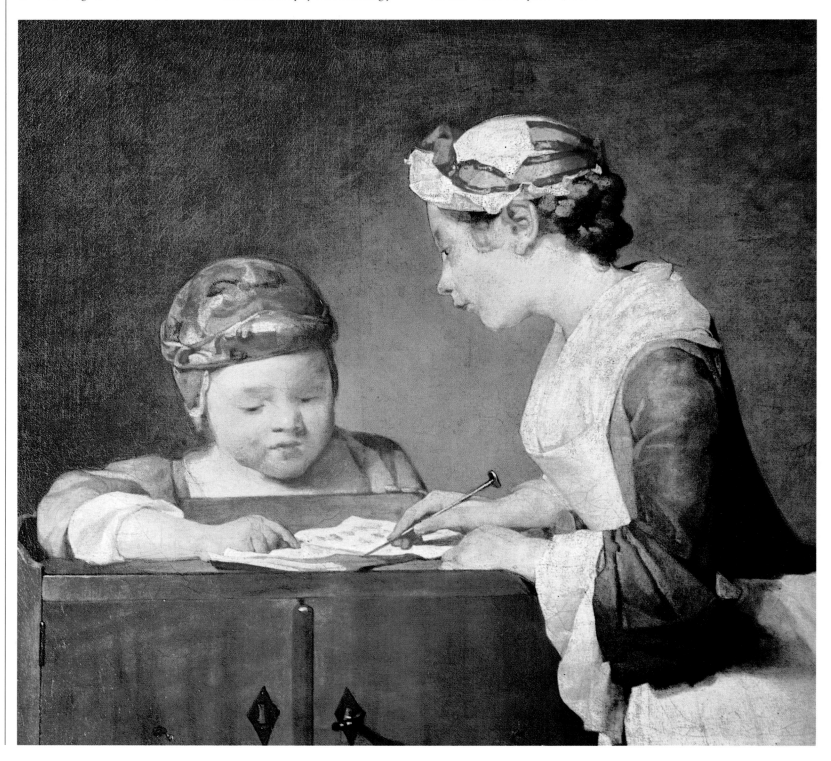

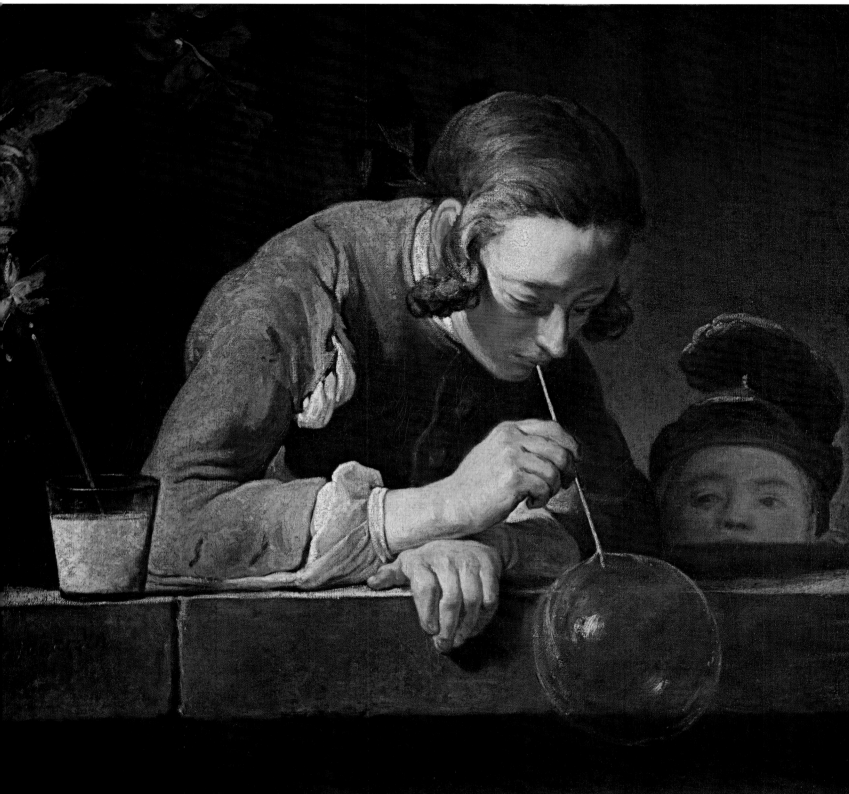

Jean-Baptiste Chardin
The Young Schoolmistress
c. 1736
oil on canvas,
24¼ × 26¼ in.
(61.5 × 66.5 cm)
National Gallery, London

A central element in the bare composition of this painting is the long hatpin with which the sweet figure of the young woman, seen in profile, points out the letter of the alphabet to her young pupil. It is not so much the careful rendering of the features as the subtle use of color that allows Chardin to bring out the psychological depth of the character.

Jean-Baptiste Chardin
Soap Bubbles
c. 1739
oil on canvas,
24 × 24¾ in. (61 × 63 cm)
Metropolitan Museum of Art, New York

This work, whose theme is taken from seventeenth-century Dutch painting, evokes the transitoriness of earthly things and at the same time the fickleness of women's feelings. The composition, based on a play of brown and gray tones, presents a classical pyramidal structure.

297

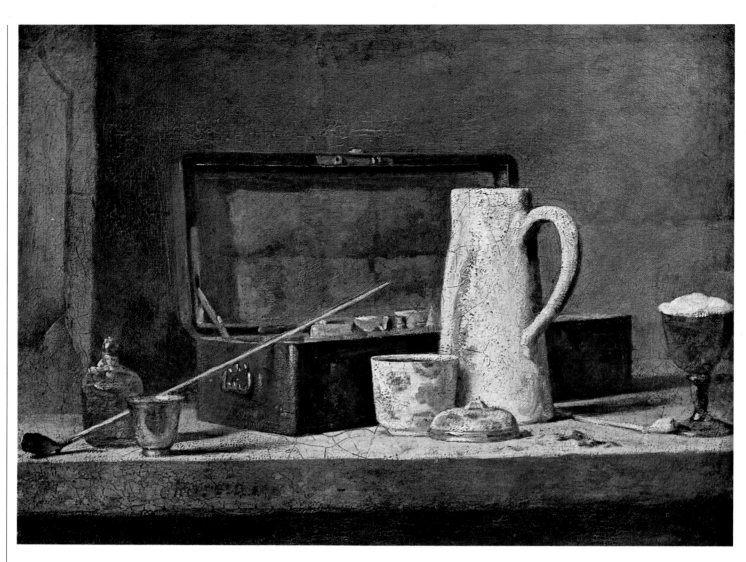

Jean-Baptiste Chardin
Pipes and Drinking Pitcher

c. 1737
oil on canvas,
12¾ × 15¾ in.
(32.5 × 40 cm)
Louvre, Paris

Owned by the artist,
the painting was described
in detail in the inventory
drawn up on the death
of his first wife in 1737:
a rosewood case with steel
handles, lined in blue satin.
Here, too, there is a
delicate harmony of blues
and whites.

Jean-Baptiste Chardin
Self-Portrait

1775
pastel, 18 × 15 in.
(46 × 38 cm)
Louvre, Paris

Exhibited at the Salon
of 1775 together with the
portrait of his second wife
Marguerite Pouget, whom
he married in 1744, it was
much admired by critics
and public alike. Writing
about the painting at the
end of the nineteenth
century, Proust praised
Chardin's eccentric
originality in portraying
himself as an old English
tourist.

Jean-Baptiste Chardin
Boy Playing with Cards

1737
oil on canvas,
32¼ × 26 in.
(82 × 66 cm)
*National Gallery of Art,
Washington*

This is the last of four
versions of the same
subject, one of many
related to childhood
and children's games.
The simplicity of the bare
yet elegant composition
and the physical
and psychological
characterization of the boy
anticipate Cézanne's famous
painting the *Card-Players*.

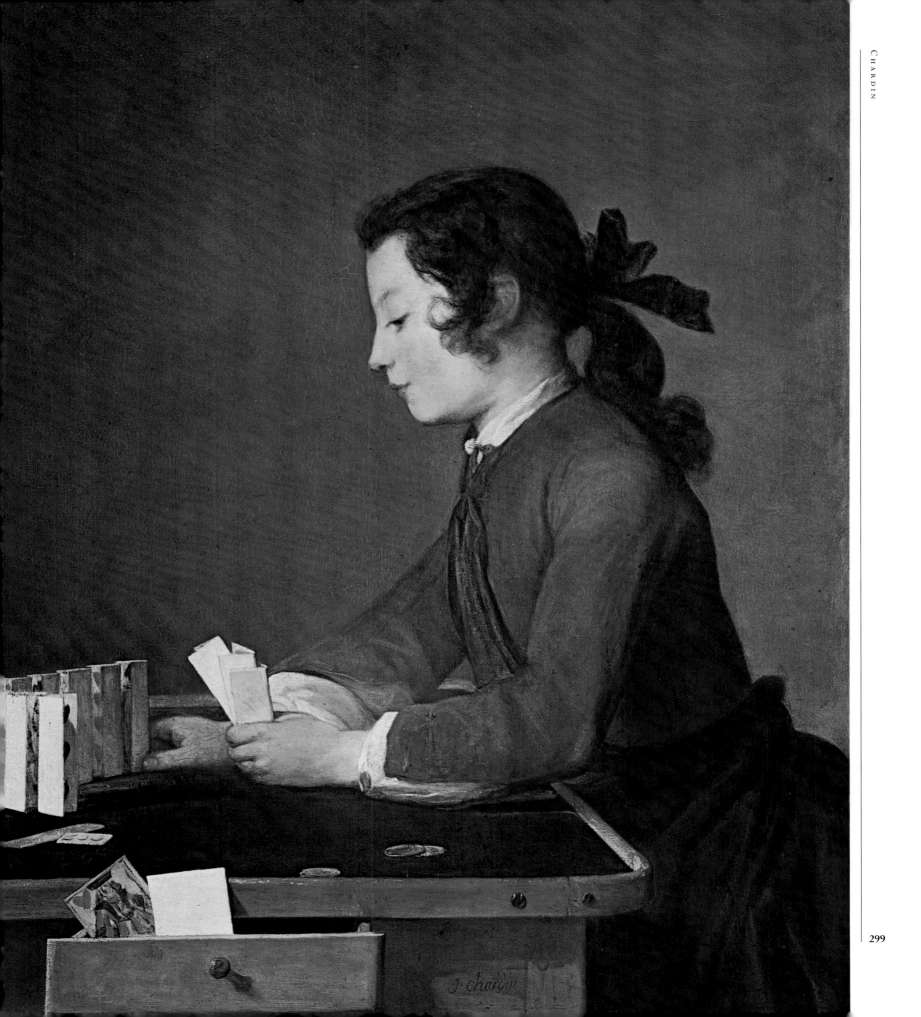

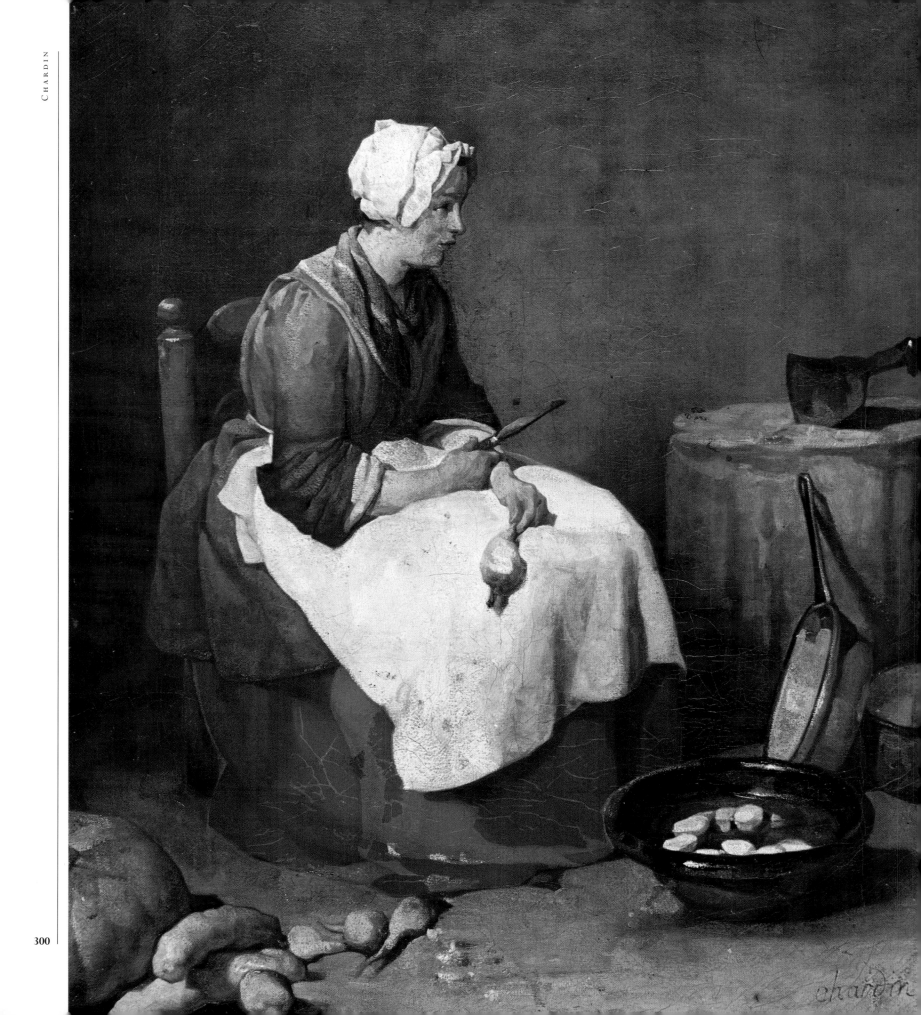

Jean-Baptiste Chardin
The Cook

1738
oil on canvas,
18 × 14½ in.
(46 × 37 cm)
Alte Pinakothek, Munich

Here Chardin adapts
a theme typical of
seventeenth-century Dutch
painting: next to the
woman, who is leaning
slightly forward, he places
round objects
characteristic of the
furnishing of a homely
interior. There is, however,
no aspect of social critique,
but rather a desire to
highlight the ordinariness
of the scene by avoiding
any picturesque detail.
The broad brushstrokes
cover the canvas with a
thick layer of paint.

Jean-Baptiste Chardin
The Return from Market

1739
oil on canvas,
18½ × 15 in.
(47 × 38 cm)
Louvre, Paris

Exhibited at the Salon
of 1739, the painting is
particularly striking due
to the brilliant
composition. To the left,
the doorway opening onto
the copper tank creates a
background perspective
that projects the
pourvoyeuse, captured
in a distracted attitude that
contrasts with the realistic
setting, toward the viewer.

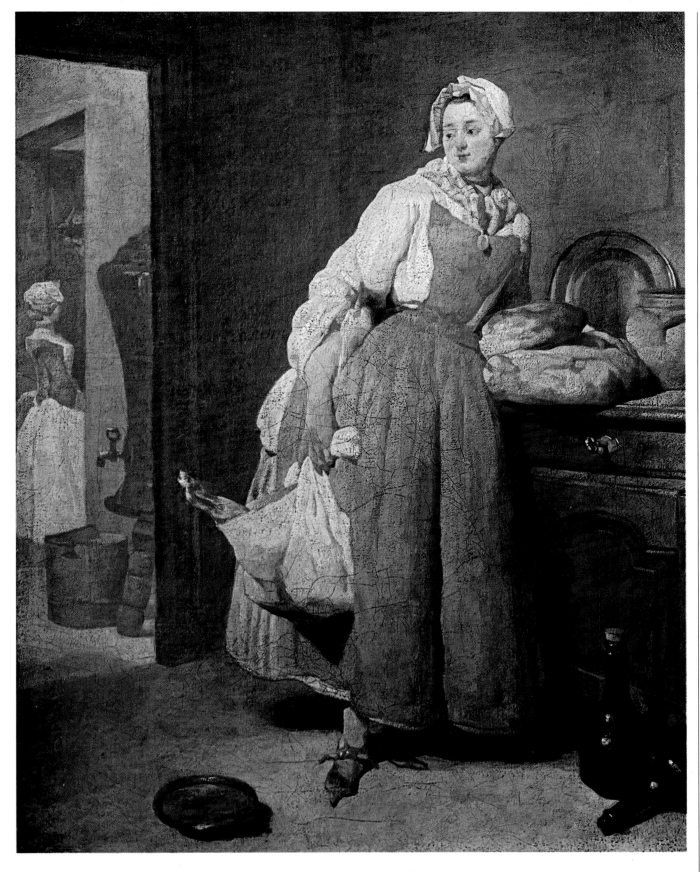

Pierre Subleyras

(Saint-Gilles-du-Sard, 1699–Rome, 1749)

Subleyras trained in Paris in the workshop of Jean-Pierre Rivalz, a painter of lower-class scenes. In 1727 he won the Prix de Rome for his *Bronze Serpent* (Fontainebleau), and the following year he moved to Italy. A protégé of Cardinal Valenti, in 1740 he was admitted to the Accademia di San Luca and in 1743 he obtained the commission for the *Mass of St. Basil*, one of the altarpieces in the basilica of St. Peter's, where he worked together with Vouet, Poussin, and Valentin,

thus becoming one of the public painters of eighteenth-century Rome. Subleyras worked in large and small formats with notable results. He painted fine portraits, such as *Benedict XIV* (Museum, Chantilly) and the *Abbess Battistina Vernasca* (Musée Fabre, Montpellier), as well as magnificent altarpieces such as the *Crucifixion* (Brera, Milan) and the *Miracle of St. Benedict* in the church of Santa Francesca Romana in Rome, revealing hidden talent as a colorist. His last works display an almost Jansenist rigor in the spare lines of the composition and the limited range of color, reminiscent of that of Philippe de Champaigne.

Pierre Subleyras
The Marriage of
St. Catherine de' Ricci

c. 1740–1745
oil on canvas
Private collection, Rome

The skillful distribution of light and shadow heightens the center of the picture, where the mystical union is celebrated, while an enigmatic, isolated figure to the right draws the viewer's attention.

Pierre Subleyras
St. Ambrose Converts
Theodosius

1745
oil on canvas
Galleria Nazionale, Perugia

Painted for the church
of the Olivetans in
Perugia, both the
composition and the
limited range of colors
demonstrate a Jansenist
purism.

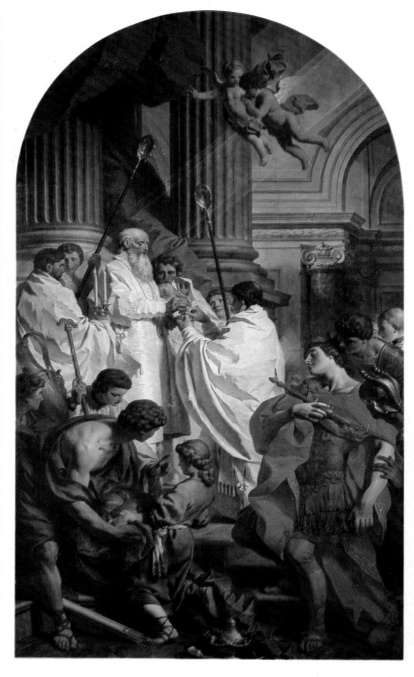

Pierre Subleyras
Mass of St. Basil

1743
oil on canvas,
52½ × 31½ in.
(133.5 × 80 cm)
Hermitage, St. Petersburg

This is the magnificent
model for the altarpiece
executed for the church
of Santa Maria degli Angeli
in Rome. Perhaps his
masterpiece of religious
painting, it is no
coincidence that Subleyras
placed it at the center
of *The Painter's Studio*
reproduced below. He
draws from and develops
a number of different
sources, achieving a work
of high nobility and great
composure. The starting
points are the *Holy
Conversations* of sixteenth-

century Venetian painting
(such as Titian's Pesaro
altarpiece in the Basilica
dei Frari in Venice, or the
Madonnas and Saints of
Paolo Veronese). The
scene is dominated by a
controlled sense of
composition, beginning
with the monumental
architecture in the
background. The two
fluted columns give a sense
of rhythm to the space and
create an atmosphere of
high solemnity. The figures
are arranged along a clear
diagonal axis, but, despite
the rigid control, the scene
remains lively. Once again
Subleyras unfurls his
memorable whites in
the center of the canvas,
creating the bright
luminosity that is his most
distinctive feature.

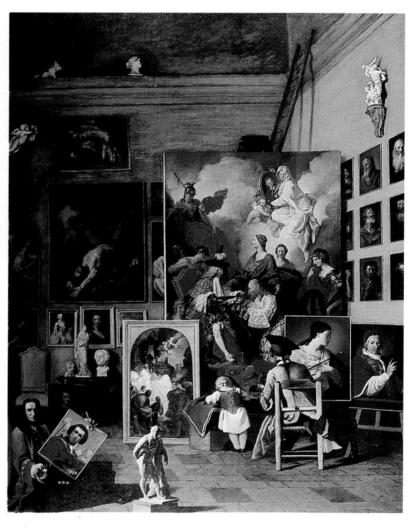

Pierre Subleyras
The Painter's Studio

c. 1747–1749
oil on canvas
Academy of Fine Arts, Vienna

Having reached the end
of his career, Subleyras
effectively and evocatively
remembers his oeuvre.
Taking the form of
a self-portrait in his studio,
the painting becomes a
summary of the artist's
works and also, through
the presence of classical
statuettes, of his sources
and influences. This work
belongs to an important

line of seventeenth- and
eighteenth-century
painting, which extends
from the allegories of Jan
Bruegel and Rubens to
the museum images of
early neoclassicism, such
as Zoffany's *Tribuna of the
Uffizi*. The artist's poetic
sensibility can be seen in
details such as the figures
with their backs to us,
which may even remind
us of Vermeer's *Allegory
of Painting*. Particularly
touching is the small figure
of the fair-haired boy intent
(it seems) on drawing.

Maurice Quentin de La Tour

(Saint-Quentin, 1704–1788)

An artist who recorded the pomp and the official side of contemporary life in France with considerable professional skill and an eye for psychological analysis, he painted portraits, all of them in pastel, that are evidence of a society that was only concerned with appearances, and toward which he adopted a detached, ironic, and at times scornful attitude.

After his training in Paris in the workshop of J. Spoëde, a painter of still lifes, in 1725 he went to England, where he stayed for two years. On his return to Paris he received numerous commissions for portraits, and in 1737 he was admitted to the Academy, taking part regularly in the Salons.

He painted portraits of Louis XV and the Marquise de Pompadour (both in the Louvre), of members of the aristocracy and of great intellectuals, including the encyclopedists Voltaire, Rousseau, and D'Alembert. The medium he used for these portraits was pastel, which had become popular in France after the stay in Paris (1720–1721) of the well-known Venetian pastelist Rosalba Carriera. Pastel proved to be the medium best suited to the nervous, impulsive temperament of the artist; his rapidity of execution was matched by a rapidity of vision that allowed him to capture his sitters in vibrant tones. His search for luxurious, refined effects, achieved through extreme technical virtuosity, does not undermine the spontaneity and freshness of pastel painting.

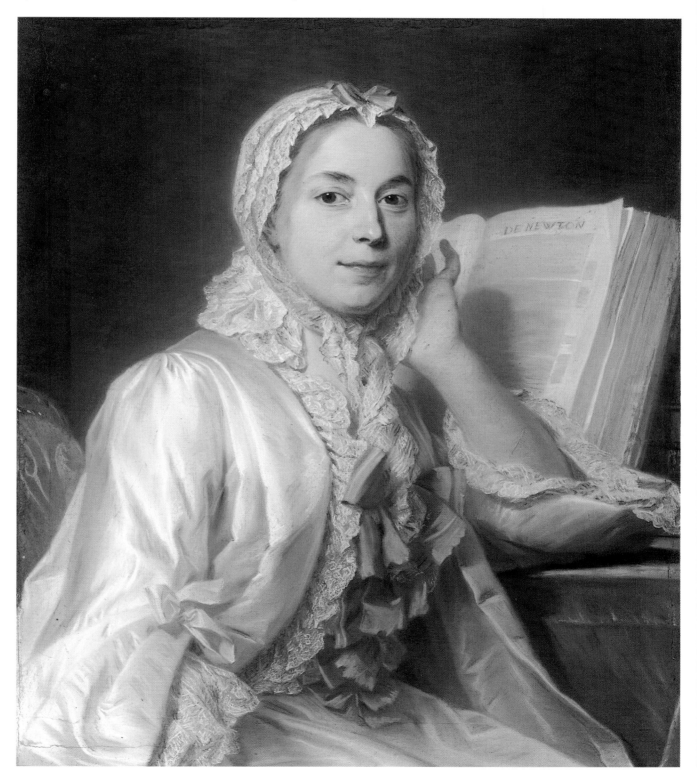

Maurice Quentin de La Tour
Portrait of Mlle Ferrand

1753
oil on canvas
Alte Pinakothek, Munich

A cultured young lady portrayed as she takes a pause from her reading of a work on Newton. In the mid-eighteenth century, the ideas of the English scientist, who had died in 1727, had reached a vast public, including women, with the publication of works like *Il Newtonianismo per le dame* (*The Science of Newton for Ladies*) (1737) by Francesco Algarotti.

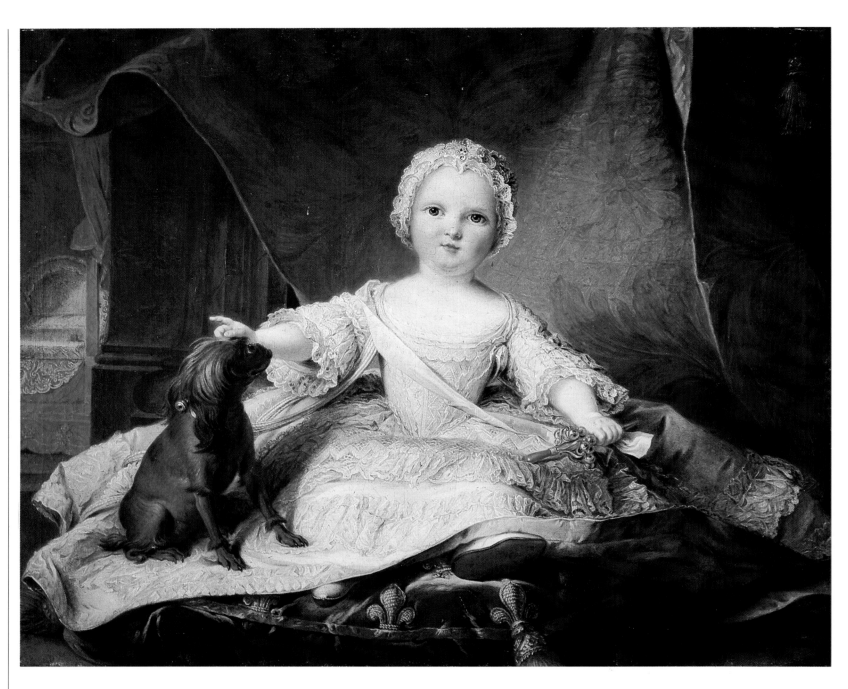

Jean-Marc Nattier

(Paris, 1685–1766)

After training in the studio of Jean Raoux, a painter of mythological portraits, Nattier completed the works Raoux had left unfinished, an experience that was to prove decisive in his development. In 1710 he was commissioned by Louis XIV to make engravings of his drawings of Rubens's great cycle, *The Life of Marie de' Medici* in the Luxembourg Palace, and in 1715 he was admitted to the Academy as a history painter. Subsequently, however, he devoted himself solely to portrait painting, becoming the most famous exponent of the mythological genre established by Raoux. Having turned down the chance to stay at the Academy in Rome, an offer

made by his godfather Jouvenet, in 1742 he became the official portrait painter to the court. He produced portraits of Louis XV, Queen Marie Leszczynski, and the king's daughters. The latter were portrayed innumerable times, depicted as nymphs, shepherd girls, or young goddesses, in a form of "posed" portraiture that preferred an unreal though measured elegance of attitude and pose to any kind of psychological interpretation. His portraits, the last record of a world still characterized by classical composure reminiscent of the art of Domenichino and Albani, acquire emblematic value, becoming the symbols of a society, an environment, and a lifestyle marked by the taste for artificial grace and affected elegance.

Jean-Marc Nattier
Portrait of Madame Maria Zeffirina

1751
oil on canvas,
27½ × 32¼ in.
(70 × 82 cm)
Uffizi, Florence

In this portrait the astonished expression, the rouged cheeks, and the coy gesture of stroking her lapdog all contribute to the sitter's doll-like appearance.

Jean-Étienne Liotard

(Geneva, 1702–1789)

After his apprenticeship in Geneva in the workshop of Daniel Gardelle, where he mainly learned the technique of miniature painting on china, in 1723 Liotard moved to Paris, where he began to work as a miniaturist and engraver. Individualism was both his limit and his strong point. Having failed in his attempt to enter the Academy in 1733, he devoted himself exclusively to portrait painting, establishing himself as a master of pastel, a medium introduced into France by Rosalba Carriera. Unlike other masters who exploited the semi-tones and the *sfumato* transitions of pastel, Liotard defined his figures with clear lines, avoiding any form of lyricism. A cosmopolitan artist, he painted the Austrian, French, English, and Dutch nobility, leaving out the whole array of curtains, drapes, crowns, and other frills that characterize court portraiture. He depicts his characters with remarkable simplicity, with clear, well-defined surfaces, as though they are engraved, without recourse to elegant, cloying formulas.

From 1779 on he received no more commissions. Concerned by the development of political events, he retired to his country house in a village to the southeast of Geneva, where he painted still lifes of naive beauty and unexpected modernity. He died in 1789, one month before the beginning of the French Revolution.

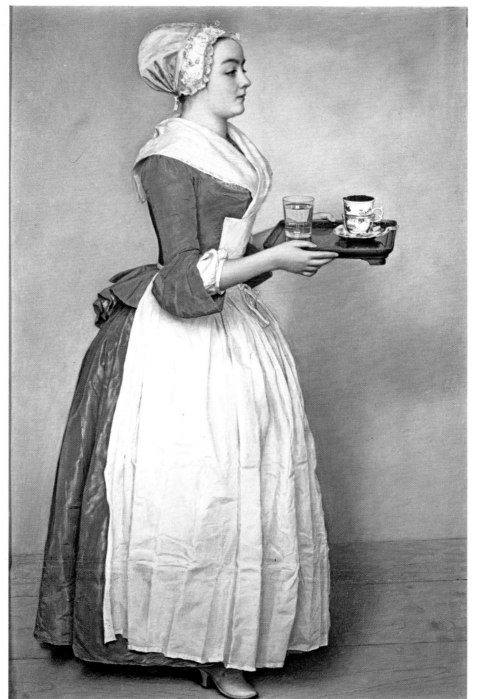

Jean-Étienne Liotard
The Chocolate Girl

1744–1745
pastel on parchment,
32½ × 20¾ in.
(82.5 × 52.5 cm)
Gemäldegalerie, Dresden

Liotard's masterpiece, it was already praised by his contemporaries for the technical perfection achieved in the use of pastels. Count Francesco Algarotti, who purchased the painting in 1745 in Venice for the royal collections of Dresden, praised its astonishing likeness. The refined use of a limited range of colors is particularly effective: the white apron stands out against the background tones of gray, pink, and ocher, which are also used for the pattern on the cup.

François Boucher
(Paris, 1703–1770)

Boucher, a brilliant decorator and colorist and a protégé of the Marquise de Pompadour, represented the elegant, refined taste of the court of Louis XV. He painted all his subjects with great perfection and taste, happy to try his hand at a wide range of genres and themes, from mythological subjects to pastoral scenes, from landscapes to portraits. After training in the workshop of François Lemoyne, he traveled to Italy in 1727, staying in Rome at the French Academy and for brief periods in Naples and Venice. He painted mythological themes such as the *Birth of Adonis* and the *Death of Adonis* (both in the Matthieu Goudchaux Collection, Paris), and the pastoral scene *Woman at the Fountain* (J. B. Speed Art Museum, Louisville).

He returned to Paris in 1731, and was admitted to the Academy as a history painter in 1734, presenting *Rinaldo and Armida* (Louvre, Paris) as his *morceau de réception*. In 1735 he received his first official commission: the decoration of the Queen's room in the palace of Versailles with four *grisailles* depicting the virtues, in which the Italian-influenced aspects of his style are given a more individual treatment. The following year he began to work with the Royal Manufactory of Beauvais, for which he produced the cartoons of fourteen tapestries in the series *Fêtes de village à l'italienne*, rustic scenes with brightly-colored figures in relaxed poses against a highly evocative background of woods and ruins.

Despite the evident influence of Watteau, Boucher evolved an unmistakably individual pictorial language aimed at exalting beauty and eroticism. In 1742 he began to work with the Paris Opéra, producing magnificent stage sets; this comes as no surprise, since his theatrical vocation is evident in both his painting and his drawing. In 1755 he was appointed painter to the king, after which he continued to alternate religious and pastoral subjects, landscapes and countryside or mythological scenes, confirming his fame as a charming painter of grace and joy.

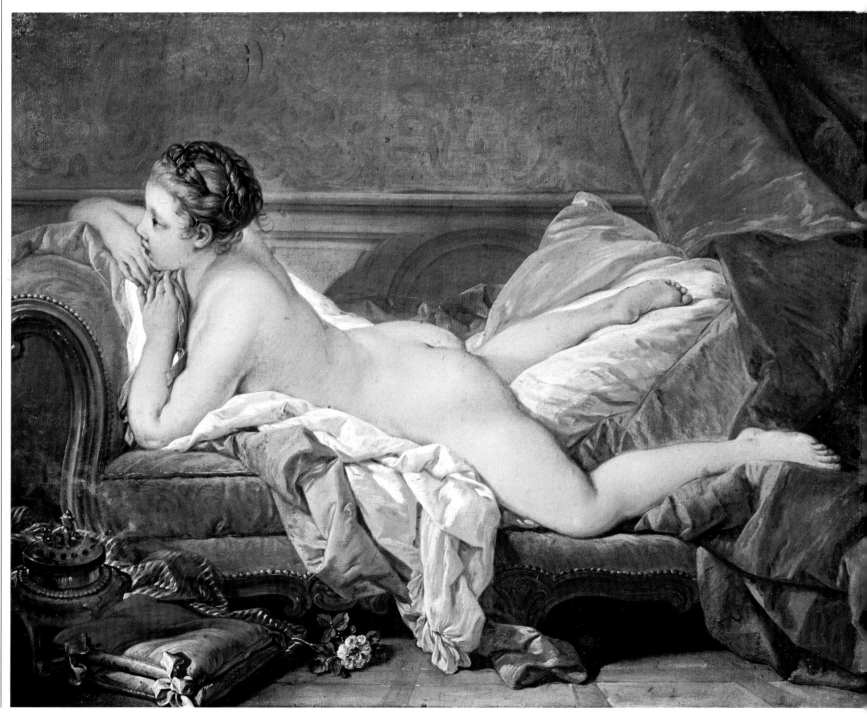

François Boucher
Nude Lying on a Sofa

1752
oil on canvas,
23¼ × 28¾ in.
(59 × 73 cm)
Alte Pinakothek, Munich

Gently reclining on the
sofa, with a rather
mischievous air, the girl's
nudity is provocative yet
graceful. The daring pose,
the reflection of the light
on the silk of the cushions,
the curtain and the
clothing, and the pink flesh
create a perfect
representation of the
frivolity and sensuality
of the age.

François Boucher
Rinaldo and Armida

1734
oil on canvas,
53½ × 67 in.
(135.5 × 170.5 cm)
Louvre, Paris

This painting, based
on *Canto XVI* of Torquato
Tasso's *Jerusalem Delivered*,
won him admittance to the
Academy. According
to tradition, Boucher
depicted Rinaldo with his
own features and Armida
with those of his wife,
a woman of renowned
beauty who appeared
in various guises in many
of his paintings.

François Boucher
Morning

1746
oil on canvas,
25¼ × 20¾ in.
(64 × 53 cm)
*Nationalmuseum,
Stockholm*

Commissioned by the
Swedish ambassador Count
Tessin, an assiduous visitor
to the Boucher household
as well as an admirer of
Mme Boucher, the painting
was to have been part of a
series of four, depicting
four different times of the

day: morning, noon,
afternoon, and night. The
light, precise design and
the skillful representation
of the drapery are the most
characteristic features of
this richly anecdotal scene.

François Boucher
Breakfast

1739
oil on canvas, 32 × 25¾ in.
(81.5 × 65.5 cm)
Louvre, Paris

A diagonal light casts dark
shadows on the richly

decorated wall and
on the floor in a scene
of bourgeois domesticity,
a subject that was unusual
for Boucher. The painting
probably represents the
family of the artist, who
takes delight in depicting
the folds of the garments,

the intricate *rocaille*
of the bronzes,
and the reflection
of the silver.

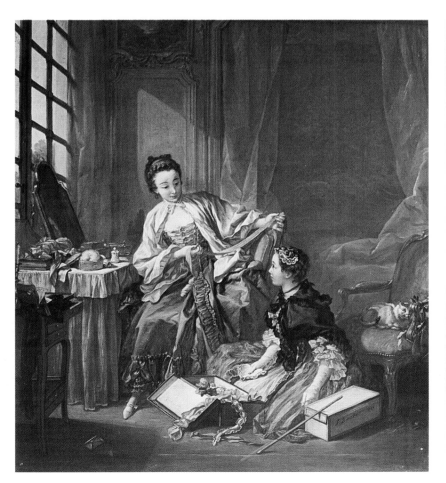

François Boucher
Triumph of Venus

1740
oil on canvas,
51 × 63¾ in.
(130 × 162 cm)
Nationalmuseum, Stockholm

A mythological scene
in which Boucher displays
his unrivaled ability
to spread light and joy.
The composition is
characterized by the rich
impasto of color and the
refined use of tones.

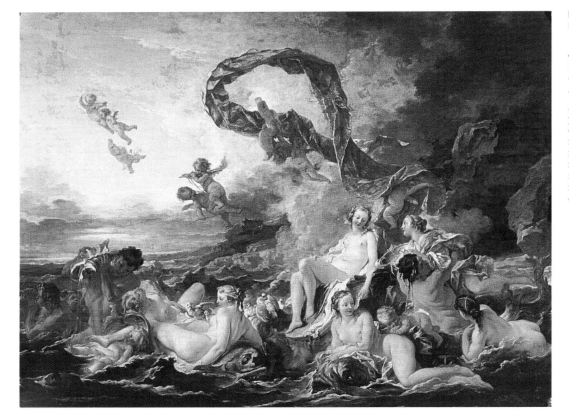

François Boucher
Diana Leaving Her Bath

1742
oil on canvas,
22¾ × 29¼ in.
(57.5 × 74 cm)
Louvre, Paris

A work of extraordinary
perfection and great
chromatic harmony,
it is perhaps Boucher's
masterpiece. In the pink
fleshiness of the nudes,
it presents a young,
mischievous model
of femininity.

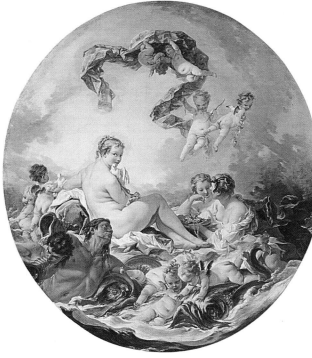

François Boucher
The Birth of Venus
The Toilet of Venus

1743
oil on canvas,
40 × 34½ in.
(101.6 × 87.6 cm) each
Private collection, New York

These are fine
representations of the
aspirations and illusions
of an age marked by its
taste for an elegant,
frivolous lifestyle. There
is, in fact, nothing very
sacred about the two
figures of Venus, who look
like elegant society ladies
occupied with an idle
game, reclining gently
to reveal the rich impasto
of their flesh.

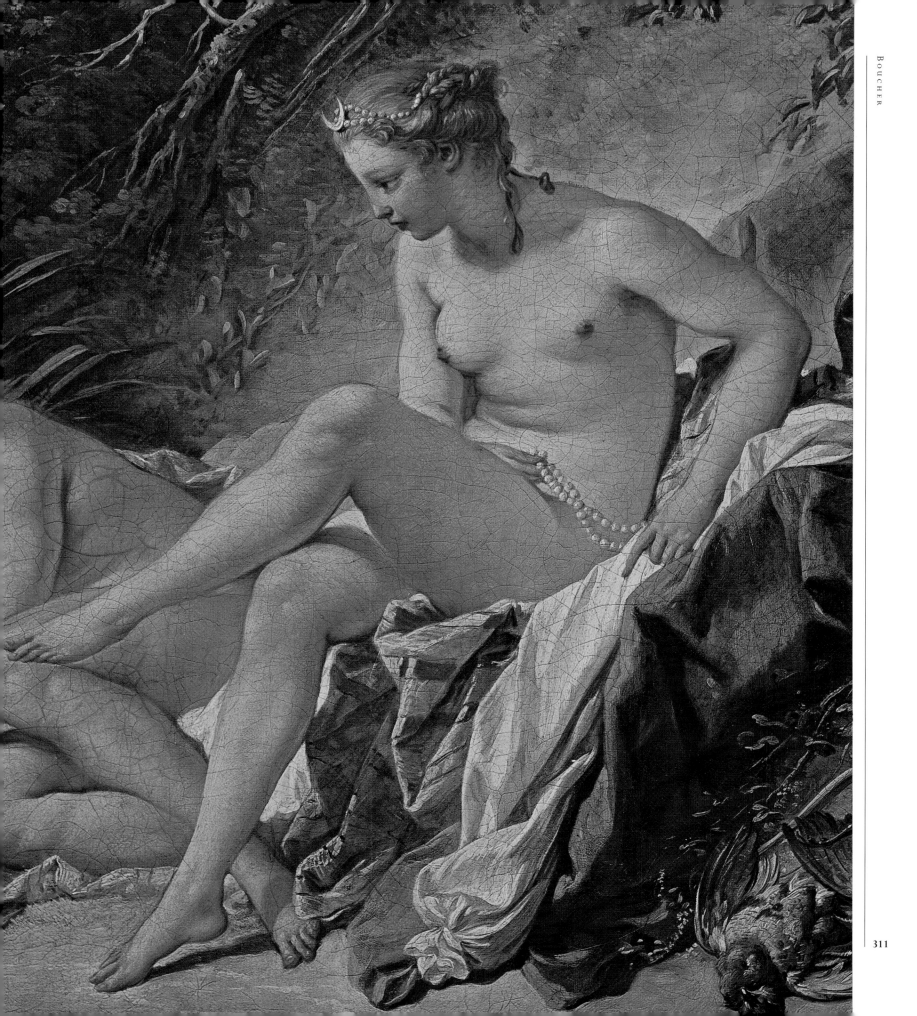

François Boucher
Winter

1755
oil on canvas,
21¾ × 28 in.
(55.3 × 71.3 cm)
Frick Collection, New York

This canvas is one of a
series of four paintings
depicting the four seasons,
commissioned by the
Marquise de Pompadour,
perhaps to be hung over
the doors in one of her
residences.

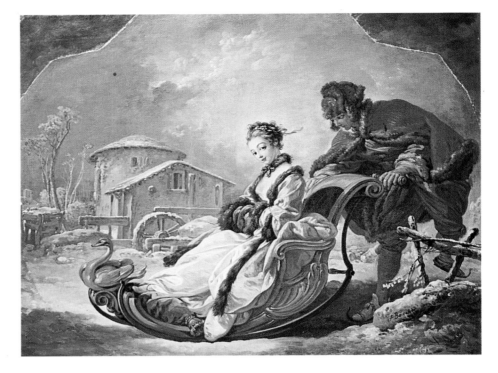

François Boucher
The Marquise de
Pompadour at Her Toilet

1758
oil on canvas,
32 × 24¾ in.
(81 × 63 cm) (oval)
*Fogg Art Museum, Cambridge
(Mass.)*

The king's favorite and
the patron of the artist,
the Marquise de

Pompadour is portrayed in
her boudoir. Every detail
of her precious outfit is
depicted with painstaking
care, from the bracelet
with the cameo to the gilt
powder box, from the
flowers decorating her hair
and scattered on the table
to the ribbons and laces
of her elaborate dressing
gown.

François Boucher
Portrait of the Marquise
de Pompadour

1756
oil on canvas,
79¼ × 61¾ in.
(201 × 157 cm)
Alte Pinakothek, Munich

Exhibited at the Salon
of 1757, the painting
presents the sumptuously-
dressed Marquise with
a book open on her lap,
in an aristocratic interior
depicted in a manner
that highlights Boucher's
mastery of decoration.

François Boucher
Portrait of the Marquise
de Pompadour

1759
oil on canvas,
35¾ × 27¼ in.
(91 × 69 cm)
Wallace Collection, London

Commissioned for the
Castle of Bellevue in 1758,
the painting represents the
Marquise in a small wood
next to Pigalle's statue
of *Love and Friendship*.
The figure of the woman,
with her noble pose
and sumptuous dress,
dominates the
composition, which is
almost entirely in shades
of ocher.

Jean-Honoré Fragonard

(Grasse, 1732–Paris, 1806)

The last great master of European Rococo, he trained in Paris, where he had moved at the age of six. After spending a few months in the workshop of Chardin, in 1750 he was accepted as a pupil of Boucher, and helped to produce the cartoons for the tapestries for the Gobelins and Beauvais manufactories. In 1752 he won the Prix de Rome with a work of great dramatic intensity, *Jeroboam Sacrificing the Golden Calf* (Louvre, Paris), and the following year he entered the Ecole Royale des Elèves Protégés, directed by Jean-Baptiste van Loo. He remained there until the autumn of 1756, when he left for Rome, staying at the French Academy for four years. Here he devoted himself to landscape painting, influenced by great Italian masters such as Tiepolo, who taught him to draw and to paint with light, and Barocci, who taught him the art of brilliant composition. After a brief stay in Tivoli and a journey to Naples, in 1761 he returned to Paris where he stayed for the rest of his life apart from brief trips to Holland in 1769, and to Italy and Germany in 1773.

In 1765 he was elected a member of the Academy, but he remained independent, choosing his patrons from the bourgeoisie and the new nobility. For them he painted mainly sweeping landscapes in the Dutch style, and "small paintings" of gallant subjects or of everyday life, the success of which earned him a reputation as a facile, superficial painter.

Around 1780 his painting took a decidedly neoclassical turn, although he maintained his own personal touch. Some of his distinctive characteristics, such as the swathes of color applied without any preparatory drawing, the brushstrokes, and the striking colors, remained constant throughout his career, whatever genres he tackled.

His versatility led him to make use of those he considered to be his masters, from Rembrandt to Rubens, Tiepolo, Watteau, and Boucher, with confident ease, as if to test out his ability. A painter of gallantry and nature, though also of domestic scenes and childhood, he left an extremely varied oeuvre that seems, with the decline of the monarchy, to evoke all that had been dear to eighteenth-century society.

Jean-Honoré Fragonard
La Gimblette
(The Ring-Biscuit)

c. 1765–1772
oil on canvas,
27½ × 34¼ in.
(70 × 87 cm)
Fondation Cailleux, Paris

A frankly libertine scene
depicting a reclining young
woman as she plays with a
lapdog. The light enhances
the pink flesh tones of her
body in a composition
characterized by a sort of
parallel between the girl's
face, lit up by a slight
smile, and the raised legs
and right arm, which
attenuate the sensuality
of the scene.

Jean-Honoré Fragonard
The Swing

1766
oil on canvas,
32 × 25½ in.
(81 × 65 cm)
Wallace Collection, London

Commissioned in 1766
by Baron de St. Julien,
the erotic nature of the
scene—the classic love
triangle in which the
lover has himself depicted
reclining in the flowers,
furtively watching his
mistress on the swing
as she is pushed by her
husband—is overshadowed
to some extent by the
skillful play of colors used
to create a dream-like
atmosphere reminiscent
of Watteau's idealized
landscapes.

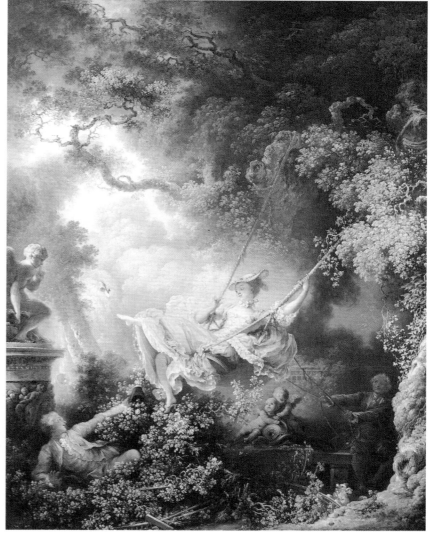

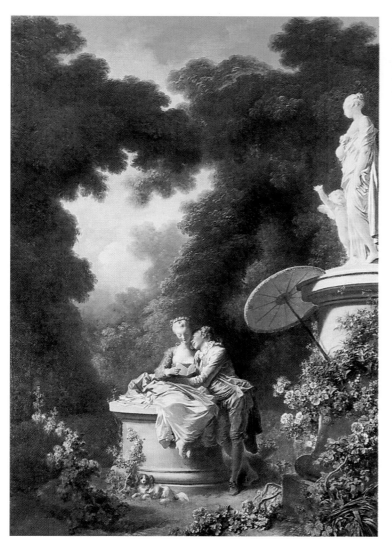

Jean-Honoré Fragonard
The Declaration of Love

1771
oil on canvas,
125¼ × 84¾ in.
(318 × 215 cm)
Frick Collection, New York

Together with *The Climb*,
The Pursuit, and *The Lover
Crowned with Flowers*, the
painting is part of the
series the *Progress of Love*
commissioned by
Mme du Barry for the
decoration of the games
room in the castle of

Louveciennes, now in
the Frick Collection
in New York. Despite the
influence of seventeenth-
century Dutch and Flemish
painting, Fragonard
displays great freedom
of expression. The effective
use of color gives the scene
an unreal atmosphere.
In the center is the girl
in the tender embrace
of her lover, while to the
right the figure of Venus,
standing on a tall pedestal,
seems to watch over and
protect the couple.

315

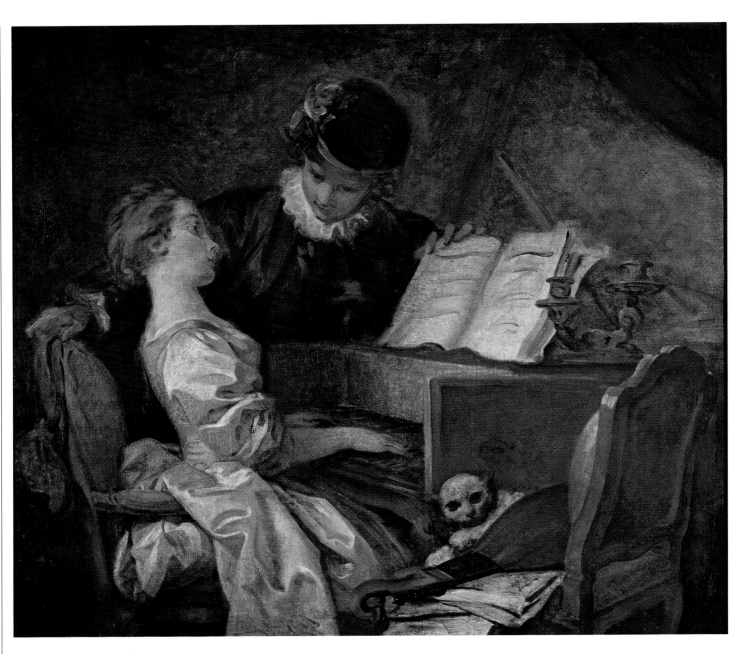

Jean-Honoré Fragonard
Music Lesson

1769
oil on canvas,
43¼ × 47¼ in.
(110 × 120 cm)
Louvre, Paris

A scene of bourgeois life
in which the feeling
of the young man toward
the girl is rendered with
extraordinary,
unsentimental immediacy.
A faithful mirror of the
spirit of his age, Fragonard
ensures that the scene
retains a composed grace
by using a limited range
of colors and avoiding
strong contrasts.

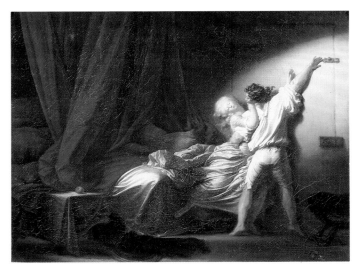

Jean-Honoré Fragonard
The Bolt

1778, oil on canvas,
28¾ × 36½ in.
(73 × 93 cm)
Louvre, Paris

This animated indoor scene
is typically libertine. A girl
is attempting to escape from
the amorous advances of a
young man, depicted as he
draws the bolt on the door.
The theatrical nature of the
scene, in which an
unexpected stream of light
isolates the bodies of the two
young people, leaving the
rest of the room in shadow,
creates an atmosphere of soft
sensuality.

Jean-Honoré Fragonard
The Reader

c. 1776
oil on canvas,
32¼ × 25½ in.
(82 × 65 cm)
*National Gallery of Art,
Washington*

Considered one of
Fragonard's masterpieces,
this is a scene of bourgeois
life from his series of
young women intent on
their private occupations.
Portrayed against a vague
background, the girl's
expression is rapt, while

the pose of the hand
holding the book is
deliberately affected.

Jean-Honoré Fragonard
Music

1769
oil on canvas,
31½ × 25½ in.
(80 × 65 cm)
Louvre, Paris

The figure of the musician,
seen from behind, with his
face turned to the viewer,
is bathed in an uneven light
that creates strong
contrasts. The
composition, based mainly
on shades of ocher, is one
of the group of portraits
symbolizing poetry,
singing, theater, and music.

Jean-Honoré Fragonard
Venus Refusing a Kiss
from Cupid

c. 1760
oil on canvas,
14½ × 13½ in.
(37 × 34 cm) (oval)
Private collection

This work is one of the
series of oval paintings
depicting real and
imaginary female figures in
affected poses, according
to the conventions of the
rising bourgeoisie.

Eighteenth-Century Italy

Giandomenico Tiepolo
The New World, detail
1791–1793
fresco, 196¾ × 67 in.
(500 × 170 cm)
Ca' Rezzonico, Venice

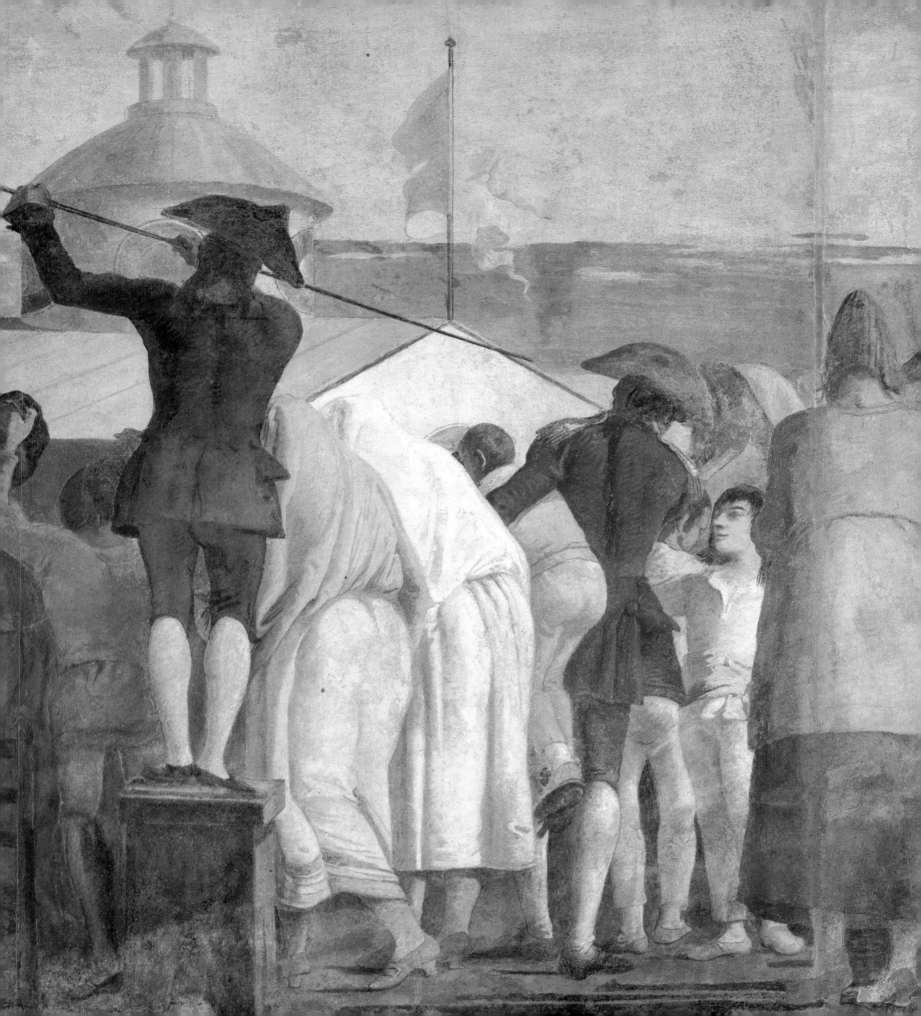

Sebastiano Ricci
Venus and Adonis
1705–1706
oil on canvas,
27½ × 15¾ in.
(70 × 40 cm)
Musée des Beaux-Arts,
Orléans

The great revolutions of the eighteenth century shifted the main thrust of historical progress away from Italy and left it as something of a backwater. While the smoke from the first factories began to rise over the green hills of England, Italy struggled in vain to free itself from an agricultural tradition that made it impossible to compete on the continental market. Impoverished and torn apart by the great powers in their fight for control of the ancient duchies, Italy was a subdued onlooker at the great events characterizing the eighteenth century. Highly precious items of art and culture left the country to embellish the homes and collections of the new sovereigns of Saxony, Prussia, Russia, Sweden, Poland, and other nations. The palaces of the central European political world became the essential points of reference for Italian artists in search of work. Great painters and humble laborers, celebrated masters and anonymous craftsmen, experts in stuccowork and unskilled house painters left Italy (Lombardy and the Veneto in particular) to settle abroad and play a leading role in the Rococo movement. Only a few areas and cities in Italy retained any contemporary glory, while most of the peninsula was "relegated" to the realm of memory as an essential stage on the cultural tours made by the young aristocrats of "modern" Europe.

The precarious state of the old patrician families, and in some cases their definitive collapse, led to a dramatic outflow of masterpieces toward the courts of central and northern Europe. Like the Gonzaga family in the previous century, the Este family were forced to sell their art collection, which became the main nucleus of the Dresden gallery. The dispersal of Italy's artistic heritage was to become still greater during the Napoleonic period, and the only possible remedy at the local level was to set up a system of Italian museums as a protective bulwark against the new foreign collections to safeguard at least the memory of the glorious past. Many of the leading Italian and foreign museums were thus founded between the eighteenth and the nineteenth centuries. In accordance with the spirit of Enlightened Rationalism, these collections do not share the celebratory and decorative character of the princely seventeenth-century collections, but display an anthological and didactic purpose, the desire to create a systematic overview of the evolution of the different schools in line with the art criticism of the period.

Giambattista Tiepolo
*Seated Man and Girl
with Vase*
c. 1755
oil on canvas,
65 × 21¼ in.
(165 × 54 cm)
National Gallery, London

During the eighteenth century, the image of Italy and the Italians became dishearteningly stereotyped: wonderful landscapes flooded with Mediterranean light, embellished by ancient ruins or historical monuments, and peopled by garlanded shepherds dancing with their nymphs. And all this was observed with "anthropological" detachment by travelers in search of strong emotions. In short, the country of painting became the country of the "picturesque." This is, of course, an exaggeration. Despite the general background of acute economic and social difficulty, there was no lack of illustrious personalities and centers of considerable vigor: the constant vitality and variety of Neapolitan culture, the laboratory of ideas and projects created by the rising House of Savoy in the youthful city of Turin, and the stern Milan of the early Enlightenment and the founding of La Scala. But eighteenth-century Italy was above all Venice. The Serenissima Repubblica di San Marco rose again after its eclipse in the seventeenth century to make its last century of independence one of dazzling splendor as one of Europe's greatest cultural centers of the figurative arts, theater, music, and many other fields.

Although the international importance of Venetian painting is unquestionably such as to merit absolute precedence with respect to the other schools of eighteenth-century Italian painting, for this very reason it is important not to overlook artists, cities, and ideas that might otherwise run the risk of falling into unmerited oblivion. Francesco Solimena, for example, strikes the rich resounding note of the late Neapolitan Baroque, a tradition of imagery that spread far beyond the boundaries of painting to affect the whole range of figurative arts at every social level, from the precious, dainty porcelain ornaments for the court to the Christmas crèches for the common folk. Nor should we forget the impetus given by the Bourbons to the excavation of the Roman cities buried by Vesuvius. In the second half of the eighteenth century, Pompeii and Herculaneum became an immense treasure trove of models for the burgeoning Neoclassical school. The arrival in Naples of the Farnese collections, previously held in Parma, also served to make the city's museums an indispensable point of reference both for archaeology and for Renaissance painting. In the north of Italy, attention should be drawn to Milan. Eighteenth-century Lombard culture was greatly influenced by an important historical event. In 1706, during the War of Spanish Succession, Milan was occupied by

Giambattista Piazzetta
*Saints Vincent Ferrer,
Hyacinth, and Louis
Bertrand*
1738
oil on canvas,
135¾ × 67¾ in.
(345 × 172 cm)
Santa Maria dei Gesuati,
Venice

Prince Eugene of Savoy and passed from Spain to the Austrian Empire. The territory of Mantua shared the same fate, while the lands on the other side of the River Adda, namely the provinces of Bergamo and Brescia, remained under Venetian jurisdiction despite their cultural proximity to Milan. This situation remained substantially stable, with minor modifications in favor of the House of Savoy, until the end of the century, when the arrival of Napoleon was to throw all territorial arrangements into disarray.

As the cradle of Enlightenment ethics, Milan developed a wholly new form of "social" painting. Giacomo Ceruti introduced images of the poor, the disadvantaged, and the marginalized into art. His paintings are striking because of their direct depiction of reality (in fact, they recall the work of another Lombard painter, Caravaggio) and the unusual sense of outrage and involvement conveyed by the artist. In this respect, they occupy a very important place in European art.

As pointed out above, Venice deserves separate treatment. Indeed, any discussion of eighteenth-century Venetian art must also include works executed at a great distance from the Rialto. The experiences of Canaletto in London, Tiepolo in Würzburg and Madrid, and Bernardo Bellotto at various central European courts provide the most celebrated examples of the truly European dimension assumed by the Venetian school and the decisive leading role it played in the development of eighteenth-century art in all countries. While the Venetian state plummeted into a decline that culminated in 1797 with the Treaty of Campo Formio and annexation by the Austrian empire, Venetian art enjoyed a period of splendor with specialized masters in various sectors.

Indeed, the eighteenth-century Venetian school offers the greatest possible variety of subject matter, dimension, and medium, from monumental frescoed ceilings to minute scenes of everyday life, from sumptuous altarpieces to delicate views of the city. The starting point for the rebirth of the Venetian school was the decisive abandonment of the "shadows" of the seventeenth century and a return to the "sunlight" of the Renaissance. Sebastiano Ricci, Piazzetta, and Tiepolo openly acknowledged that they drew upon the great sixteenth-century masters, especially Veronese, to produce sumptuous scenes full of color and movement, adding a taut, effervescent vein of inspiration to the classical models. Giambattista Tiepolo, in particular, reached

Canaletto
*Procession of Knights
of the Order of the Bath
Before Westminster
Abbey*
1747–1755
oil on canvas,
39 × 39¾ in.
(99 × 101 cm)
National Gallery, London

Francesco Guardi
Town with Canal
1765–1770
oil on canvas,
11¾ × 20¾ in.
(30 × 53 cm)
Uffizi, Florence

the climax of a luminous expressive crescendo in immense secular allegories, which were an explosion of light and color irresistibly propelled toward the heavens.

Tiepolo is perhaps the most important and influential painter of the late European Baroque. Impetuous and overpowering, capable of orchestrating broad theatrical effects without neglecting descriptive detail, Tiepolo summarizes the rise and fall of the Rococo style in his long career. Having reached its height around 1760, the Rococo became unfashionable almost overnight, supplanted and practically ridiculed by Neoclassicism. This explains how one of Europe's most celebrated and sought-after painters could come to die alone and almost forgotten, far away from his native land, in the space of a few short years.

Another characteristic aspect of Venetian painting is the *veduta*, or view, the particular type of landscape made famous throughout Europe by Canaletto, who was worthily succeeded by his nephew Bernardo Bellotto. Based on the observation of reality but also on the use of subtle optical devices to correct perspective and enhance theatrical effect, *vedute* were by far the most popular type of painting with travelers, especially the English. Their generally small format facilitated transport and the fascinating image of Venice increased their appeal. This accounts not only for the great length of time spent abroad by the most successful *vedutisti*, but also for the almost total absence of their work in Venice. In actual figures, the Venetian museums, with their wealth of local masterpieces, have only three paintings by Canaletto and one by Bellotto. The exception is Francesco Guardi, whose rough-and-ready, "dirty," and poetic painting offers an image of Venice that is far less attractive than the luminous array of monuments rising above the lagoon provided by Canaletto. Guardi's work brings to an end the artistic history of Venice, eroded by damp and the weight of its past. The last images are provided by Giandomenico Tiepolo, the son of the great Giambattista and initially his father's assistant, the painter of canvases and frescoes where the melancholy of an era drawing to a close is tempered with irony, an interest in everyday detail, and an awareness of the small pleasures, trifles, and inevitable tricks of existence.

Francesco Solimena

(Canale di Serino, 1657– Barra, Naples, 1747)

A long-lived and brilliant painter of European renown, Solimena was the leading painter of southern Italy from the end of the seventeenth to the mid-eighteenth century, especially after Luca Giordano moved to Madrid. Solimena was trained in the workshop of his father, a fairly good painter of the Neapolitan school, and made his debut in the intense, dynamic atmosphere of seventeenth-century Neapolitan art. The first frescoes executed independently (for the chapel of St. Anne in the church of Gesù Nuovo in Naples, painted at the age of twenty in 1677) display a careful study of Baroque decoration and an early taste for rich, dynamic, monumental compositions. During the 1680s, Solimena received increasingly important commissions for work in Neapolitan churches and established himself as one of the leading painters of the local school. With their spectacular impact and expressive tension, the frescoes in the sacristy of San Paolo Maggiore constitute an authentic masterpiece. The vigor of his contrasts was partially attenuated during a stay in Rome shortly before the year 1700. Contact with artists connected with the Accademia di San Luca and the French Academy at Villa Medici led Solimena to address mythological subjects with a restraint drawn from classicism. In Naples, Solimena was for many years the unchallenged leader of the artistic scene, a role confirmed by the great frescoes executed at an advanced age, such as the *Expulsion of Heliodorus from the Temple* on the broad secondary façade of the Gesù Nuovo. Solimena's style was a source of inspiration not only for painters but also for those working in the various decorative arts, such as goldsmiths, silversmiths, and the creators of the characteristic figurines used in Neapolitan Christmas crèches.

Francesco Solimena
St. Bonaventura Receives the Banner of the Holy Sepulchre from the Virgin Mary

1710
oil on canvas,
94½ × 51¼ in.
(240 × 130 cm)
Cathedral of Aversa (Caserta)

Solimena's religious works are a triumphant spectacle of striking poses, gestures, and colors. He uses taut sculptural modeling based on a strong contrast of light and shadow to stage magnificent Baroque scenes, seeking to involve the public as in a dazzling, popular theatrical production.

Francesco Solimena
Judith with the Head of Holofernes
1728–1733
oil on canvas,
41¼ × 51¼ in.
(105 × 130 cm)
Kunsthistorisches Museum, Vienna

Solimena displayed an equal mastery of fresco and easel painting, being able to rely on expert handling of light and a compositional flair that was naturally oriented toward the dramatic. This formula was to receive significant international recognition. The works sent to Vienna (including a large altarpiece commissioned by Prince Eugene of Savoy for the Belvedere chapel) became precise points of reference for Austrian Rococo painters.

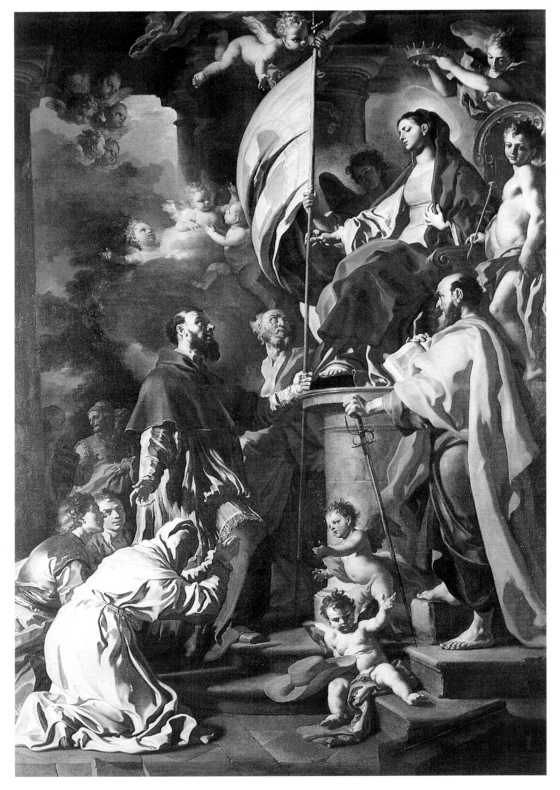

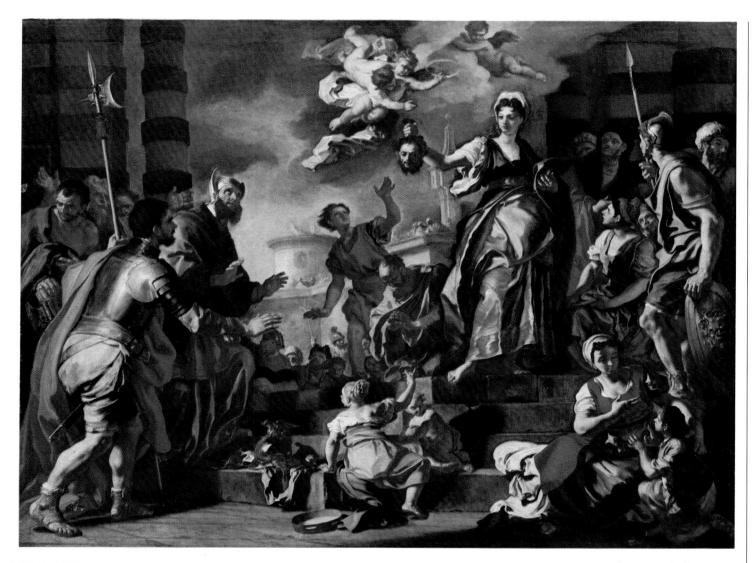

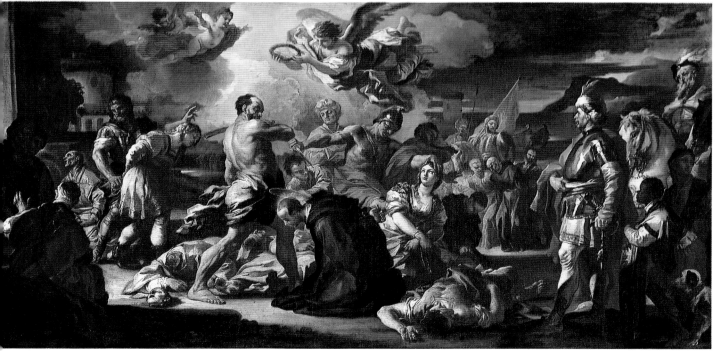

Francesco Solimena
The Martyrdom
of St. Placid and St. Flavia

1697–1708
oil on canvas,
29½ × 63¼ in.
(75 × 153 cm)
Museum of Fine Arts, Budapest

This is another example
of religious drama staged
by Solimena. The work was
executed in the period
of his closest contact with
classicism during a stay
in Rome. For this reason,
the composition has a less
agitated rhythm than usual,
with greater breadth and
calm, and the figures
assume poses of noble
elegance.

Giacomo Ceruti

"Il Pitocchetto" (Milan, 1698–1767)

An artist of great moral nobility, Ceruti was the leading exponent of the "pauperistic" trend in eighteenth-century European painting, firmly rooted in the wholly Lombard tradition of realism that also included Caravaggio. He worked mainly in Brescia for patrons from the solid provincial aristocracy who were capable of appreciating the innovations of his art. A versatile artist, he also tried his hand at religious painting (admittedly with no great success). His portraits, still lifes, and above all the scenes illustrating the grim and bitter life of the poor were far more successful. Ceruti produced canvases of great intensity, with a capacity to move the viewer, equaled by few other paintings in the eighteenth century. Anticipating the moral and social philosophy of the Enlightenment, Ceruti drew attention to human problems seldom touched upon by previous painters. He addressed these subjects with a solid technique of great energy and solemn monumentality. The protagonists of this everyday human adventure are not "minor" figures but are powerfully represented in a style of painting that does not hesitate to adopt an epic tone.

Giacomo Ceruti
Washerwoman

c. 1736
oil on canvas,
57 × 51¼ in.
(145 × 130 cm)
Pinacoteca Tosio-Martinengo, Brescia

In this poor courtyard setting, Ceruti's washerwoman and youth are deeply human figures. The painter expresses resignation and dignity in a masterpiece of unforgettable intensity. Ceruti's pictorial immediacy is readily demonstrated by the handling of minor details such as the plant poking out from beneath the washtub.

Giacomo Ceruti
Evening in the Piazza

c. 1730
oil on canvas,
82¾ × 117¼ in.
(210 × 298 cm)
Museo Civico d'Arte Antica, Turin

Ceruti captures the last spark of carefree joy in children before it is extinguished by the sad burden of drudgery.

Sebastiano Ricci
(Belluno, 1659–Venice, 1734)

An innovative artist, great traveler, and dashing figure of adventure, Sebastiano Ricci was of crucial importance for the new direction taken by European painting on the threshold of the eighteenth century. He boldly decided to abandon the contrasts of light and shade, the somber hues, and dramatic violence predominant in seventeenth-century painting, and return to the luminous, brightly colored, and imaginative painting of the Venetian Renaissance, drawing inspiration from the most sumptuous scenes depicted by Paolo Veronese. After his initial training in the Veneto, Ricci began to travel. During his first stay in Emilia he had direct experience of the work of the Carracci family, which led in turn to an admiration for Correggio's swirling perspectives. He then worked in Rome, Milan, Florence, and once again Parma. Each stay was marked by works of steadily increasing originality in which Ricci's style became more firmly established. He was accompanied by his nephew Marco Ricci, an interesting landscape painter. Sebastiano painted on the grand scale: solid, well-constructed figures in highly dynamic scenes featuring light colors, virtuoso foreshortening, and exquisite detail. The frescoes in Florence reveal the influence of Luca Giordano. After a journey to Vienna (where he was to make a number of visits), Sebastiano returned to Venice. Although this stay, which saw his first altarpieces for the local churches, lasted only three years, it was sufficient to mark a decisive turning point for the Venetian school of painting. Thanks to Ricci, the Venetian painters abandoned the "shadows" of the seventeenth century for the blue skies of the eighteenth century. In 1711, at his nephew's invitation but also as a result of legal proceedings, Sebastiano Ricci moved to London, where he worked for five years, mainly producing easel paintings but also some impressive decorative compositions. Having become a public figure of European renown (while passing through Paris he was made an honorary member of the Académie Royale), he returned to Venice in 1716. Among his altarpieces, attention should be drawn to the *St. Peter Freed from Prison* in the church of San Stae, one of a set of canvases by the leading painters of the day. The *tondi* on the ceiling of the church of San Marziale confirm his unfailing flair for perspective and compositional virtuosity.

Sebastiano Ricci
Christ Praying in the
Garden of Gethsemane

c. 1730
oil on canvas,
37½ × 30 in. (95 × 76 cm)
*Kunsthistorisches Museum,
Vienna*

The elegance of Sebastiano Ricci's late works can be appreciated not only in the more theatrical and crowded compositions, but also in the smaller canvases on concentrated, mystical themes. This episode from the Passion shows his talent for iridescent effects (particularly in the angel's garments) that are clearly reminiscent of Veronese.

Sebastiano Ricci
Bathsheba Bathing

1720
oil on canvas,
46¾ × 78¼ in.
(118.5 × 199 cm)
Museum of Fine Arts, Budapest

This luminous composition, repeated by the master in a number of versions, provides a highly effective summary of the characteristics of eighteenth-century painting. Comparison with Rembrandt's totally different handling of the same subject is quite illuminating. Bathsheba's existential dilemma is of no importance to Ricci. The biblical subject is merely a pretext for a spectacular and enticing secular scene, focused on the gleaming nude figure of the beautiful girl attended by a group of handmaidens. Attention should also be drawn to the two fluted columns behind Bathsheba: here Ricci borrows one of Titian's masterstrokes to introduce two apparently incongruous architectural elements, which succeed, however, in imparting a remarkable upward thrust to the work.

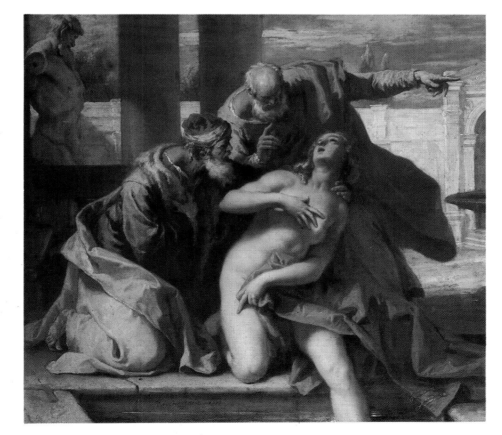

Sebastiano Ricci
Susanna and the Elders

1713
oil on canvas,
32¾ × 40¼ in.
(83.2 × 102.2 cm)
Duke of Chatsworth Collection, Chatsworth (Devonshire)

Painted during Ricci's stay in England, this canvas is deftly focused on the complex twisting of the figures, which form a rotating group within a sophisticated architectural setting.

Sebastiano Ricci
Madonna and Child
with Saints

1708
oil on canvas,
159¾ × 82 in.
(406 × 208 cm)
*Church of San Giorgio
Maggiore, Venice*

Sebastiano Ricci's entire
career must be assessed
in terms of the two parallel
strands of his secular
works and his altarpieces.
In the latter area, the
references to sixteenth-
century painting are still
more marked and explicit.
Summoned to paint a

Sacra Conversazione for
the great church erected
by Palladio in front
of the basin of San Marco,
containing celebrated
paintings by Tintoretto,
Sebastiano Ricci went
straight back to Veronese,
jumping one and a half
centuries to the golden age
of cheerful, joyous painting
bursting with color. The
placing of the Madonna
to one side of the
painting's major axis
is also a direct reference
to the compositional
layout introduced by
Titian and developed
by Veronese.

Sebastiano Ricci
St. Gregory the Great
Invokes the Virgin to End
the Plague in Rome

1700
oil on canvas,
141 × 74 in.
(358 × 188 cm)
*Basilica of Santa Giustina,
Padua*

This magnificent religious
painting forms a link
between the end of the
period of Ricci's youthful
travels and the beginning
of his work in the Veneto
as a mature artist. The
moving scene is based on a
kind of dramatic podium
composed of the bodies of
plague victims, above

which Sebastiano Ricci
creates two strong
diagonals, one cutting
across the whole work
from the bottom left-hand
corner to the canopy
behind the kneeling saint,
and another running
parallel to it with the
figures of the Madonna
and Child.

Sebastiano Ricci
The Meeting of Bacchus and Ariadne

c. 1713
oil on canvas,
30 × 25 in.
(75.9 × 63.2 cm)
National Gallery, London

The figure of the sleeping girl is the luminous fulcrum around which this lively scene revolves. It is possible to discern the influence of the works Johann Liss painted in Venice, which constitute an interesting interpretation of Titian's painting in Baroque terms. This work shows how Ricci's apparent creative freedom and interest in movement are actually based on very precise compositional structures. The horizontal line of the girl's body intersects at right angles with the vertical trunk of the tree to create an orderly framework within which Ricci arranges his animated figures.

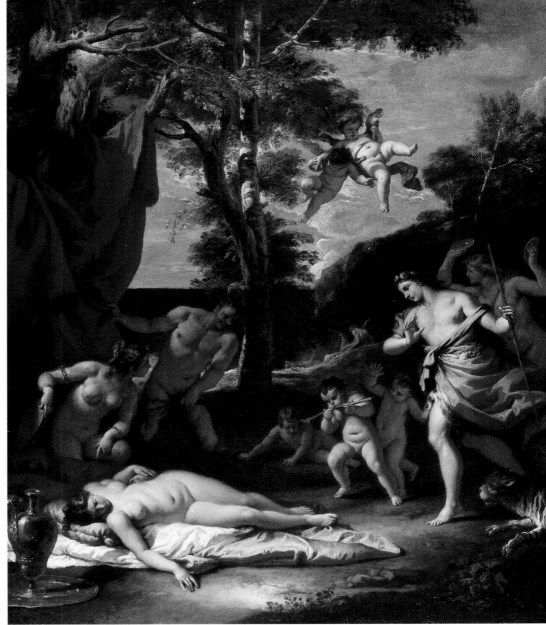

Sebastiano Ricci
Bacchus and Ariadne

c. 1713
oil on canvas,
74½ × 41 in.
(189 × 104 cm)
Chiswick House, London

This is another work from his English period that demonstrates the highly sophisticated "gallantry" of some of Sebastiano Ricci's secular subjects, which were to influence the tastes of aristocratic European collectors in the space of a few short years.

331

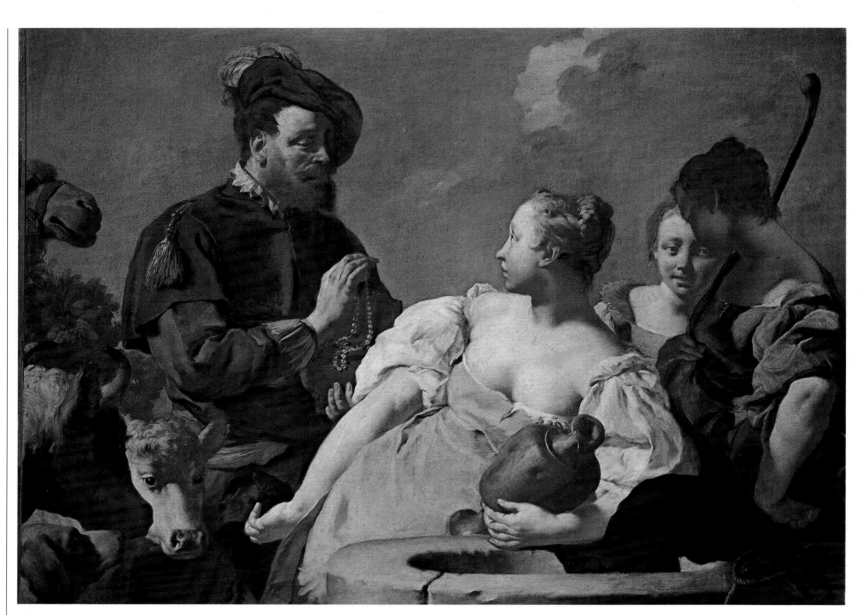

Giambattista Piazzetta

(Venice, 1683–1754)

Piazzetta shares with Sebastiano Ricci the merit of opening up new horizons for eighteenth-century Venetian painting, thus paving the way for the great decorative works of eighteenth-century European art. Unlike Ricci, Piazzetta painted mostly religious works and never executed frescoes, but his dynamic and dramatically intense altarpieces are to be regarded as cornerstones of international art. Considerable importance also attaches to his etchings and illustrations for books. The son of a wood carver, Piazzetta was to display throughout his long career a particular taste for well-rounded, sculptural figures outlined by light. From 1703 to 1705 he completed his training with an interesting stay in Bologna in the workshop of Giuseppe Maria Crespi. It is significant to note that Piazzetta drew inspiration in Bologna not from works by

the Carracci family or Guido Reni, but from Guercino's early compositions and their strong chiaroscuro contrasts. On his return to Venice, he did not hesitate to tackle demanding altarpieces and increasingly important commissions for religious works. From the time of the canvases for the church of San Stae, he frequently found himself working alongside Sebastiano Ricci and the young Giambattista Tiepolo. The interplay of reciprocal influences, ideas, and cross references established among the three masters led gradually to a general lightening of the chromatic range. In his mature work, Piazzetta also opened up to "sunlight" and allowed light to flow freely into his canvases. After 1735, it was certainly through contact with Tiepolo that he produced a number of works on amorous themes for private collectors. In his old age, Piazzetta assumed a very important teaching role, initially with the numerous pupils that passed through his workshop and then as founder of the Accademia di Belle Arti.

Giambattista Piazzetta
Rebecca at the Well

c. 1740
oil on canvas,
40¼ × 54 in.
(102 × 137 cm)
Pinacoteca di Brera, Milan

This work dates from Piazzetta's late period, when his canvases were suffused with a clear light that indicates the influence of Tiepolo. The subject is taken from the Bible, but portrayed in charmingly secular fashion with narrative details precisely depicted around the beautiful, luminous central figure of the blonde girl.

Giambattista Piazzetta
Idyll on the Beach

1745
oil on canvas,
77¼ × 64½ in.
(196.5 × 146 cm)
*Wallraf-Richartz Museum,
Cologne*

In his rare secular
paintings, Piazzetta displays
a calmer and more relaxed
attitude than in his
dramatic religious scenes.
The composition unwinds
slowly with the rhythm
of a *largo* in an eighteenth-
century concerto, and
follows the flow of light.
The figures, however,
are always robust and
vigorously modeled.

Overleaf:
Giambattista Piazzetta
St. James Being Led
to Martyrdom

1722–1723
oil on canvas,
65 × 54¼ in.
(165 × 138 cm)
Church of San Stae, Venice

The chancel in the Baroque
church of San Stae
(Sant'Eustachio) on the
Grand Canal in Venice
contains twelve canvases
of identical format and
similar subject matter
painted by twelve artists
of the early eighteenth
century. This authentic
"group exhibition" has
fortunately remained intact
in its original location and
precisely documents
the developments of the
Venetian school in the
eighteenth century.
Piazzetta's work is to be
regarded as one of the
most interesting, alongside
those of Sebastiano Ricci
and the novice
Giambattista Tiepolo.
Piazzetta confines himself
to two monumental
figures, the burly cut-
throat and the intractable
saint, who continues
to clasp a massive,
well-thumbed tome even
at the moment of capture.
The dramatic inspiration,
concision, and
monumentality of the
work make it a
masterpiece greatly
admired by painters
and experts in eighteenth-
century art.

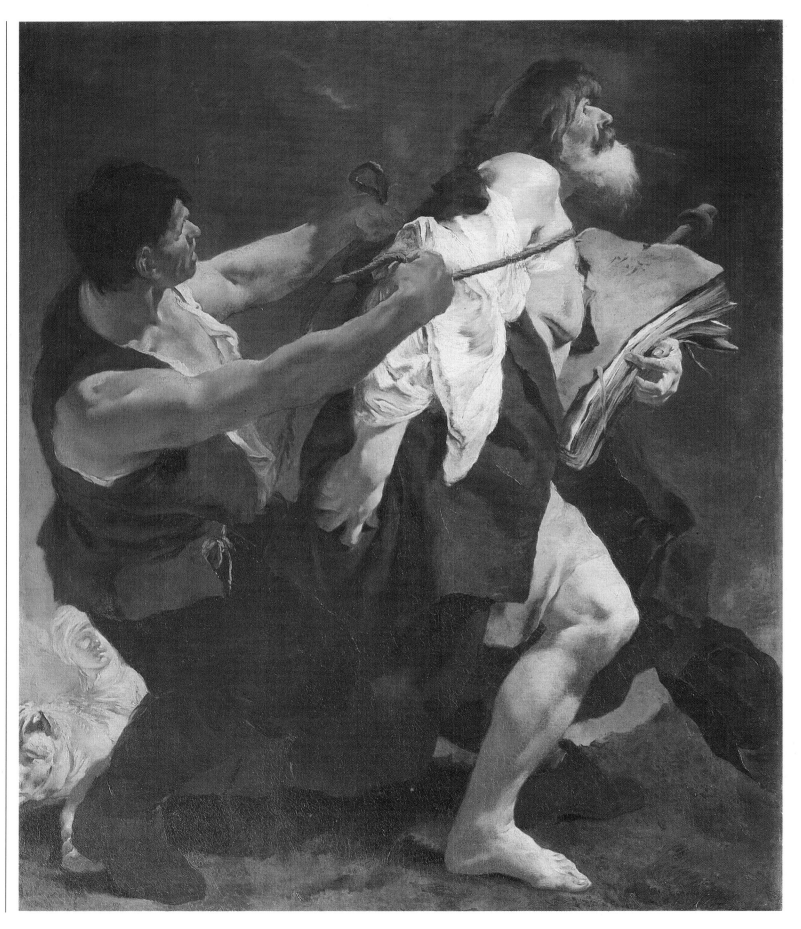

Giambattista Piazzetta
The Apparition of the
Madonna and Child
to St. Philip Neri

1725–1726, oil on canvas,
144½ × 78½ in.
(367 × 200 cm)
*Church of Santa Maria
della Fava, Venice*

The vertical elongation of the
scene is corrected and
attenuated by a series of
sophisticated compositional
devices. The structure of the
canvas is based on the vertical
shaft of light moving slowly
to the right to follow the light
garments of the Virgin and
the kneeling saint. A diagonal
starts from the angel in the
lower left-hand corner and
ends in the dark blue drapery
in the opposite corner.

Giambattista Piazzetta
Guardian Angel with
St. Anthony of Padua
and St. Gaetano Thiene

c. 1729, oil on canvas,
98½ × 44 in.
(250 × 112 cm)
San Vitale, Venice

In this luminous image, the
angel floods the superbly
executed scene with light.

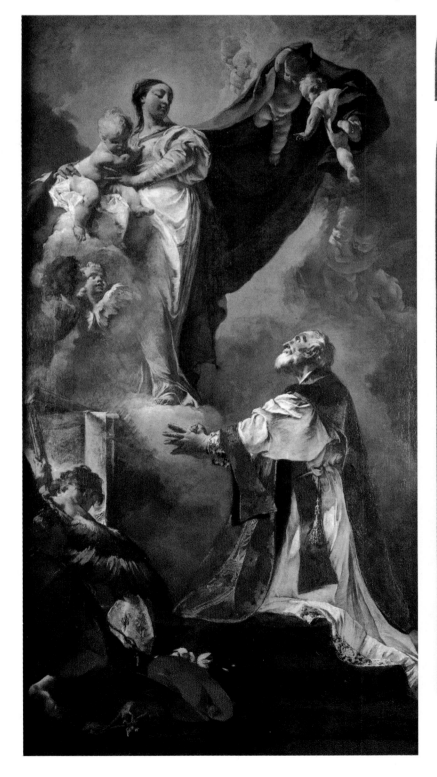

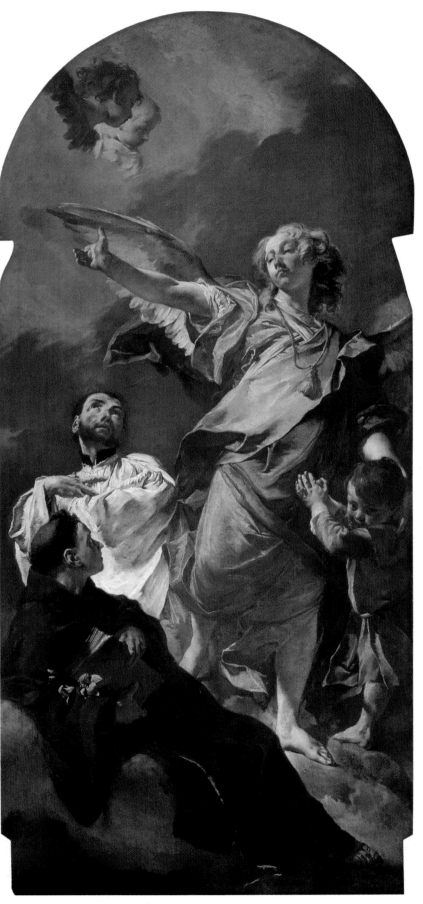

335

Giambattista Tiepolo

(Venice, 1696– Madrid, 1770)

Eighteenth-century European art is dominated by the expansive, overpowering figure of Giambattista Tiepolo, who set the tone for the great late Baroque decoration of stately palaces throughout Europe until the 1770s, both through the numerous spectacular works executed by his own hand and through those of his many followers, imitators, and copiers. Tiepolo's sumptuous and fascinating large-scale frescoes are unquestionably the best-known aspect of his activities, so much so that there is a risk of regarding him primarily as a great decorative artist. On the contrary, Giambattista Tiepolo was a versatile master capable of tackling a whole range of different subjects, techniques, and formats. His eclectic approach is based on an

inimitable blend of wild fantasy and minute realism. In every composition, even the most extravagant and whimsical, Tiepolo always includes naturalistic details.

A pupil of Gregorio Lazzarini, Tiepolo completed all his training and the early stages of his career in Venice. In 1719 he married Cecilia Guardi, the sister of the painters Giovanni Antonio and Francesco. This period marked his debut as a promising painter of religious scenes for Venetian churches, and in 1700 he was engaged in the collective task of decorating San Stae. Encouraged by Piazzetta, the young Tiepolo began to create effects of diffused lighting and bold, melodramatic gestures, and developed a remarkable talent for the decoration of palatial interiors. A spectacular demonstration of this is provided by the series of frescoes in the archbishop's palace in Udine (1726), a splendidly rich and varied cycle of works that gave Tiepolo a leading role not only in

the Venetian school, but in European Rococo art as a whole. Tiepolo was inspired by Venetian sixteenth-century art, and especially the luminous period of Veronese and Palladio, and he worked on commission both for important Venetian churches and for nobles in different regions. His works include the important frescoes executed in Milan (Palazzo Archinto, Palazzo Dugnani, and Palazzo Clerici) during the 1730s. He was very competently assisted by Girolamo Mengozzi Colonna, a specialist in *quadrature*, illusionistic architectural settings that Tiepolo filled with narrative scenes. The climax of Tiepolo's consistent talent as a painter of religious scenes and secular allegories came in Venice in the early 1740s with his almost simultaneous work on canvases for the Scuola del Carmine and frescoes for Palazzo Labia. Though collectors and patrons throughout Europe (including the kings of Sweden) were competing for his services, at that time

Tiepolo had not yet set foot outside Italy. He finally accepted the proposals of the prince-bishop of Würzburg, who offered him the opportunity to fresco the staircase and the most imposing area of the great Residenz, the architectural masterpiece of Balthazar Neumman. In 1750 Tiepolo left for Germany, where he was to stay for three years, accompanied by his son Giandomenico. On his return to the Veneto, Tiepolo painted sumptuous and exquisite decorations for a number of villas on the mainland before leaving Italy again in 1762 for the court of Madrid. Tiepolo painted his last great secular compositions in the palace of the Spanish kings, but was exposed, at the same time, to competition from Anton Raphael Mengs and burgeoning Neoclassicism. His last years in Madrid, where he died in 1770, were filled with bitterness at his sudden loss of favor.

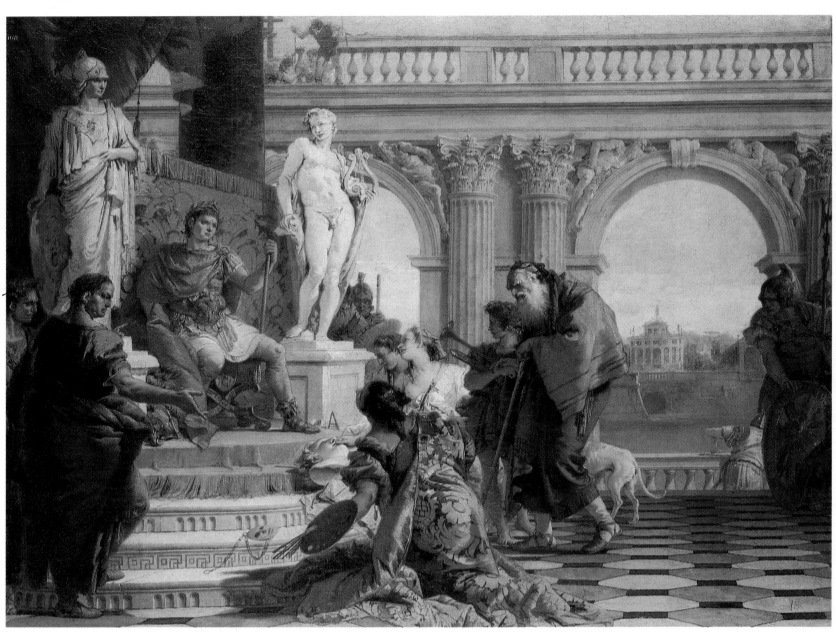

Giambattista Tiepolo
Maecenas Presents the Arts
to Augustus

1744, oil on canvas,
23¼ × 35 in.
(69.5 × 89 cm)
Hermitage, St. Petersburg

This brilliant painting was
intended for Count Brühl,
the immensely powerful
prime minister of Saxony,
whose palace in Dresden
appears in the background
beyond the impressive
Palladian arches of
the Corinthian portico.
The complex allegorical
theme is rendered in a
spectacular burst of color,
gesture, and expression
in line with the
developments in late
Baroque theater.

Giambattista Tiepolo
The Temptations
of St. Anthony

1725, oil on canvas,
15¾ × 18½ in.
(40 × 47 cm)
Pinacoteca di Brera, Milan

This delightful early work
displays Tiepolo's talent for
paintings on a small scale,
not only for vast frescoes.

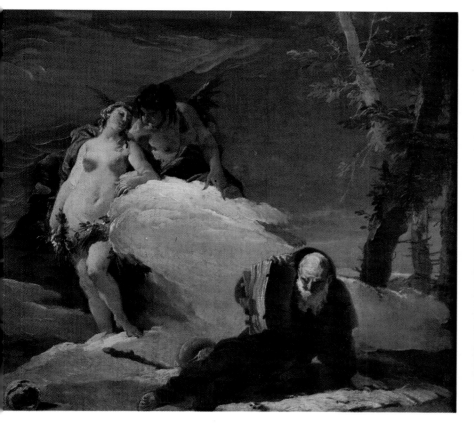

Giambattista Tiepolo
The Rape of the Sabine
Women

c. 1720–1723
oil on canvas,
113½ × 231½ in.
(288 × 588 cm)
Hermitage, St. Petersburg

Tiepolo's early works offer
a very interesting insight
into his complex artistic
relationships at the
beginning of his career. He
recaptures the spirit of
sixteenth-century Venetian
painting, filtered through
Sebastiano Ricci, but for
the moment continues to
use strong chiaroscuro
contrasts (reminiscent of
Piazzetta's technique), and
a dramatic tone still
characteristic of the
seventeenth century.

Giambattista Tiepolo
The Triumph of Marius

1729, oil on canvas,
214¾ × 127¾ in.
(545.5 × 324.5 cm)
*Metropolitan Museum of Art,
New York*

This is part of the cycle
of ten canvases painted
for Ca' Dolfin, the
residence of the patriarch
of Venice, Dionisio Dolfin.
Dismantled and dispersed
in various international
museums in 1870, the
series marked a pivotal
turning point in Tiepolo's
career between his early
period and the beginning
of his maturity and full
artistic independence. The
magniloquent and heroic
spirit of the work, the
splendor of the colors and
the handling of perspective
are all characteristic
of European Rococo.

337

Giambattista Tiepolo
Hannibal Recognizes
the Head of His Brother
Hasdrubal
1725–1730
oil on canvas,
150¾ × 71¾ in.
(383 × 182 cm)
*Kunsthistorisches Museum,
Vienna*

One of the fundamental
group of canvases painted
for Ca' Dolfin (see the
Triumph of Marius on the
previous page), this
work is paired in the
Kunsthistorisches Museum
with another portraying
the *Death of the Consul
Lucius Junius Brutus*.

Giambattista Tiepolo
Rachel Concealing the Idols

c. 1726
fresco,
157½ × 196¾ in.
(400 × 500 cm)
*Gallery of the Archbishop's
Palace, Udine*

Giambattista Tiepolo
Education of the Virgin

1732, oil on canvas,
146½ × 78¾ in.
(372 × 200 cm)
Santa Maria della Fava, Venice

The Venetian altarpieces
form an engrossing chapter
in the history of eighteenth-
century painting, as the
leading artists of the

Venetian school of the
period were constantly
being called upon to work
in the same churches.
In the case of the two
splendid works reproduced
on this page, attention
should also be drawn to
the opportunity for a close
comparison offered by two
of Piazzetta's works on
nearby altars. Tiepolo's

composition is based on a
diagonal that starts in the
bottom left-hand corner
and runs through the three
figures of St. Anne, the
infant Mary, and Joachim,
from whose head it then
proceeds in the opposite
direction, following the
flight of angels, to end in
the top left-hand corner.

Giambattista Tiepolo
Apparition of the Virgin
to the Dominican Saints
Rose of Lima, Catherine
of Siena, and Agnes
of Montepulciano
1740, oil on canvas,
133¾ × 66¼ in.
(340 × 168 cm)
*Church of Santa Maria
dei Gesuati, Venice*

Tiepolo's exceptional
mastery of composition
is again demonstrated
by this astounding work,
where the white sections
are placed in the
foreground toward the light
and the solid, deep colors
of the Virgin's garments
are in the penumbra of the
middle ground. The setting

is architecturally framed
between the corner
of a building on the right
and a Corinthian column.
The Virgin is placed
slightly toward the right
and Tiepolo, with a true
master's touch, balances
all the elements with the
simple addition of the little
bird.

Giambattista Tiepolo
The Triumph of Flora

1743–1744
oil on canvas,
28¼ × 35 in.
(72 × 89 cm)
*M. H. de Young Memorial
Museum, San Francisco*

This exuberant
mythological work was
originally paired with the
*Maecenas Presents the Arts
to Augustus*, and an allusion
to Count Brühl's
residences thus appears
once again with the
fountain from the
minister's villa in Dresden.
It should be remembered
that Tiepolo had never
been to Saxony, and based
his painting of these details
on drawings and
descriptions of the period.

Giambattista Tiepolo
Rinaldo in Armida's Garden

c. 1745
oil on canvas,
73½ × 102¼ in.
(187 × 260 cm)
The Art Institute, Chicago

Literary subjects were
great favorites with
Tiepolo, who frequently
drew inspiration from
celebrated pages
of classical poetry.
The episodes he found
most congenial, after his
wilder early period, were
romantic scenes such
as this instant of rural
bliss for the protagonists
of *Jerusalem Delivered*.
Attention should again be
drawn to the exceptional
handling of naturalistic
detail.

Giambattista Tiepolo
Neptune Offers to Venice
the Riches of the Sea

c. 1748–1750
oil on canvas,
53¼ × 108¼ in.
(135 × 275 cm)
Doges' Palace, Venice

Conscious of his position
as heir to the great
Venetian tradition, Tiepolo
portrayed the last triumph
of the Republic of the
Serenissima in this
allegorical work. The onset
of decline can only be
glimpsed in the
melancholy expression
of the lion beneath the arm
of the magnificent female
figure symbolizing Venice,
queen of the seas.

Giambattista Tiepolo
The Banquet of Cleopatra

1744
oil on canvas,
98 × 136¼ in.
(249 × 346 cm)
*National Gallery of Victoria,
Melbourne*

This sketch is part
of a large group of studies
(drawings, sketches, and
small oil paintings) carried
out by Tiepolo for the
decoration of the main
hall of Palazzo Labia,
the most important work
undertaken on a patrician
palace in Venice.

Giambattista Tiepolo
Portrait of Antonio
Riccobono

c. 1745
oil on canvas,
47¼ × 35½ in.
(120 × 90 cm)
*Accademia dei Concordi,
Rovigo*

Few though there are,
Tiepolo's portraits
constitute an interesting
section of his oeuvre.
Being obliged to restrain
his customary vigor,
the artist gave his sitters
dynamic expressions,
seeking to capture
the figures in action.

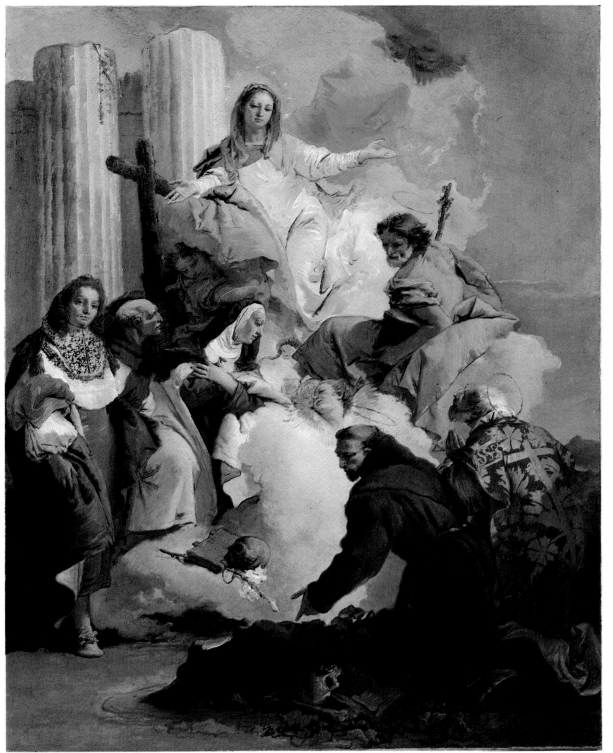

Giambattista Tiepolo
The Immaculate Virgin
with Six Saints

1755–1756
oil on canvas,
28¾ × 22 in.
(72.8 × 56 cm)
Museum of Fine Arts, Budapest

This extremely unusual
altarpiece constitutes a
brilliant and even witty
tour de force in its solution
to the problem
of combining a group
of very different figures
in very different forms
of dress, from friars in
tattered habits to the
somewhat perplexed
nobleman in splendid
garments and footwear
who represents St. Louis
of France, and seems to
have stepped straight out
of the court of Versailles.

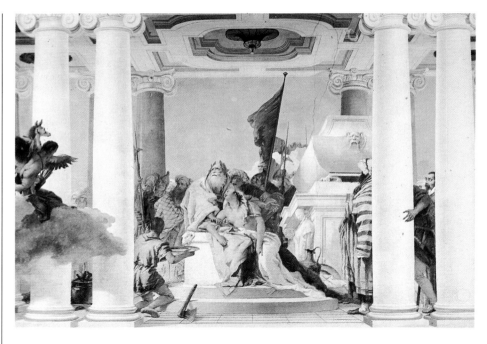

Giambattista Tiepolo
Frescoes in the main wing
and guest wing of Villa
Valmarana, Vicenza

The Sacrifice of Iphigenia
fresco, 137¾ × 275½ in.
(350 × 700 cm)

Mars, Cupid and Venus
fresco, 78¾ × 72¾ in.
(200 × 185 cm)

1757
*"portego" or portico
of the main wing and "room
of the gods" in the guest wing*

The frescoes in Vicenza
are works of exquisite,
luminous beauty.
The scenes in the main
wing are inspired by
celebrated passages from

the great classical poems
(the *Iliad*, the *Aeneid*,
Orlando Furioso, and
Jerusalem Delivered), and
the room in the guest wing
frescoed by Giambattista is
flanked by those decorated
by his son Giandomenico.

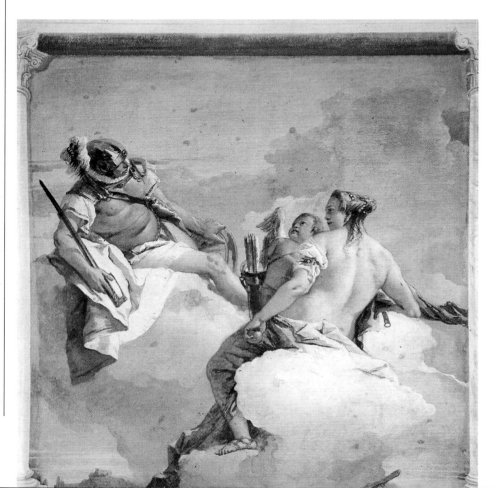

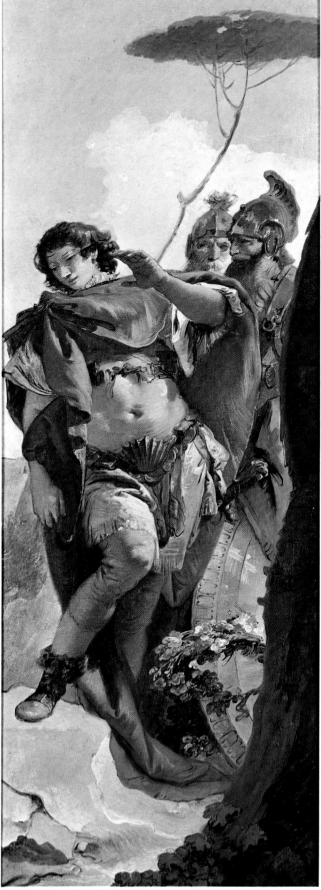

Giambattista Tiepolo
Rinaldo and the Magical
Mirror

c. 1755
oil on canvas,
65 × 21¼ in.
(165 × 54 cm)
National Gallery, London

This work is derived from
one of the frescoes at Villa

Valmarana, and in
particular from the
splendid room dedicated
to *Jerusalem Delivered.*

Giambattista Tiepolo
Apollo and Daphne

1765–1766
oil on canvas,
27 × 34¼ in.
(68.8 × 87.2 cm)
*National Gallery of Art,
Washington*

This is a late work already
touched by the

disenchantment of Tiepolo's
last years. Apollo's rush
toward amorous conquest
is halted in sorrowful
amazement at the
metamorphosis of Daphne,
who prefers transformation
into a laurel bush to capture.
The spacious luminosity
of the scene contrasts
with the suspended feeling

characteristic of the late
works painted by Tiepolo
in Madrid, when the rigor
of Neoclassicism, which
was to make the
effervescent virtuosity and
whimsical fantasy of the
Rococo look completely
"outmoded" in the space
of a few short years, was
just beginning to spread.

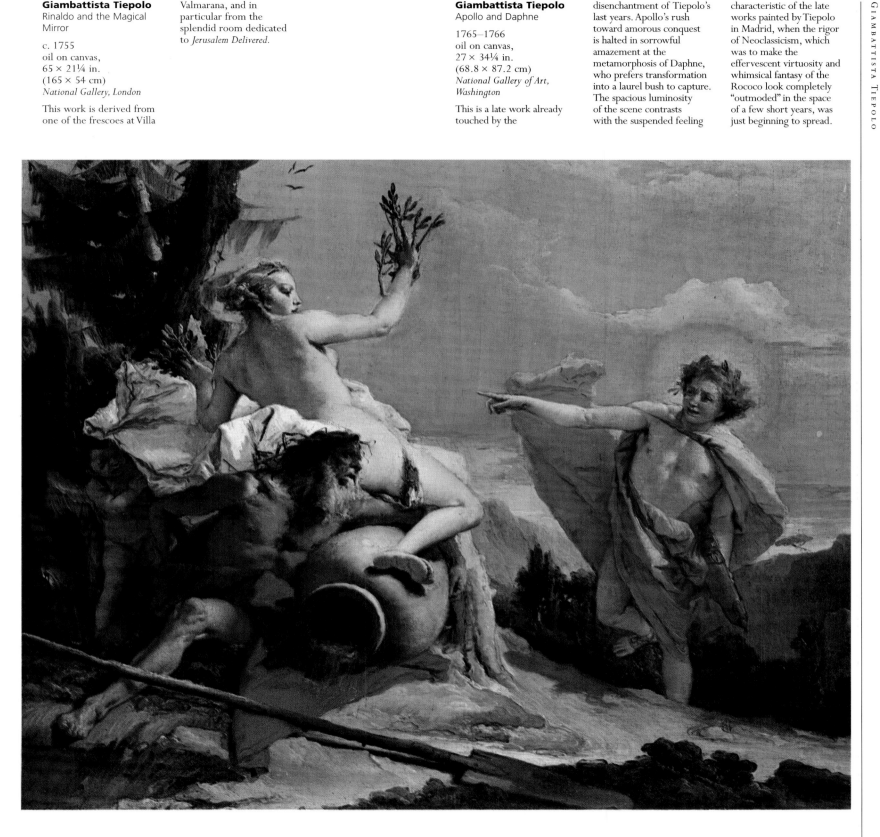

Giandomenico Tiepolo

(Venice, 1727–1804)

Giambattista Tiepolo had many children, two of whom (Giandomenico and Lorenzo) followed in their father's footsteps, first as his assistants and then embarking on their own careers to pursue their respective inclinations. Lorenzo distinguished himself as a portraitist and engraver, but without ever completely abandoning his father's sphere. On the other hand, Giandomenico took advantage of the training received in his youth, the journeys undertaken with his father, and the work carried out alongside him to forge an unmistakable style of his own that was to make him one of the most interesting painters in the second half of the eighteenth century. The stages of Giandomenico's early career are sign-posted by his father's great works in Venice, Würzburg, Vicenza, Stra, and Madrid. Giandomenico soon established himself as his father's principal and most faithful assistant. He acquired a perfect mastery of fresco technique and executed a splendid *Stations of the Cross* in the Venetian church of San Polo, which was a superb tribute to the style of Giambattista. Very soon, however, Giandomenico was to strike out on an expressive path of his own linked to themes of everyday life, viewed with a hint of irony but also with a sincere spirit of involvement. Excellent examples of this are furnished by the frescoes in the guest wing of Villa Valmarana in Vicenza. He followed Giambattista to Madrid in 1762 and experienced first hand the sudden demise of Tiepolesque art, since its popularity with the court was supplanted by the Neoclassicism of Mengs. The years in Spain were, however, very important for the contact between Giandomenico and the young Goya, who was influenced by the Venetian's particular and highly effective way of interpreting reality. On his father's death in 1770, Giandomenico returned to Italy and executed important decorative projects in Brescia, Genoa, and Venice. In later years the decadence of Venice led Giandomenico to withdraw to Zianigo in the country, where the moving cycle of frescoes on the walls of the family villa display lightness of touch, but also the melancholy of a highly aware and disenchanted artist.

Giandomenico Tiepolo
The Offering of Fruit to a Lunar Divinity

Peasant Family at Table

1757
frescoes
Guest wing, Villa Valmarana ai Nani, Vicenza

The fresco shown above is from the "Chinese room" in the guest wing of Villa Valmarana, one of the most interesting parts of the building. The taste for *chinoiserie* spread throughout eighteenth-century Europe with very striking results. Attempts to imitate the celebrated and extremely expensive porcelain led in the various courts to an almost obsessive fascination with the Orient. Pagodas were erected in aristocratic gardens from England to Prussia, the rooms and façades of princely residences were decorated with "Chinese" motifs, and fashions supposedly deriving from Cathay were imitated even in food. Giandomenico Tiepolo illustrated a less sumptuous China for this family of the provincial nobility, but the elegance of the frescoes in the "Chinese room" in the guest wing of Villa Valmarana is unequaled by the Chinese-style decorations found anywhere else in Europe. Against pale, luminous backgrounds, Giandomenico Tiepolo painted groups of figures and single trees to conjure up human situations and landscapes with very simple means in precisely the same way as the art of the Far East.

Giandomenico Tiepolo
Pulcinellas on a Swing

c. 1791–1793
detached fresco,
78¾ × 67 in.
(200 × 170 cm)
Ca' Rezzonico, Venice

This work comes from
the Tiepolo family villa
at Zianigo, between Padua
and Venice, where
Giandomenico frescoed
a number of rooms with
scenes expressing his
mood of cheerful
disenchantment.

Giandomenico Tiepolo
A Dance in the Country

c. 1756
oil on canvas,
29¾ × 47¼ in.
(75.6 × 120 cm)
*Metropolitan Museum of Art,
New York*

In this interesting example of brilliant, bustling genre painting, Giandomenico observes his own period. The influence of his father, Giambattista, can be seen, despite the great difference in subject matter, above all in the bright costumes and the theatrical handling of the action.

Giandomenico Tiepolo
Bringing the Trojan Horse into the City

1773
oil on canvas,
15¾ × 33½ in.
(40 × 85 cm)
*National Gallery,
London*

This effervescent composition was the model for one of the canvases of a great cycle of paintings on the Trojan Horse commissioned by an as yet unidentified patron. All the compositions are characterized by an unusual and asymmetrical approach that crowds all the figures into one half of the canvas and leaves the other half free for landscapes executed in deep perspective in a contemporary rather than "old-fashioned" style. Even in a cycle on a literary theme, Giandomenico does not choose the path of fantasy, like his father did, but prefers to concentrate on descriptive and realistic aspects. In this case, for example, he illustrates with a certain precision the efforts of the Trojans to move the enormous horse, mounted on an inadequate platform with wheels, by hauling it with ropes.

Giandomenico Tiepolo
The Summer Walk

1757
fresco
Guest wing, Villa
Valmarana, Vicenza

Giandomenico Tiepolo's masterpiece is unquestionably the cycle of frescoes executed in succession in the fairly small rooms in the guest wing of Villa Valmarana just outside Vicenza. While Giambattista covered the walls of the main wing with a magnificent cycle of fantastic images inspired by the heroes and memorable episodes of the great epics, Giandomenico openly chose quite the opposite approach, by juxtaposing his father's flights of fancy with highly concrete figures and situations that are, however, never merely banal. Giandomenico's style remains elevated, the work is painstakingly executed, and the handling of light is extraordinarily faithful to nature (as in the effect of early autumn on the foliage of the trees). In a period of transition for European art, midway between the last excesses of the Rococo and the reform of taste initiated by the Enlightenment, Giandomenico Tiepolo adds a very interesting note of realism. An apparently "minor" work executed in the shadow of his father, the frescoes in Villa Valmarana actually constitute a valuable anthology of themes that were to be developed in the decades to come. The scenes of peasant life, for example, are a precise precedent for Goya's early work.

Canaletto

Giovanni Antonio Canal
(Venice, 1697–1768)

Canaletto is the leading figure in the history of the *veduta* or view painting, that particular, independent style of landscape art that was first introduced at the end of the seventeenth century by the Dutch painter Gaspar van Wittel, and spread all over Italy from Rome to Venice and Naples. He is also one of the world's best-known and best-loved painters. His tireless production of works for export to aristocratic collections is a constant hymn to beauty: to the splendor of architecture, the wonders of the heavens, and the enchantment of nature. The most famous works are of course those depicting his native city. Canaletto's Venice is a fabulous city, both alive with the bustle of countless activities and transfixed eternally as a legend that history cannot mar, but only enrich with new episodes. It is certainly no coincidence that even now, over two centuries after his death, Canaletto's work remains constantly in great demand on the art market, regardless of changes in fashion and taste. The son of a theatrical scene painter (this reference to his father's work is essential if we are to understand the developments in technique and the type of image adopted by the artist during his long career), Canaletto followed his father's craft in the theaters of Venice and Rome.

In Rome he had the opportunity to see and study the work of van Wittel, and came into contact with important painters of classical ruins. His first paintings were in fact depictions of the ancient buildings and ruins of Rome that displayed a bold and theatrical handling of perspective. The first person to appreciate the young artist's work was a theatrical impresario, the Londoner Owen Mac Swinney, who drew the attention of his fellow countrymen to Canaletto. At the age of thirty, Canaletto began to paint views of Venice aimed primarily at European gentlemen on the Grand Tour. His choice of spectacular settings and clear blue skies soon brought him fame, and the British consul in Venice, the highly cultured collector Joseph Smith, commissioned him to paint dozens of paintings. These were subsequently bought *en bloc* by George III and now constitute the exceptional collection of Canaletto's works, the largest and most important in the world, held by the British royal family at Buckingham Palace and Windsor Castle. Using his training as a painter of stage sets and his skill in perspective distortion to obtain spectacular effects, Canaletto established a model for views of Venice not only in paintings but also in drawings and engravings, which increased his fame still further. Links with Canaletto became synonymous with success throughout Europe, and it is no coincidence that his nephew Bernardo Bellotto was to adopt

the pseudonym "Canaletto" outside Italy, almost as though seeking to pass himself off as his celebrated uncle. In 1746 the "real" Canaletto moved to London and spent a successful period of ten years in England, during which he painted a constant stream of views of Venice (based on painstakingly detailed drawings he had taken with him). He also produced memorable views of the capital and the English countryside that were to provide inspiration for the local painters. On his return to Venice, he took up the chair in perspective at the Accademia di Belle Arti founded by Piazzetta and directed by Giambattista Tiepolo.

Canaletto
The Basin of St. Mark–Looking Eastward

c. 1738
oil on canvas,
49¼ × 80½ in.
(125 × 204.5 cm)
Museum of Fine Arts, Boston

Perhaps Canaletto's absolute masterpiece, and certainly one of the most audacious views painted in the eighteenth century, this large canvas (over two meters wide) underscores the importance of

Canaletto's use of optical instruments and his painstaking study of perspective. The painter assumes a raised but not precisely determinable viewpoint in the area of the Punta della Dogana at the mouth of the Grand Canal, where his horizon opens up with the effect of a wide-angle lens to encompass a vast panorama. Canaletto maintains a sharp clarity of vision even in the furthest distances by

avoiding any focus on details in the foreground. The monuments lining the Riva degli Schiavoni and the church of San Giorgio Maggiore, placed practically in the center, do not constitute the final visual objectives, but are absorbed within a single, choral image cadenced by masts and crowned by a sky that generations of painters were to seek in vain to imitate for nearly a century.

Canaletto
View of the Grand Canal

c. 1735
oil on canvas,
28¾ × 50¾ in.
(73 × 129 cm)
*Wallraf-Richartz Museum,
Cologne*

Canaletto's numerous
views of the Grand Canal
were also made famous by
the series of etchings based
on them by Antonio
Visentini. Canaletto
authoritatively established
the canonical views of the
city, which are still
repeated today by amateur
and professional
photographers. Even when
no famous buildings or
sights are shown (as in this
case), the monumental
sweep, the handling of
perspective, the splendor
of the lighting, and the
reflections on the water
celebrate the flawless
enchantment of Venice.

Canaletto
Reception of the French
Ambassador

1726–1727
oil on canvas,
71¼ × 102 in.
(181 × 259 cm)
Hermitage, St. Petersburg

It was above all in the
works of his youth and
early maturity that
Canaletto chose to depict
festivities and splendid
occasions in order to
enhance the charm of
Venice even further. This
painting adopts a steep
perspective monumentally
cadenced by the succession
of arches of the Libreria
Sansoviniana. The dome
of the church of Santa
Maria della Salute in
the background serves as
the perspective focal point
for the sumptuous setting
that opens with the gold
of the boats and the
liveries in the foreground.

Canaletto
The Brenta Canal and Port in Padua

1735–1740
oil on canvas,
24½ × 43 in.
(62.5 × 109 cm)
National Gallery of Art, Washington

Every so often, as was the custom of the more affluent inhabitants of Venice, Canaletto allowed himself a holiday on the banks of the Naviglio di Brenta, the canal between Mestre and Padua, lined with old villas and pleasant towns. These occasions produced a number of delightful paintings in which the artist abandons his monumental theatrical settings for enjoyable views of the countryside.

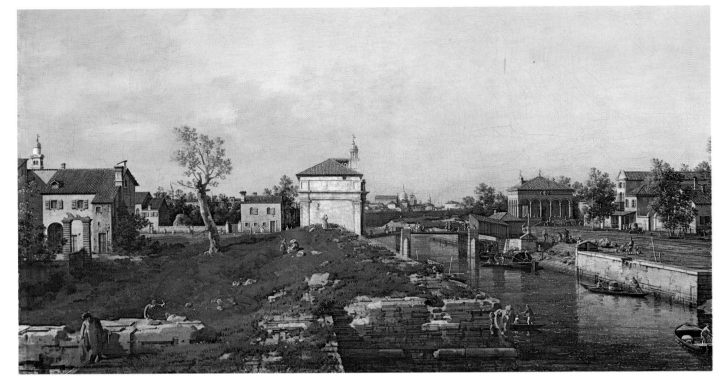

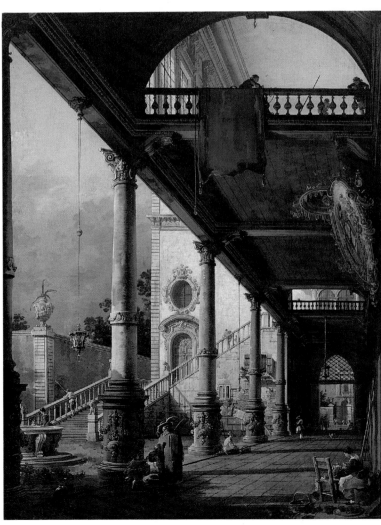

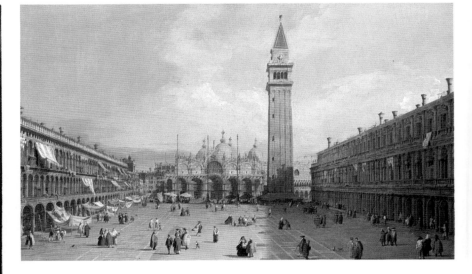

Canaletto
Perspective with Portico

1765
oil on canvas,
36½ × 51¼ in.
(92 × 130 cm)
Accademia di Belle Arti, Venice

This late work is one of the few by Canaletto that have remained in Venice. It is not a view but a demonstration study of perspective and scene painting applied to a wholly imaginary building. It was probably painted for teaching purposes in the context of Canaletto's lessons for students at the Academy, where he taught perspective.

Canaletto
Piazza San Marco

c. 1730
oil on canvas,
27 × 44¼ in.
(68.6 × 112.4 cm)
Metropolitan Museum of Art, New York

The difference in spirit between Canaletto and Francesco Guardi is clearly illustrated by a comparison of the views of Piazza San Marco painted by the two artists from the same point at the same hour of the day, but with very different results.

Canaletto
The Doge's Procession to the Church of San Rocco
1735, oil on canvas,
57¾ × 78¼ in.
National Gallery, London

Every year in the month of August the painters of Venice would exhibit their works in front of the Scuola di San Rocco in a bustling fair that displayed the progress and development of the local school. This occasion also enjoyed some official recognition, and Canaletto's painting depicts the visit paid to the exhibition by the Doge (in the center, beneath the parasol, wearing heavy robes of gold thread trimmed with ermine at the height of the summer!) and the Venetian senators. The paintings were hung on the façades of the buildings and an awning was extended over the route to protect the visitors from the sun. The holes for the poles used to support the awning can still be seen today in the square adjacent to the Scuola and the church of San Rocco.

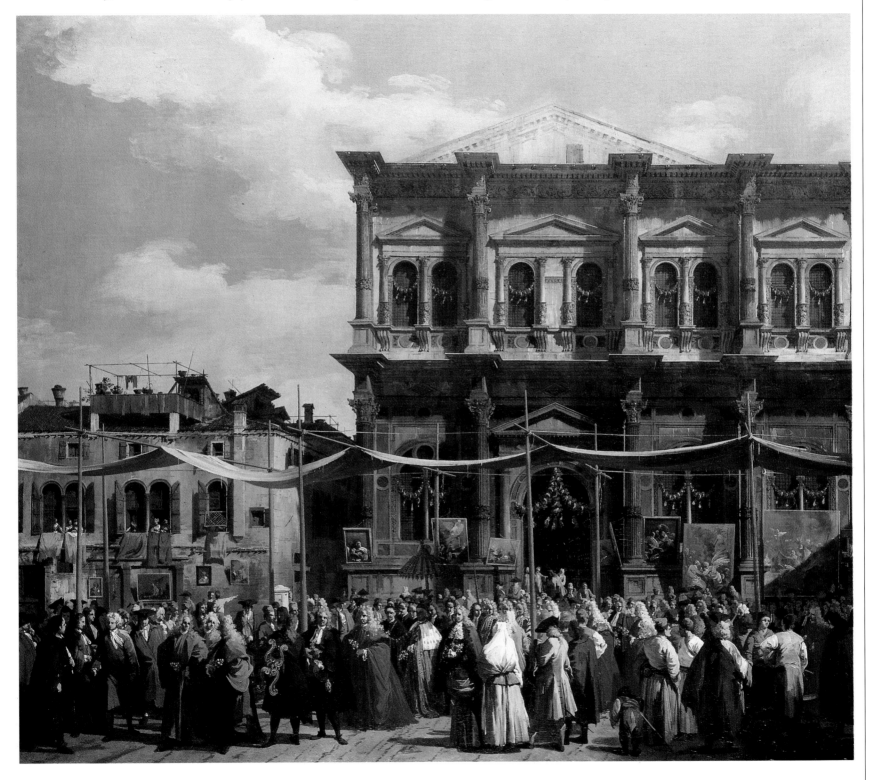

Canaletto
The Bucintoro Returning to the Quay on Ascension Day
1730–1735, oil on canvas,
30¼ × 49¼ in.
(77 × 125 cm)
Royal Collections, Windsor

This is one of the works commissioned by the consul, Smith, and then purchased for the collections of the British royal family. It is difficult to imagine a painting capable of attesting more completely to the beauty of Venice's monuments and, through the presence of the Bucintoro, or Doge's galley, to the constant splendor of public life in Venice.

Canaletto
View of San Giovanni
dei Battuti on Murano
c. 1725–1728, oil on canvas,
26 × 50¼ in.
(66 × 127.5 cm)
Hermitage, St. Petersburg

Here we see the other side of the lagoon. This time Venice appears as a distant presence in the background and the work focuses on the "minor" life of the canals of Murano.

The light is the same, but there is a greater sense of space and even the figures appearing in the painting are dressed more modestly than the Venetian citizens.

Canaletto
Capriccio with Palladian
Buildings

c. 1730
oil on canvas,
22 × 31 in.
(56 × 79 cm)
Galleria Nazionale, Parma

In this early work,
Canaletto creates a
"virtual" image of the
Grand Canal in Venice
with Palladio's redesigned
Rialto bridge (a project
that never got beyond the
drawing board) and lined
with other buildings
by the great architect.

Canaletto
The Interior of the
Ranelagh Rotunda
in London

1754
oil on canvas,
18 × 29¾ in.
(46 × 75.5 cm)
National Gallery, London

This is one of the most
important works of
Canaletto's English period,
and again demonstrates his
absolute mastery of
perspective. The painting
can be seen as an
exposition of the concepts
involved in representing
space in depth, but also as
evidence of the painter's
great interest in the new
architectural context
encountered during his
long stay in London.

Canaletto
The Eastern Façade
of Warwick Castle

c. 1751
oil on canvas,
16½ × 28 in.
(42 × 71 cm)
City Art Museum, Birmingham

Canaletto chose cloudless
days flooded with light
to celebrate the beauty
of the English countryside.
His clear identification
of the relationship between
parks and historic buildings
was to become a model
for the entire tradition
of landscape painting right
up to Constable and
Bonington.

Bernardo Bellotto

(Venice, 1721–Warsaw, 1780)

Bernardo Bellotto, Canaletto's nephew on his mother's side, was a great traveler. He made only rare, brief stays in Venice (and hence plays a very minor role in Venetian painting), but spent far more important periods in the capitals of eighteenth-century Europe, which he depicted with extraordinary and perhaps unsurpassable skill. Endowed with exceptional talent, Bellotto studied with his uncle and displayed a truly precocious flair for the

small figures used to animate views. At the age of seventeen, he was already a registered member of the guild of Venetian painters, but left soon afterward for his first long journey. His route took him to Rome, but by way of many other Italian cities. Even in the early years of his career, Bellotto displayed a great ability to capture the architectural, environmental, and even atmospheric features of the places he visited. Even more meticulous and precise than his uncle, Canaletto, Bellotto loved variety. Only in very special circumstances would he repeat views already painted, since he always preferred to seek out new

ones. Above all, his work is dominated by light. Wherever he was, Bellotto waited for the finest days and clear, fresh skies to observe the panorama with absolute precision and perfect clarity. On his return to Venice after his travels in Italy (which took him to Rome, Florence, Turin, Milan, the lakes of Lombardy and Verona), in 1747, at the age of only twenty-six, he accepted the invitation of Augustus III, the prince-elector of Saxony, and moved to Dresden. His first stay in Saxony produced two series of splendid canvases depicting the "Florence of the Elbe," painted for the prince and for his prime

minister, Count Brühl, who was also a patron of Giambattista Tiepolo. In 1758, Empress Maria Theresa summoned Bellotto to Vienna, where he produced views of the capital of the Hapsburg Empire. The prince-elector of Bavaria then invited Bellotto to Munich, where his stay was prolonged for five years. There followed another stay in Dresden and then his final years were spent in the service of Stanislaw II of Poland in Warsaw, which he depicted with loving care in views that later served as models for reconstruction work after the devastation of World War II.

Bernardo Bellotto
The Kreuzkirche in Dresden

between 1747 and 1756
oil on canvas,
77½ × 73½ in.
(197 × 187 cm)
Hermitage, St. Petersburg

A few years later, during
his second stay in Saxony,
Bellotto was to paint the
demolition of the Gothic
church, which had been
bombarded and was rebuilt
in Rococo style.

Bernardo Bellotto
Piazza della Signoria
in Florence

c. 1742, oil on canvas,
24 × 35½ in. (61 × 90 cm)
Museum of Fine Arts, Budapest

Bellotto visited the
wonders of Florence,
Rome, and other cities in a
very different way from the
tourists of today. Although
perfectly recognizable, the
piazzas, the monuments,
and even the light look
somehow different. The
appeal of Bellotto's art also
lies in his ability to arouse
admiration for beauty and
regret for a bygone age.

Bernardo Bellotto
View of Gazzada

1744
oil on canvas,
25½ × 39¼ in.
(65 × 100 cm)
Pinacoteca di Brera, Milan

Bellotto was above all a
painter of urban settings
and architectural views,
which makes his rare
canvases depicting the
countryside appear still
more precious and
entrancing. This work
depicts the moorland area
of Gazzada in Lombardy
with Monte Rosa in the
distance. With exquisite
sensitivity to nature
(worthy indeed of his
great Venetian forerunners
from Giovanni Bellini
to Giorgione and Titian),
Bellotto captures the first
russet hues of the leaves
at the beginning of autumn
and a light breeze stirring
the linen hung out to dry
by the washerwomen
on the left.

Bernardo Bellotto
View of the New Market in
Dresden

1751
oil on canvas,
53½ × 93 in.
(136 × 236 cm)
Gemäldegalerie, Dresden

Dresden is the city to
which Bellotto devoted
most attention in very
large canvases with an
incredible feeling of space.
While the views of Italian
cities arouse nostalgia,
those of Dresden are a
terrible, moving journey
back into the past. The
capital of Saxony and
of European Rococo was
razed to the ground by
bombs in 1945 and only a
few monuments have been
reconstructed. This
imposing square is now
entirely modern and
unrecognizable. The great
Marienkirche with its
stone dome is a pile of
rubble and the decision
to rebuild it has only been
made recently.

Bernardo Bellotto
The Moat of the Zwinger in
Dresden

1749–1753
oil on canvas,
52¼ × 92½ in.
(133 × 235 cm)
Gemäldegalerie, Dresden

The extremely unusual
Zwinger Palace, consisting
of a series of pavilions
arranged around a vast
courtyard, is fortunately in
a better state of repair.
This historical painting
(with the unforgettable
detail of soldiers cheerfully
performing their duty
of feeding the swans
in the moat) depicts the
main entrance to the
palace as well as the
sixteenth-century castle
of the prince-electors in
the middle ground.

Opposite page:
Bernardo Bellotto
The Kaunitz Palace
and Gardens in Vienna

1759–1760, oil on canvas,
52¾ × 93¼ in.
(134 × 237 cm)
Museum of Fine Arts, Budapest

Bernardo Bellotto
View of Vienna from
the Belvedere

1759–1760, oil on canvas,
53¼ × 83¾ in.
(135 × 213 cm)
*Kunsthistorisches Museum,
Vienna*

Commissioned by Empress
Maria Theresa of Austria,
this masterpiece shows
Vienna's hills in the
background and the
monuments rising above
the historic center. The view
is seen from the terrace of
the Belvedere, the villa built
just outside the city gates
by Eugene of Savoy. Bellotto
used this vantage point
to create an image of the
city that is extremely clear,
but in no way cold or
anonymous. On the
contrary, Bellotto has
chosen to portray the
parade of splendid though
somewhat bored figures
of the local nobility in the
warm afternoon light.

Francesco Guardi

(Venice, 1712–1793)

Unlike the other *vedutisti* Canaletto and Bellotto, Guardi remained in Venice all his life. He never ventured abroad, and his rapid, impulsive, often dramatic technique gained him far less success with travelers and collectors. His images of a weary, impoverished Venice in decline are, however, moments of lofty and heart-rending poetry in the European art of the late eighteenth century. The brother of Giovanni Antonio Guardi, an important figure painter, and brother-in-law of Giambattista Tiepolo, Francesco Guardi started painting views at an advanced age after abandoning his earlier career as a painter of religious scenes and copyist. His views are often those depicted in celebrated and dazzling works by Canaletto, but given a completely different interpretation so that the triumphant image of Venice shimmering in the wondrous beauty of its palaces reflected in the canals gives way to a subdued, faded city inhabited by poor people forced to work hard for their living.

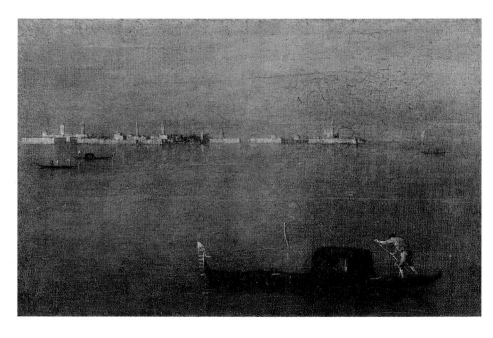

Francesco Guardi
The Fire at the Oil Warehouse at San Marcuola

1789–1790
oil on canvas,
16¾ × 24½ in.
(42.5 × 62.2 cm)
Alte Pinakothek, Munich

Gondola on the Lagoon

c. 1780
oil on canvas,
9¾ × 15 in. (25 × 38 cm)
Museo Poldi Pezzoli, Milan

These two works dating from Guardi's last years poetically symbolize the decline of Venice. The gondola seems to float on a timeless horizon, suspended between sea and sky in a general blurring of outline. The great fire of November 28, 1789, is turned into an allegory of a dying city during its last days of independence.

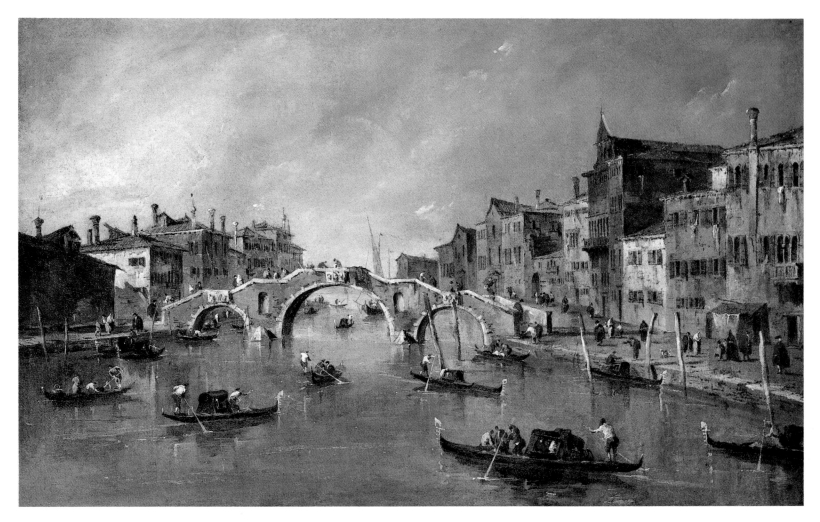

Francesco Guardi
View of the Canale
di Cannaregio

after 1788
oil on canvas,
18¾ × 29¼ in.
(47.6 × 74.3 cm)
*National Gallery of Art,
Washington*

As an alternative to the
classic views of the city,
Guardi focuses on a
lesser-known Venice to
reveal the incredible appeal
of this very particular
urban environment,
but also to stress the
melancholy of decay
and decline. The waters
of the canal are muddy
and a leaden sky looms
over the dilapidated
buildings as though about
to crush them.

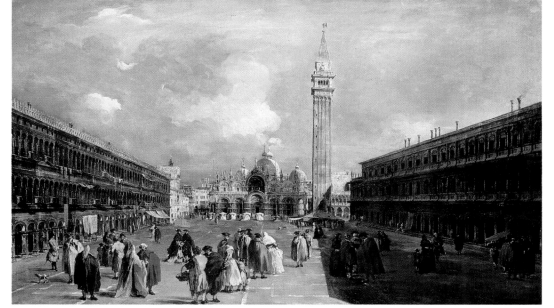

Francesco Guardi
Piazza San Marco Toward
the Basilica

c. 1760–1765
oil on canvas,
28½ × 46¾ in.
(72.5 × 119 cm)
National Gallery, London

The great views of the
most spectacular urban
settings and monuments of
Venice are among Guardi's
masterpieces. The typical
image of Piazza San Marco
is depicted in an original
way since the focus is on
the unusual relationship
between the threatening
sky and the architectural
scene. All the figures are
animated by the
impetuous, effervescent
style of painting.

Eighteenth-Century Great Britain

Joseph Wright of Derby
Experiment with an Air Pump, detail
1768
oil on canvas,
72 × 96 in. (183 × 244 cm)
National Gallery, London

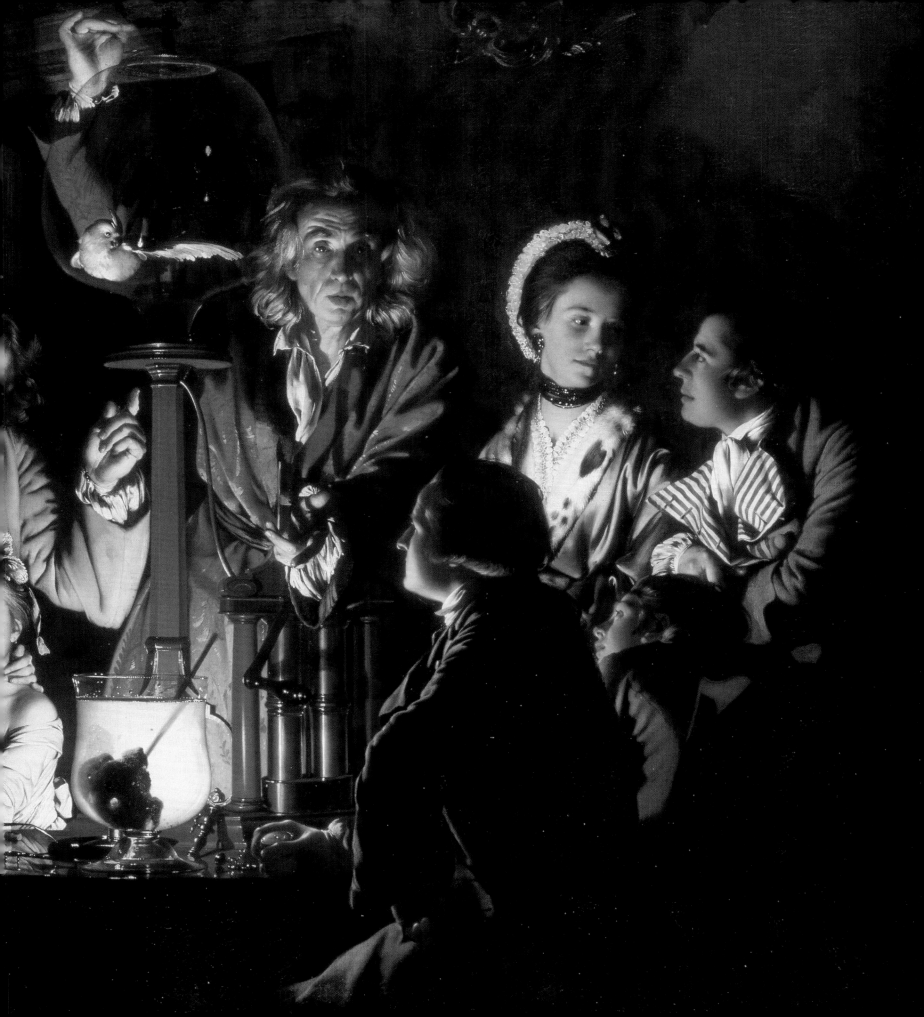

Thomas Gainsborough
Master John Heathcote
1770
oil on canvas,
50 × 39½ in.
(127 × 101 cm)
National Gallery of Art,
Washington

I n the eighteenth century, English society was char-acterized by a combination of aristocratic culture and middle-class morality. In the Augustan period (1702–1714) and under the Hanovers, the classical ideal that had formed during the Restoration (1660–1702) also became established among the middle class, and thus absorbed its moral values.

At the beginning of the century, painting was still domi-nated by mediocre foreign artists, generally from France and Italy; only very slowly did a national culture of paint-ing take hold, in which portraiture, the only real source of income for English painters, assumed fundamental importance. This was particularly true from the third decade onward, with the emergence of painters like Allan Ramsay and Joshua Reynolds, and later Thomas Gainsborough.

The main patrons of art were still the aristocrats, who for the decoration of their large country residences com-missioned family portraits against the background of landscapes, gardens, or interiors that would display the extent of the wealth and influence deriving from their landed properties.

This led to the rise of the conversation piece, that is the informal group portrait, a pictorial genre that was born in the Netherlands and in early French Rococo, and that was welcomed with particular favor in England, where it was identified with patronage of a wider social range, in-cluding the minor landed nobility and the middle classes. In the search for a national artistic identity, the English artists created and funded a series of private academies in which they drew up a common set of pictorial rules. First among them was the Great Queen Street Academy, active from 1711 to 1720, which promoted greater awareness of the anatomy and physiognomy of the human figure through the study of the nude. William Hogarth was behind many of the efforts made during this period to improve the education of English artists and to pro-mote patronage; between 1720 and 1724, when he was among the members of the Saint Martin's Lane Academy, he made a vital contribution to the reformulation of anatomical studies, initiating a substantial reappraisal of the depiction of the female body. Hogarth can be consid-ered, to all intents and purposes, the founder of the Eng-lish school of painting, whose moment of greatest splen-dor came during the 1760s. The decade opened with the

first great exhibition of contemporary English art, and saw the birth in 1768 of the Royal Academy of Arts—an official institution capable of rivaling the French and Italian Academies—upon pressure from the artist members of the Saint Martin's Lane Academy and with the patronage of King George III. Equally important was the role of the Grand Tour, a tradition that began with the Elizabethans as the finishing school of the English ruling classes and extended in the eighteenth century to the middle classes, giving artists and gentlemen the chance to perfect their education in the arts. For young English painters, the Grand Tour was generally a journey to Italy, particularly to Rome, the cradle of classical art. The experiences of individual travelers, the publication of travel journals—such as the guide for art lovers published by Jonathan Richardson in 1722—and the growth of the national artistic heritage contributed to the renewal of the pictorial language of English art. Hogarth, however, was opposed to the Grand Tour, for he believed that it played a decisive role in undermining the market of contemporary English art by encouraging the sale of ancient and modern painting from abroad. It was largely Hogarth's farsightedness that led to the foundation, in 1761, of the Society of Artists of Great Britain (1761–1791) and the Free Society of Artists (1761–1783), exhibition societies that presented themselves above all as points of reference for the market by providing annual opportunities for encounters between artists and buyers. Exhibitions encouraged both novelty and variety, promoting a popular art that was a compromise between portraiture and historical painting, a more demanding genre not traditionally practiced by English painters. We might think, for example, of the modern moral subjects by Hogarth, which provide enigmatic images of daily life combining characters and setting, and lead the observer to an awareness of the social issues that afflicted the eighteenth century. In this phase of transition, the presence of American painters such as Benjamin West and John Singleton Copley was decisive; they brought new life to the historical genre, favoring the gradual passage from classical subjects to those of contemporary life. An important example of this is *The Death of General Wolfe* by Benjamin West, the "first great epic work in modern dress," whose revolutionary scope was also to be felt beyond the shores of England.

John Singleton Copley
Mrs. John Winthrop
1773
oil on canvas,
35½ × 29 in.
(90.2 × 73 cm)
Metropolitan Museum
of Art, New York

William Hogarth

(London, 1697–1764)

An engraver and art theorist, Hogarth's first approach to painting came in the workshop of Sir James Thornhill, the most successful painter in England in the early eighteenth century, whose daughter he married in 1729. The heir to Thornhill's school, the Great Queen Street Academy, active from 1711 to 1720, he was mainly attracted by subjects of contemporary life, despite returning on various occasions to historical or mythological themes.
His fame initially rested almost exclusively on book illustrations and satirical prints in which the influence of the minor Dutch artists can be seen.
He began to devote himself to painting around 1728; his first works are conversation pieces and portraits, whose distinctive feature is a lively feeling for the representation of scenes, a completely new development in English painting.

In 1732, driven by a desire to increase his earnings and to reach a wider audience, Hogarth created a new form of art: the modern moral subject. He translated stories of contemporary life into paintings and engravings, conceived as theater scenes, in which it is possible to discern the influence of Lord Shaftesbury's ideas on the moral duties of art, ideas that were widespread among the English public. Fielding himself used Hogarth's cycles to draw inspiration for some of the characters in *Tom Jones*. Opposed to the official academy that leads to excessive rigidity in ideas about art and to the codification of artistic practice and development, Hogarth upheld the freedom of the market and the deregulation of the academy.
Hogarth always lived in England, apart from a brief trip to Paris in 1743 with the painter F. Hayman. In 1757 he became court painter, an appointment made by George II and renewed by George III.
In 1753 he published *The Analysis of Beauty*, a theoretical treatise in which he argued

against classicism and outlined the characteristics of the English school of painting, of which he is considered the true founder.

William Hogarth
Marriage à la Mode.
After the Wedding.

1734–1735
oil on canvas,
27½ × 36 in. (70 × 91 cm)
National Gallery, London

For the six scenes forming *Marriage à la Mode*, Hogarth drew inspiration from the growing fashion for matrimonial alliances between the old aristocratic families and wealthy middle-class traders, who

were willing to do anything to obtain social prestige, even if they had to purchase it. In this painting, the second in the series, a conversation piece is depicted ironically: the monumental Palladian architecture and the refined decoration of the drawing room are in striking contrast to the attitude in which the characters are depicted, which is more suited to a tavern than to an aristocratic environment.

Opposite page:

William Hogarth
Lobster-Seller

c. 1740
oil on canvas,
25 × 20½ in.
(63.5 × 52.5 cm)
National Gallery, London

Unique in its spontaneity and freshness, it possesses the charm of a painting that is dashed off without preparatory drawings, reminiscent of the manner of Frans Hals and a precursor of the developments of Impressionism. This work appeared in Christie's sales catalog of 1790 under the title *Lobster-Seller*.

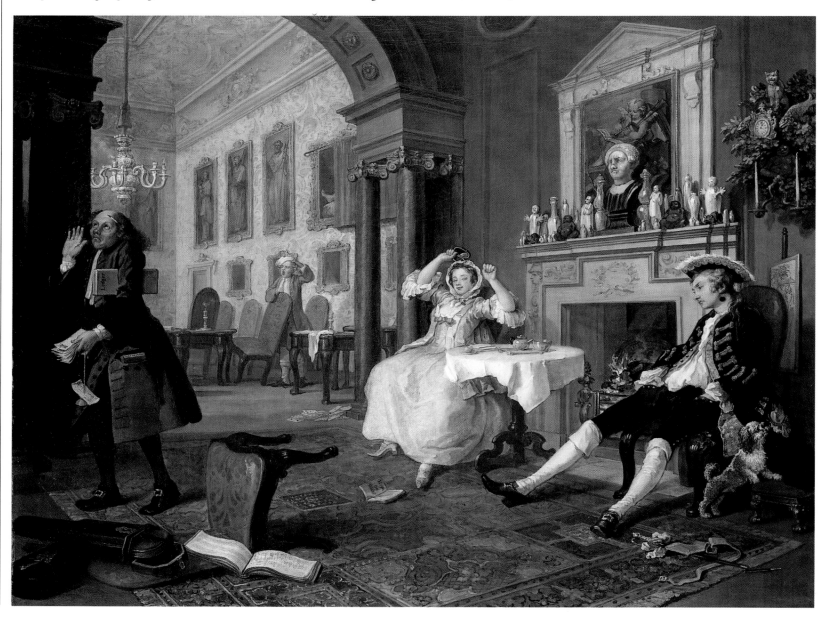

William Hogarth
The Strode Family

1738
oil on canvas,
34¼ × 36 in.
(87 × 91.5 cm)
Tate Gallery, London

This is a fine example of a
conversation piece, a genre
practiced by Hogarth at
the beginning of his career,
and provides a precise
picture of contemporary
life. In the intimacy of a
bourgeois interior,
William Strode, a member
of a wealthy family of
merchants, is portrayed
with his wife Anne, the
butler intent on pouring
tea, and two guests:
Mr. Smyth, the future
Archbishop of Dublin,
whom he had met in
Venice during his Grand
Tour, and Colonel Strode,
who is pointing to his dog
with his rifle.

William Hogarth
Self-Portrait with Pug

1745
oil on canvas,
35½ × 27½ in.
(90 × 70 cm)
Tate Gallery, London

Through a series of
emblematic objects
arranged with skillful
theatricality, Hogarth
makes a statement of his
poetics. He depicts himself
as an image painted in an
oval placed on top of a pile
of books, which on closer
inspection prove to be
volumes by Shakespeare,
Swift, and Milton; in the
foreground, on the other
hand, he depicts a dog,
signifying his loyalty to
nature, and a palette, the
symbol of his profession,
traversed by a curving line,
with the words "The Line
of Beauty and Grace."
This line, as he wrote later
in his treatise *The Analysis
of Beauty* (published in
London in 1753), is the
basis of beauty and grace
in painting.

William Hogarth
The Wedding of Stephen
Beckingham and Mary Cox

c. 1729
oil on canvas,
50½ × 40½ in.
(128.3 × 103 cm)
*Metropolitan Museum of Art,
New York*

William Hogarth
Canvassing for Votes

1754
oil on canvas,
40 × 50 in.
(101.6 × 127 cm)
*Sir John Soane's Museum,
London*

This is the second in a
series of four paintings
on the "modern moral

subject" of elections,
which Hogarth painted
between 1753 and 1758.
The scene is filled with
representatives of the two
political parties, the Tories
and the Whigs. Corruption
is rife; in the two inns
under siege, the supporters
of the two sides are busy
handing out bribes and
favors. In the center of the

scene is the emblematic
figure of the citizen
receiving money from
the representatives of both
parties.

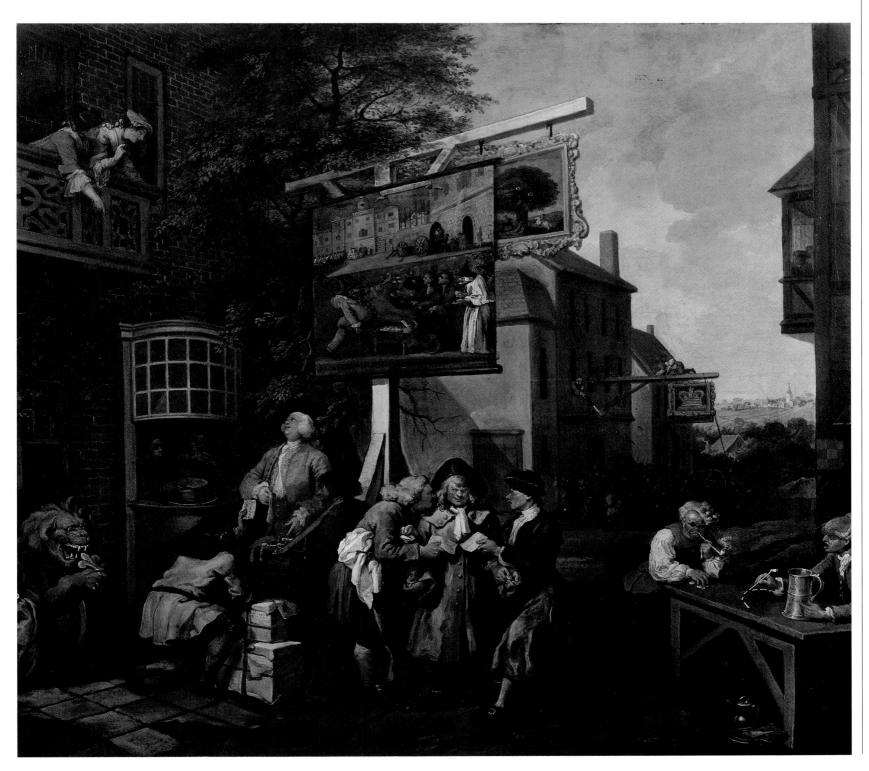

Allan Ramsay

(Edinburgh, 1713–Dover, 1784)

The son of a Scottish poet, Ramsay moved
to London in 1734 after learning the
rudiments of painting in Edinburgh.
From here, two years later, he went on a
journey to Italy, which took him first to
Rome and then, in 1738, to Naples, where
he frequented the workshop of Francesco
Solimena, whose work he appreciated
for its classical style and for the fine play
of chiaroscuro.

He returned to England the following year,
settling in London, where he swiftly
established himself as the greatest portrait
painter of his time. A salient feature of his
work is the combination of Roman
classicism and English tradition. The
characters, depicted in modern dress, are
arranged according to the compositional
schemes of classical statuary. The
continuous reference to the classics, and
the preference for movements and gestures
taken from Roman statues to confer
solemnity on scenes of private life, do not
prevent his portraits from retaining the
lively grace and the lofty though light tone
that characterize the cosmopolitan style in
Europe.

Compared to Hogarth's crude
expressiveness, Ramsay evolved a pictorial
style capable of capturing the recesses
of the souls of the characters portrayed,
in a manner that would be adopted later
by Reynolds. In 1755 he returned to Italy,
where he stayed for two years, drawing
at the French Academy. His style
consequently became more refined, as is
shown by the series of full-length portraits
of the royal family, painted after his return
to London in 1758. In the last years of his
career, Ramsay preferred archaeological
studies, which, from 1765 onward, became
his exclusive occupation, leading him
to return twice more to the imposing ruins
of imperial Rome.

Allan Ramsay
Queen Charlotte
with Her Eldest Children

c. 1765
oil on canvas,
98 × 63¾ in.
(249 × 162 cm)
*Royal Collections, Windsor
Castle*

From 1758 to 1765,
when he abandoned
painting, Ramsay portrayed
the royal family on several
occasions in paintings of
elegant, composed
naturalness, characterized
by a delicate chromatic
range that combines light
effects and silvery
shadows.

Allan Ramsay
Portrait of George III

c. 1762
oil on canvas,
31½ × 25 in.
(80.3 × 64.3 cm)
*National Portrait Gallery,
London*

This is a portrait of
unquestionable charm, in
which the rich play of light
and shadow on the fabric
enhances the refinement
of the figure, arranged
in a pose reminiscent
of van Dyck. The true
subject of the painting is
the luxurious cloak and
decorations, which serve
to increase the idealization
of the subject.

Joshua Reynolds

(Plympton Earl, Devonshire, 1723–London, 1792)

A major exponent of the great period of English portrait painting, Joshua Reynolds began his training in 1740 at the London studio of the fashionable portraitist Thomas Hudson, but, at the same time, he also took a considerable interest in the work of Hogarth and Ramsay. His journey to Italy, begun in 1749 with his friend Commodore Keppel, had a decisive effect on his development. During his stay in Rome from 1750 to 1753, interrupted by brief visits to major Italian cities such as Florence, Bologna, and Venice, Reynolds was particularly attracted by classical statuary and by sixteenth-century painting, especially that of Raphael and Michelangelo, although his fierce parody of the *School of Athens*, the fresco by Raphael in the Stanze Vaticane, might suggest a desire to distance himself from the solemn decoration that characterizes sixteenth-century art. Although he rejected the title of academician, he did in fact nurture sincere admiration for classical art, both ancient and modern. This is evident in the portrait of his friend Commodore Keppel (1753, National Maritime Museum, Greenwich), inspired by the *Apollo del Belvedere*, where he evolves a highly personal style that shows his debt to the great Venetian artists of the sixteenth century, from Titian to Paolo Veronese, and to seventeenth-century Flemish and Dutch painting, from Rembrandt to Rubens and van Dyck.

In 1753 he settled in London, where he stayed for the rest of his life, except for a brief journey to Belgium and Holland in 1781, which confirmed his lively interest in the dramatic possibilities of color and in the momentary, impetuous gesture, characteristics he had admired in the paintings of Rubens.

Around 1774, his unquestioned fame as a portrait painter began to be overshadowed by the rising star Thomas Gainsborough.

Joshua Reynolds
Colonel George
K. H. Coussmaker,
Grenadier Guards

1782
oil on canvas,
93¾ × 57½ in.
(238.1 × 145.4 cm)
Metropolitan Museum of Art, New York

Against the background of a typically English landscape, the aristocratic figure of the colonel is captured in a pose of studied nonchalance, in which the line of the body is repeated in the trunk of the tree and the extended neck of the horse, thus underlining the noble bearing of the figure.

Joshua Reynolds
George Clive and His Family with an Indian Servant-Girl

1765
oil on canvas,
55 × 67¼ in.
(140 × 171 cm)
Gemäldegalerie, Berlin

A bourgeois interior is depicted with a section of landscape to the left, which casts a ray of light that falls indirectly on the figures of the mother and the young girl, who are facing the spectator. On the left Lord Clive, leaning on the back of a chair, watches the scene, his gaze almost merging with that of the viewer.

Joshua Reynolds
Lady Cockburn and Her Eldest Children

1773
oil on canvas,
55¾ × 44½ in.
(141.5 × 113 cm)
National Gallery, London

This painting shows many different influences, from Italian painting to Dutch painting. Of central importance is the reference to the allegory of *Charity* as depicted by van Dyck, Pontormo, and Guido Reni, whose overall composition Reynolds follows. By altering the pose and the expression of the mother and the children, who form a crown around her, Reynolds displays an extraordinary ability to use different sources to create a wholly individual pictorial style.

Joshua Reynolds
Lady Delmé and Her
Children

1777–1780
oil on canvas,
94 × 58 in.
(239 × 147 cm)
*National Gallery of Art,
Washington*

Framed by an elegant
English park, in the
foreground is a majestic,
refined female figure who
recalls the manner of
Italian painting, and
especially Correggio.
At the woman's side,
two children and a dog
complete the scene, which
falls into the category of
the conversation piece,
a genre that was greatly
appreciated by middle-
class patrons.

Joshua Reynolds
Lady Sunderlin

1786
oil on canvas,
93 × 57 in.
(236 × 145 cm)
Gemäldegalerie, Berlin

The female figure,
depicted in a manner
reminiscent of van Dyck,
is seen against a landscape
clearly influenced by
Leonardo da Vinci. The
figure of the woman stands
out against a dense clump
of trees, while to the right
of the painting the various
planes disappear into the
horizon in a play of light
and depth.

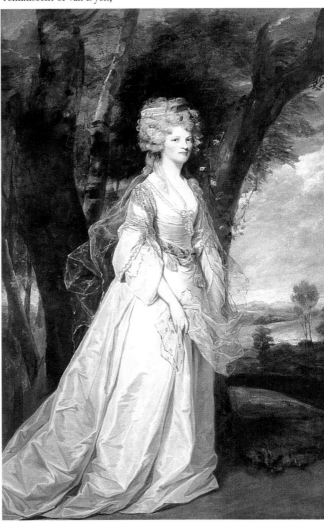

Joshua Reynolds
Portrait of John Campbell,
Lord Cawdor
1778
oil on canvas
Cawdor Castle, Scotland

Joshua Reynolds
Master Hare

c. 1788–1789
oil on canvas,
30¼ × 25 in.
(77 × 64 cm)
Louvre, Paris

This is one of the most refined examples of child portraiture, a genre in which Reynolds was an unrivaled master. The informal atmosphere, the fantasy and lightness of touch, and the skillful use of light make this portrait an extremely fine example of Reynolds's great freedom of interpretation.

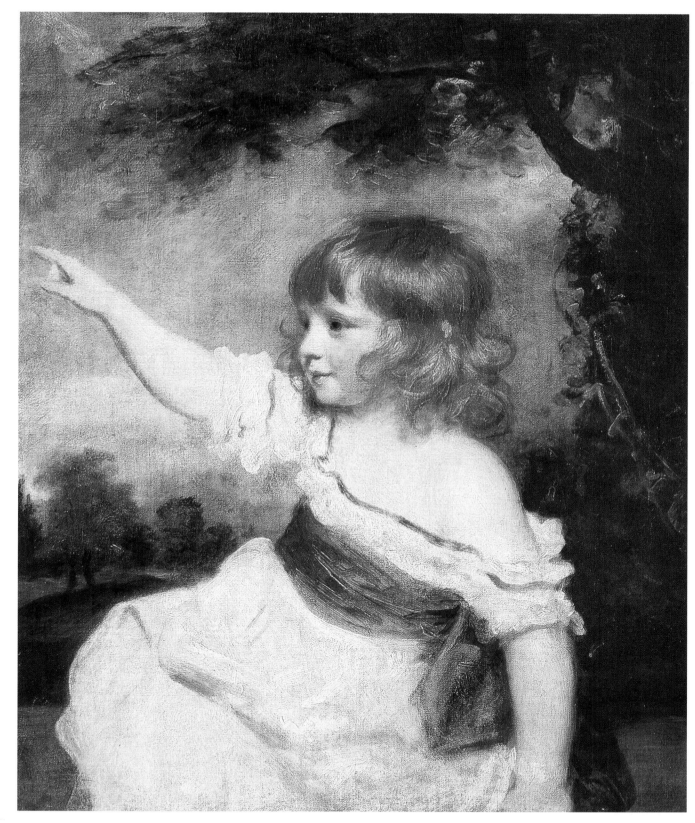

Thomas Gainsborough

(Sudbury, Suffolk, 1727–London, 1788)

Gainsborough differed from his great rival Reynolds in both temperament and artistic style. Whereas Reynolds's art was solemn and objective, Gainsborough's was characterized by a delicate, lyrical approach, learned from French art, which was much in fashion in eighteenth-century England. Reynolds himself, in the famous *Discourse* delivered at the Royal Academy several months after Gainsborough's death, acknowledged his rival's greatness, his "powerful intuitive perception," and his impeccable art hidden behind an apparently facile, coarse language.

The son of a cloth merchant from Suffolk, he trained in London, where he worked as an assistant to Hubert Gravelot, a French draftsman and engraver. On his return to Sudbury in 1749, he began to work as a portrait painter for local customers (magistrates, tradesmen, minor nobles) who demanded portraits that presented a good likeness, but were simple and, above all, inexpensive.

Throughout his life, from his first stay in London on, Gainsborough also devoted himself to landscape painting, the genre in which he regarded himself to be most gifted, despite the lack of commissions. In actual fact, his talents were equally distributed between landscapes and portraits, for he was able in both genres to achieve a perfect marriage of nature and culture, spontaneity and artifice.

In 1759 he moved to Bath, the fashionable spa town, where he began to be appreciated and sought after, even though his natural, vigorous painting still lacked elegance and depth. In 1774 he returned to London, where he worked for important patrons and achieved a new height of refined elegance. The favorite painter of George III and Queen Charlotte, he painted numerous portraits of members of the royal family. In 1784 he painted the portrait of the three eldest princesses, a splendid work that was cut in vandalistic manner to one third of its original size in order to hang it above a door in one of the rooms of Windsor Castle, where it is still held.

Toward the end of his career his technique became more fluid, his brushwork free and sensual, and his compositions highly individual. Gainsborough combined what was his true artistic vocation, landscape painting and figures, and it is precisely from this marriage between subject and background, between fiction and nature, that his portraits take shape, escape from the confines of traditional portraiture and gain the favor of the most demanding public.

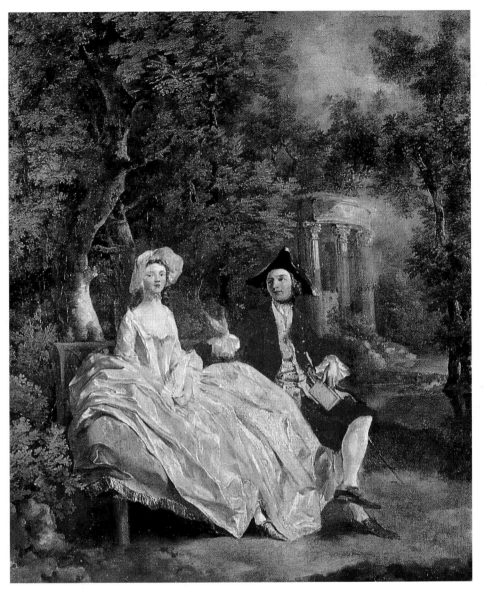

Thomas Gainsborough
Conversation in a Park

c. 1740
oil on canvas,
28¾ × 26¾ in.
(73 × 68 cm)
Louvre, Paris

The current identification of the painting dates back to 1806, when it was sold at a Christie's auction, and is still highly debated. The strongest doubts relate to the male figure; the bright red clothes, the book resting on the legs, and above all the sword, not a fitting emblem for an artist, all point to a young nobleman. However, the work does undoubtedly portray a married or engaged couple, and the detail of the sword, like the temple in the background, heightens the romantic atmosphere.

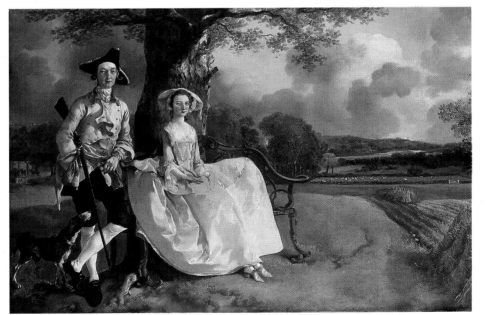

Thomas Gainsborough
Mr. and Mrs. Andrews

1750
oil on canvas,
27½ × 47 in.
(69.8 × 119.4 cm)
National Gallery, London

The figures portrayed may be Robert Andrews and his wife Frances Carter, or it may be a simple marriage portrait. Frances Carter brought a dowry of a property, which came into the possession of Robert Andrews in 1750. The painting that bears this date can therefore be read as a triple portrait: of Robert Andrews, his wife, and his property.

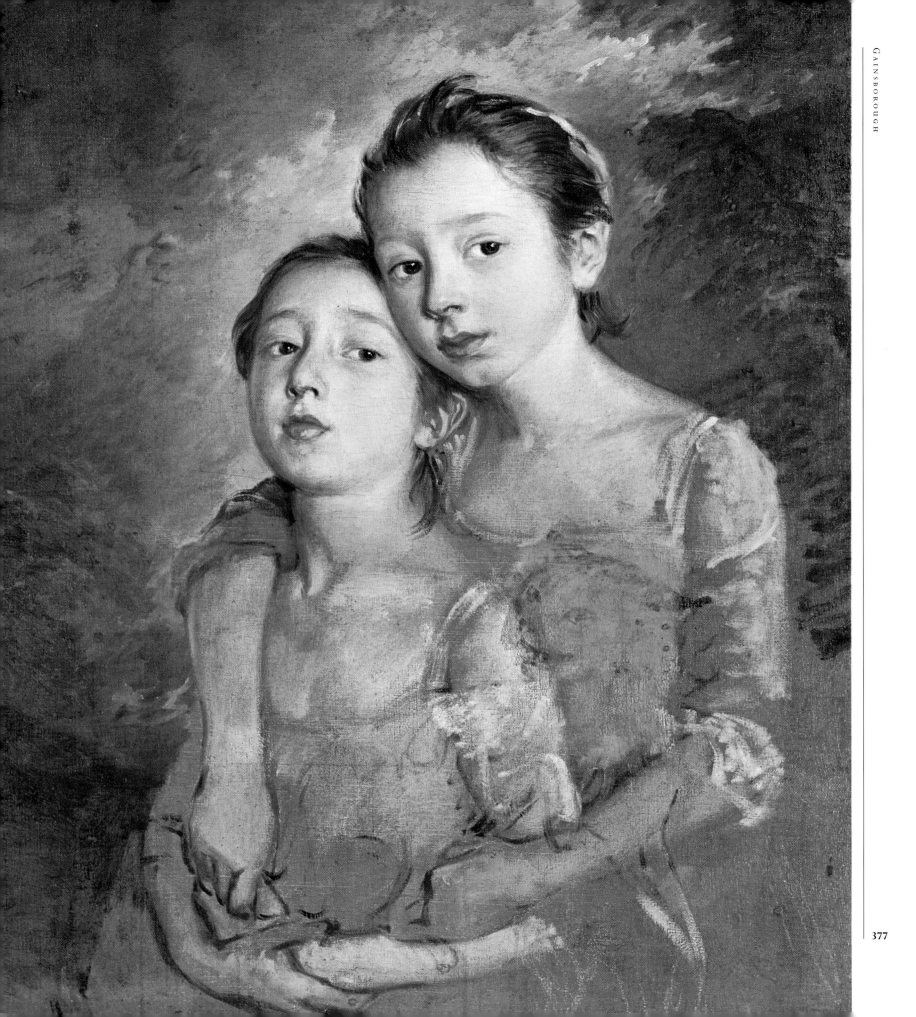

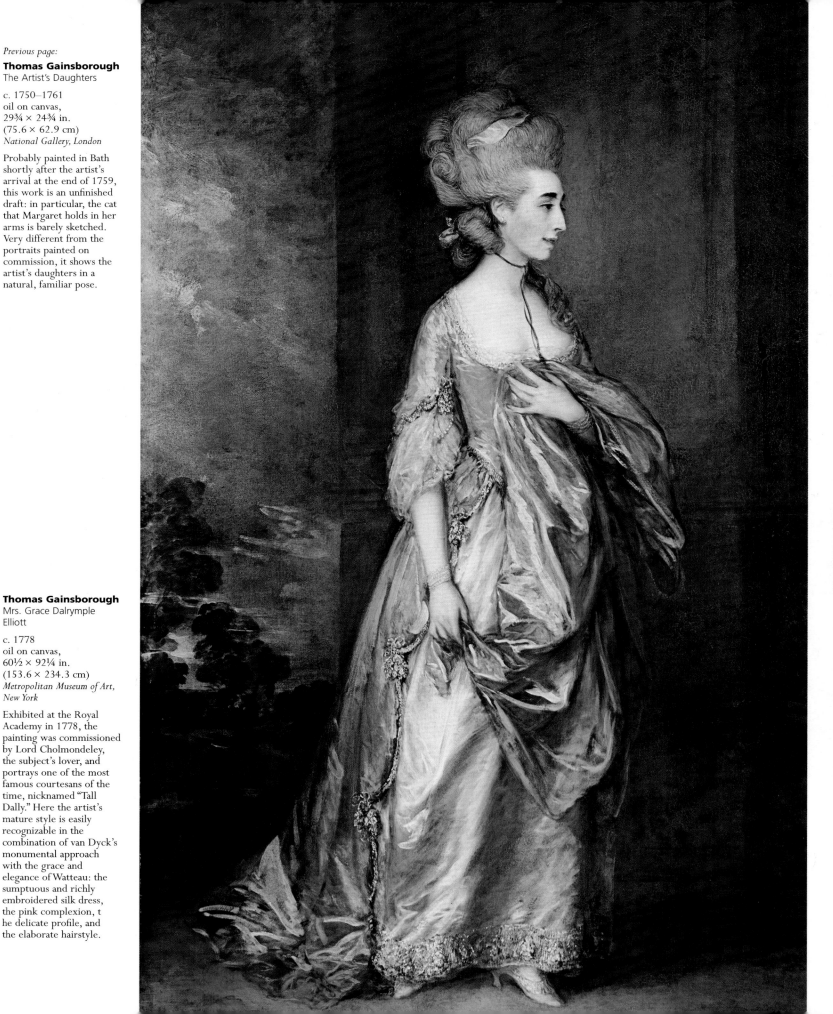

Previous page:

Thomas Gainsborough
The Artist's Daughters

c. 1750–1761
oil on canvas,
29¾ × 24¾ in.
(75.6 × 62.9 cm)
National Gallery, London

Probably painted in Bath
shortly after the artist's
arrival at the end of 1759,
this work is an unfinished
draft: in particular, the cat
that Margaret holds in her
arms is barely sketched.
Very different from the
portraits painted on
commission, it shows the
artist's daughters in a
natural, familiar pose.

Thomas Gainsborough
Mrs. Grace Dalrymple
Elliott

c. 1778
oil on canvas,
60½ × 92¼ in.
(153.6 × 234.3 cm)
*Metropolitan Museum of Art,
New York*

Exhibited at the Royal
Academy in 1778, the
painting was commissioned
by Lord Cholmondeley,
the subject's lover, and
portrays one of the most
famous courtesans of the
time, nicknamed "Tall
Dally." Here the artist's
mature style is easily
recognizable in the
combination of van Dyck's
monumental approach
with the grace and
elegance of Watteau: the
sumptuous and richly
embroidered silk dress,
the pink complexion, t
he delicate profile, and
the elaborate hairstyle.

378

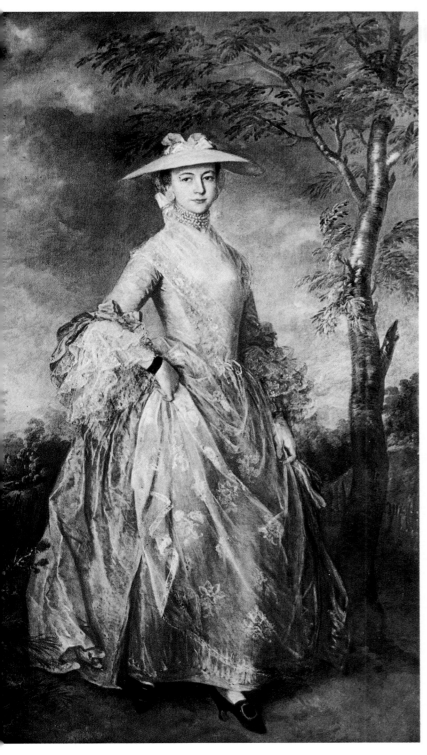

Thomas Gainsborough
Mary, Countess of Howe

1764
oil on canvas,
90 × 60 in.
(244 × 152.4 cm)
Kenwood House, London

In his adaptations of van Dyck, Gainsborough makes an original, creative use of his source. While maintaining the main lines of the figure, he changes the position of the legs or the arms; in the same way this painting is a "variation on a theme." One innovative feature, however, is the use of landscape as background, common to all his portraits, a landscape depicted with the same gradations of light and shadow and the same intensity of color as in the figures.

Thomas Gainsborough
Mrs. Siddons

1785
oil on canvas,
49½ × 39¼ in.
(126 × 99.5 cm)
National Gallery, London

The painting depicts the greatest tragic actress of the second half of the eighteenth century. From 1782 on, Mrs. Siddons dominated the London theater seasons, and posed for several artists. Her most famous portrait is *Mrs. Siddons as the Tragic Muse* by Reynolds, who painted her in theater costume. It was exhibited at the Royal Academy in 1784. Gainsborough, on the other hand, chose to portray Mrs. Siddons in an everyday setting: the actress is not wearing a stage costume, but a long blue and white striped dress, a yellow silk cloak edged with beaver, and a black hat decorated with ribbons and ostrich feathers. The painting remained unsold in the artist's studio in Schomberg House, and was then given to the Siddons family, in whose hands it remained until 1862, when it was purchased by the National Gallery.

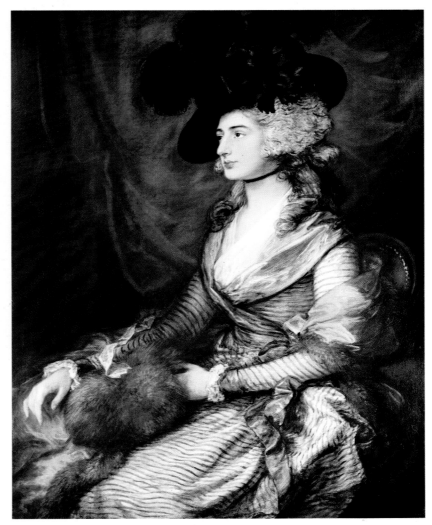

Thomas Gainsborough
The Marsham Children

1787
oil on canvas,
95½ × 71½ in.
(243 × 182 cm)
Gemäldegalerie, Berlin

The painting belongs to
the genre of conversation
pieces, namely, informal
group portraits. The figures
portrayed in full length
and life size are the
children of a family well-
established in London
society. In front of a fake
landscape background,
they are framed by the
foliage of the trees,
surrounded by a natural
setting rendered with the
same intensity of color
as the figures themselves,
which creates a subtle
blend of subject and
background.

Thomas Gainsborough
The Morning Walk

1785
oil on canvas,
93 × 70½ in.
(236 × 179 cm)
National Gallery, London

Commissioned by William
Hallett on the occasion of
his marriage to Elizabeth
Stephen, in 1785, the
painting shows the bride
and groom in wedding
dress. Elizabeth is wearing
an ivory-colored silk dress,
with a black silk sash
around the waist, and an
extravagant hat with a
large green ribbon and
ostrich feathers; William is
wearing a black velvet suit,
his hair is powdered, and
he is holding a black hat.
In evident contrast to
the extreme elegance and
nobility of the characters
is the presence by their
side of a Pomeranian dog.
This dog was often painted
by Gainsborough, since
it belonged to his dear
friend the viola da gamba
composer Carl Friedrich
Abel.

Johann Zoffany
The Tribuna of the Uffizi

1772–1778
oil on canvas,
48½ × 61 in.
(123.5 × 155 cm)
*Royal Collections,
Windsor Castle*

In the famous octagonal
Buontalenti Room,
classical sculptures on high
pedestals are arranged
in a disorderly manner,
observed by a crowd of
ordinary spectators,
museum staff, and art
lovers. On the red velvet
walls it is possible to make
out paintings by Pontormo
(*Charity*), Reni (*Suicide
of Cleopatra*), Raphael
(*Madonna della Seggiola,
Madonna del Cardellino,*
and *Saint John the Baptist*),
Rubens (*Consequences of
War*), Pietro da Cortona,
Titian, and Hals,
"paintings within the
painting" of exceptional
documentary value.

Johann Zoffany
(Frankfurt, 1733–London, 1810)

German by birth, Zoffany trained in the
workshop of Marteen Speer, one of the
leading exponents of Bavarian Rococo.
From 1750 to 1753 he worked in Rome,
where he met the portrait painter Anton
Raphael Mengs.
In 1760 he moved to London, where he
changed his surname from Zauffely to
Zoffany. Here he found himself in an
artistic context in which the main demand
was for portraits and conversation pieces.
His meeting with the famous actor David
Garrick marked a turning point, for it led
to the commission of a portrait and a series
of theater scenes that, by following a
tradition established by Hogarth, brought
him immediate success.
His great gift for capturing a likeness and
his attention to detail constitute the main
distinctive features of his pictorial
language. He painted numerous portraits
of the royal family and in 1772 was
nominated as a member of the Royal
Academy by George III. In the same year
he visited Florence, where he remained
until 1778 to paint *The Tribuna of the Uffizi*,
commissioned by Queen Charlotte. On his
return to London in 1779, he found that
tastes had changed and that his fame had
been overshadowed by the rising stars of
English painting, Reynolds and
Gainsborough.

Johann Zoffany
Charles Towneley
in His Sculpture Gallery

1782
oil on canvas,
50 × 40 in.
(127 × 102 cm)
*Towneley Hall, Art Gallery
and Museum, Burnley*

The collector Charles
Towneley is portrayed in
his library in the company
of three friends: the
politician and art lover
Charles Greville, the
paleographer and curator
of the British Museum
Thomas Astle, and the
French antiquarian Pierre
d'Hancarville. Around
them are marbles gathered
from various parts of the
house, fine examples from
his collection, which was
purchased by the British
Museum on his death in
1805. The figure of the
Discus Thrower, in the
bottom left of the painting,
was added at Towneley's
request, after the discovery
of the statue in 1791.

Joseph Wright (Wright of Derby)

(Derby, 1734–1797)

Tradition and modernity, admiration for the art of Caravaggio and, at the same time, an interest in scientific and technical discoveries, intertwine and merge in the painting of Joseph Wright, which was in many ways atypical of English eighteenth-century art. Despite his training in London in the studio of the portrait painter Thomas Hudson, Wright was actually more attracted, from the beginning, by compositions with artificial lighting, in the manner of the Dutch Caravaggists, from van Honthorst to Terbrugghen. Hence his journey to Italy, in 1773, was decisive, bringing to a conclusion a line of research begun around 1750, documented by his many candlelit pictures and illustrations of scientific experiments and industrial subjects.

His frequent visits to factories and foundries stemmed from his need to draw from life scenes in which artificial lighting is employed. The results are paintings that record the dawn of the Industrial Revolution and reflect the well-known interest in technology of the British. In the last twenty years of his career, he painted classical themes and subjects drawn from Shakespeare, as well as landscapes of his native Derbyshire.

Joseph Wright of Derby
Eruption of Vesuvius

1774
gouache,
13 × 21 in.
(33 × 53 cm)
Derby Museum and Art Gallery, Derby

This is one of a series of paintings of Vesuvius executed after his stay in Italy, during which he witnessed an eruption, an event often painted by French and Dutch artists, as well as by Neapolitan landscape painters.

Opposite page:
Joseph Wright of Derby
A Philosopher Gives a
Lesson with a Mechanical
Planetarium

1766
oil on canvas,
58 × 80 in.
(147.3 × 203.2 cm)
*Derby Museum and Art
Gallery, Derby*

Exhibited at the Society
of Artists in 1768
together with the

*Experiment with an Air
Pump*, the painting shows
a group gathered around
a planetarium with a lamp
in place of the sun.
The canvas is animated
by an intense play of light
and shadow that highlights
the faces of the figures,
completely absorbed in
the philosopher's lesson,
creating a self-contained
scene that totally excludes
the spectator.

Joseph Wright of Derby
Landscape with Rainbow:
View in the Vicinity
of Chesterfield

c. 1795
oil on canvas,
32 × 42 in.
(81 × 107 cm)
*Derby Museum and Art
Gallery, Derby*

A work of his late
maturity, it shows the
influence of the

landscapes enjoyed
during his travels in Italy.
The frame of outlined
trees recalls the grottos
he greatly admired
when he was in Naples
and Salerno. The
landscape, observed
from within a grotto,
is crossed by a bright
rainbow that further
heightens the romantic
atmosphere.

Joseph Wright of Derby
The Indian Widow

1785
oil on canvas
*Derby Museum and Art
Gallery, Derby*

The painting is the
expression of a view that
was widespread in
eighteenth-century
England, according to
which the native is no
longer to be considered
an alien to be killed or
enslaved, but the subject
of scientific interest.
Against the background
of an idealized landscape,
the majestic figure of a
woman sits in a
melancholy attitude at the
foot of a ghostly tree.

Benjamin West

(Pennsylvania, 1738–London, 1820)

An American who came at an early age to Europe, West established a new kind of history painting featuring contemporary subjects. After his stay in Italy, from 1760 to 1763, during which he came into contact with Winckelmann's circle, he settled in London, where he first set up as a portrait painter. He subsequently devoted himself to subjects of ancient history, winning the favor of the court and of George III, who commissioned a series of religious paintings, never completed, on themes from the Old and New Testaments, conveniently modified to suit Protestant requirements. He then began to evolve a new form of modern history painting, with figures in contemporary dress treated in classical and Baroque style. *The Death of General Wolfe* and *Penn's Treaty with the Indians* are typical examples of this new genre, in which the real and the ideal are combined in a rather confused way, after the classical manner, in particular that of Poussin. On the death of Reynolds in 1792, he was nominated the second president of the Royal Academy (founded in 1768). His later works are more individual in style, and are also interesting due to the clear influence of the romantic theories of Edmund Burke and his meditation on the concept of the "sublime."

Benjamin West
Portrait of Colonel Guy Johnson

c. 1775
oil on canvas,
80 × 54¼ in.
(203 × 138 cm)
National Gallery of Art, Washington

West's preference for neoclassical canons is evident in his portrait of the British Colonel Guy Johnson, the officer in charge of problems regarding the American Indians. In the shade behind him is an Indian chief, his helper and advisor during the various war missions. The focal point of the composition, the mannered figure of the Indian, acts as a link between the colonel and the scene in the background, an Indian camp at the foot of a waterfall, visible though a sort of opening on the left of the picture. Some of the realistic details are particularly evocative, such as the symmetrically arranged arrow and rifle, which symbolize the two different cultures.

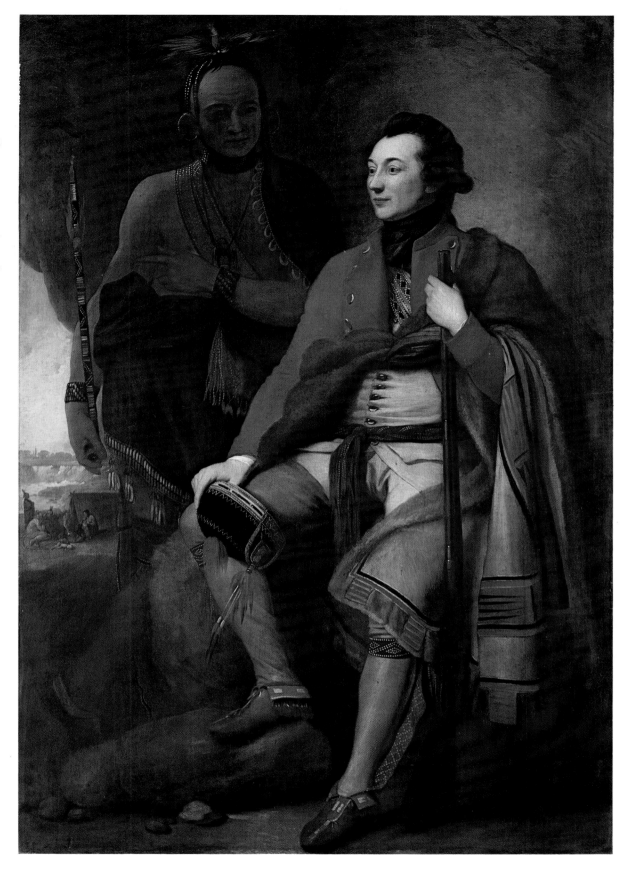

Benjamin West
The Death of General Wolfe

1770
oil on canvas,
60 × 84½ in.
(152.6 × 214.5 cm)
National Gallery of Canada, Ottawa

The first epic work in contemporary dress, this painting depicts the conquest of Quebec in 1759, an episode that was decisive in the final defeat of the French forces in the American colonies. Adopting the iconography of Italian seventeenth-century "depositions," West arranges the figures in the measured space of a deep stage. Among the many people surrounding the dying general are two soldiers in prayer and an Indian who, as well as locating the event in geographical terms, allows the artist to cite classical sculpture. Exhibited at the Royal Academy in 1771, the painting was greatly admired by George III, who commissioned a copy for himself, and appointed West as history painter to the court.

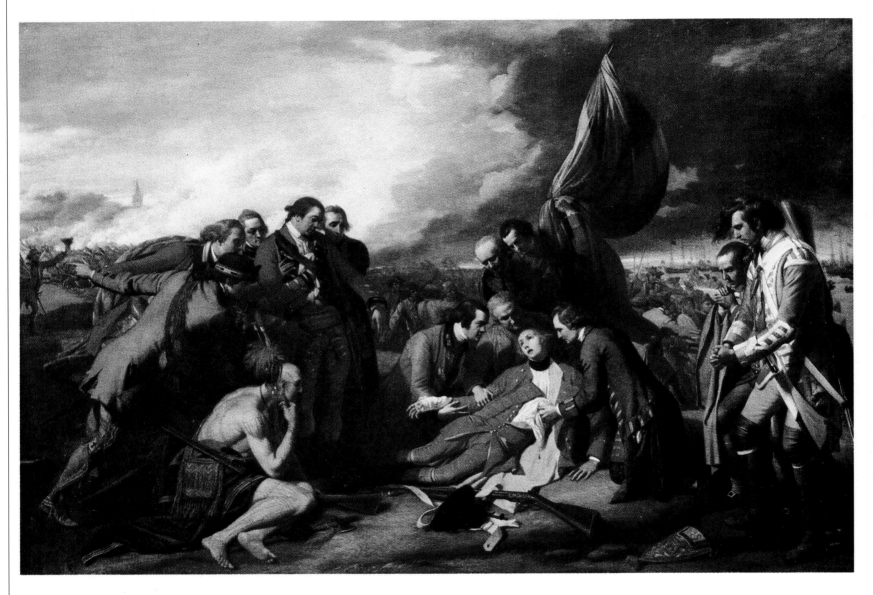

Benjamin West
Penn's Treaty with
the Indians

1771–1772 oil on canvas,
75 × 108 in.
(190 × 274 cm)
*The Pennsylvania Academy
of Fine Arts, Philadelphia*

The composition of this
history painting recalls the
great Venetian school of
the fifteenth century.
Against the background of
an imaginary landscape,
where European-style
buildings are seen side by
side with Indian huts, a
real event unfolds: the
peace negotiations
conducted by William
Penn with the Indians. In
the foreground, the group
of Europeans headed by
Penn, wearing austere
black cloaks and hats,
attempts to establish a
dialogue with the natives,
whose colorful, humble
clothes accentuate the
inevitable contrast between
the two civilizations.

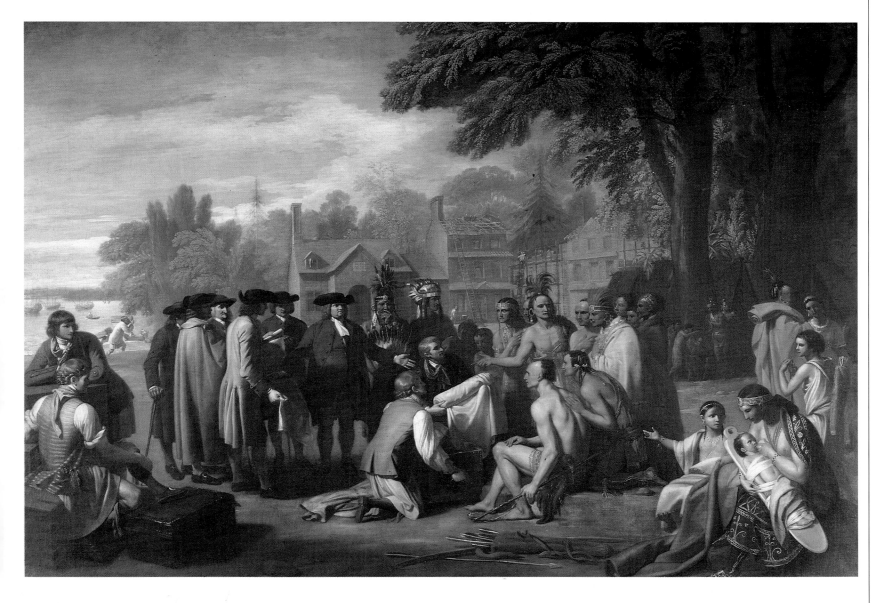

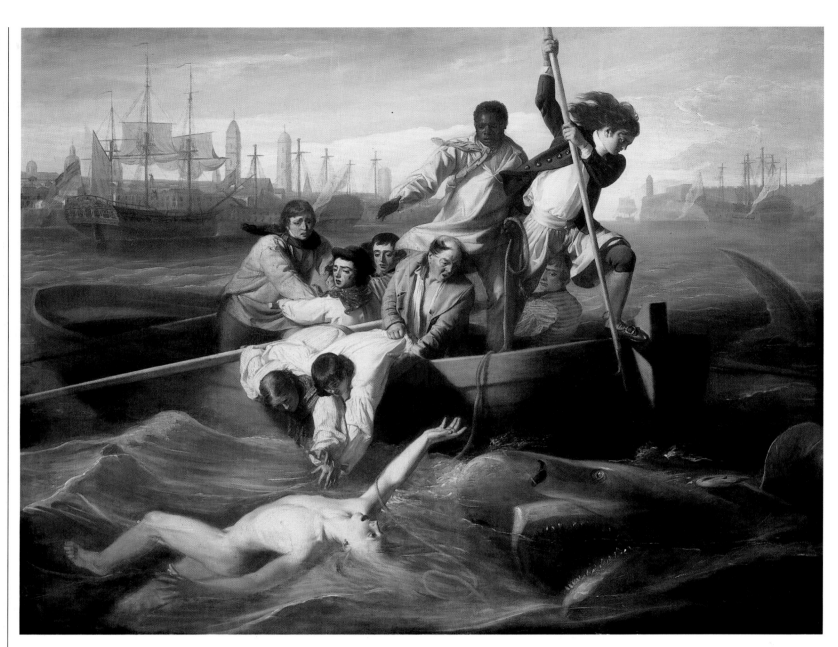

John Singleton Copley

(Boston, 1738–London, 1815)

In middle-class, commercial Boston, Copley did his apprenticeship in the workshop of the engraver Peter Pelham, his mother's second husband. Influenced at first by contemporary American portrait painters, he soon evolved a distinct style of portraiture all his own. His practice of mezzotint engraving was evident in his manner of painting, especially in the gradations of light and shadow and the refined, delicate use of colors. His portrait painting shows his evident desire to combine a formal, classical vision of society with an attempt to convey the freshness and spontaneity of everyday life. In 1774, encouraged by his fellow American Benjamin West, he began the Grand Tour that was to take him to

London, Paris, Genoa, and finally Rome, which proved to be the decisive stage of his journey. It was in Rome that he heard the news of the American War of Independence, which broke out in 1775. He decided not to return to the United States, but to move with his family to London. Here his work was admired by George III, who made him a member of the Royal Academy in 1783. During his time in London he continued to practice portrait painting, although his work lacked the concrete yet refined simplicity and the psychological perception that had marked his American portraits. Following in the footsteps of West, he also devoted himself to modern history painting, confirming his bent for contemporary themes, and his desire to find in modern life the same examples of virtue, pride, and dignity found in ancient models.

John Singleton Copley
Brook Watson and the Shark

1778
oil on canvas,
71½ × 90½ in.
(182 × 230 cm)
National Gallery of Art, Washington

The first painting of contemporary history based on a personal story, it was commissioned by the English merchant Brook Watson, and depicts an episode that happened during his childhood: threatened by a shark in the port of Havana, he was saved by a group of sailors. Exhibited at the Royal Academy in 1778, the painting is striking for the grandeur of the composition, which is reminiscent of a biblical scene.

John Singleton Copley
The Copley Family

c. 1776
oil on canvas,
75½ × 90½ in.
(184.4 × 229.7 cm)
*National Gallery of Art,
Washington*

Painted after his move to
London, this work shows
the influence of Reynolds
in the gradual
replacement of the linear
style, with which Copley
generally defined figures
and drapery, by freer,
broader brushwork.
The influence of Reynolds
is also evident in the
arrangement of the
figures according to the
iconography of the Italian
seventeenth-century
masters. The maternal
group is clearly based
on the versions of *Charity*
by Reni and Pontormo,
while the self-portrait is
reminiscent of the manner
of Pompeo Batoni,
a portrait painter who
was fashionable
in England.

John Singleton Copley
Paul Revere

c. 1768–1770
oil on canvas,
34½ × 28 in.
(87.5 × 71.5 cm)
Museum of Fine Arts, Boston

The classical nature of the
composition, clearly
inspired by Titian,
contrasts with the realism
of the scene. The subject
seems almost to be caught
by surprise at a moment in
his daily life, which is
alluded to by the objects
randomly placed on the
table. The intense
expression of the face and
the composed attitude
show the artist's desire to
bring out the inner nature
of the character.

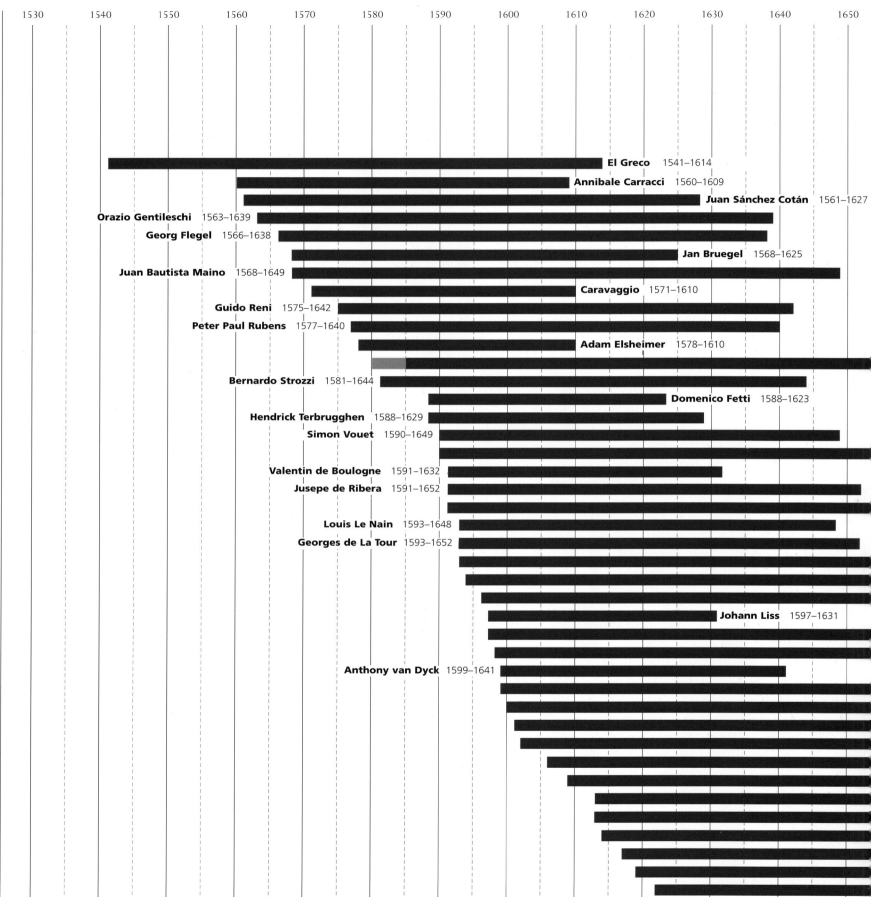

1530	1540	1550	1560	1570	1580	1590	1600	1610	1620	1630	1640	1650

El Greco 1541–1614

Annibale Carracci 1560–1609

Juan Sánchez Cotán 1561–1627

Orazio Gentileschi 1563–1639

Georg Flegel 1566–1638

Jan Bruegel 1568–1625

Juan Bautista Maino 1568–1649

Caravaggio 1571–1610

Guido Reni 1575–1642

Peter Paul Rubens 1577–1640

Adam Elsheimer 1578–1610

Bernardo Strozzi 1581–1644

Domenico Fetti 1588–1623

Hendrick Terbrugghen 1588–1629

Simon Vouet 1590–1649

Valentin de Boulogne 1591–1632

Jusepe de Ribera 1591–1652

Louis Le Nain 1593–1648

Georges de La Tour 1593–1652

Johann Liss 1597–1631

Anthony van Dyck 1599–1641

1660	1670	1680	1690	1700	1710	1720	1730	1740	1750	1760	1770	1780

Frans Hals 1580/1585–1666

Gerard van Honthorst 1590–1656

Guercino 1591–1666

Jacob Jordaens 1593–1678

Nicolas Poussin 1594–1665

Pietro da Cortona 1596–1669

Sebastian Stosskopf 1597–1657

Francisco de Zurbarán 1598–1664

Diego Velázquez 1599–1660

Claude Lorrain 1600–1682

Alonso Cano 1601–1667

Philippe de Champaigne 1602–1674

Rembrandt van Rijn 1606–1669

Johann Heinrich Schönfeld 1609–1683

Gerard Dou 1613–1675

Mattia Preti 1613–1699

Juan Carreño de Miranda 1614–1685

Bartolomé Esteban Murillo 1617–1682

Charles Lebrun 1619–1690

Juan de Valdés Leal 1622–1690

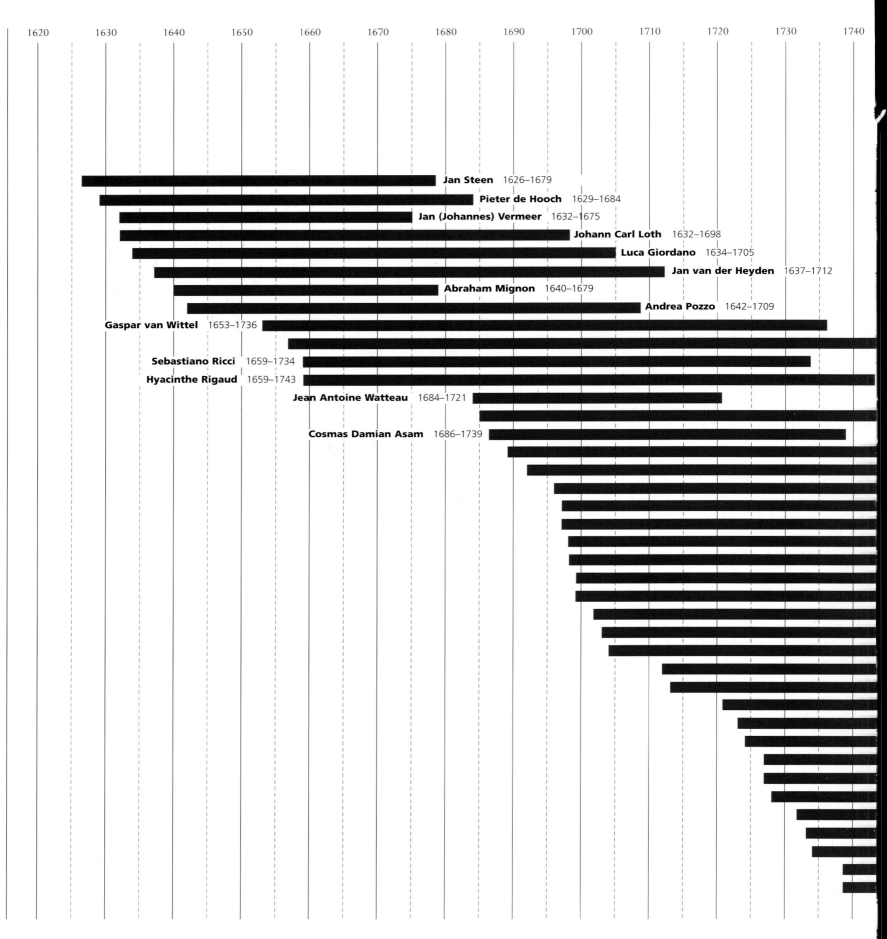

1620 1630 1640 1650 1660 1670 1680 1690 1700 1710 1720 1730 1740

Jan Steen 1626–1679

Pieter de Hooch 1629–1684

Jan (Johannes) Vermeer 1632–1675

Johann Carl Loth 1632–1698

Luca Giordano 1634–1705

Jan van der Heyden 1637–1712

Abraham Mignon 1640–1679

Andrea Pozzo 1642–1709

Gaspar van Wittel 1653–1736

Sebastiano Ricci 1659–1734

Hyacinthe Rigaud 1659–1743

Jean Antoine Watteau 1684–1721

Cosmas Damian Asam 1686–1739

Year													
1750	1760	1770	1780	1790	1800	1810	1820	1830	1840	1850	1860	1870	

Francesco Solimena 1657–1747

Jean Marc Nattier 1685–1766

Giambattista Piazzetta 1689–1754

Egid Quirin Asam 1692–1750

Giambattista Tiepolo 1696–1770

William Hogarth 1697–1764

Canaletto 1697–1768

Paul Troger 1698–1762

Giacomo Ceruti 1698–1767

Pierre Subleyras 1699–1749

Jean-Baptiste-Siméon Chardin 1699–1779

Jean-Étienne Liotard 1702–1789

François Boucher 1703–1770

Maurice Quentin de La Tour 1704–1788

Francesco Guardi 1712–1793

Allan Ramsay 1713–1784

Bernardo Bellotto 1721–1780

Joshua Reynolds 1723–1792

Franz Anton Maulbertsch 1724–1796

Giandomenico Tiepolo 1727–1804

Thomas Gainsborough 1727–1788

Anton Raphael Mengs 1728–1779

Jean-Honoré Fragonard 1732–1806

Johann Zoffany 1733–1810

Joseph Wright of Derby 1734–1797

Benjamin West 1738–1820

John Singleton Copley 1738–1815

Index of Artists

Photographic References
Archivio Electa, Milan
Archivio Mondadori, Milan

Thanks also go to the photographic
archives of the museums and organizations
that have provided the photographs.

The publisher is ready to supply further
information on the photographic sources
not mentioned to those entitled to
request it.

This volume was printed by Elemond S.p.a.
at the plant in Martellago (Venice), 1999.